BEYOND BELIEF

MODERN ART AND THE RELIGIOUS IMAGINATION

ROSEMARY CRUMLIN

Catalogue research and collaboration
MARGARET WOODWARD

Sponsored by

THE MURDOCH FAMILY

Sisters of Mercy Australia

MAB Corporation, Rochford International

Indemnified by the Victorian Government through Arts Victoria,
Department of Premier and Cabinet

National Gallery of Victoria

Note for the reader

Dimensions of works listed in this catalogue are provided to the nearest millimetre. Where there are three dimensions provided for a work, height precedes width, and width precedes depth (height by width by depth).

Published by the National Gallery of Victoria
180 St Kilda Road, Melbourne, 3004

National Library of Australia Cataloguing-in-Publication entry:

Crumlin, Rosemary.
 Beyond belief: modern art and the religious imagination.

 Bibliography.
 Includes index.
 ISBN 0 7241 0199 3.
 ISBN 0 7241 0200 0 (pbk.).

 1. Christian art and symbolism – Modern period, 1500– –
 Australia – Melbourne (Vic.) – Exhibitions. 2. Art,
 Australian – Exhibitions. I. Woodward, Margaret, 1938–.
 II. National Gallery of Victoria. III. Title.

704.9482099451

Designer: Norma van Rees
Editor: Brett Lockwood
Initial manuscript preparation: Deidre Missingham
Word processor: Judy Shelverton
Photography: Supplied by lending institutions
Film separations: Colorific
Printed by: A. E. Keating

Exhibition dates: 24 April – 26 July 1998

CONTENTS

Francis Bacon
Ernst Barlach
Max Beckmann
John Bellany
Joseph Beuys
Arthur Boyd
James Brown
James Lee Byars
Leonora Carrington
Julio Castellanos
Francesco Clemente
Marc Chagall
Gaston Chaissac
Maurice Denis
Otto Dix
Harald Duwe
James Ensor
Max Ernst
Herbert Falken
Audrey Flack
Max Gimblett
Daniel Goldstein
George Grosz
Jenny Holzer
Alfred Hrdlicka
Jean-Robert Ipoustéguy
Maria Izquierdo
Wassily Kandinsky
Frida Kahlo
Anselm Kiefer
Hilma af Klint
Oskar Kokoschka
Käthe Kollwitz
Lee Krasner
Alfred Manessier
Robert Mapplethorpe
Agnes Martin
Henri Matisse
Colin McCahon
Annette Messager
Robert Motherwell
George Mung Mung
Barnett Newman
Hermann Nitsch
Emil Nolde
Georgia O'Keeffe
José Clemente Orozco
Mimmo Paladino
Pablo Picasso
Arnulf Rainer
Germaine Richier
Mark Rothko
Georges Rouault
Horst Sakulowski
Antonio Saura
Karl Schmidt-Rottluff
George Segal
Ben Shahn
Cindy Sherman
David Alfaro Siqueiros
Kiki Smith
Stanley Spencer
Dorothea Tanning
Rover Thomas
Mark Tobey
Rosemarie Trockel
Werner Tübke
Remedios Varo
Andy Warhol
Ben Willikens
Gustave van de Woestyne
Nahum B. Zenil

CONTRIBUTING AUTHORS

The contributors, who were invited to journey through the works and to make their individual responses, come from different countries and cultures, and speak out of different disciplines and belief systems. Their voices are brought together here. R. C.

Doug Adams. Professor of Religion and the Arts, Pacific School of Religion, California. USA.

Diane Apostolos-Cappadona. Professorial Lecturer in Religion and Art, Georgetown University, Washington DC. USA.

James R. Blaettler SJ. Professor of Art History, Fairfield University, Connecticut. USA.

Andrew Bullen SJ. Poet, lecturer in philosophy, United Faculty of Theology, Melbourne. Australia.

Mary Charles-Murray. Writer—religion and visual arts; Professor of Theology, University of Nottingham. England.

Armando Colina. Director, Galeria Arvil, Mexico City. Mexico.

Isobel Crombie. Senior Curator of Photography, National Gallery of Victoria. Australia.

Rosemary Crumlin. Guest curator, general editor of *Beyond Belief*, lecturer—art and religion. Australia.

Jane Daggett-Dillenberger. Curator, Professor Emerita, Graduate Theological Union, Berkeley. USA.

Tom Devonshire-Jones. Art historian, a founder of international group Arts and Christian Enquiry (ACE), London. England.

Geoffrey Edwards. Senior Curator, Sculpture and Glass, National Gallery of Victoria. Australia.

Fiona Elliott. Translator, lecturer at Edinburgh University. Scotland.

Audrey Flack. Artist and writer, New York. USA.

David Freedberg. Professor of Art History, Columbia University. Andrew W. Mellon Professor, National Gallery of Art, Washington DC. USA.

Patricia Fullerton. Curator and writer. Australia.

Kelly Gellatly. Senior Assistant Curator, Australian Photography, National Gallery of Australia.

John Gregory. Head, Department of Visual Arts, Monash University. Australia.

Maria Harris. Teacher, held Tuohy Chair in Interreligious Studies, John Carroll University, Cleveland; New York. USA.

Deborah J. Haynes. Director of Women's Studies, and Associate Professor of Fine Arts, Washington State University. USA.

Heinrich Heil. Writer on the arts: living and working in Cologne. Germany.

Tracey Judd. Senior Curatorial Assistant to Director, National Gallery of Victoria. Australia.

Veronica Lawson. Senior Lecturer in Theology, Aquinas Campus, Australian Catholic University, Ballarat. Australia.

Cathy Leahy. Curator of Prints and Drawings, National Gallery of Victoria. Australia.

Helen Light, Australia. Director/Curator Jewish Museum of Australia.

Gerd Lindner. Art historian, Director, Panorama Museum, Bad Frankenhausen. Germany.

Herman Lombaerts. Professor of Pastoral Theology, Catholic University of Leuven. Belgium.

Friedhelm Mennekes SJ. Curator, Kunst-Station Sankt Peter (Centre for Contemporary Art), Köln. Germany.

Gordon Morrison. Division Head, Exhibitions and Collection Management, National Gallery of Victoria. Australia.

Patrick Negri. Lecturer—art, religion and culture, Melbourne College of Divinity. Australia.

Rod Pattenden. Coordinator, Institute for Theology and the Arts, Sydney. Australia.

Juliette Peers. Art historian, writer, university lecturer, RMIT, Melbourne. Australia.

Charles Pickstone. Art critic, Vicar of Church of England parish, St Laurence, Catford. England.

Johannes Röhrig. Art historian, lecturer, Köln. Germany.

Judith Ryan. Senior Curator of Australian Art, National Gallery of Victoria. Australia.

Horst Schwebel. Professor, Philipps University of Marburg; Director, Institute for Church Building and Contemporary Church Art, Marburg, Germany.

Peta Allen Shera. Researcher, contributor to independent films. Australia.

Geoffrey Smith. Curator, Twentieth Century Australian Art, National Gallery of Victoria. Australia.

Jason Smith. Curator, Contemporary Art (Australian and International), National Gallery of Victoria. Australia.

Maria Stergiou. Art historian, Zürich. Switzerland.

Jacqueline Strecker. Art historian and Curator, National Gallery of Victoria. Australia.

Mark C. Taylor. Cluett Professor of Humanities, Williams College, Massachusetts. USA.

Kenneth Wach. Senior Lecturer, School of Studies in Creative Arts. Victorian College of the Arts, University of Melbourne. Australia.

Elaine Wainwright. Lecturer in Biblical Studies, Feminist Theology, Brisbane College of Theology. Australia.

Michael Warren. Professor of Theology, St John's University, New York. USA.

Evelyn Weiss. Vice Director, Museum Ludwig, Köln. Germany.

Katharina Winnekes. Art historian, curator, Erzbischöfliches Diözesanmuseum Köln, editor *Kunst und Kirche*. Germany.

Tom Wolfe. Author. USA.

Margaret Woodward RSJ. Educator—the arts, culture, social justice. Australia.

Linnea Wren. Professor in Art History; with Krysta Hochstetler and Kaylee Spencer. Gustavus Adolphus College. Minnesota. USA.

LENDERS TO THE EXHIBITION

Andy Warhol Museum, Pittsburgh

Anonymous private collections, Mexico, Germany, USA, France

Anthony d'Offay Gallery, London

Art Gallery of Western Australia

Audrey Flack, USA

Bundanon Trust, Australia

Collection of A. Grassi, Milano

Collection of Kiki Smith, USA

Collection of Max Gimblett and Barbara Kirshenblatt-
 Gimblett, New York

Collection of Nahum B. Zenil, Mexico

Curtis Galleries, Minneapolis

Deutsches Architektur-Museum, Frankfurt am Main

Erzbischöfliches Diözesanmuseum, Köln

Evangelische Akademie Tutzing, Germany

Folkwang Museum, Essen

Francesco Clemente

Galeria Arvil, Mexico City

Galerie Nathan, Zürich

George Grosz Estate

The Hilma af Klint Foundation, Stockholm

Hirshhorn Museum and Sculpture Garden, Smithsonian
 Institution, Washington, DC.

James Brown

Jenny Holzer Studio, New York

Käthe Kollwitz Museum, Köln

Kunstsammlung Gera, Germany

Kunst-Station Sankt Peter, Köln

Le Case D'Arte, Milano

The Metropolitan Museum of Art, New York

Michael Werner Gallery, New York & Cologne

Monika Sprüth Galerie, Köln

Musée Départemental Maurice Denis, 'Le Prieuré',
 St Germaine-en-Laye

Musée National Message Biblique Marc Chagall, Nice

Museum am Ostwall, Dortmund

Museum Ludwig, Köln

Museum of Fine Arts, Ghent

The Museum of Modern Art, New York

Museum voor Schone Kunsten, Oostende

National Gallery of Australia, Canberra

National Gallery of Victoria, Melbourne

New Orleans Museum of Art, Louisiana

Nolde Foundation, Seebüll

Panorama Museum, Bad Frankenhausen

The Saatchi Collection, London

Sidney Janis Gallery, New York

Städtische Galerie im Lenbachhaus, Munich

Tate Gallery, London

University of California, Berkeley Art Museum

Valencian Institute of Modern Art, Centro Julio Gonzalez

Vatican Museums, Vatican City

Warmun Community, Turkey Creek, Western Australia

DIRECTOR'S FOREWORD

Beyond Belief: Modern Art and the Religious Imagination is an exhibition of a kind too rarely seen in this country—one which looks beyond the reliable appeal of famous-name artists (though these are indeed here too) to explore a complex, multidimensional and sometimes elusive theme which runs across cultural, chronological and intellectual boundaries. This is not an easy exhibition, but it is one that will richly reward the viewer willing to engage with a profound and central topic in twentieth-century art.

The pervasiveness of broadly religious and spiritual themes in twentieth-century Western art may at first seem to stand in contradiction to the secularization of so many aspects of life and culture during our times. The religious underpinnings of so much Western art before this century—from its subject matter to its sources of patronage and its devotional purposes—are obvious and uncontentious. With the art of our own century, however, the religious dimension is altogether more subtle, often more abstract and inevitably more personal. From images created with a clear public message and usage in mind, we move into a world of individual spiritual discovery, personal visual languages and images which seek to explore and evoke rather than to define and prescribe. Some artists employ familiar religious iconography as convenient signifiers of an earlier culture and mind-set—artifacts to be used in a quintessentially modern image-making of juxtaposition, anomaly and incongruity. Others eschew icons altogether to explore more mystical spiritual concerns in images of diffuse abstraction. The visual languages, the spiritual purposes and the artistic results are infinitely varied, but all are united by an absorption in the confrontation between art and religious experience. In this exhibition, these pervasive currents of religious experience and thinking can be traced running through the work of many of the twentieth-century's most important artists and schools.

Beyond Belief, like the issues its artists are grappling with, is an exhibition to be engaged with rather than just viewed. The works themselves are born of a deeply-felt engagement with some of the central issues of existence and meaning in life, and the exhibition is designed to draw the viewer into this dialogue (as Rosemary Crumlin does with David Freedberg in this catalogue). Beyond the pure beauty of the works and the visual enjoyment this gives rise to, lies an invitation to an unapologetically more intellectual and thought-provoking experience.

The exhibition has been the brainchild of Sister Rosemary Crumlin who, after developing the concept for some years, was engaged to realize it by the National Gallery of Victoria in 1994. Since then she has steered it through many complex negotiations with lenders and contributors to the catalogue, supported at crucial junctures by a distinguished committee of advisors from around the world. The exhibition and catalogue are testimony to her clarity of vision and determination.

The Trustees of the Gallery are also to be acknowledged for supporting an exhibition of such ambition and complexity in the conviction that the experience we would be bringing to our audience more than justifies the substantial costs and many logistical difficulties of such a project.

The measure of any exhibition is the generosity of its lenders and we have been supported most magnanimously by private and public owners from around the world. To all of them we express our most sincere thanks.

A special debt of gratitude is owed to the principal sponsors of the exhibition, the Murdoch family, who have expressed a keen interest in the development of the exhibition from its inception and have supported its realization most generously. Without their assistance, and that of the support sponsors—Sisters of Mercy, Australia; MAB Corporation; Rochford International; and Channel Seven, Melbourne, the exhibition would have remained a tantalizing dream.

Timothy Potts

ACKNOWLEDGMENTS

The ways in which artists have sought to express their deepest questions of meaning have relevance for us all. *Beyond Belief: Modern Art and the Religious Imagination* reveals and explores the manner in which many great artists have, with ruthless honesty, approached these questions. This book is the third in a trilogy. *Images of Religion in Australian Art* (1988) and *Aboriginal Art and Spirituality* (1991) were concerned with Australian art. *Beyond Belief: Modern Art and the Religious Imagination* continues the conversation across many countries and different cultures. Conceived at the time of the 1988 exhibition, it has involved, over the last nine years, the wit and wisdom of artists, curators, friends, colleagues, academics and gallery directors from many different countries. I acknowledge and thank them and hope that they find here a reflection of their own understandings.

For the last three and a half years the exhibition has been the project of the National Gallery of Victoria under the leadership of Timothy Potts. In thanking him and his predecessor, James Mollison, for their insight and enthusiasm, I acknowledge also the generosity and competence of those who, within the Gallery, have been very involved: Derek Gillman has supervised the curatorial aspects; Gordon Morrison, the management and coordination of the exhibition; and Janine Bofill, registrar, the physical aspects of the loan agreements and transport of the works; Philip Jago the publications; Jennie Moloney, the reproductions; and Daryl West-Moore, the design. I have been grateful too for the opportunity to work daily in the congenial and professional company of the staff of the Gallery.

Consultants and contributors

From the genesis of this idea I have looked often to those who have agreed to be consultants to the project. They are all people of eminence in their fields who have shared their experience and maintained a supportive interest. They include Diane Apostolos-Cappadona (Professorial Lecturer in Religion and Art, Georgetown University, USA); Jim Briglia (theologian and philosopher, Melbourne, Australia); Armando Colina (Director, Galeria Arvil, Mexico); Tom Devonshire-Jones (art historian, London); Jane Daggett-Dillenberger (Professor Emerita,

Graduate Theological Union, Berkeley, USA); John Dillenberger (Professor Emeritus, Graduate Theological Union, Berkeley, USA); Herman Lombaerts (Professor, Faculty of Pastoral Theology, University of Leuven, Belgium); Friedhelm Mennekes SJ (curator and author, Kunst-Station Sankt Peter, Köln, Germany); Horst Schwebel (Professor, Philipps University of Marburg, Germany); Shane Simpson (writer and lawyer, Sydney, Australia); and Mark C. Taylor (Cluett Professor of Humanities, Williams College, Massachusetts, USA).

To Friedhelm Mennekes I owe a special debt of gratitude for his ongoing attention and support to this project and its vision.

My warmest appreciation is expressed to the contributors of essays and entries that have enabled this catalogue to reflect the rich cultural diversity of the art.

Sponsors

Naming sponsors on the title page is not sufficient to acknowledge their part in this project. They have each offered, not only generous financial support, but also friendship, encouragement, enthusiasm and a firm belief in the value of the project. My Congregation, the Sisters of Mercy, Parramatta; the Murdoch family—Dame Elisabeth, Rupert and Anna; Michael Buxton, and Patricia Rochford have my deepest gratitude. I recognize also the special help that has made possible the Vatican, Chagall and Nolde loans.

Finally

I would like to acknowledge by name just a few people who have given unstintingly of their competence, time and skills to bring this catalogue to its final state. Foremost among these is Margaret Woodward who, in the last months, has committed vast energy and outstanding academic skills in working alongside me on the catalogue. The designer, Norma van Rees, and the editor, Brett Lockwood, have been both highly professional and most generous.

Rosemary Crumlin

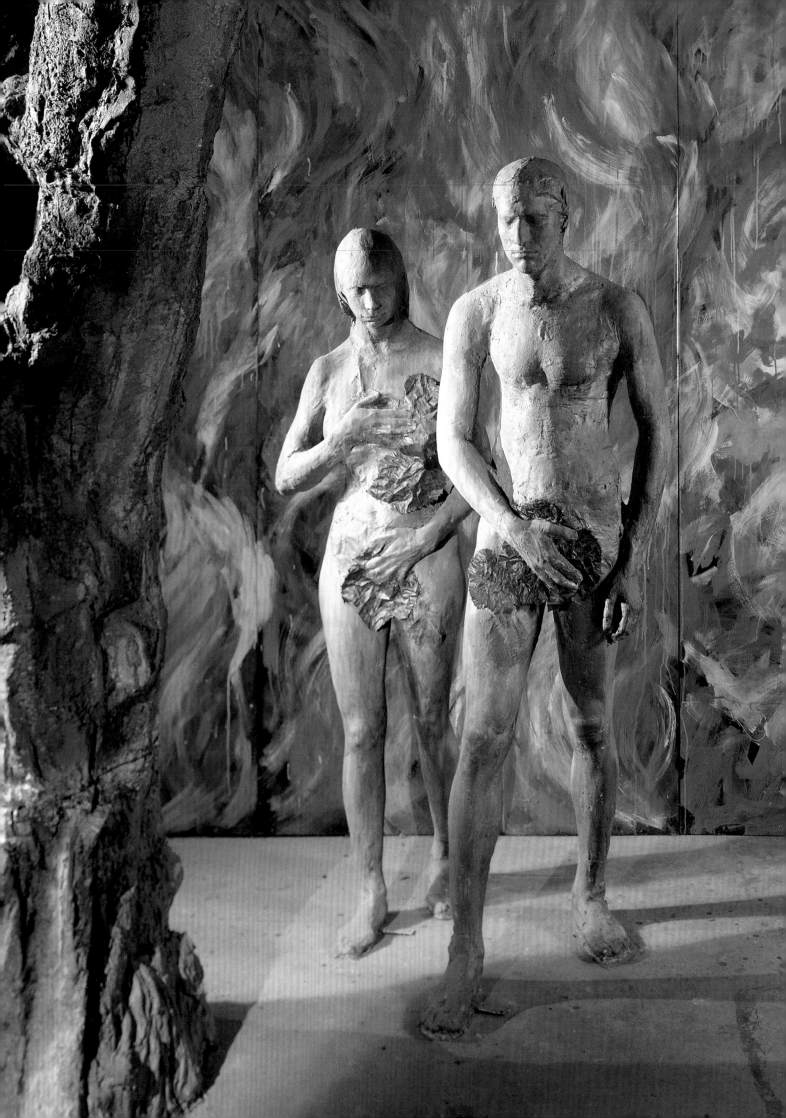

BEYOND BELIEF: MODERN ART AND THE RELIGIOUS IMAGINATION

Rosemary Crumlin

Ringing in the midsummer darkness. Struggling through the house to reach the phone and turn on the fax. A voice—'O sorry, have I rung you in the middle of the night? I'm so sorry. I thought I was in New York! Can you ring back on this number?' Grasping a felt-tipped pen. 'Yes', taking down the number. Now, with glasses on and light on, I ring the number. 'This number cannot be reached. Try again.' And again. Clearly I have the wrong number. A chasm opens up before me. What if I cannot reach him, what if he doesn't ring back? How shall I know about his response to the transcript of his article now due at the publishers? How shall I concentrate on the catalogue introduction with this major fragment of the picture missing?

That is the kind of project this has been—filled from the beginning with questions, uncertainties, darknesses and the sound of ringing in the night. And the promise of dawn.

The idea for this exhibition and book was born of a simple question. What would happen if it were possible to bring together some of the great religious works of the century—and to them bring some of the thinkers of the century? From this came other questions. For instance, would the power of the art stimulate new insight into what the century has been and who we are as we stand at the brink of a new millennium? The exhibition and the catalogue, *Beyond Belief: Modern Art and the Religious Imagination*, explore these questions through the eyes of artists and the reflections of contributors.

The exhibition, as it has evolved, is neither historical (although it includes history) nor to be understood as a survey of religious and spiritual images of the century, for the movement within the exhibition is essentially nonlinear, with recognition always given to the complexity and open-endedness of the art. Gathering the works around a theme—the religious imagination—would only be restrictive if too narrow an interpretation were taken of the key concepts. In fact, in this exhibition, the intention has been the reverse. Central to the exhibition are the works themselves; it is they that spin off meanings and challenge previously held concepts and structures.

The works in the exhibition do nevertheless span the twentieth century. The earliest, Maurice Denis's *The Catholic Mystery* (Le Mystère Catholique) (1889) (p. 41) and James Ensor's *Christ calming the storm* (Le Christ apaisant la tempéte) (1891) (p. 43) hover at the edges of a century of revolutions, wars and new beginnings. Both works hold the past in recognizable ways—the Denis with its expression of religious (Catholic) youthful fervour, and the simple but competent modelling; the Ensor with its swirling light-filled brush-strokes and its Christ, the Son of God at the eye of the storm. Both herald the future in their self-conscious organization of the picture plane.

At the other end of the century, and of the exhibition, are Francesco Clemente's meditations on his journey up Mount Abu in India and Audrey Flack's huge head of the goddess Daphne, with fruit and branches for hair and, on her forehead, a skull, reminder and warning of the destruction of war.

At the beginning of the century, the iconography of religion and spirituality was usually Judaeo-Christian, narrative and figurative. By the close of the century, the interest

George Segal
The Expulsion (detail) 1986–87
see p. 151

is not so much narrative and scriptural as diffusely spiritual, questioning, and focused less on a life after death than on a spirit that swells within the body, the earth, and—more rarely—society. Such changes can be clearly identified by looking at the shifts in the iconography of the works.

In the early part of the century, Western artists who sought explicit religious or spiritual expression almost always had recourse to Judaeo-Christian story and symbol. This was only to be expected, as Christianity was the prevailing culture and its iconography had been dominant since the Middle Ages. The use of this subject matter did not necessarily coincide with a commitment to the tenets of any institutional religion but was sometimes little more than a well-worn reservoir of vocabulary made familiar to the artist through study of the Old Masters.

Gradually this changed. Artists such as Kandinsky, Tobey and, more recently, Kiefer, Clemente and Flack, found inspiration and sometimes faith in other religious and spiritual traditions, especially theosophy, Eastern religions, the kabbala and the Goddess movement. Those who turned to Christianity for inspiration, such as Rainer, Falken, and the East Germans Sakulowski and Tübke, struggled for new and more relevant symbols to express their concerns. For them, the figure of Christ remains central, but he has become bleeding and ghost-like (p. 139), pregnant (p. 146), rescued by a concentration camp inmate (p. 155), or tied like a clown to a cross (p. 137).

Abstract art in the hands of Tobey, Rothko, Newman, Manessier, Krasner, Martin and Gimblett reflects a meditative or almost mystical communion with the sublime. Not mediated through recognizable subject matter linked with memory, myth or even symbol (except for the Manessier), their works invite a response which is likewise pure, untainted and even mystical.

For women artists, finding a vocabulary for their spiritual or inner life in an art culture and a religion which is patriarchal has posed particular problems. Of the seventeen women in this exhibition, only three—Izquierdo, Richier and Messager—have explicitly Christian subject matter. Maria Izquierdo's *Altar of Dolorosa Madonna* (Altar de Dolores) (p. 89) is a self-portrait as well as a votive image; Germaine Richier's *Christ of Assy* (1959) (p. 101) was a commission and was removed from its place because she was a communist; Annette Messager's *The Cross* (Le Croix) (1946) (p. 167) is hung with hand-sewn felt body-parts. The prevailing metaphors for the women artists, including those from the early part of the century, are four: body, earth, goddess and alchemy. In agreeing to be part of this exhibition, many of the women artists spoke of their inner lives in terms of 'searching', 'affecting people's lives', and 'being in the body and the earth'. The wide parameters of *Beyond Belief* influenced their decisions to participate.

The final shape of the exhibition carries with it the history of its gathering of works in much the same way as the works within it are marked with the DNA of the artists. The original plan had been for an exhibition of some of the most familiar religious icons of the twentieth century, works so familiar through reproduction that they are easily recognizable. It soon became clear that this would be neither desirable nor possible. If the exhibition restricted itself to the familiar, the tamed, the friendly, then it would lose its power to challenge, to be a resting place, and to raise new questions.

As the search for seminal works continued, the exhibition plan began to take on a life less preordained. The aim did not alter but the shape became more diverse, richer, more reflective of the complexity of the century. Works were borrowed from museums, private collectors, dealers and institutions—German, Mexican, English, French, Spanish and

Australian. Two decisions influenced the distinctive shape of this exhibition. One was to include a major group of works by Mexican artists. The other was to acknowledge that among the great artists of this century are indigenous artists of equal stature. Both choices demonstrate well that the power which great art has to explore the very depths of human yearning is universal and beyond the boundaries of any one group of people.

Hung together, the Mexican artists present, in Eduardo Galeano's words, a 'universe seen through a keyhole',[1] a view from a culture whose artists absorbed what Europe had to offer, returned to Mexico, and pursued justice and the power of art as a communicative tool with great energy and commitment. Orozco, Siqueiros, Castellanos and Zenil use the iconography of Christianity to promote social awareness. Castellanos's *The angel kidnappers* (Los Robachicos) (1943) (p. 81), for instance, with its winged and smiling angels removing the child of poverty, is a potent reminder of the way both religious and secular authorities in other countries have perpetrated comparable injustices in the name of what is 'good' and what is 'for the best'. The women in this group—Kahlo, Varo, Izquierdo and Carrington—comment equally strongly by immersing themselves in autobiographical journeys that are simultaneously sexual, spiritual and richly imaginative.

One of the most complex works to negotiate was the sculpture *Mary of Warmun* (The pregnant Mary) (c. 1983) (p. 129), by the Australian Aboriginal elder George Mung Mung. It was carved for the community at the remote Kimberley settlement near Turkey Creek in Western Australia. It is not owned by a single person, nor is it a possession in the same way that non-Aboriginal people often hold what they own. So the decision to lend was taken by the whole family, who travelled great distances to sit together and weigh up whether she (George's *Mary*) should travel down to Melbourne so that their father could be honoured by the 'white fellas'.

Belief in the journey that was the gathering of the works had come to take on meanings *beyond* any narrow definition. It had come to encompass Christianity and Buddhism, theosophy and anthroposophy, the kabbala and Judaism. But like an umbrella, the term sheltered other understandings—the search for faithfulness, integrity, and some sort of inner life that does not entail commitment to ritual or permanence or religion. And even beyond those understandings, *beyond belief* came, as a phrase, to point to the capacity of art itself to become symbol, a vessel of the Sublime, and to speak in a way that 'refuses to stir the ashes but rather attempts to light the fire'.[2]

Like the exhibition, the catalogue *Beyond Belief: Modern Art and the Religious Imagination* is the result of a collaboration involving the full resources of the National Gallery of Victoria, and curators, philosophers, theologians, art historians and educationists from Germany, France, Mexico, Belgium, England, Australia and the United States. Both the book and the exhibition may contribute to an international dialogue about what this century holds most deeply in ways that are beyond ordinary scrutiny and beyond any restrictive understanding of belief.

Rosemary Crumlin is an author, adult educator and curator and general editor of Beyond Belief. *She has also written on the Blake Prize for Religious Art, and curated and wrote the accompanying books for the exhibitions* Images of Religion in Australian Art *and* Aboriginal Art and Spirituality.

Notes

1 Eduardo Galeano, *Days and Nights of Love and War*, New York, Monthly Review Press, 1983, p. 107.
2 Eduardo Galeano, op. cit., p. 193.

BEYOND BELIEF AND THE POWER OF THE IMAGE

David Freedberg talking with Rosemary Crumlin

David Freedberg's book, *The Power of Images*,[1] is one of the most influential texts in the revival of interest in religious art of the last decade. In this interview, David Freedberg speaks with Rosemary Crumlin about ideas and issues surrounding the works exhibited in *Beyond Belief: Modern Art and the Religious Imagination.*

Rosemary Crumlin What would you say to those people who see some anomaly in linking art and religious imagination at this time in history?

David Freedberg A great taboo of the twentieth century has been precisely the association of religion and art. We've tended to say that art is something separate from religion. What the *Beyond Belief* exhibition shows is that art and religion interpenetrate, that they're mutually fructifying, and that religious imagination is present in all areas of life. I believe that in one way or another everybody is endowed with a religious imagination. Perhaps it's suppressed at various stages in a life or in history or in certain societies. One very interesting thing about this selection of particularly powerful images is that it calls forth those remnants of religious imagination that have been suppressed or somehow submerged in everyday gallery beholders.

RC Does the range of images, the inclusion of some works not apparently 'religious', work against this 'calling forth'?

DF Many of the images in this exhibition are reliant upon the standard iconographic tradition. They show scriptural themes, standard Christian or mystical themes. It isn't surprising that to those disposed towards being receptive to them these images have a religious resonance. But those other images which don't have an overtly religious subject matter command our attention for aesthetic reasons, inducing in us a sense of engagement, of empathy even. This causes us to pause, to meditate on their effects. That kind of meditation often can be anagogical. Such images remind us of the idea of what used to be called 'anagogical ascent', ascent from this world to something beyond.

RC But aren't we currently living in an age where the focus is on the aesthetic rather than the religious?

DF In recent years, I've considered the position of Hans Belting in his great book on the history of religious images, *Likeness and Presence*,[2] and his claim that until the Reformation, people were living in what he called the age of the icon, in other words, the age of devotional images. He contended that all images inspired devotion of one kind or another, but that the Reformation in the sixteenth century, and the kinds of self-conscious art historical writing that we encounter in Vasari, brought about a change. Instead of living in an age of the image, he said, we live in an age of art. That is, somehow aesthetic ideas, the aesthetic aspects of an image, have become paramount. The beholder meditates more on purely artistic questions than on devotional responses.

I'm very sceptical about this for several reasons. Firstly, I think that even before the Reformation, aesthetic responses went hand in hand with devotional responses. Aesthetic responses were always used to engage the devotional or religious responses of beholders. However much we emphasize—look to—the artistic and formal aspects of an image, there are still recollections, reminiscences and fragments of devotional and of religious responses that were, in a way, much clearer and more evident before the Reformation.

RC Could you give me some examples of what you mean?

DF Look at Picasso's *Weeping woman* (1937) (p. 67). Even unconsciously, most beholders of this work, including those not steeped in the Christian tradition, would recollect images—for example, of the Mater Dolorosa, the Sorrowing Virgin, or of Veronica—and that in itself would be sufficient to spark some kind of religious response or religious engagement. Of course, when you look at something like the Picasso, the question is what is beyond the subject matter, what happens beyond the pure recognition of iconography, the purely associative quality of a subject such as the weeping woman. What devices draw us more into the picture? Those very angular forms, the wide-open eyes, those twisted eyebrows—all this allows in us a sense of empathy not only for the state of the woman represented but also for the emotion which we somehow dimly recollect from our most religious and engaged responses to images. To some extent in the Picasso the aesthetic aspects of the image go along with pure subject matter and not overtly with the subject of the Mater Dolorosa or the Veronica—but there is no escaping responses predicated on the recollection, however vaguely, of such themes.

Consider also more modern images such as the Colin McCahon (p. 127) or the Cindy Sherman (p. 161). The McCahon may not be overtly of the crucified Christ, nor the Sherman of the Madonna and Child, but there's enough there to make us associate our responses to those old images—again, however dimly—with our responses to works such as these. This also applies to Arthur Boyd's painting of the female crucified (p. 141). What makes it so powerful is that even as we see it is a woman who is crucified, the image carries with it some of the resonance not only of a crucified woman but of the crucified Christ. If we group works such as these together, it is easy to see how we cannot say, as Belting said, that we no longer live in an age of the religious image. We are still in it. Even though, perhaps, we tend to focus more on the purely formal aspects of images, we cannot divest ourselves, even now, of the remnants of whatever religious feelings we have, or once had. Such responses remain in the presence of even the most artistic works and in the presence of particularly powerful works.

RC In your book, *The Power of Images*, you suggest more adequate ways of approaching problems of response to art. These strategies seem to make works more accessible to the beholder. Perhaps there is also greater access for religious imagination?

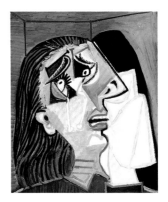

Pablo Picasso
Weeping woman 1937
see p. 67

Arthur Boyd
Crucifixion, Shoalhaven 1979–80
see p. 141

DF An interesting test we can apply to works in the present exhibition is to ask: How are we engaged by these works, how is the religious imagination *sparked* by them? Obviously, one way is via the subject matter. But there is another, more purely formal way, the most striking examples for which are the expressionist works assembled in *Beyond Belief*, such as the Ernst (p. 49) and the Beckmann (p. 59), and those of the Mexican painters Orozco (p. 79) and Siqueiros (p. 83).

Here you have intense pictorial activity which draws the beholder in, which engages and even compels attention. In the very act of being compelled we are forced to reflect on our own solitude before what is represented. That sense of ourselves interacting with a representation has within it some of the qualities of a mystical experience, a devotional experience—and by any standards you could call this religious. I think of the Ensor, *Christ calming the storm* (1891) (p. 43), where you have this extraordinary, vortex-like picture, with swirling brushstrokes that draw you right into the centre of the image. You have to concentrate on the little white figure which is, of course, Christ. This response is evoked independently of any religious knowledge—let's say, even if you are not a Christian. That particular kind of concentration on the biblical story is certainly akin to the spiritual experiences that one would have before more overtly ritualized images. These swirling forms, this intensity of repeated brushstrokes, are all devices that compel the viewer's attention.

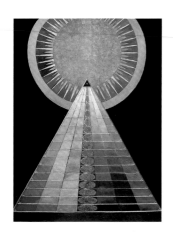

Hilma af Klint
Group X, Altar paintings #1 1915
see p. 57

RC But not every work in this exhibition has this kind of pictorial intensity.

DF The other pole is that of the quiet images. I mean images such as the Hilma af Klint *Group X, Altar paintings #1* (1915), where it is the pure geometric form which induces a state of repose, of calm. These are very clearly anagogical works. They are directly akin to the old idea of spiritual or mystical ascent from our earthbound existence to a radiance above, or to love, literally above the base of the image. One of the interesting parallels to be made in this exhibition, simply in formal terms, is between the Hilma af Klint work and the work of another modern mystical painter, Francesco Clemente (p. 179), and the very well chosen O'Keeffe picture (p. 65) where the crucifix is superimposed on the heart.

Other works here which arouse intense mystical engagement are those of the Abstract Expressionists, the Rothko (p. 109), the Newman (p. 107)—and to some extent, the Goldstein (p. 175). The aesthetic strategies I described earlier in the case of the German Expressionists and the Mexican painters are strategies for engaging the attention of the beholder. With Rothko and Newman, we have pictorial strategies which are very clearly there for the purpose of engaging contemplation. Remember that both Rothko and Newman were Jewish artists. They were painting in a culture in which the representation of the godhead was not at all *de rigueur*; indeed, was forbidden. But the absence of figuration does not diminish the ability to elicit a religious response. Here, as in the Hilma af Klint, we have a sense of absorption into a picture, into pure meditation and pure spirituality.

RC So are you saying that it is the response of the person, who that person is, and what they bring to the encounter, that is of key significance?

DF Yes. But what these particular forms of engagement also signify is the way in which the power of the images contributes to the religious imagination as much as the other way round.

RC Are there other strategies besides the ones you've mentioned?

DF What might be offset against the plain pictures, the absorptive pictures, the contemplative pictures, is how powerful the representation of the body itself is in bringing us to a picture. We identify with bodies in the images and, of course, with bodies in pain. The more we see a body to be like our own, the more we are likely to feel empathetic, to be engaged with its suffering. Hence we can know the power of everything, from the Kokoschka (p. 47) to the Picasso (p. 67). The intensity of brushwork and the swirling compositions on the one hand, and the bodies on the other—the powerful figures within a picture which cause us to identify with these bodies—these are the strategies for engagement. Against these can be set the strategies for contemplation found in the Abstract Expressionists.

RC What about the Frida Kahlo painting (p. 85), with its explicitly sexual imagery?

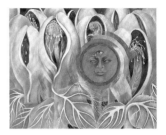

Frida Kahlo
Sol y vida (Sun and life) 1947
see p. 85

DF I've always maintained, as I did in *The Power of Images*, that one of the ways of our understanding intense religious responses to images is to think about the intensity of our secular and our sexual responses to images. What is interesting about the Kahlo is the suggestion of sexuality that emerges in the picture and that compels our attention, causing us to think about the basic process of life itself and the role of the sun. What happens with the Kahlo work is the combination of the fundamental experiences of life with the challenge of sexual response. There is a strong sexual presence here, and it is associated with the ideas of growth, creation and resurrection. People now have no difficulty in understanding that works of art may engage sexual responses. If we reflect on those kinds of responses, we can also realize that art can engage great spiritual responses. In a way, there is a continuum—and that, indeed, is 'beyond belief'.

What we learn from our engagement with images in the picture, with figures in the picture, is the ease with which we merge representation itself with what is represented. We learn from strong responses how we, as everyday, ordinary beholders, are inclined to merge the image itself with what is represented. This kind of conflation was discussed endlessly in the great Byzantine debate about the status of images in the religious life and in life in general. The theology of images in Byzantium at the time of the great Byzantine iconoclastic debates is exemplary for all later theories of images.

RC Yes, but I understand that these centred on sacred art, images associated with worship. Hardly any of the works here were conceived or have functioned in this way …

DF The debates came to a head in the Second Council of Nicaea, where there was discussion of what images are supposed to do, how they are supposed to affect us, the extent to which we can regard images as mediating between us and the beyond, how much we are actually allowed to think ourselves into pictures. In the discussion, the arguments and the theories presented are exemplars for all subsequent discussion of images. Similarly, I think that our religious response to images is, in a way, exemplary for all our responses to images. One of the great lessons of this exhibition is to show us how, if we think about our responses to religious images, we may also learn about the way in which we engage with all other kinds of images.

David Freedberg, author of The Power of Images, *is Professor of Art History at Columbia University, New York, and Andrew W. Mellon Professor at the National Gallery of Art, Washington, DC.*

Notes

1 David Freedberg, *The Power of Images: Studies in the History and Theory of Response*, Chicago, Chicago University Press, 1994.

2 Hans Belting, *Likeness and Presence*, Chicago, University of Chicago Press, 1989.

REALIZING NOTHING

Mark C. Taylor

It is up to us to accomplish the negative. The positive is given.

Franz Kafka

Modernity and revolution are inseparable. Following the modernist imperative to 'make it new', revolutionary activity prepares the way for the imminent arrival of a transformative future in the present by breaking decisively with the past. While the revolutions associated with modernity range from the sociopolitical and economic to the artistic and cultural, none has had a more lasting effect on a broader range of human endeavour than the French Revolution. Overthrowing the *ancien régime* in the name of universal reason and freedom, supporters of the Revolution promised a new age governed by the principles of *Liberté*, *Egalité*, and *Fraternité*. Kant, who might well be dubbed *the* philosopher of the French Revolution, stresses the undeniable relationship between the Enlightenment and the Revolution when he declares: '*Sapere aude!* "Have courage to use your own reason"—that is the motto of enlightenment.'[1] When thought and action are no longer determined by external authorities, but are guided instead by autonomous reason, the results, Kant believes, are revolutionary.

One of the most problematic external authorities that must be overcome is religion. According to Kant, human liberation presupposes freedom from the imposition of beliefs and prescription of actions by representatives of an established priesthood. Rather than simply rejecting religion, Kant attempts to place it within the limits of reason alone. When properly understood, religion is indispensable to responsible moral activity. Having limited reason to 'make room for faith' in his *Critique of Pure Reason*, Kant proceeds to develop a moral religion based upon the purported universality of the categorical imperative in his later *Critique of Practical Reason*. However, for those who lived through the Reign of Terror, Kant's vision of a moral universe supported by a rational religion seemed as empty as the supposedly revolutionary principles of liberty, equality and fraternity. In Hegel's memorable words: 'Universal freedom ... can produce neither a positive work nor a deed; there is left for it only *negative* action; it is merely the *fury* of destruction.'.[2] From the ashes of this destruction, modern and postmodern worlds arise.

The ostensible failure of the French Revolution precipitated a crisis of belief for many who had hoped for radical social and political change. Though not always obvious, the principle of revolution is deeply rooted in the Western *religious* imagination. The new world the revolution promised was, in effect, a secularized version of the Kingdom of God. When this new age was—as it always is—deferred, revolutionary prophets turned inward in an effort to recover the origin of their vision. M. H. Abrams summarizes the importance of this development thus:

> To put the matter with the sharpness of drastic simplification: faith in an apocalypse of revelation had been replaced by faith in an apocalypse by revolution, and this now gave way to faith in an apocalypse by imagination or cognition. In the ruling

two-term frame of Romantic thought, the mind of man confronts the old heaven and earth and possesses within itself the power, if it will but recognize and avail itself of the power, to transform them into a new heaven and new earth, by means of a total revolution of consciousness. This, as we know, is the high Romantic argument, and it is no accident that it took shape during the age of revolutions.[3]

The locus of revolution, in other words, shifts from the outward to the inward. Reenacting an ancient religious debate, Romantics insist that there can be no outer change without inner transformation. As artists and poets sought to cultivate an 'apocalypse by imagination', they turned once again to Kant. If the eighteenth century effectively ends with his analysis of truth in the first *Critique* (1781) and goodness in the second *Critique* (1788), the nineteenth century actually begins with Kant's exploration of beauty in the third *Critique* (1790).

Kant's *Critique of Judgment* inspired a group of artists and writers who gathered in Jena during the 1790s to form what Philippe Lacoue-Labarthe and Jean-Luc Nancy correctly describe as 'the first "avant-garde" group in history'.[4] By extending the principle of autonomy from the domains of thought and action to the realm of aesthetic experience and judgment, Kant developed an account of the imagination and, in correlation, of beauty and the sublime. This has directly or indirectly influenced virtually all subsequent art and aesthetics. Aesthetic judgment, he argues, not only mediates thought and action but also reconciles the opposition between reason and sensation that continues to plague rational reflection as well as moral activity. For the Jena romantics, Kant's imaginative account of beauty suggested a new understanding of religion in which art is the modern expression of religion and religion is undeniably aesthetic.

While most of the members of this early avant-garde subscribed to one or another version of this religion of art, Friedrich Schleiermacher elaborated the most influential formulation of the intricate interplay between art and religious experience in *On Religion: Speeches to its Cultured Despisers* (1799). Whereas Kant attempts to relocate religion from the realm of theory or thought to the domain of practice or action, Schleiermacher situates religion squarely in the province of sensibility, affection, intuition, or feeling. His insistence on the close relation between religion and artistic awareness reflects a common eighteenth-century tendency to associate aesthetics with perception and sensation instead of reason and conceptual thought.[5] Religion, however, is not just any sensation: it involves a unique intuition in which the 'original' unity of subjectivity and objectivity is directly apprehended. Schleiermacher describes this primal oneness as the 'first mysterious moment that occurs in every sensory perception, before intuition and feeling have separated, where sense and its objects have, as it were, flowed into one another and become one'. This moment of primal unity constitutes 'immediate consciousness'.[6] Since immediacy is *prior* to the differentiation between subjectivity and objectivity, it remains completely indeterminate. Far from an identifiable object or a delimited subject, what

occasions religious experience is actually no-thing. Religious reflection, which is inevitably *après coup*, involves the impossible 'presentation of the unpresentable'. That which cannot be presented or can be presented only as unpresentable cannot be represented, or can be represented only in and through the negation of representation. In the course of the twentieth century the task of representing the unrepresentable shifts from the religious to the artistic imagination.

The problem of how to figure the unfigurable runs throughout the visual arts in this century. From Kasimir Malevich's fourth dimension and the surrealists' unconscious to Clement Greenberg's flatness and Abstract Expressionism's improvisational gestures, avant-garde artists have been preoccupied with what Jean-François Lyotard aptly labels 'the aesthetics of the sublime'. While Lyotard correctly identifies the paintings of Barnett Newman as illustrative of this important trend, his failure to appreciate the way in which nineteenth-century thinkers appropriated Kant's analysis of the beautiful and sublime for theological purposes obscures the implications of Newman's work for the broader question of the relation between modern art and the religious imagination. Harold Rosenberg goes so far as to describe Newman as a 'theologian of nothingness'.

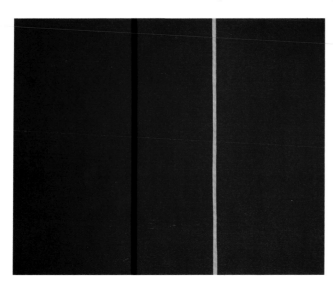

Barnett Newman
Covenant 1949
see p. 107

In order to appreciate the importance of this observation, it is necessary to understand precisely what is involved with this nothingness and why Newman lends it religious significance. Newman's signature works are monochromatic paintings transected by one or more vertical stripes, which are labelled 'zips'. In *Covenant* (1949) (p. 107), for example, the rich brownish red of the painted surface is interrupted by a black and a cream zip. Here, as elsewhere, the title frames the otherwise frameless work. Though the terms of the covenant are not clear, the work of art assumes a religious function by binding the viewer back to the primal origin from which everything comes and to which all returns.[7] This origin is, like Schleiermacher's archaic unity, prior to and a condition of the possibility of differentiation between subject and object. The point at which subject and object remain indistinguishable is, for Newman, sublime. Though implicit in many of his works, the sublime is most forcefully presented in *Vir Heroicus sublimis* (1950–51). This immense canvas (242 cm by 541 cm) is painted in a brilliant red, with five zips ranging in colour from cream and white to shades of pink and crimson. Newman intended his paintings to be viewed at close range. When one gazes at *Vir Heroicus sublimis* closely, the painting creates an hallucinatory effect that engulfs the viewer. The sense of direct participation is enhanced by the characteristic absence of a frame. When art works, it creates a perfect union of subject and object in the presence of the moment. 'The sublime', Newman insists, 'is Now'. In his most concise explanation of the purpose informing his work, he writes:

> We are reassessing man's natural desire for the exalted, for a concern with our relationship to the absolute emotions. We do not need the obsolete props of an outmoded and antiquated legend. We are creating images whose reality is self-evident… We are freeing ourselves of the impediments of memory, association, nostalgia, legend, myth, or what have you, that have been the devices of Western

European painting. Instead of making *cathedrals* out of Christ, man, or 'life', we are making it out of ourselves, out of our own feelings. The image we produce is the self-evident one of revelation, real and concrete, that can be understood by anyone who will look at it without the nostalgic glasses of history.[8]

In this highly suggestive text, Newman makes several points that are crucial for understanding his work. First, the moment in which the sublime is experienced is a present that is undisturbed by the past. To realize this present, the past—that is, memory, legend and myth—must be wiped away. Second, the presence of this present is self-evident or immediate. Im-mediacy, however, can only be experienced negatively. Accordingly, Newman translates the *via negativa* from theological doctrine to artistic practice. Just as the religious mystic negates human language in order to let divine silence 'speak', so Newman erases representations in an effort to create a vision of the nothing that is everything. Therefore, his figuring is always a dis-figuring, which is supposed to allow the unpresentable to be represented as unrepresentable. Third, the presence of the sublime is not merely the experience of the real but *is* the real as such. In a manner similar to Schleiermacher's proclamation that 'divinity can be nothing other than a particular type of religious intuition', Newman insists that 'our own feelings' are, in effect, divine. If our own feelings are the realization of the real and the real is actually nothing, then the experience of the work of art is the realization of nothing. This nothing is not the same as non-being; to the contrary, the nothing to which Newman devoted his work is the no-thing that is the plenitude of being. In the sublime Now, nothing is being, absence is presence, and emptiness is fullness. The task of the artist is 'to induce nothingness to exclaim its secrets'.[9] Though seemingly simple, meeting this challenge is exceedingly difficult. 'Emptiness', Newman concluded, 'is not easy. The point is to produce it'. If true emptiness cannot be produced, the sublime cannot be experienced.

When Newman 'seeks sublimity in the here and now', Lyotard explains, 'he breaks with the eloquence of romantic art but does not reject its fundamental task, that of bearing pictorial or otherwise expressive witness to the inexpressible. The inexpressible does not reside in an "over there", in another work, or another time, but is this: that something happens. In the determination of pictorial art, the indeterminate, the "it happens" is the paint, the picture. The paint, the picture as occurrence or event, is not expressible, and it is to this that it has to witness.'[10] When 'it happens in paint', the work of art becomes something like a performative utterance that creates a state of affairs instead of referring to antecedent objects or conditions. In this way, painting becomes a technique for '*practising* the sublime'. Through this practice the artist assumes the mantle of the priest who performs rituals that create the possibility of experiencing the 'moment of totality'. As Newman implies, this totality emerges when abstraction is pushed to the limit. Newman observes: 'I knew that if I conformed to the triangle, I would end up with a graphic design or *an ornamental image*. I had to transform the shape into *a new kind of totality*.'.[11] When the last trace of representation is eliminated, the canvas becomes the real (no)thing where absolute unity or complete at-onement is totally present. In a work like *Onement* (1948) echoes of the ancient biblical commandment can be seen: 'Hear, O Israel, Adonai is our God, Adonai is One!'.

While Newman freely mixes Christian and Jewish motifs, his art resonates most deeply with the Jewish kabbalistic tradition. In all of his mature work he repeatedly struggles to realize the nothingness figured in the unfigurable point of the *Zim zum* (1969).[12]

Mark C. Taylor is Cluett
Professor of Humanities,
Williams College,
Massachusetts, and Director of
the Critical Issues Forum at the
Guggenheim Museum, New
York. His many books include
Disfiguring: Art,
Architecture, Religion, and
Hiding.

Newman's *oeuvre* can be understood as the visual trace of the obscure voice that echoes throughout Edmond Jabés remarkable *El, or The Last Book*:

> 'God refused image and language in order to be Himself the point. He is the image in the absence of images, language in the absence of language, point in the absence of points,' he said.[13]

The point of Newman's art is to render this absence present. In a world where the gods seem present primarily by their absence, the work of art is to effect an apocalypse by imagination, through which reality is transformed by realizing nothing.

Notes

1 Immanuel Kant, 'What is Enlightenment?', in Lewis White Beck (ed.), *On History*, New York, Bobbs-Merrill, 1963, p. 3.

2 G. W. F. Hegel, *Phenomenology of Spirit*, trans. A. V. Miller, New York, Oxford University Press, 1997, p. 359.

3 M. H. Abrams, *Natural Supernaturalism: Tradition and Revolution in Romantic Literature*, New York, W. W. Norton, 1977, p. 334.

4 Philippe Lacoue-Labarthe and Jean-Luc Nancy, *The Literary Absolute: The Theory of Literature in German Romanticism*, trans. Philip Barnard and Cheryl Lester, Albany, State University of New York Press, 1988, p. 8.

5 In this context, it is important to note that *aesthetic* derives from the Greek *aisthetikos*, which means 'pertaining to sense perception'.

6 Friedrich Schleiermacher, *On Religion: Speeches to its Cultured Despisers*, trans. John Oman, New York, Harper and Row, 1958, p. 112.

7 The word *religion* derives from the Latin *religare*, which means to bind (*ligare*) back (*re*).

8 Barnett Newman, 'The Sublime is Now', in John O'Neill (ed.), *Barnett Newman: Selected Writings and Interviews*, Berkeley, University of California Press, 1990, p. 173.

9 Harold Rosenberg, *Barnett Newman*, New York, Harry N. Abrams Inc., 1978, p. 42.

10 Jean-François Lyotard, 'The Sublime and the Avant-Garde', in Andrew Benjamin (ed.), *The Lyotard Reader*, Cambridge, Basil Blackwell, 1989, p. 199.

11 Rosenberg, op. cit., p. 59.

12 The name of Newman's last and most successful sculpture is *Zim zum I*. This work is formed by two walls, each consisting of six steel panels set at right angles and separated by an empty space.

13 Edmond Jabés, *The Book of Questions: El, or The Last Book*, trans. Rosemarie Waldrop, Connecticut, Wesleyan University Press, 1984, p. 15.

BEYOND BELIEF: THE ARTISTIC JOURNEY

Diane Apostolos-Cappadona

Two paintings in this exhibition reflect significant moments 'on the edge' of new borders in the history of Western art, and thereby, of Western cultural attitudes towards the human and the divine.[1] Both of these paintings bear similarities in their visual projections of the encounter with the spiritual. Maurice Denis stood at the historical margin between the nineteenth and twentieth centuries, between the traditional and the modern in art, and between the singularity and the universality of the spiritual in art. Mark Rothko spans the space between World War II and the Vietnam War, between the Freudian and the Jungian, and between the epic and the mythic vision of American artists. While Denis's *The Catholic Mystery* (Le Mystère Catholique) (1889) (p. 41) may be seen in contrast to Rothko's *Brown, black on maroon* (1957) (p. 109), the modes and manners of connection rather than their differences provide a means of understanding the religious imagination and modern art, a turning point, if you will, away from 'the traditional' and towards 'the new'.

Traditionally in the West, religious art has been defined as Christian and has had a series of recognizable, if not definable, categories. Works of Christian art were catego-

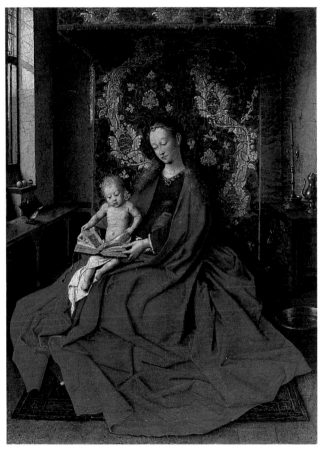

rized as follows: *didactic* images that taught 'the faith'; *liturgical* objects used for ritual worship; *devotional* visions that nurtured prayer and contemplation; *decorative* entities whose beauty elevated the soul to the spiritual realm; *symbolic* forms that revealed coeval objective and subjective meanings; and works of art that *combined* any or all of the earlier categories.[2] One could reflect upon the presentation of *The Madonna and Child* (1433), now attributed to a follower of Jan van Eyck, as an example of all these categories. Christian art has been characterized as the visualization of theological content by an artist who sacrifices individual identity to become the vehicle for God's self-expression. That cultural revolution known as the Reformation created the problematic of 'how to define Christian art?' when the once-common religious foundation of Western Europe was shattered between Roman Catholicism and Protestantism.

Thus, the traditional recognition, if not employment, of 'sacred art' as art for corporate worship and religious inspiration was undermined by a pluralism of Christian attitudes towards image, incarnation and ritual. The slow, and perhaps painful, separation of Christian art from worship—overtly in Protestantism and covertly in Roman Catholicism—led to a recognizable cultural reality that art was autonomous and in its

autonomy became a potential religious entity in its own right. With the advent of the twentieth century and its ensuing technological, scientific, and economic developments, the cultural matrix that had been the foundation of traditional religion, especially of Western Christianity, began to fragment. Recognition of the authenticity of other world cultures and religions encouraged movement away from 'religion' and towards 'spirituality'—a cultural move parallelled in the visual and performance arts—an identifiable turning point in our cultural definitions of art, religion, and society.[3]

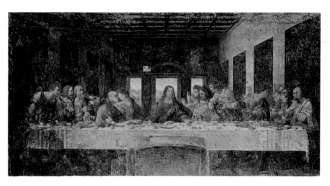

Leonardo da Vinci
(1452–1519)
The Last Supper 1495–97
Milan, Refectory of the Convent
of S. Maria delle Grazie

Ben Willikens
Abendmahl (Last Supper)
1976–79
see p. 135

Modern art has been criticized for its denial of the traditional patterns of sacred meanings and for its elevation of the human imagination. If in fact it has done so, modern art has declared that human beings have the freedom and the power to create a world out of the original material they possess by virtue of their existence. This call to autonomy has been reflected in the denial of those characteristics of art which identified the visual as real, such as the representational human figure, accepted understandings of perspective—foreground, middleground, and background—and a simultaneous visual connection to the natural through light and shadow, and figure-ground relations. Simply enough, traditional works of art were objective in their emphasis on the objects being seen, and their presentation, which created a 'reality' within the artistic frame. Works of modern art are subjective in their emphasis on the process of seeing in which the autonomy of both the artist and the viewer have authorized their individual creations of new worlds. Modern art transcends concrete experience and creates a symbolic construct of time and space, especially in connection with eternal archetypes and spiritual essences which evoke emotive responses. Modern artists have the singular opportunity of *presencing* the spiritual significance of the totality of human experience in their recognition of the foundational necessity of the religious imagination—a significant turning point in cultural history.[4]

Throughout the history of Christian art, artists such as Jan van Eyck, Botticelli, Michelangelo, Maurice Denis, James Ensor, and even Emil Nolde, formulated, retrieved and reconfigured themes and motifs such as the Annunciation and the Last Supper. In each re-presentation of a motif, the artist reflected both the contemporary theology and art style, and from the Renaissance onwards, also placed an individual mark on that picturation. With his placement of ostensibly female figures within the glow of celestial light, Denis has relied upon the visual history of the Annunciation motif to bestow an immediate aura of authenticity to his painting. Images communicate authority and reality through (what I have elsewhere identified as) the process of visual analogy.[5] Each new image offers a fresh and independent re-presentation that depends upon an earlier classical image or traditional masterpiece on the theme, as for example in Leonardo da Vinci's *Last Supper* (1495–97), and Ben Willikens' *Last Supper* (Abendmahl) (1976–79) (p. 135). Viewers have an internal history of visual images that began in childhood and included sacred images from church, the Bible, or such mundane items as Christmas and Easter cards. These images were invested with reverence and adoration merited by their 'sacred authority'—their ability to *presence* the holy, to heal, to transform, to elicit spiritual conversion, to be the site of the sacred, to give voice to the religious imagination.

Rothko, on the other hand, has removed all recognizable figurations from his paintings. He emphasizes instead the abstract—the essence of an idea or an emotion—in a

visual mode intended to evoke our response through the process of seeing. In this, Rothko recognizes that the root of an image's power is simultaneously its visual nature and the nature of the visual. Images evoke an aesthetic experience which at the highest level can bring the individual to a moment of spiritual ecstasy or union, or more simply, a heightened sense of being. Images are capable of educing such responses because images operate in the aesthetic realm. Etymologically, our English word 'aesthetic' is derived from the Greek word *aisthetikos*, a variant of *aisthanesthai*, meaning to perceive—as in to know, not simply to see—through the senses. At its highest levels, as in Rothko's art, the aesthetic brings forth all the senses of the human person, heightens a recognition of the self and of the body, and merges these heightened sensitivities with the engaged bodiliness and consciousness to bring the individual to a recognition of 'knowing'—a process analogous to the meditational practices of many eastern religions—through an engagement with the religious imagination.[6]

In its move from the nineteenth-century Denis to the twentieth-century Rothko, modern art witnessed the move *away* from the representational human figure as witnessed in the paintings of Wassily Kandinsky, Marc Chagall and Mark Tobey. One interpretation for this absence of the human presence is the visualization of the denial of death, finitude, and limitations. Such an interpretation reinforces the critique of modern art as the rejection of tradition, especially in terms of religion, and as the promoter of human autonomy. Alternatively, I would suggest that in modern art—especially in the Abstract Expressionism of Rothko, Barnett Newman and Robert Motherwell—the viewer (and by extension the artist) is the figure in the painting. Thus the size and scale of modern art must extend beyond the bounds of the average person, for the canvas must both surround and envelop the viewer, who becomes simultaneously viewer *and* figure. Demanding the creativity and attention of the viewer, modern art becomes participatory and the viewer a co-creator in its creative process. Denis requires that we *see* meaning of religion and sacred mystery in a new way, but Rothko challenges us to enter into the painting—into 'the process of making'—and in so doing to re-create both the world and ourselves.[7]

Ironically, the artistic and religious pluralism that supported the development of 'the modern' was radically transformed in the 1960s, first with the infusion of Zen Buddhism, and later with the rapid technological and communication advances that have fostered the computer age and globalization, as evidenced by James Lee Byars's *Four in a vestment* (1996) (p. 171). Compounded by the fragmentation of 'the modern in search of a soul', to paraphrase Carl G. Jung, modern art struggled with the need for the human presence, for the representational figure. In many ways, Andy Warhol stands as prototype of this search for spiritual and technological consumerism, as evidenced in his *Details of Renaissance paintings* (*Leonardo da Vinci, 'The Annunciation' 1472*) (1984) (p. 153). He retrieved the figure, but what figure? Not an idealization or a realistic rendering of the human form, not even a philosophic fragmentation. Rather, artists since Warhol have struggled with a nostalgia for the figure while reflecting the contemporary cultural ambivalence towards identity and gender, as attested to by the art of Cindy Sherman, Francis Bacon and Anselm Kiefer.

On the eve of the twenty-first century, contemporary artists such as Audrey Flack, James Brown, Kiki Smith, and Nahum B. Zenil dare to *presence* figurations of what the French call '*l'imaginaire*' by reclaiming images of human finitude as symbols of authentic humanity. In this quest, they recognize the beauty of 'the variable' as the modern exemplar of the ideal. And by so doing they risk the possibility of restoration by giving vision, and therefore voice, to love, not fear; to spiritual wholeness, not physical fragmentation.

They shatter the divide between Denis and Rothko in their recognition of the critical need for the former's employment of the representational figure as the horizon (and/or entry point) for the viewer and the latter's reliance upon abstraction to educe the *presence* of the religious imagination.

This brief overview of the artistic journey from the late nineteenth into the twenty-first century can only highlight critical turning points in the cultural perceptions of modern art and the religious imagination.[8] As two of the fundamental, if not the two essential, characteristics of the human spiritual quest, art and the religious imagination have worked in tandem throughout world religions and cultures in the never-ending search for meaning; that is, for that time and space that is 'beyond belief'. The religious imagination has helped to frame those critical cultural questions that identify each historic era, while the arts have provided an avenue for answering those same questions, especially with the absence and presence of the figure throughout the twentieth century. As the new century was born in an atmosphere of expectations and expanding borders, the issues of the transformation of the traditionally defined 'religious' into the universality of the spiritual, and of the role of the individual into a recognition of the communal, became reflected in the artistic move away from figuration towards abstraction. While the close of the twentieth century rapidly approaches, our society's preoccupations with social justice and engendered identities have influenced the motifs and forms of art; and curiously, figuration and abstraction have become fused in an attempt to capture, if not retrieve, the aesthetic energy of the religious imagination. We stand on the brink of the new millennium like the figurations in the void, wondering what it will be like in the new world … what we will see.

Diane Apostolos-Cappadona, Professorial Lecturer in Religion and Art, Georgetown University, Washington DC, is editor of Symbolism, the Sacred and the Arts, *co-editor of* Art as Religious Studies *and* Dance as Religious Studies, *and author of* Dictionary of Christian Art *and* Encyclopaedia of Women in Religious Art.

Notes

1 See Mircea Eliade, *Symbolism, The Sacred, and the Arts*, New York, Continuum, 1996; and two key works addressing modern art and the spiritual, Robert Rosenblum's *Modern Painting and the Northern Romantic Tradition: Friedrich to Rothko*, New York, Harper & Row, 1975, and Maurice Tuchman (ed.), *The Spiritual in Art: Abstract Painting 1890–1985* (exhib. cat.), Abbeville Press, 1986.

2 Jane Turner (ed.), *The Dictionary of Art*, Grove, London, Macmillan Publishers, 1996.

3 Diane Apostolos-Cappadona, 'Mircea Eliade: The Scholar as Artist, Poet, and Critic', in Mircea Elaide, op. cit., pp. xi–xvi.

4 On the discipline of 'seeing', especially as it relates to modern art, see my essay in Doug Adams and Diane Apostolos-Cappadona (eds), *Art as Religious Studies*, New York, Crossroad, 1987, pp. 3–11, and Diane Apostolos-Cappadona, 'Dreams and Visions: Religious Symbols and Contemporary Culture', *Religion and Intellectual Life* 1:3 (1984), pp. 95–109.

5 For both a definition and methodology for 'visual analogy', see my essay, 'The Art of Seeing: Classical Paintings and *Ben-Hur*' in John R. May (ed.), *Image and Likeness: Religious Visions in American Film Classics*, New York, Paulist Press, 1992, pp. 104–15, 190–1, and John Berger, *Ways of Seeing*, Penguin, London, 1977, pp. 9–10.

6 For theories of the religious imagination, see my essays, 'Imagination in the Creative Process: Tagore and Coleridge', *Fourth International Symposium on Asian Studies*, 1982, pp. 537–46, and 'Imagination in the Aesthetic of Rabindranath Tagore', *Journal of Studies in Mysticism* 2:1 (1979): pp. 35–47.

7 Informing this interpretation of the spirituality of Rothko's paintings are Robert Rosenblum, op. cit., pp. 10–40, 195–218; Brian O'Doherty, 'Rothko: The Tragic and the Transcendental' in his *American Masters: The Voice and the Myth*, Random House, 1973; and Rothko's statement, 'The Romantics Were Prompted', reproduced, in Herschel B. Chipp (ed.), *Theories of Modern Art*, Berkeley, University of California Press, 1968, pp. 548–9.

8 See Rosenblum, op. cit., and Tuchman, op. cit.

INTERCONNECTION: RELIGION AND ART

Friedhelm Mennekes

Like all cultural phenomena, religion and art exist in an immense variety of forms. Reflecting the inner self, they find expression in diverse cultures, traditions and languages. In this sense religion and art are both rooted in the human need to create, in the euphoria of any such creation, and in the constant human compulsion to communicate one's deepest feelings. Yet these two may only be comprehended within the context of certain signs, language and social expressions, each of which 'depends' on a form able to convey the human experience behind it.

Language, theatre, play, drawing, modelling, music, dance, ritual, prayer—all active cultural forms—express individual meaning and convey it to other individuals. During the course of history, such forms have reached a high level of quality and independence, although admittedly often losing any feeling for their original connections or, especially, for their shared roots in the social realities of human existence.

The exhibition *Beyond Belief: Modern Art and the Religious Imagination* is about art and religion. For a long time, these two 'systems' were aware of their own interconnection, drawing reciprocally on each other for their forms of expression, until they separated— which they did at the very latest with the onset of modernity in the West; so that now they reflect and illuminate one another, at best, at one remove. It is this mutual illumination that has nurtured the works discussed in this exhibition.

Religion is a system that results from a creative act, from faith. This involves ritual, public witness, community. Faith is prayer, devotion, self-discovery. Faith is always subjective, whether practised within a social context or on an entirely individual level. Thus it is in direct contact with life itself. In this sense then, faith seems to be at one with philosophy, face to face with the questions of life; however, on the other hand, it appears to be the complete opposite, demonstrably vapid and passé, the epitome of the outmoded and outdated. Yet the more disparate the manifestations of faith, the less applicable these ascriptions are and the more diverse the ways in which faith sets itself apart from them.

> Ultimately faith is the only key to the universe, the final meaning of human existence, and the answers to questions on which all our happiness depends cannot be reached in any other way.[1]

Although faith is anchored in society and the community, it is still an individual experience. But '[t]he very obscurity of faith is an argument of its perfection. It is darkness to our minds because it so far transcends our weakness. The more perfect faith is, the darker it becomes.'[2]

In this thicket of darkness and light, opposition and agreement, longing and fulfilment, the believer comes to a number of inner conclusions and experiences. There is the creativity that flows from enthusiasm, the vitality of the individual who has drunk from the source of life and knows of that baffling certainty formulated in Ignatius of Loyola's epitaph: *Non coerceri maximo tamen contineri a minimo Divinum est*—to be divine is not to be encircled by the greatest but rather to be touched by the smallest.

From such an open definition of religion, it is only a short way to art. Without plating down the classic difference between these two cultural forces in modernity, there is a discernible factual closeness linking the two: they both constitute practical, existential modes of behaviour. Since at least the beginning of this century, art has been aware of its capacity to play a part in developing new 'world designs'. Art realised that part of its own inherent nature is to develop new forms of seeing and understanding. Many artists felt an almost missionary compulsion to open up as-yet obscured forms of access, to reveal the hitherto unknown.

In fact, it was no less than the fathers of modern art who demonstrated this in their thinking and doing; and it was first and foremost in their creative output, revitalising the art of the time, that they showed their allegiance to the spiritual and esoteric. One need only recall Wassily Kandinsky's *On the spiritual in art* (1912), Piet Mondrian's *The new plastic in painting* (1917) or Kazimir Malevich's *The non-objective world* (1927). These connections have been underlined by important international exhibitions in recent years, above all, in Berlin by two events: *Geist des Glaubens — Geist der Avantgarde* (Spirit of belief — Spirit of the avant-garde) (1980) and *Gegenwart Ewigkeit. Spuren des Transzendenten in der Kunst unserer Zeit* (Currents, or present-day eternity. Signs of traces of transcendence in the art of our time.) (1990); in the United States by the major exhibition of abstract art, *The Spiritual in Art: Abstract Painting 1890–1985* (Los Angeles 1986); and in Austria by the exhibition ENTGEGEN. *Religion. Gedächtnis. Körper* (Memory. Body.) (Graz 1997). Just a few names here may serve to represent the many artists in this field whose work stretches unbroken right down into the present day: Wassily Kandinsky, Mark Tobey, Robert Motherwell, Pablo Picasso, Mark Rothko, Agnes Martin, Antoni Tàpies, Barnett Newman, Joseph Beuys, Arnulf Rainer, Georgia O'Keeffe, James Lee Byars and Rosemarie Trockel.

In conjunction with the widespread 'intensification' of art production—as seen in new ways of handling materials, colour and figure—the work of many artists, particularly those named here, displays a pronounced leaning towards the transcendental, though this in itself may take very diverse, completely new forms, and pursue quite different paths. Nevertheless, in all cases there is an overall striving to come to terms with the world as a whole and with the problem of how an artist may 'form' it. For example, the work of Antoni Tàpies (Large diptych, red and black) (1980) powerfully conveys the concept of 'Oneness' and what this means. For Tàpies, everything is ultimately connected as One, there is an underlying Oneness, even if our feeling for this has been largely lost today.

While art in its various procedures is less rationalized and, together with religion, is closer to this reality than other cultural forces, nevertheless many religious communities do appear to have been gripped by a wave of rationalization in their thinking and living. It is no coincidence that artists continually bemoan the fact that much religious witness in the West has gone the way of intellectualization and enlightenment. At the same time, pointed reference is made to the fact that a significant aspect of religious culture comprises creative, sensuous elements in its ritual praxis. It is art, and it is this artistic element in religion—above all in its inherent striving for form—that binds religious inwardness to reality. Art keeps religion's feet on the ground, as it were, preserves it from

other-worldliness and from effusive-ecstatic escapades. Art demonstrates spiritual facts such as peace, depth, intensity, and so on. Thus art lends form, colour, tension and proportion to the invisible. It harnesses awe and leads dawning comprehension to active creativity.

The connections between religion and art may be revealed in a great number of different ways, as in Mark Tobey's use of space (p. 105), Barnett Newman's strategies to tax the viewer's perception (p. 107), the diffusion of Mark Rothko's colour fields (p. 109) and Joseph Beuys' extended concept of art (p. 119). Other examples might include Josef Albers' squares (*Homage to the square: autumn echo*), which, in their own particular way, show how different forms of religion and art do offer a way for the individual to approach the invisible. From the interaction of his colours as the viewer regards the work, it becomes evident that the viewer is actually already in possession of the picture's 'knowledge'. The colours open up an infinitely deep cosmos to viewers which they can step into only to find that they are already the real bearers of the painting's observations and contents. And in the midst of the relativity of the perception of knowledge, the horizon of the world of religion opens up to the viewer where the relativity of individual perception finds its final connection: art as a way to explore this dimension and to grasp the *spiritual* in life. As Josef Albers once said: 'that is what I want to do: to make twentieth-century meditational images'.

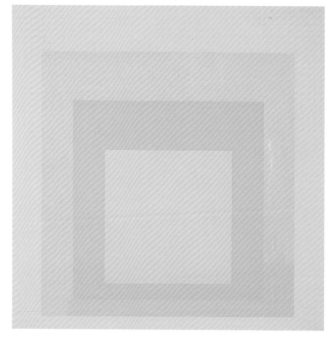

Josef Albers
(1888–1976)
Homage to the square: autumn echo
n. d.
National Gallery of Victoria
Purchased with the assistance of the National Gallery Society of Victoria, 1968
© Josef Albers / Bild-Kunst
Reproduced by permission of VISCOPY Ltd, Sydney 1997

Art and religion alike lead into the future. The individual can only approach the future by means of a series of honest questions. Many works in this exhibition formulate this questioning, but one sculpture in particular comes close to the heart of this matter: it is by American artist James Lee Byars, and its title is *The conscience* (1985) (p. 171).

The conscience, like Byars' other sculptures such as *The figure of question is in the room* (1986 and 1989), invites the viewer to stand before deeply human questions. The fact of being questioned acts on the individual like a powerful current, a current that affects the whole of life. Such questioning applies to the whole world and how one experiences it. But at the same time, the individual becomes the question, because the question that the individual puts is himself or herself. And this question is always posed by any individual, whether spoken out loud or not. The individual cannot avoid the question because his or her existence *is* the question and in this existential questioning each individual is thrown back on his or her own resources. The individual asks from *out of the depth*, for that depth is the individual.

Questions mean movement, wondering and sensing, seeking and grasping. In this open-ended process the individual needs company, conversation and dialogue, the community of all those who can and want to ask. In this respect the partnership of art and religion is significant, for this dialogue plumbs the depths of such questioning—to humankind's best ability and in pursuit of the best answers.

A fruitful partnership between religion and art is exemplified in the work of the Catalonian Antoni Tàpies. By the very materiality of his works as well as by his language of signs and forms, Tàpies induces in his viewers a particular thoughtfulness, in that they

James Lee Byars
The figure of question is in the room
1989
Courtesy Michael Werner Gallery, New York and Cologne

seek to discover the basis of his materials and language, responding directly to their complexity and touched by them. In so doing, Tàpies very obviously draws on elements of everyday life and presents things as they *commonly* appear. At the same time he treats them on an aesthetic level and extricates them from their everyday origins. But it is through this very process that he conveys his own experience of connections that are important to him, his mystical sense of the underlying oneness of all things. Thus the individual is brought to a contemplation of the inner self, which sets free that individual's sense of proportion and spirituality as well as allowing each to feel his or her own connection to everything else.

At the deepest level of what they do, neither religion nor art explains the unknown. Explanation cannot be provided by some label or picture title. That would be a form of self-betrayal. And yet these two forms of human seeking are by no means purely arbitrary. On the contrary, in art and religion alike, the unknown is incorporated into our daily life and imaginative faculties in a vital, effective and significant manner. The unknown remains unknown although it is bound up in acquired linguistic and communicative forms and although it is compellingly portrayed by artists. The all-too-distant is within our sights but will never be reached. It remains a perpetual mystery, for it can never cease to be a mystery:

> The function of art and the function of faith is not to reduce mystery to rational clarity, but to integrate the unknown and the known together in a living whole, in which we are more and more able to transcend the limitations of our external self.[3]

Translated by Fiona Elliott

Friedhelm Mennekes, curator, Kunst-Station Sankt Peter (Centre for Contemporary Art) Köln, has written numerous works on religion and art, including Triptychon *and* Faith: das religiöse im werk von James Brown.

Notes

1 Thomas Merton, *New Seeds of Contemplation*, New York, New Directions Books, 1972, p. 130.
2 Ibid., p. 134.
3 Ibid., p. 136.

THROUGH FEMINIST BIBLICAL EYES

Veronica Lawson and Elaine Wainwright

The representation of gender is its construction—and in the simplest sense it can be said that all of Western art and high culture is the engraving of the history of that construction.

Teresa de Lauretis[1]

And I thought how unpleasant it is to be locked out; and I thought how it is worse perhaps to be locked in …

Virginia Woolf[2]

The symbolic universe of the biblical narrative informs many of the images in this exhibition of contemporary religious imagination. Such images will, therefore, continue the 'engraving of the history' of gender representation. In recent years, there has been both a critique of the representation of female gender in biblical interpretation and iconography, and a reclaiming, as well as an appropriation, in contemporary Jewish and Christian religious imagination, of the female at the heart of the tradition. Is this what is intended? The worlds of visual art and biblical literature intersect in a unique way either to reinscribe or to subvert the power of female gender representation. As feminist biblical scholars we are 'suspicious' readers of the written word who know the experience of being locked out from the symbolic space created by the biblical text and its traditional interpretations. For us, entry into the world of the text is often gained by the violence of reading as male or of reading against the grain of the narrative's gender construction. Once gained, entry can result in a sort of imprisonment, the experience of being locked into a male-constructed world where female voices struggle for a hearing and female agency is often ignored. Visual images can function to legitimize and/or reinforce the male gender bias of the written word. They can also function to release the female wisdom-spirit that has informed the biblical storytelling.

The participant in or viewer of this exhibition enters it—as one does the biblical narrative—through the story of beginnings. While the biblical narrative concludes the story of creation with the expulsion from the garden, the contemporary viewer's initial encounter with the religious imagination of our time is through George Segal's *The Expulsion* (1986–87) (p. 151). In the life-size painted plaster figures of the man, woman and tree, the artist confronts viewers with the profoundly human and ecological questions raised by the Genesis narrative. The invitation to enter the space created by the work brings the biblical world into dialogue with the contemporary in a way that can also elicit a new imagination. The experience of women within patriarchy and the contemporary feminist reclaiming of Eve as active participant in the choice for cultural transformation—what is good, a delight to the eyes, and able to make one wise (Genesis 3:6)—provides a particular lens for viewing *The Expulsion*. From this perspective, the viewer is acutely aware that the man is foregrounded in the installation and that the woman shadows him as both step forward onto the right foot, with eyes cast down. While both hold fig leaves to their

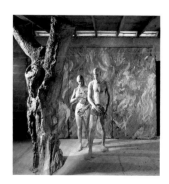

George Segal
The Expulsion 1986–87
see p. 151

genitals, the visual depiction of shame is twofold for the woman. The mutuality and equality of creation in the image of the divinity, male and female, remains behind them in the garden. Thus Segal's work can stir the religious imagination to see beyond traditional belief: it reminds the viewer that the foregrounding of the male becomes the order of a disordered world.

The feminist religious imagination is wonderfully expressed in Remedios Varo's *Creation of the birds* (1957) (p. 87), in which the owl, symbol of wisdom in classical and popular mythology, is assimilated to the figure of divine creator imaged as female. The creator is depicted as an alchemist transforming inorganic elements into living creatures, as an artist painting the birds into life, and as a musician communicating her own music through the medium of the violin string which becomes the artist's brush. The owl, partially feathered, partially clothed in women's clothing, captured in the act of creating feathered creatures like herself, evokes the biblical motif of creation in the image of the creator. For the feminist biblical interpreter, there are echoes of the biblical figure of wisdom who is imaged female.

The sacred writings of Israel were produced at a time when male deities were beginning to dominate and subvert the great mother, with Israel as participant in this movement. Their metaphors for and images of the creator in particular and divinity in general are, therefore, predominantly male. Traces of earlier religious tradition survive in maternal images scattered throughout the text. However, within the later tradition, the creative and sustaining power of the deity is imaged in Wisdom/Sophia who personified the female. The *Creation of the birds* as an evocation of Sophia-God, the female alchemist and wise owl, represents the creative imagination and metaphorical activity that is a significant goal in feminist biblical interpretation, feminist spirituality, and the reclaiming of women's power in contemporary cultural expressions.

Viewers conscious of the biblical narrative may find themselves pausing before Oskar Kokoschka's *Annunciation* (Verkündigung) (1911) (p. 47), in which two figures are set against the backdrop of ordinary life—a woman and an androgynous figure representing the angel of the traditional story. The woman is heavily pregnant in a way that might be read as a deconstruction of the idealization of Mary as virgin and the devaluing of sexuality that traditional interpretations have supported. This image is in stark contrast with Maurice Denis's *The Catholic Mystery* (1889) (p. 41), in which the typically subservient woman whose halo functions to idealize her subservience leans toward the straight and erect males depicted in the garb of the authorized bearers of the mystery (their halos underscoring legitimization rather than idealization). However, there is a decentring of the orthodox position by the depiction of the child visible within the womb of the mother—the life of the potential child contrasting sharply with the very rigid construction of book and candle.

In both Kokoschka's *Annunciation* and Dorothea Tanning's *Guardian angels* (1946) (p. 93) there is significant reimaging of those figures which the biblical tradition presents as the visible manifestation of divinity, depicted as they are in both the biblical text and history of Western art as male. The gestures of Kokoschka's androgynous 'angel' figure evoke protection. The left hand is raised in a gesture of holding off or repulsing some threat to the pregnant woman, the image evoked being all the ravages of patriarchy which have threatened women's life and life-giving potential. The right hand of the 'angel' is held in a gesture of protection toward the birth channel. In Tanning's *Guardian angels*, where the viewer would expect images of protection, the surreal intermingling of empty beds,

Oskar Kokoschka
Verkündigung (Annunciation)
1911
see p. 47

female bodies, high-heeled shoes and wings that interweave with the drapery to form a strange and fearful forest challenges the traditional depictions.

Several images evoke new interpretations of that most traditional of Christian images, the cross. This image is being deconstructed in our times from a number of perspectives, one of which is its potential to lock women into suffering. In Arnulf Rainer's *Wine crucifix* (1957/78) (p. 139), the typical starkness and clear lines of the cross blur into curves and permeable edges as the black and red seeps down the picture. The black upright evokes the pregnant body of a woman, the image of a woman in labour as symbol of the cross, as John 16:21 suggests:

> When a woman is in labor, she has pain, because her hour has come. But when her child is born, she no longer remembers the anguish because of the joy of having brought a human being into the world.

The bar of the cross hovers as it were over the pregnant woman and the wine/blood permeates the image, merging life and death (or suffering) in a way which women's bodily experiences of menstruation and pregnancy touch in regular cycles. The technique of overpainting which is characteristic of Rainer's work can be seen in his image as symbolic of the rereading or re-creating of traditional biblical images that women are undertaking out of their own creative energies and life experiences.

Participants in this exhibition, like contemporary interpreters of the biblical tradition, do not need to stay locked within a male-centred symbolic universe. The visual images, like the narratives and metaphors of the biblical text, can be reclaimed and reinterpreted beyond original intention. The exhibition itself also extends the religious imagination beyond traditional belief. The final image encountered as one leaves this group of works, Audrey Flack's *Daphne* (1996) (p. 183), resonates with Frida Kahlo's *Sun and life* (Sol y vida) (1947) (p. 85) to evoke both divinity and humanity in multivalent ways which are both ancient and new. The intermingling of creativity and fruitfulness with female imagery in both these works can function to reinform belief which has been shaped by the Jewish and Christian traditions. It can also point to a new religious imagination into the twenty-first century.

We could have focused upon many works within this group, but we have chosen those that enabled us to demonstrate the way in which a feminist perspective could inform the entire experience of encounter with the whole. And we have chosen to conclude with two works that evoke hope and possibility for a future in which a new religious imagination neither locks in nor locks out.

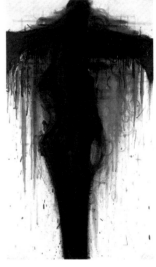

Arnulf Rainer
Wine crucifix 1957/78
see p. 139

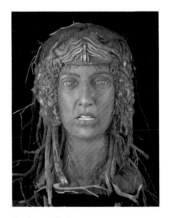

Audrey Flack
Daphne 1996
see p. 183

Veronica Lawson is Senior Lecturer in Theology, Aquinas Campus, Australian Catholic University, Victoria.

Elaine Wainwright is a Lecturer in Biblical Studies and Feminist Theology at Brisbane College of Theology.

Notes

1 Teresa de Lauretis, *Technologies of Gender: Essays on Theory, Film, and Fiction*, Bloomington, Indiana University Press, 1986, p. 3.

2 Virginia Woolf, *A Room of One's Own*, London, Hogarth Press, 1967, p. 37.

EDUCATING FOR BEYOND BELIEF INTO THE TWENTY-FIRST CENTURY

Maria Harris

On the threshold of the third millennium, symbol-making and the creation of genuine works of art are in a strikingly powerful place. That place is not only or even exclusively spatial. Instead, the place is temporal. Dominant themes of modern times—liberation, connectedness, and suffering, coupled with technical genius—impinge on this temporal location, making demands on all who dwell in it. The demands are reminders that we must be 'against forgetting' the depth, the history, and the tragedy of our times.[1]

In this context, the exhibition of the group of works ironically named *Beyond Belief* opens. This title is paradoxical, since it connotes the everyday, superficial, offhand, 'You aren't going to believe this', even as it suggests the profound disposition in which art as *a way of knowing* is an educational force that takes viewers past dogma and doctrine, past verbal formulae, past what can be codified as law. The dogma, the doctrine, and the codes then take their appropriate roles as pointers and guides toward understandings that can never be completely captured by discourse. They become signposts on the journey toward wisdom, mystery and revelation.

Revelation is, in fact, a clue to the remainder of the exhibition's title: *Modern Art and the Religious Imagination*. Responding to the moral demands the times make on us, the artistic genius represented in this group of works collaborates with the religious imagination. That imagination has been construed as the human capacity to make the impossible possible and the unseen seen, and is at the same time contemplative, ascetic, creative, and archetypal.[2] The religious imagination offers a language, a semantic, and a symbolism that *reveals* thought. However, the thought is never purely mental, for insight does not come from the mind alone. Instead, those who sing a lasting song do their singing—and their thinking—deep in 'the marrow bone'.[3]

Education and the exhibit

In the religious realm, five educational forms have traditionally mediated the fruits of the religious imagination to those in search of revelation. These forms are (1) community, (2) liturgy, (3) works that serve justice, (4) preaching, and (5) instruction or *catechesis*. In the realm of art, we are educated as viewers *by* these forms, but we are also educated as viewers *to* these forms.

In the rest of this essay, I reflect on how these forms might serve us as we participate in the exhibition.

1 *Community* It is significant that we do not come to this group of works alone. We come, instead, with hundreds, indeed thousands of others, aware of their presence as we walk through the rooms of the gallery. Perhaps we engage in conversation with one another as we are stopped by a particular work. But we are also in community with the art work itself. (I resist calling it the art *object* because the works convey such overwhelming *subjectivity*.) At a still deeper level, we are in community, even communion, with the artists whose work we encounter. Unquestionably, their vision, their style,

their materials, and their choices have an impact on what we see and on what we eventually know and do as a result of our presence in the experience.

2 *Liturgy* The educational form of *liturgy*—often called worship—is present here too. It is no secret that in many parts of the world, houses of worship are virtually empty on weekends, even if services go on. But if official places of worship are empty, museums are packed. In search of the kind of sacred meaning supplied by worshipful liturgy, men and women find themselves educated and nourished by coming to an event such as the showing of this group of works; an event self-described as a point of intersection for modern art and the religious imagination. Prayer is very real in such settings—not so much in the form of petitionary request as in the nondiscursive forms of contemplation, encounter with the holy, and grappling with demons. As we stand in puzzlement, awe, or both, before the works in each room, the liturgy we are enacting fosters an appreciation of the sacred presence manifest in these works.

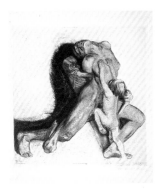

Käthe Kollwitz
Tod und Frau (Death and woman)
1910
see p. 60

3 *Works that serve justice*, or that mirror injustice, constitute a third educational form and a tradition in painting that ranges from Goya's *Disasters of War* (c. 1810–20) to Picasso's *Guernica* (1937). In this exhibit, we come face to face with such work in depictions of crucifixion, suffering, or evil that refuse to leave us unmoved. A human 'No' to violence and brokenness arises in response to such works, and in response to their originators, who act as agents of awareness and even of prophecy. In any one of the rooms we may find ourselves arrested and held, even held accountable, as we are stopped by Kollwitz's *Death and woman* (Tod und Frau) (1910) (p. 60) or Tanning's *Guardian angels* (1946) (p. 93) or Orozco's *Martyrdom of Saint Stephen* (El martirio de San Esteban) (1943) (p. 79) or Duwe's *Last Supper* (Abendmahisbild) (1978) (p. 133), or any one of the countless other pieces that demand our participation.

Kiki Smith
Lilith 1994
see p. 181

4 *Preaching*, or the announcement of a *kerygma*, is the fourth religiously educational form. In the Christian gospels, the word *keryx* means a herald or a runner who is sent into the centre of the city, into the public space, *into the gallery*, carrying the good news, message, or story that demands proclamation, even celebration. In the modern world, the meaning of preaching is often limited to only one of its forms, the Sunday sermon or homily that accompanies the reading of the Scriptures. Actually, the art house—gallery or museum—is for many people today the quintessential place of education to sacred story. In such places, the myths sedimented deep in the religious consciousness of a particular people spill over sectarian boundaries as they are re-rendered in each age. Here in Melbourne, they are exemplified by *Daphne* (1996) (p. 183), by *Mithra* (1996) (p. 173), and by (Kiki Smith's) *Lilith* (1994) (p. 181), for example; by the stories of the expulsion from the garden (*The Expulsion*) (1986–87) (p. 151) and the finding of Moses (*The finding of Moses*) (1924) (p. 42); and by the message *I have Angst* (Ich habe Angst) (1988) (p. 159).

5 *Instruction* In conclusion, we are educated by the instruction that is consciously and directly provided by and in the exhibition itself, instruction that will be continued over the years by this catalogue, the group of works' primary catechism. In between the opening and closing educational events, instruction goes on through the additional lectures, panels, and symposia being offered. It goes on through the work of academics; in the taped instruction available through the use of headphones; and not least by our own notes, our own sketches, and our own interactions with one another and with the artists.

The learning that issues from each of these forms need not be dissected. But it may need to rest, in unhurried germination, at nonconscious levels of our souls before issuing in speech. For the present, as the group of works conveys the power of art to move the viewer's religious imagination beyond simple or insufficient faith, it may be wise to remember that we are being educated, essentially, by *form*. Each of the educational processes I have described is, at root, a form, and form is the incarnation and the shape of content.[4] Each is an avenue through which we connect with what we did not at first know we knew. Each is at the service of something greater than itself: the mystery, wisdom, and revelation discovered by each person who enters this showing—perhaps tentatively—and then takes the steps it offers that lead beyond belief.

Maria Harris is a writer and teacher who has held both the Howard Chair in Religious Education at Andover Newton College, Boston, and the Tuohy Chair in Interreligious Studies at John Carroll University, Cleveland.

Notes

1 The phrase is Carolyn Forche's. See Carolyn Forche (ed.), *Against Forgetting: Twentieth Century Poetry of Witness*, New York, W. W. Norton and Co., 1993.

2 See Philip Wheelwright, *The Burning Fountain*, Gloucester, Mass., Peter Smith, 1982. See also Maria Harris, *Teaching and Religious Imagination*, San Francisco, Harper & Row, 1987.

3 The thought belongs to William Butler Yeats. See *The Variorum Edition of the Poems of W. B. Yeats*, Peter Allt and Russell K. Alspach (eds), New York, The Macmillan Company, 1957, p. 553.

4 See Ben Shahn, *The Shape of Content*, New York, Vintage, 1957.

SURPRISED INTO SEEING

Margaret Woodward

Beyond …

Beyond Belief is an apt naming of art and imagination that elude definitional interpretation and engage in redescription, fresh mythologizing and significant iconic invention. To stand before the works in this exhibition is to begin to perceive the shifting reciprocities of art and religious imagination. It is also to discover something of ourselves, of our own perceptions and beliefs. As R. S. Thomas cautions in his poem, *Gallery*, art works

> … are not asleep.
> They keep watch on
> our taste. It is not they
>
> are being looked at
> but we …[1]

The viewer who, looking, is looked at by the art in this exhibition may well be challenged to go *beyond* a familiar way of seeing and, in so doing, to be awakened to fresh vision and to break free of fixed expectations. For instance, a Christian whose notion of the relationship between religious imagination and art has been governed mainly by exposure to sacred art or to art whose 'narrative' character has been influenced by Christianity's emphasis on the word and on a verbal decoding of the visual, may be initially *bewildered* (faced with the untamed, the wilderness) by the relationship between image and title in Barnett Newman's *Covenant* (1949) (p. 107), or by Agnes Martin's serene *Untitled #8* (1980) (p. 143). How puzzling that Martin's grid patterning interacts with delicate and dissolving colour in such a way that the viewer may be able to find no meaning outside of the work itself, but yet become conscious of a significant interplay between its plastic presence and meaningful depths! Exploration of such 'puzzles' can reopen one's eyes to the familiar as well as to the unfamiliar. Alternatively, refusal to move *beyond* the already-known produces the situation of closure delineated by poet and artist Breyten Breytenbach:

> Of course one can no longer see the painting as it has become invisible. Too many people with framed expectations have looked at it. When a thing is looked at too often it loses its reality. Too many eyes kill the light and fade the pigment … in this way it has become a mirror … Bring it to your face. Can't you see the self-portrait?[2]

How, then, might the art in this exhibition de-familiarize, releasing from stifling stability both religious imagination[3] and perception of the art works? Defamiliarization[4] involves many elements: the unexpected, the unthinkable,[5] delight,[6] surprise, incongruity, indeterminacy,[7] fresh metaphor, and revitalizing effort.

Defamiliarizing refractions

The art works in *Beyond Belief* allows attention to how some works with explicitly religious titles disrupt expectation. Consider the title *Last Supper*, a naming that recalls familiar

religious story and image of Christ's final meal with his apostles before his death, and encourages anticipation of direct rendering of this event.

In Harald Duwe's cluttered image, *Last Supper* (1978) (p. 133), representation of twelve pseudo-apostles, clad in dull-coloured, middle-class conventionality and grotesquely posed, verges on caricature. Priestly gestures—the hand extended in blessing, thumb and index finger held together as though having touched the consecrated host— travesty the Mass. In post-Christian, literalising image, Christ is present in the torn hand and dismembered body parts laid out on the table. Not eucharistic banquet, this, but carrion feast for the Judases of consumerism and materialism. Duwe's painting functions as dual interrogation: of contemporary society by the eucharist and of the meaning and pertinence of eucharist by the realities of contemporary society. The work confronts; it does not answer.

Ben Willikens' *Last Supper* (Abendmahl) (1976–79) (p. 135) deliberately recalls Leonardo da Vinci's *Last Supper* (1495–97) (p. 22)—the table, perspective and central focus. But in Willikens' image the table is bare. Christ and the apostles are missing (was any one/One here?); colours, muted; religious symbols, absent. Even the artist seems silent within this perfectly proportioned space. Is the work cold, barren? Some see it so. Yet this stripping bare issues in a grand and beautiful image. Denuded of colour, the work can reflect all colour. The room's emptiness is a making room. Absence of human figures allows the viewer to enter, lured by perspective and light to the central arch beyond which the whiteness flows. What is entered remains indeterminate: is this a site of empty traces, or one where absence hints at presence, at transcendence? Born of aesthetic rather than religious concerns, the work releases fresh possibilities for religious imagining. Is it that the better the art, the more fertile are such possibilities? Is there also an evocative indeterminacy in Willikens' *Last Supper* that induces the viewer to look longer, to move tentatively into it? For such reasons, does Willikens' work strike a deeper chord than that of Duwe?

One might ask, too, whether a limiting of imagination impoverishes art. Though both George Grosz and Antonio Saura address the unspeakable, the power of their paintings and depth of imagination differ markedly. In Grosz's *Cain* or *Hitler in Hell* (1944) (p. 75), a hunched Hitler peers out upon a hellish German landscape where flames spurt, earth flowers with anonymous twig-like skeletons, and the body of Hitler-Cain's brother Abel is an undulation of the terrain. Historically timely as is this image, it is overcome by its own explicitness. Detail shows too much, reveals too little. Allegory disallows the imperative of silence.

Responsive to but not confined by a different historical context, Antonio Saura's *Crucifixion* (1959) (p. 117) gives more effective form to apocalyptic horror. 'There is no beauty nor comeliness'[8] in the crucified one. Distorted body parts explode in space, strangely vital against stark blackness. The scream of life is caught in the rictus of death. Here is all cruelty, all loss, all life-struggle, Holocaust evil and wars, the particular as well as the universal. The painting itself seems slashed into existence, born of visceral anguish. Unlike Grosz's overcommunicative image, Saura's work is painfully precise in its *being* rather than in any visual *telling*—'Only the wound speaks its own word'.[9]

Surprised into seeing

Importantly leavening the many twentieth-century images of death and destruction are works that defamiliarize by their balancing of delight and surprise, serving perhaps as a

Harald Duwe
Abendmahisbild (Last Supper)
1978
see p. 133

Antonio Saura
Crucifixion 1959
see p. 117

necessary reminder that 'Only in the positive do we suffer the negativeness of the negative'.[10] Among these is Gaston Chaissac's *Person with a green face* (Personnage au visage vert) (1959) (p. 113). Totemic, childlike and sophisticated, shaped to the irregular wood, the image is at once funny and poignant. Like a clown mask, the green face unmasks, disclosing and calling forth elemental feelings as its eyes stare challenge at the viewer. The totemic quality reminds of drama and ritual, of the kind of liminal comedy which, if it has pathos as theme, will have the comic, de-patheticisation, as its animating principle.[11] In this way a defamiliarizing inversion occurs—simultaneously giving expression to and transforming the pain at which, perhaps, the green face hints.

Other works also delight. There is James Ensor's airy and idyllic *The finding of Moses* (*Moses and the birds*) (1924) (p. 42), with its swans, peacocks, tiny figures, and infant Moses reaching out, that dispels the customary pious solemnity of the biblical narrative. There is the spontaneity and dignity of George Mung Mung's *Mary of Warmun* (The pregnant Mary) (c. 1983) (p. 129), and the sheer pleasure of its detail. There is the mobile, androgynous and dangerously human angel leaning over the Virgin in Oskar Kokoschka's *Annunciation* (Verkündigung) (1911) (p. 47). And there is the billowing exuberance of the flower-focused figure in Stanley Spencer's *Christ in the wilderness: 'Consider the lilies ...'* (1939) (p. 71)—a remarkable image of hope and concern amid wartime destruction, and a defamiliarizing reminder to both religious and aesthetic imagination that sometimes 'Joy takes more courage than grief'.[12]

Fresh perspectives

A 1980s book containing artists' biographies reads: '*Kahlo, Frida*. See *Rivera*'. The entry for Rivera yields solitary mention: 'm. Frida Kahlo'. In contrast, *Beyond Belief* brings to the viewer the extraordinarily vibrant power of Kahlo's *Sun and life* (Sol y vida) (1947) (p. 85); but also the compelling lyricism of Remedios Varo's *Creation of the birds* (1957) (p. 87); the felt-in-the-body declaration of fiercely vulnerable love in Jenny Holzer's *Mother and child* (1990) (p. 163), which recalls the female strength of Byzantine Madonnas; and the direct assertion, eloquent and untranslatable, of Rosemarie Trockel's *I have Angst* (Ich habe Angst) (1993) (p. 159), a text which, like Holzer's, gathers intensity in the materiality of art. The inclusion of these and works of other women artists defamiliarizes. It reminds of many interactive qualifiers—gender, culture, class, belief systems, social and political contexts—which, unrecognized, may have confined vision and imagination. Newly aware, the reflective viewer may choose to de-commit to those constrictive lenses habitually brought to bear upon art works, moving instead towards a deeper and more valid commitment and towards richer modes of seeing and imagining.

The continuing 'beyond' ...

The theme, *Beyond Belief*, hints at tensions between art and religion that are essential if neither is to sacrifice its integrity. 'Pictures aren't made out of doctrines.'[13] Art itself is a going *beyond*: the artist's intentionality cannot prescribe what springs out of the reciprocities and resistances of artist and media: the power of paint or ink or marble, of progressive formings and of the work's final realization. If deep human and religious questions, doubts, mysteries and meanings come alive again for the viewer, this is surely a tribute to the qualities of the art.

Gaston Chaissac
Totem — Personnage au visage vert (Person with a green face)
1959
see p. 113

Stanley Spencer
Christ in the wilderness: 'Consider the Lilies ...' 1939
see p. 71

Margaret Woodward, *writer and educator with a particular interest in the arts, culture and social justice, has been a Research Fellow and China Project Director, Asia Pacific Education Centre, Monash University, Melbourne.*

Notes

1 R. S. Thomas, *Collected Poems 1945–1990*, London, Phoenix, 1995, p. 455.

2 Breyten Breytenbach, *All One Horse: Fictions and Images*, London, Faber & Faber, 1990, p.86.

3 Scripture scholar, Walter Brueggemann, associates with this the activity of the prophets who, by their capacity 'to draw new pictures, form new metaphors and run bold risks ... created a new arena for Israel's imagination ... a different presumptive world ... which permits different decisions'. Walter Brueggemann, *The Creative Word*, Philadelphia, Fortress Press, 1983.

4 This term was introduced by Victor Shklovsky: see Shklovsky, 'Art as technique' in L. T. Lemon and M. J. Reis (eds), *Russian Formalist Criticism: Four essays*, Lincoln, University of Nebraska Press, 1965, pp. 3–24.

5 'Unthinkable' here refers to what is suppressed as overwhelming or threatening, to much that customary frameworks of seeing and thinking have denied admittance, to significant expressions of deep human feeling, and to that which goes beyond the already-conceived.

6 Sometimes such delight rewards effort; sometimes it occurs within engagement with the rich intricacies and ambiguities of the art work, recalling Bruner's contention that 'The road is better than the inn'. Jerome Bruner, *On Knowing: Essays for the Left Hand*, Cambridge, Mass., Belknap Press, 1976, p. 110.

7 The indeterminacy referred to here calls for participation, the interaction of the viewer who must move within the 'gaps' and silences created in works that leave meanings open and do not confine these in precise interpretation or detail. Indeterminacy leaves space for the viewer to engage in his or her own responsive making.

8 Isaiah 53:2.

9 Antonio Porchia, *Voices*, trans. W. S. Merwin, Chicago, Big Table Publishing Co., 1969, p. 13.

10 Jurgen Moltmann in Teofilo Cabestrero (ed.), *Faith: Conversations with Contemporary Theologians*, New York, Orbis, 1980, p. 125.

11 This creative juxtaposition is described in Vaclav Havel, 'The anatomy of the gag', *Modern Drama*, 23, 1, pp. 13–24.

12 Eduardo Galeano, *Days and Nights of Love and War*, New York, Monthly Review Press, 1983, p. 175.

13 In R. Goldwater and M. Treves (eds), *Artists on Art*, New York, Pantheon Books, 1972, p. 315.

CATALOGUE ENTRIES

> Remember that a picture—before being a battle horse, a nude woman, or some anecdote—is essentially a plane surface covered with colours assembled in a certain order.
>
> *Maurice Denis*[1]

To some contemporary viewers, *The Catholic Mystery* (Le Mystère Catholique) (1889), created by 18-year-old French artist Maurice Denis, may seem dated in its assurances, too sweetly-hued in its pieties, insular and hierarchical in its depiction of Catholicism. Yet Denis, who spoke in religious terms of the artist's 'mission' as being 'to transform worldly beauty into enduring icons',[2] abhorred sentimental devotionalism[3] and focused on the significant materiality of the art work itself. In viewing this painting, it is important to 'remember', as Denis urged, what a picture is, and to recognize 'the emotion [that] springs from the canvas itself'.[4] Anticipating twentieth-century abstraction, his aesthetic included the conviction that colour could be spiritual, could symbolize, and that shape and line could evoke the pure, the divine. Kandinsky and Chagall are among the many modern artists who acknowledge their debt to Denis.

The young artist soon became a key theoretician for the Nabis,[5] a group that included such artistic luminaries as Bonnard and Vuillard. However, this 1889 painting, which is one of six versions of *The Catholic Mystery*, reflects the influence of Fra Angelico as well as of Denis's recent introduction to Symbolism, to the work of Gauguin through Sérusier and to the ideas animating the Nabis. In its economy of detail, delicate colour, balance, restraint and spatial evocation of both intimacy and privacy, the work recalls Fra Angelico's *The Annunciation*—a title that Denis initially gave to his early versions of *The Catholic Mystery*. But Denis's emergent aesthetic is already evident in this mystical work which, though charged with religious feeling, avoids illustration or traditional iconic representation.

A suffusion of light links the priest and two acolytes. There is verticality in their pose, in the lines of the cleric's garb, in the Gospels held upright and in the clasped candles. The window-frame cross-pattern finds echoes in the priest's vestment. Crosses on the drapes contrast with the curves of the seated Mary. There is an intermediary curving in the right drape, the lily leaves, the wall designs and decorated vase. The Virgin herself is shaped by a rounding, pregnant light, and her hand circles mystery. Halos, like the cross motif, become multifaceted symbols. Circles suggest holiness, heaven, majesty and, perhaps, pre-Christian religious images and cosmologies.[6] Crosses recall Christ's presence, passion, death, resurrection and judgement—the whole Christian mystery. Pale colours prevail in the slowed liturgical procession. A vibrant and unexpected red adds beauty and creates a pause, a space for silence and meditative awe. Denis's use of paint allows the figures simultaneously to emerge and dissolve: the seen suggests the unseen. *Chronos* becomes *kairos*, sacred time, but through the windows a familiar landscape locates the enclosed scene in actual time and space.

Later, though, Denis was to move towards a classical *oeuvre* and a position of artistic and political conservatism. But *The Catholic Mystery* shows him as an innovative thinker and artist, whose early works exemplify his influential aesthetic and are alive with religious resonance.

Margaret Woodward

Notes

1 In Maurice Denis, 'Definition du Neo-traditionnisme', first published in *Art et Critique*, Paris, August 1890; quoted in translation in Robert Goldwater and Marco Treves, *Artists on Art: From the 14th–20th Centuries*, London, John Murray, 1976, p. 380.

2 Maurice Denis, *Journal*, vol. 1, Paris, La Colomb, 1957–59.

3 'Do you suppose that Botticelli wanted to put into his *Spring* all the sickly delicacy and precious sentimentality that we have read into it?' Denis, quoted in Goldwater and Treves, op. cit.

4 Ibid.

5 From Hebrew: *prophets* or *enlightened ones*. The group formed in 1889.

6 Influenced by Sérusier, the Nabis were interested in the occult and in ancient cosmologies and religions.

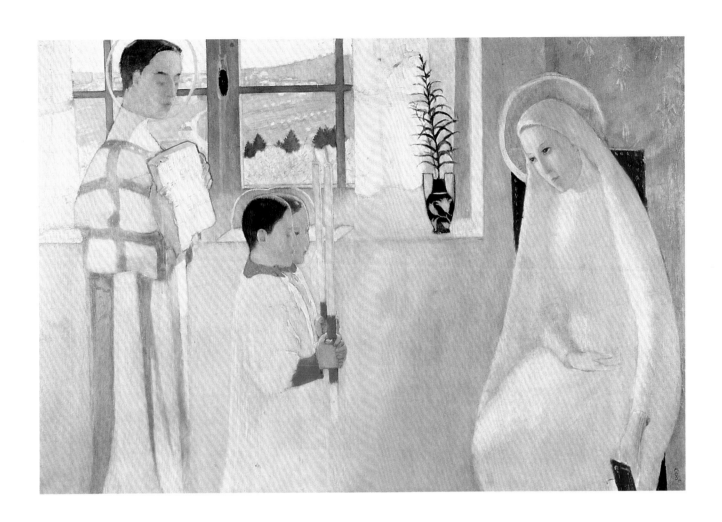

Maurice DENIS
1870–1943
Le Mystère Catholique (The Catholic Mystery) 1889
oil on canvas
97.0 × 143.0 cm
Musée Départemental Maurice Denis, 'Le Prieuré', St Germaine-en-Laye

> For me, art is the daughter of pain, and except for rare moments I have been in league with bitterness and disillusion.
>
> *James Ensor*[1]

These two works, executed more than thirty years apart, represent such 'rare moments' for James Ensor. They are paintings of joy and light without any of the sombre and neurotic overlays of much of Ensor's other religious work.

Christ calming the storm (Le Christ apaisant la tempête) (1891) was completed towards the end of Ensor's most creative and productive period. Since 1882 he had been involved in visionary works representative of a religious imagination often coloured by a macabre sense of life. Rejected from exhibitions with Les Vient (which he had helped to found), and deeply constrained within his own psyche, Ensor used his art to release tension and to satirize what he saw as mean-spiritedly condemnatory. In works such as *Entry of Christ into Brussels* (1888–89) and *Man of sorrows* (1891), he gave form to this inner sight and also passed merciless comment on himself, the Church, Belgian society and his fellow artists.

Christ calming the storm has the same setting as its antecedent, a small etching, *Christ calming the tempest* (1886)—the North Sea outside his Ostend window, the solitary boat crowded with frightened disciples and caught in a freak squall, the serene figure of Christ with arms outstretched commanding the sea to be still.[2] The mood is tranquil rather than stormy. Ensor's painting is filled with impressionist light, created with rhythmic strokes of yellows, blues, reds and whites which circle the boat. Given the context of his other 1891 works and of his increasingly fragile mental state, this is probably more than a simple narrative painting. Does Ensor here, as in *Man of sorrows*, identify with Christ, with power to assault evil wherever it is found?

Little has been written about *The finding of Moses* (1924) (also known as *Moses and the birds*). After 1900 Ensor painted less and less and most of what he did was little more than a reworking of his earlier ideas; often he simply changed the dates on existing works. It was as if the struggles and failures of the last decades of the nineteenth century had exhausted his creativity, and even though he acquired acclaim and respect, collected many public honours, and was the subject of monographs and retrospectives (for example, Brussels 1920, Antwerp 1921), he never regained the sharpness of his earlier work.

An exception is *The finding of Moses*, a work of exquisite sensuality in the lavishness of its colour and the handling of the subject matter. Found by the Egyptian Pharaoh's daughter, the child is special—a small man with arms raised in anger, a crown on his head, and long rays, like a gigantic aureole, emanating from his head. Pharaoh's daughter points to Moses' penis, source of virility, glowing red with promise. Around them the scene resembles a stage setting rather than a natural landscape. Beautiful birds fill the canvas, the air, the river, the banks; figures dance in and about the trees; the main characters engage in mysterious, theatrical pseudo-religious rites.

In *The finding of Moses*, Ensor is revealed as a wonderful story-teller, a creator of myth with a magical facility of colour and brushstroke. It is a work which teases the religious imagination while it seduces the eye.

Rosemary Crumlin

Notes

1 James Ensor, 1897, quoted in Jane Turner (ed.), *Dictionary of Art*, New York, Grove, 1996, p. 411.
2 Mark 4:35–41.

James **ENSOR**
1860–1949
The finding of Moses (Moses and the birds) 1924
oil on canvas
119.5 × 128.5 cm
Berkeley Art Museum, University of California
Gift of Joachim Jean Aberbach
© James Ensor 1924 / SABAM
Reproduced by permission of VI$COPY Ltd, Sydney 1997

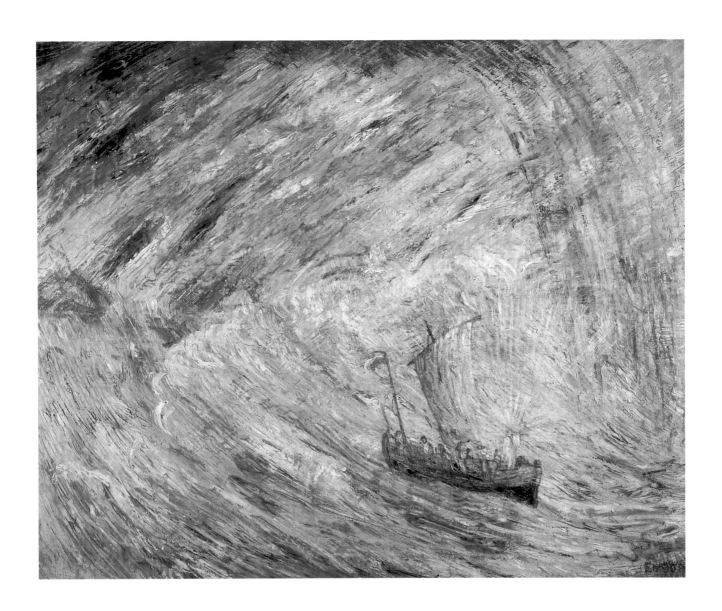

James ENSOR

1860–1949

Le Christ apaisant la tempête (Christ Calming the Storm) 1891

oil on canvas

80.0 × 100.0 cm

Museum voor Schone Kunsten, Oostendene

© James Ensor 1891 / SABAM

Reproduced by permission of VI$COPY Ltd, Sydney 1997

> The world sounds. It is a cosmos of spiritually effective beings.
> Even dead matter is living spirit.
>
> *Wassily Kandinsky*[1]

By the time Russian lawyer, philosopher and artist Wassily Kandinsky painted *All Saints I* (Allerheiligen I) (c. 1911), he had already formulated, in 'On the Spiritual in Art',[2] a coherent theoretical base for abstract art as the most perfect vessel for a cosmic spirituality.

One way to enter into Kandinsky's work is to track across his paintings as they move from easily recognizable iconography into what he regarded as 'pure' form, into works in which colour and form 'sing' in abstract rhythms of interdependence. *All Saints I* represents an important step in this process. Its iconography is discernible if placed alongside a glass painting of the same year, also called *All Saints I*, yet its forms and colours set up complex relationships independent of their subject matter.

In the Russian Orthodox Church, the feast of All Saints on the first Sunday after Pentecost marks the beginning of the second cycle of the liturgical year. The first cycle, from Advent to Pentecost, celebrates redemption, what God has done for humanity; the second, what human beings are called to do to bring about salvation for the world. Like the glass painting, the work in this exhibition celebrates those who have responded to this call. Towards the centre right is St Vladimir, who first brought Christianity to Russia; the crowned Virgin Mary is just discernible; and St George riding in to slay the dragon has become more prominent than in the glass painting. In the top left-hand corner, the Angel of the Apocalypse heralds redemption. The dove and crucifix of the glass painting are no longer key compositional elements.

Even in the painting on glass, Kandinsky has moved away from a three-dimensional spatial organization to a flatter, apparently more 'innocent' narrative method akin to the folk paintings of his native Russia. But in the oil version, colour is no longer a descriptive device; essentially, it is a tool for creating symbolic patterns across and around the entire picture. Kandinsky has moved from being a raconteur, an outsider and observer, to being a participant, not simply in the story but in the life that is the painting itself. He is not so much the organizer of the space as the agent through whom the painting is brought to life. He often referred to this pursuit of pure form as an 'inner necessity'.

Although quite small, *All Saints I* is very important in the history of modern art. In it, Kandinsky sealed the direction of much modern painting towards a lyrical abstraction born of a clearly-held philosophical position that believed in the power of the individual to achieve a spiritual rather than a social revolution in the whole of life. In this he is 'father' and model for later artists in this exhibition, including Mark Tobey, Alfred Manessier and Mark Rothko.

Rosemary Crumlin

Notes

1 In Wassily Kandinsky and Franz Marc (eds), *Blau Reiter Almanac*, New York, New Documentary Edition, Viking Press, 1974, p. 173.

2 Kandinsky's influential book, rejected by the first publisher, was accepted by Piper Verlag in 1912 only on condition that Kandinsky pay half the publishing costs.

Wassily **KANDINSKY**
1866–1944
Allerheiligen I (All Saints I) c. 1911
glass painting
34.5 × 40.5 cm
Städtische Galerie im Lenbachhaus, Munich
© Wassily Kandinsky 1911 / ADAGP
Reproduced by permission of VI$COPY Ltd, Sydney 1997

Wassily KANDINSKY
1866–1944
Allerheiligen I (All Saints I) c. 1911
oil on cardboard
50.0 × 64.5 cm
Städtische Galerie im Lenbachhaus, Munich
© Wassily Kandinsky 1911 / ADAGP
Reproduced by permission of VI$COPY Ltd, Sydney 1997

Nothing at all else in this place — oh see

This terrifies. And both were terrified.

Then the angel sang his melody.

<div align="right">*Rainer Maria Rilke*[1]</div>

OSKAR KOKOSCHKA

Almost every Christian artist has painted at least one version of the Annunciation, just as they have all painted the Crucifixion. Within the framework of traditional Christian belief the Annunciation is the beginning of the story of salvation—Mary's assent to the divine request is simultaneously miraculous and imperative. Isn't it curious for an artist in the modern 'age of disbelief' to paint such a motif? How could he make it different from the thousands of images that have come before his and yet make his recognizable as THE Annunciation?

Those critics and art historians who write about Oskar Kokoschka emphasize his pronouncement that 'art must be communicable',[2] his interest in art as a product of human experience, and his expressionistic use of colour. They also note which masters, especially El Greco, were influences on this period of Kokoschka's art. The painter himself acknowledged the 'reawakening of my religious past'[3] when he returned to Vienna in May 1911. 'No longer confused by external activity, the eye could turn inward, illuminating my inner self. It was like a gift from God, allowing me to see everything in an entirely new light'.[4] During this time, Kokoschka painted several biblical theme paintings including *Annunciation* (Verkündigung) (1911). Yet when we actually *look* at this painting, what do we see?

Our immediate response may be one of wonder at how this depiction of two figures—ostensibly a nude androgynous figure and a clothed female figure—can possibly be perceived as an 'image of sacrality'? Is there any iconographic and/or thematic connection to traditional Christian images of the Annunciation? If not, is this merely a thematic rouse by one who paints and lives in the 'age of disbelief'? Yet the painting has an internal visual energy that simultaneously intrigues and distances—a visual energy enhanced, if not provoked, by the evocative gestures and the drama of light and shadow.

If we can break down the traditional boundaries of what the Annunciation looks like and what it means, we can go forward with what it is *we see* in and through Kokoschka's painting. The immediate dichotomy between the nude figure and the clothed figure is heightened by the contrast in light and shadow, active and passive gestures, and erect and recumbent postures. If we look *into*, not simply *at*, this painting, we come to *see* the centrifugal energy released through the four hands. We note the dramatic inclined alignment of the three hands with Mary's left foot at the central axis of the canvas. Her elongated right fingers simultaneously express bewilderment and possession, and are mirrored in her left fingers, which rest symbolically upon her receptive womb. The traditional 'empty space', signifying the mystery of the Incarnation in classic Annunciation paintings, is rendered powerfully by Kokoschka's delicate placement of Gabriel's calm yet controlling right hand in the almost undetectable 'empty space' between Mary's right knee and left shin.

Gabriel's wide-eyed countenance looks away from the Virgin's trance-like face, connoting the explosive spiritual force which shatters traditional pictorial conventions, as an artist in the age of disbelief moves us visually beyond belief towards the eternal mystery of the sacred:

> A painter doesn't copy anything, he makes a picture. A picture is something that wasn't there before, you have to *make* it. A picture has to derive from a phenomenon that amazed me, terrified me, opened my eyes wide, and I must keep them open to master the phenomenon. You 'make yourself a picture', and when you have it, it gives you a fright. The terror is in the picture just as it was in the phenomenon before.[5]

Diane Apostolos-Cappadona

Notes

1 Rainer Maria Rilke, *The Life of the Virgin Mary* (Das Marien-Leben), trans. and intr. by Stephen Spender, Vision, 1951, p. 19.

2 Oskar Kokoschka, *My Life*, trans. David Britt, Macmillan, 1974, p. 229.

3 Ibid., p. 70.

4 Ibid.

5 'Colloquy between Oskar Kokoschka and Ludwig Goldscheider', from Ludwig Goldscheider in collaboration with Oskar Kokoschka, *Kokoschka*, Phaidon Press (?London), 1963, p. 8.

He allowed himself to be influenced by everything, he let it go, he put it back together again, and so on. Result: Chaos in the brain. Also in his painting: his eyes drank in everything that came into sight; later, with more selectivity, he loved Van Gogh, Goya, Seurat, Matisse, Macke, Kandinsky ...[1]

Thus Max Ernst described himself as a youthful painter at the mercy of multiple enthusiasms. With the intense facility of clever 'student' work, *Crucifixion* (Kreuzigung) (1913) confirms Ernst's artistic precociousness, and he made his first trip to Paris on the proceeds of its sale. Yet the painting offers more than an emerging artist's knowledge of avant-garde fashionable mannerisms.

Hindsight suggests further meanings of Ernst's *Crucifixion* beyond those intended by the artist. The young beardless Christ on the Cross brings to mind the sacrifice of a generation of young men on the battlefields of World War I, emphasized by the fashionable dress of the Maries which places this picture unmistakably in its historical context. Moreover, in their bourgeois neatness, the Maries could be read as 'society' and therefore as representative of 'the system', or even as first cousins to those heartless women on British propaganda posters who tell their menfolk to enlist. As with Georg Heym's 1911 poem, *Der Krieg* (War), which evokes a society gripped by total war and apocalyptic destruction, one has to remind oneself constantly that Ernst's *Crucifixion* predates the outbreak of hostilities. Pre-1914 German Expressionism seemed on occasion haunted by a prophetic awareness of the future upheavals of the twentieth century.

The reality was perhaps more prosaic. Ernst was commissioned to paint a male nude and, as so often in art history, a St Sebastian or a Crucifixion was deemed an acceptable 'cover' for such an image.[2] The depiction of Christ with Ernst's features resonates strangely with one of the key stories in his frequently narrated personal mythology: the tale of how, when as a child he was running away from home, a band of pilgrims mistook him for the infant Jesus. After Ernst's return home, his father, an amateur artist and pious Catholic, painted his son in this guise. Ernst's father's *oeuvre*, moreover, provided a strong impetus towards religious art, and as his works were suave and tightly detailed in the manner of much lithographed ephemera of the period (prayer cards and *glänzbilder* or scraps), may have initiated an interest in Ernst in the imagery of nineteenth-century popular arts and commercial printed material.

Crucifixion is also a testament to Ernst's Rhineland origins and to the inspiration of the rich art collections of Cologne.[3] Expressionist painters found inspiration in German medieval and Renaissance painting, as in Ernst's quotations from Grünewald's Isenheim Crucifixion (c. 1512–16). The persistence of traditional religious iconography within the German avant-garde pre-1914 was rearticulated by the experience of World War I, when historical and cultural borrowings increasingly became a comment upon current experience, either to emphasize the harrowing nature of daily life or to transcend it.[4]

Yet *Crucifixion* speaks of Max Ernst's future as well as of his origins. Here is prefigured not only the sacrifice of a generation of young men, but also the magic chemistry of juxtaposition and gesture that makes many of his collages so enjoyable to view, independent of their status as avant-garde art works. Here already are those enigmatic, distinct, disturbing, pungent interactions between the protagonists that enliven the various plates of *La semaine de Bonté* (The work of goodness), for example. Perhaps the young man is not crucified by imperialist rivalries but by the frequently deadly gender conflicts imaged by twentieth-century modernism.

Juliette Peers

Notes

1 Quoted in *Max Ernst in Köln: Die Rheinische Kuenstsezebe bis 1922*, Köln, Rheinland Verlag, 1980, p. 68.

2 William A. Canfield, *Max Ernst: Dada and the Dawn of Surrealism*, Munich, Prestel, 1993, p. 393.

3 Diane Waldeman traces an 'obvious affinity with the Cologne Primitives'. See her biographical essay in *Max Ernst — A Retrospective*, New York, Solomon R. Guggenheim Museum, 1975, p. 18.

4 This quotation of medieval artworks may have served a further emotional need, for example focusing upon past German artistic achievement as an answer to racist reductionist propaganda (such as that of Australia's Norman Lindsay) showing Germans as subhuman apes and gorillas in military uniforms.

Max ERNST

(1891–1976)

Kreuzigung (Crucifixion) 1913

oil on paper

50.5 × 43.0 cm

Museum Ludwig, Köln. Donation Haubrich

© Max Ernst 1913 / ADAGP

Reproduced by permission of VI$COPY Ltd, Sydney 1997

> Knowledge and science are inadequate when it comes to the simplest questions about time and eternity, about God, about heaven and Satan. Faith alone has no limitations.
>
> *Emil Nolde*[1]

Emil Nolde produced his most important series of religious paintings and prints in a concentrated burst of activity between 1909 and 1912. A man of deep religious feeling, Nolde valued the primacy of simple mystical faith over religious doctrine. His freedom from what he called 'rigid dogma and the letter of the Bible' was first realized in his paintings *Last Supper* and *Pentecost* (both 1909), which mark the artist's 'change from optical, external stimuli to values of inner conviction'. This orientation is also apparent in the 1911 series of religious etchings *Saul and David* (Saul und David), *Christ and the adulteress* (Christus und Die Sünderin), *Solomon and his wives* (Salamo und seine Frauen) and *Scribes* (Schreftgelehrte). These works are concerned not with a literal illustration of biblical narrative, but rather with the expression of emotion or of imaginary scenes inspired by the text. The jealous rage and mental anguish of Saul is the subject of *Saul and David*, and Christ's compassion towards sinners is movingly depicted in *Christ and the adulteress*. In *Solomon and his wives* Nolde delights in the depiction of the exotic features of Solomon's foreign wives, revealing his intense interest in the art of non-European cultures. This interest also inspires the mask-like faces in *Scribes*, an imaginary scene showing a debate between the Pharisees, Jewish religious officials described in the bible, who were more interested in the letter of God's law than its spirit. These works display an expressive intensity that is achieved through Nolde's primitivising style and simplified compositions that focus attention on the emotional exchanges of the principal characters. However, the expressivity of these etchings is most strikingly enhanced by their extraordinary tonal and textural effects. Achieved by Nolde through unorthodox methods, the dramatic eddies of tone and varied textures across the plates' surfaces contribute to the psychological dimension of the images.

Acclaimed as one of the most innovative printmakers of the twentieth century, Nolde produced a total *oeuvre* of some 500 etchings, lithographs and woodcuts during his lifetime.

Emil **NOLDE**
1867–1956
Prophet 1912
woodcut
Schiefler-Mosel 110 – Sho 88
32.2 × 22.7 cm
Nolde Foundation, Seebüll, Germany
© Nolde – Stiftung Seebüll

Attracted by the expressive potential of the different print media, Nolde explored the inherent characteristics of each of the techniques. His distinctive approach to woodcut and lithography is exemplified in *Prophet* (1912) and *The Three Wise Men* (Die Heiligen Drei Könige) (1913).

Prophet remains one of the most memorable woodcuts of the German Expressionist era, marrying the ascetic features of the prophet with the woodcut's capacity for inventive simplification and stylization of form. *The Three Wise Men* is one of a series of thirteen large colour lithographs made by the artist at the Westphalen print studio in Flensburg during 1913. This series marks the climax of German Expressionist printmaking, and shows the artist's relentless pursuit of different effects by exploiting lithography's capacity for limitless colour variations. Among the greatest achievements of the German Expressionist movement, Nolde's religious paintings and prints are characterized by an emotional intensity and extreme primitivism of form and mystical fervour.

Cathy Leahy

Notes

1 Emil Nolde, *Jahre der Kämpfe*, Berlin, Rembrandt, 1934. All quotations are from this second volume of the artist's autobiography, translation in H. B. Chipp, *Theories of Modern Art: A Sourcebook by Artists and Critics*, Berkeley, University of California Press, 1968, pp. 146–51.

Emil NOLDE
1867–1956
Die Heiligen Drei Könige
(The Three Wise Men) 1913
colour lithograph printed in black,
blue and red
Schiefler-Mosel 49, Probedruck – Sli 171
65.0 × 54.3 cm
Nolde Foundation, Seebüll, Germany
© Nolde – Stiftung Seebüll

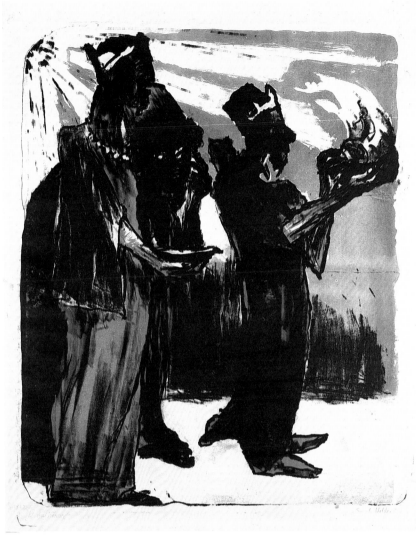

Schriftgelehrte (Scribes) 1911
line etching and tonal etching
Schiefler-Mosel 154II – SR 266
26.9 × 29.8 cm
Nolde Foundation, Seebüll, Germany
© Nolde – Stiftung Seebüll

Saul und David (Saul and David) 1911
line etching and tonal etching
Schiefler–Mosel 152II – SR 263
30.1 × 24.8 cm
Nolde Foundation, Seebüll, Germany
© Nolde – Stiftung Seebüll

Salamo und seine Frauen (Solomon and
his wives) 1911
line etching and tonal etching
Schiefler-Mosel 153II – SR 265
30.3 × 25.2 cm
Nolde Foundation, Seebüll, Germany
© Nolde – Stiftung Seebüll

Christus und die Sünderin (Christ and the
adulteress) 1911
line etching and tonal etching
Schiefler-Mosel 155III, 6 – SR 269
30.0 × 25.0 cm
Nolde Foundation, Seebüll, Germany
© Nolde – Stiftung Seebüll

But concerning myself I know I have no program; I only have the inexplicable desire to understand why I see and feel, and to find the purest expression for this. In addition I also know that these are things to which I can draw near through means of art, but not through thought or word.

Karl Schmidt-Rottluff [1]

Karl Schmidt-Rottluff wrote this in 1914, two years after the break-up of the German Brücke group, of which he had been a founding member in 1905. Although he did not know it at the time, *Pharisees* (1912) was to be one of his last paintings with the group. It is also one of the clearest manifestations of the spirit and aims of the group, which included his friend Erich Heckel, Ernst Ludwig Kirchner and at other times, Max Peckstein, Otto Mueller and Emil Nolde.

Essentially the Brücke was a group of young artists joined by a spiritual dream—to bring about a world in which unity rather than an exaggerated and selfish individualism would prevail. As a group they were much clearer about what they were rejecting than about where they were going. As Heckel recalled: 'That from which we had to leave was very clear, that to which we were going was far less certain'.[2] The name 'Brücke', 'bridge', was suggested by Schmidt-Rottluff, but is to be understood more as a metaphor for a spiritual quest than as a prescription of a clear set of aims. Indeed, when in 1913 Kirchner tried retrospectively to delineate clear and revolutionary goals, the group disbanded in protest.

Pharisees was completed in 1912, the year that Schmidt-Rottluff, Kirchner and Heckel had painted the chapel for the Cologne Sonderbund Exhibition, in which they all participated. He spent the summer, as usual, in the flat country of Dangast by the North Sea. The year had been filled with exhibitions of the group in Hamburg, Berlin and Munich. The group was most sought after and influential. Their youthful energy, drive and enthusiasm bore abundant fruit.

Pharisees looks like a carving translated into paint, with Schmidt-Rottluff using the brush in a simple, strong, flattened and brutal way, reminiscent of the style of his woodcuts of the same period (*Heads I*) (*Köpfe I*) (1911). Formal values predominate: the four heads together build an abstract pattern of oblique directions, emphasized by the rhythmic use of clean, bold, pure colours—reds, yellows, blues and greens—strengthened by solid black shapes. The work's debt to African carving, to medieval woodcuts, to Fauve intensity and to analytical Cubism is clear, but what makes this painting important is its essential unity as a picture surface. Beyond the drama of the faces set in such close and shallow proximity is a mastery of pictorial organization radical in its simplicity and certainty. The qualities which propelled German youth into an idealistic war are translated here into painting. Here the relentless pursuit of a purity of expression unfettered by trappings of sophistication is evident. The work hovers at the edge of abstraction, but Schmidt-Rottluff was unable to take his spiritual quest to its logical conclusion. It was up to Kandinsky in Munich (p. 45) to free art from the restrictions of subject matter so as to answer more purely the call to 'inner necessity'.

Rosemary Crumlin

Notes

1 Karl Schmidt-Rottluff, 'Response to Questionnaire Concerning a New Program for Art', *Kunst und Künstler 12* (1914), quoted in *Brücke: German Expressionist Prints from the Granvil and Marcia Specks Collection* (exib. cat.), Illinois, Reinhold Heller, 1988, p. 17.

2 Ibid., p. 8.

Karl SCHMIDT-ROTTLUFF
1884–1976
Pharisees 1912
oil on canvas
75.9 × 102.9 cm
The Museum of Modern Art, New York, Gertrud A. Mellon Fund 1955
© Karl Schmidt-Rottluff 1912 / Bild-Kunst
Reproduced by permission of VI$COPY Ltd, Sydney 1997

> I feel ever more the unity of creator and created; what becomes is the other form of the creator, his phases, his mirror image. The moment is a metamorphised piece of eternity.
>
> *Ernst Barlach*[1]

The Avenger (Der Rächer) (1914) alights as God's warrior. Understood in the Hebrew Bible as a redress of injustice, the act of vengeance became for Ernst Barlach a parable of spiritual unease. Freely enlisting, Barlach rushed headlong into the fray of the Great War—as if embodying his own lithograph, *Wartime: The Holy War* (1914). This sculptor and printmaker, poet and dramatist, propelled himself on a moral mission. He became a willing father for the apocalyptic Fatherland, a barefoot Moses posed to proclaim Yahweh's prerogative in the face of disobedience: 'I will make the words, the avenger of my covenant, sweep over you.' (Lev. 26:25).

The figure has been streamlined for the machine age. The aerodynamics of industrial-strength mediation is evident: elbows jut forward, and are brought together like a farmer's plough, to make a violent, primitive act not only potent and personal but believably prayerful. Reminiscent of Gothic individualism, a monkish crusader is stripped bare of his solitude. But is he in pursuit of a suddenly recognized demon who would have him chasing windmills?

Moving beyond the naturalism of Jugendstil and the realism of his earlier work, Barlach informed his Expressionism with Cubism. Fan-like folds make architectonic planes of a heavy, cumbersome overgarment. Capitalizing on torqued diagonals, Barlach continually shifts vertical and horizontal formal aspirations for the expression of frightened resignation. One foot firmly on the ground, the figure with its furrowed brows and fateful eyes mirrors the unending inhibitions that blind body to soul, soldier to field. Unlike Marinetti's interpretation of Futurism, Barlach's work only apes the 'beauty of speed'. Neither is it Boccioni's *Unique forms of continuity in space* (1913). This 'primitive' avenger with his sword sprung back, streamlined to his body, accepts a time-honoured task; for he has 'clothed himself with garments of vengeance' (Isaiah 59:17). Simplification issues into monumentality; hewn material metamorphises into reluctant abandonment. Does Barlach deny progress its piety?

Confiscated by the Nazis in 1937, a woodcarving of *The Avenger* shifts to lightning rod. It could not but absorb the great void Barlach foresaw in his very first play, *The Dead Day* (1912). For it was not a generative father who now hovered and descended to create. 'De-accessioned', the created became an artifact of cultural fallowness, the victim of ploughshares reworked for the 'heroic' violation of human rights. Marginalized and unavenged, souls are no longer given the privilege of embrace.

James R. Blaettler

Notes

1 Ernst Barlach, 'Die Wandlung Gottes' (The Transformation of God), in Friedrich Dross, *Ernst Barlach: Leben und Werk in seinen Briefen*, Munich, R. Piper and Co., 1962, p. 169. Trans. of passage by James R. Blaettler.

Ernst BARLACH
1870–1938
Der Rächer (The Avenger) (1914)
bronze
44.0 × 22.0 × 58.0 cm
Museum Ludwig, Cologne
© Ernst und Hans Barlach Lizenzverwaltung Ratzeburg

… when the balance between male and female is attained one can leave the physical plane and join the angels.

Hilma af Klint[1]

The vibrant colour, pure abstraction and arcane symbolism of the paintings dating from 1907 of Swedish mystic Hilma af Klint establish her as a precursor to Kandinsky, Malevich and other artists regarded as leaders in the modern movement. Yet recognition of her art came only after her work was exhibited in 1985, forty-three years after her death.[2]

Group 9 series SUW, The swan #17 (1914–15) and the *Group X, Altar paintings #1* (1915) belong to the two middle phases of af Klint's career. By then she had abandoned her career as a portraitist and, under rigorous asceticism and spiritual guidance, had painted automatically. Although still in touch with her spiritual guides, here she more consciously follows her own vision, using two powerful symbols, the sphere and the triangle. The circle, as seen in Tibetan mandalas, Aztec sun worship or Gothic rose windows, signifies ultimate wholeness. The triangle in Christianity symbolizes the Trinity, the union of opposites and the union of the soul with God. For Hilma af Klint these symbols played a special role in her seances for over twenty years with four women in the 'Group of Five'. Crucial to their meetings was a carefully composed altar on which symbolic objects included a setting of a cross in front of a gold triangle, which may have inspired her imagery, particularly in *Altar paintings #1*.

The swan #17 appears as a self-contained image, but it relates to twenty-three other works in the series. Starting as realistic depictions of black and white swans, often interlocking, with beaks and feet of blue and yellow, in the series the birds are reduced to cubes, spirals, discs and other esoteric images, resulting in the pure abstraction of this painting. Against a red background the sphere is halved into a black and white side offset by blue, yellow and pink.[3] Recurring colours and symbols show a concern for symmetry and the balancing of opposites: dark-light, blue-yellow, circular-rectangular, horizontal-vertical, male-female and astral-physical, similar to the Buddhist concept of Yin and Yang. The series concludes with a powerfully charged embrace between a black and white bird, in which all conflicting elements are united.

Hilma af Klint's interest in the nature of evolution and unity derives from her studies of theosophy, which considered duality to be important. An intentional message of her work was that

> … the sexes of men and women in the real world are reversed in the astral world; and … this reversal provides a resolution of the duality within human existence.[4]

Duality is also the key to the *Altar paintings #1*, where an equilateral triangle reaches into a radiant sphere. Two colour pathways, cut into three ascending and horizontal lines, create a prismatic pattern of shimmering tile-like forms. The pyramidal structure is divided down the centre by gold discs that lie flat at the base but spin on entering the celestial sphere, culminating as a gold spot in a black triangle. (A small triangle halved in black and red is also central to *The swan*.) In both paintings red and gold suggest masculinity, while blue and silver refer to female qualities. The separated pathways suggest that only entry to the heavenly sphere can provide true wholeness.

Except for seeing the work of Edvard Munch in 1896 and of Kandinsky in 1914, Hilma af Klint remained isolated from contemporary European art influences. Following her own spiritual path and intuitively adopting universal archetypes, she arrived at the same point as modernists who consciously studied the occult to achieve abstraction.

Such was her faith in her spiritual mission that she planned a museum to house her work and approached Rudolf Steiner to interpret her art. Disappointed that neither expectation could be fulfilled in her lifetime, she decreed that nothing be shown until twenty years after her death, in the hope that by the end of the century we might come to some understanding of the spiritual content of her work.

Patricia Fullerton

Notes

1 Ake Fant, 'The Case of the Artist Hilma af Klint', *The Spiritual in Art: Abstract Painting 1890–1985*, Los Angeles, Los Angeles County Museum of Modern Art, 1985, p. 161.

2 Ibid.

3 The artist's great-nephew, Gustaf af Klint, has suggested that the colour pink represents 'Eros'; yellow, masculinity; and blue, female qualities.

4 Fant, op. cit. Influences include Russian theosophist H. P. Blavatsky, and her disciple, Annie Besant; Rudolf Steiner, founder of anthroposophy; her Nordic environment, stimulating interests in nature and mysticism; and her father, who shared his knowledge of botany, astronomy and geometry.

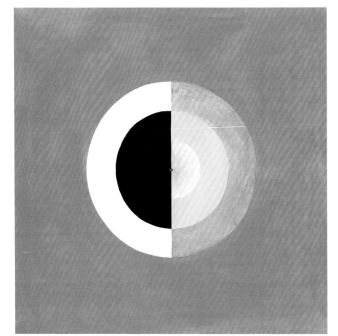

Hilma AF KLINT
1862–1944
Group IX series SUW, The swan #17 1914–15
oil on canvas
155.0 × 152.0 cm
The Hilma af Klint Foundation, Stockholm
© Hilma af Klint Foundation 1997

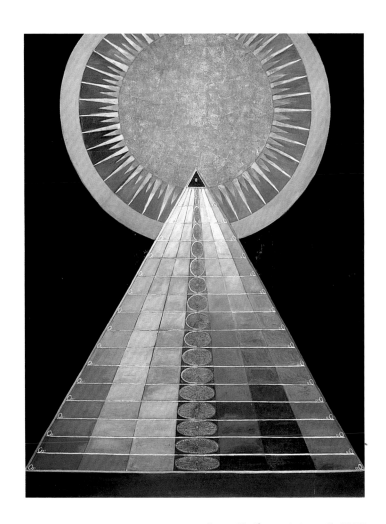

Group X, Altar paintings #1 1915
oil, tempera and gold on canvas
185.0 × 152.0 cm
The Hilma af Klint Foundation, Stockholm
© Hilma af Klint Foundation 1997

This image, on one level a biting indictment of inhumanity, reflecting the artist's recent experience of World War I, can also be understood to reveal Beckmann's developing concern with spiritual transcendence.

'In my paintings I accuse God of his errors ... My religion is hubris against God, defiance of God and anger that he created us [such] that we cannot love one another'.[1] This Nietzschean condemnation may provide one key to the significance of this and several other large-scale works on religious subjects produced by the artist following his involvement as a German soldier in World War I. Thus in the 1984 Beckmann retrospective, *The descent from the cross* (1917) was characterized as a 'merciless indictment', devoid of conventional religious solace, marked by 'disembodied numbness', and dominated by the 'superhumanly large and terrifying' figure of Christ.[2] However, this was a period of great volatility for Beckmann and his art. His letters from the Belgian front in 1915 register contradictory responses to the war, ranging from exhilaration to horror, and *The descent* is similarly complex in tone. In fact, it could be an early instance of Beckmann's mature world-view as formulated by Hans Belting: 'His tragic experience seeks a formula of redemption.'.[3]

Beckmann's style is also on the turn here, from the fulsome pictorialism of his prewar youth to the vigorous modernism of his maturity. The thin application of paint, jittery linearity and spatial ambiguity relate as much to medieval and Renaissance tradition as to contemporary German developments. The huge, spread-eagled figure of Christ may refer directly to the Isenheim *Crucifixion* (c. 1512–16) by Grünewald, one of the artists of the past whom Beckmann described in 1917 as the 'great painters of masculine mysticism'.[4] But whereas Grünewald's appalling Christ still writhes in agony, his skin a mass of bloody wounds,

Beckmann's cadaverous figure floats in mid-air, his arms outstretched like a traditional *Pieta*.

In 1918, Beckmann ridiculed artistic taste for 'false, sentimental and swooning mysticism', but as the war was ending he was already exploring spiritual and transcendent traditions—including Gnosticism and Buddhism—and with the benefit of hindsight we can recognize here an early instance of his effort to move 'from the illusions of life toward the essential realities that lie hidden beyond', as he put it later in regard to *Departure* (1932–33).[5] This attitude, of course, parallels the general preoccupation with the spiritual informing the art of contemporaries such as Kandinsky and Mondrian. Here, though, this developing interest imbues Beckmann's account of the Crucifixion with a paradoxically traditional message of deliverance, intimated by the heaven-seeking ladder and the calm gaze of the young female figure (Mary/Mary Magdalene?) directed towards us.

The descent and its pendant, the mysterious *Christ and the woman taken in adultery* (1917), were among ten of Beckmann's paintings included in the infamous 'Degenerate Art' exhibition staged by the Nazis in Munich in 1937, designed to demonstrate the absurdities of 'nonapproved' modern art. Beckmann immediately left Germany for Amsterdam, and then went in 1947 to the United States. *The descent from the cross* was bequeathed to Museum of Modern Art (New York) in 1955 by Beckmann's New York dealer Curt Valentin.

John Gregory

Notes

1 Max Beckmann, 1919, quoted in Peter Selz, *Max Beckmann*, New York, Abbeville Press, 1996, p. 8 (from a conversation recorded by Reinhard Piper).

2 Carla Schulz-Hoffmann and Judith Weiss (eds), *Max Beckmann: Retrospective*, St Louis, Saint Louis Art Museum, 1984, pp. 202–3, cat. no. 17 (Schulz-Hoffmann).

3 Hans Belting, *Max Beckmann: Tradition as a problem in modern art*, trans. P. Wortsman, New York, Timken Publishers, 1989, p. 105; for the war correspondence, see Max Beckmann, *Self-portrait in words: Collected writings and statements*, Barbara Copeland Buenger (ed.), Chicago, Chicago University Press, 1997, esp. pp. 151ff.

4 Buenger 1997, ibid., p. 180.

5 The comments on *Departure* are quoted in Selz, op. cit., p. 53; for the 'Creative Credo' of 1918 see Buenger, op. cit., pp. 181ff, esp. p. 185.

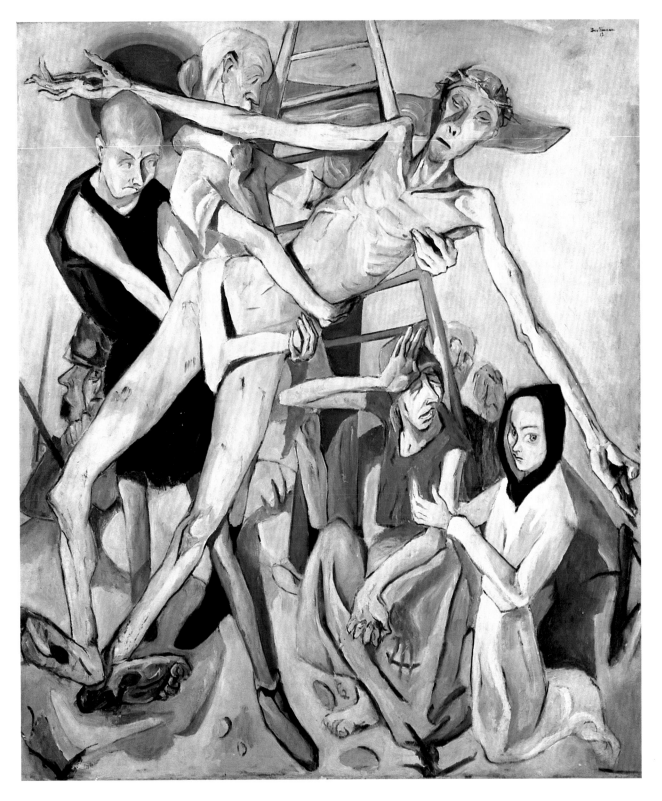

Max BECKMANN
1884–1950
The descent from the cross 1917
oil on canvas
151.2 × 128.9 cm
The Museum of Modern Art, New York.
Curt Valentin Bequest 1955
© Max Beckmann 1917 / Bild-Kunst
Reproduced by permission of VI$COPY Ltd, Sydney 1997

> While I drew, and wept along with the terrified children I was drawing, I really felt the burden I am bearing. I felt that I have no right to withdraw from the responsibility of being an advocate. It is my duty to voice the sufferings of humankind, the never-ending sufferings heaped mountain-high. This is my task, but it is not an easy one to fulfil.
>
> *Käthe Kollwitz*[1]

Deeply Christian and avowedly socialist in upbringing, Käthe Kollwitz achieved a unique integration of work and life. Kollwitz stated that initially she chose the workers, the poor and underprivileged as subject matter for her art because she found the simplicity of their lives beautiful. It was only later, she claimed, that she responded to the breadth and nobility of their lives.

She identified with their struggles. Her first major work, the *Die Weber* cycle, a series of prints dramatizing an abortive rebellion by Silesian handweavers in 1844, reflected her passionate sympathy for the downtrodden victims. Her second major print cycle, *Bauernkrieg* (The Peasant's Revolt) (1908), recorded a revolt by the serfs in Southern Germany in 1525 against their unjust landlords. *Inspiration* (1905), a preparatory etching for the *Bauernkrieg*, powerfully illustrates both the singlemindedness of the artist and the person depicted. By concentrating on the head and upper body of the serf holding the scythe, Kollwitz suggests the moment when anger becomes rebellion with weapon in hand.

Kollwitz dispensed early with organized religion, but Christian symbolism occasionally featured in her work. *From many wounds you bleed, O people* (Aus vielen Wunden blutest Du, O Volk) (1896) was to be the final image in the *Die Weber* cycle, but was rejected by Kollwitz. It is perhaps one of her most atypical works, being symbolic, stylized and Christian in its iconography. Here the people, the *Volk*, are represented by the sacrificed Christ figure. In *Pieta*, her poignant and prophetic lithograph of 1903, the symbol of Mary weeping over her dead son suggests the universality of human suffering and death and prefigures what becomes a preoccupation of Kollwitz, and later a personal reality when she loses her own beloved son. However, the figures of mother and son are simple and sculptural, and not at all formal in their iconography; and the resulting emotional impact is all the more direct.

Kollwitz's woodcuts, lithographs, etchings and later sculptures decried war, famine and hunger. She fought to heal the world of the indignities and tragedies inflicted by people on people.

Kollwitz saw death and separation and sadness as the essence of the human condition and was preoccupied with that also. But death as the enemy of man is an inescapable attribute of life. The etching, *Death and woman* (Tod und Frau) (1910), encapsulates her artistic and spiritual concerns. Death is the enemy wrestling life away, separating parent and child. The image is monumental, the moment is monumental—when death confronts life. Käthe Kollwitz could not fight death. She could not ennoble life.

Käthe Kollwitz believed that she had a responsibility, as a human being, to fight for justice and uphold human dignity. For this reason Käthe Kollwitz devoted her art to *tikkun olam*—to repairing the world.

Helen Light

Notes

1 Quoted in Hans Kollwitz (ed.), *The Diaries and Letters of Käthe Kollwitz*, Chicago, Henry Regnery Company, 1955, p. 96.

Käthe KOLLWITZ
1867–1945
Tod und Frau (Death and woman) 1910
soft-ground etching with emery paper
Klipstein 103 VII
44.7 × 44.6 cm
Käthe Kollwitz Museum Köln. Träger: Kreissparkasse Köln
© Käthe Kollwitz 1910 / ADAGP
Reproduced by permission of VI$COPY Ltd, Sydney 1997

Käthe KOLLWITZ
1867–1945
Pieta 1903
lithograph
Klipstein 70
45.3 × 61.3 cm
Käthe Kollwitz Museum,
Köln.
Träger: Kreissparkasse Köln
© Käthe Kollwitz 1903 /
Bild-Kunst
Reproduced by permission of
VI\$COPY Ltd, Sydney 1997

Inspiration 1905
soft-ground etching with
emery paper
Klipstein 91 IXb
56.4 × 29.7 cm
Käthe Kollwitz Museum,
Köln.
Träger: Kreissparkasse Köln
© Käthe Kollwitz1905 /
Bild-Kunst
Reproduced by permission of
VI\$COPY Ltd, Sydney 1997

Aus vielen Wunden, blutest Du, O Volk
(From many wounds you bleed, O people) 1896
etching and aquatint
Klipstein 29 IIb
12.9 × 33.3 cm
Käthe Kollwitz Museum Köln. Träger: Kreissparkasse Köln
© Käthe Kollwitz 1896 / Bild-Kunst
Reproduced by permission of VI\$COPY Ltd, Sydney 1997

The handwritings of the artist

These four paintings span more than sixty years of Marc Chagall's life. In 1912 he was twenty-five and newly-arrived in Paris; in 1978, he was eighty-eight and in St-Paul-de-Vence. In between was a lifetime of story-telling in paint, line, glass and stage sets. Taken together, these works present a screen through which Chagall's Jewishness and his lifelong preoccupation with the theme of faithfulness emerge clearly. Stylistically the works relate closely, although the later works are softer in line, more sensuous in colour, and changes in his handling of narrative are evident.

A pinch of snuff (c. 1912) may centre upon the story of the Rabbi of Chelm in Poland, a man so good that God allowed the devil to tempt him to evil. Eventually the Rabbi was tricked into arriving late from his walk for a religious obligation. Taking a pinch of snuff was his way of keeping temptation at bay. The Star of David holds the letters 'Life'. In the 1912 oil version of the same title, the Star of David contains the letters 'Death'. The choice is between 'life' and 'death'.

The Hebrews adore the golden calf (Les Hébreux adorent le veau d'or) (1931) and *Joshua* (Josué) (1931) were preliminary gouaches for a book commissioned by art dealer Ambroise Vollard. They tell of episodes on the journey of the Chosen People from Egypt into the Promised Land. While Moses is on Mount Sinai receiving the Decalogue, Aaron and the people forsake God; they build and worship a golden calf. (Exodus 32:1–29). This is the greatest sin—a radical turning from God. It is Joshua, Moses' successor, who leads his people into the land of plenty. (Joshua 1:1–10).

God allows the faithful Job, 'a man of blameless and upright life', to be deprived of everything he has achieved throughout a long life (including his reputation) as a test of his love (Book of Job). In 1975, Chagall, with an old man's vision, looks back on both his own life and that of his people in *Job* (1975) as in *The fall of Icarus*, *Don Quixote* and *The Prodigal's return* of the same year.

Rosemary Crumlin

Notes

1 H. Chipp, *Theories of Modern Art*, University of California Press, 1969, p. 442.

 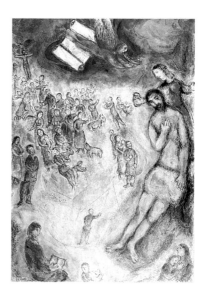

Marc CHAGALL
1887–1985
Josué (Joshua) 1931
gouache on paper
62.0 × 49.0 cm
Musée National Message Biblique Marc Chagall, Nice
© Marc Chagall 1931 / ADAGP
Reproduced by permission of VI$COPY Ltd, Sydney 1997

▲

The Hebrews adore the golden calf (Les Hébreux adorent le veau d'or) 1931
oil and gouache on paper
62.0 × 48.5 cm
Musée National Message Biblique Marc Chagall, Nice
© Marc Chagall 1931 / ADAGP
Reproduced by permission of VI$COPY Ltd, Sydney 1997

Marc CHAGALL

1887–1985

Job 1975 *(facing page)*
oil on canvas
170.0 × 121.0 cm
Private collection, Paris
© Marc Chagall 1975 / ADAGP
Reproduced by permission of VI$COPY Ltd, Sydney 1997

▲

A pinch of snuff c. 1912
watercolour and gouache on paper
28.9 × 20.3 cm
Metropolitan Museum of Art, Bequest of Scofield Thayer, 1982
© Marc Chagall 1912 / ADAGP
Reproduced by permission of VI$COPY Ltd, Sydney 1997

In a landscape of sky and solitude, O'Keeffe's cross and heart eclipse.

GEORGIA O'KEEFFE

In 1932 Georgia O'Keeffe travelled to the Gaspé Peninsula in Canada and painted *Cross with red heart*, a poem of surveyed opposites, and the image that appears in this exhibition. O'Keeffe is one of America's most celebrated artists, but her lesser-known works are her images of wooden crosses: both the Canadian crosses and those that preceded them in her work, the Penitente crosses of New Mexico.[1] O'Keeffe's own description of the Canadian crosses as 'singing in the sunlight' and their 'feeling of gaiety',[2] have encouraged *Cross with red heart* to be read as joyful and optimistic.[3] The work is also a landscape dazzling in its (a)loneness.

O'Keeffe's subtly-tilted cross suggests that her image is as much about the surrounding light and sky as it is about the cross itself. Compositionally, the balance between these elements is both challenged and maintained by the sixteen spikes that radiate from the cross's centre into the cloud-swept sky. For a Christian reading, the cross is an immediate focus of attention as a landscape that incorporates Christ's body and his suffering. Tilted, O'Keeffe's cross may suggest the stepping aside of a spiritual collective; the start of an icon and symbol-less journey … A journey not so much against religion, but towards all that (literally) surrounds it. Painted so darkly, the cross becomes displaced by the sky in its unfathomable, exhilarating and seemingly weightless stretch. Created from both layers and lack of colour, the sky fills the painting's most desirable space and offers an alternative locus of meaning.

Cross with red heart can be read as an exploration of landscape and separation. Every element in the work—earth, sky, cross and heart—is terrain for our imaginings. Degrees of habitation, of human contact, are suggested, from the seemingly untouched sky to the decorations adorning the cross. Moreover, all rely upon a sense of solitude for their clarity. At a frontier in her work and life, O'Keeffe once wrote to a friend:

> it would have been nice to be by you …
> but maybe the loneness … gave me a chance
> to see more and know more what I saw.[4]

In her painted heart so small, barbed and exposed, a sense of chosen isolation is evoked. Yet this loneness in the heart on the cross, in the cross alone and titled under the sky, is not necessarily touched with regret, as in her letter, or even lonely. In paint, solitude becomes decorated, adored and radiating; an attitude of optimism in crisp white, blue, green and red. In her eclipse of the cross structure and the fluidity of the atmosphere, of darkness and colour, a heart is red sky scarred, separate, and open to be seen.

Peta Allen Shera

Notes

1 Works such as *Black cross, New Mexico* and *Grey cross with blue* (both 1929). The Penitentes are a Catholic group who re-enact Christ's crucifixion.
2 Georgia O'Keeffe, *Georgia O'Keeffe*, New York, Viking Press, 1976.
3 It has become almost standard to include O'Keeffe's recollection of the Gaspé crosses in discussing this painting. Critics such as Roxana Robinson, in *Georgia O'Keeffe, A Life*, London, Bloomsbury Publishing, 1990, p. 376, and Jan Garden Castro, in *The Art and Life of Georgia O'Keeffe*, New York, Crown Trade Paperbacks, 1995, p. 102, have, albeit on different levels, seen joy and optimism in this work.
4 O'Keeffe to Arthur MacMahon, 25 September 1916, in Roxana Robinson, op. cit., p. 163.

Georgia O'KEEFFE
1887–1986
Cross with red heart 1932
oil on canvas
211.4 × 102.3 cm
Curtis Galleries, Minneapolis, Minnesota
© Georgia O'Keefe 1932
Reproduced by permission of Curtis Galleries 1997

And they say unto her, Woman, why weepest thou? *John 20:13*

Jesus saith unto her, Woman, why weepest thou? *John 20:15*

From its scriptural beginnings, the Christian 'gift of tears' was visualized in the motif of the weeping woman.[1] The woman regularly associated with tears was the *magna peccatrix* ('the great sinner'), Mary Magdalene, who cried penitential tears. As 'the great mourner' she also wept copious tears at the foot of the cross, during the anointing of Christ's body, and prior to the resurrection. Although not the only Christian weeper—Mary as *mater dolorosa* and Peter as penitential saint loom large in this tradition—the Magdalene became *the* female weeper whose bodily and facial contortions symbolized the human conditions of anguish, fear, terror, regret and pain, as well as the salvation of 'the gist of tears'. Grünewald's agonized Magdalene in the Isenheim Altarpiece (c. 1512–16) captured Picasso's attention between 1930 and 1932, thereby influencing his modern versions of the Crucifixion and *Guernica* (1937).[2]

Between January and November of 1937—the traumatic and yet decisive year of *Guernica*—Picasso painted some sixty images of the *Weeping Woman*. Perhaps not an overwhelming number of images in such a lengthy artistic career, yet the time dedicated to this theme and the number of weeping women attest to the centrality of this topos in Picasso's *oeuvre*. In reflecting upon his work, the artist advised: 'The painter takes whatever it is and destroys it. At the same time he gives it another life ... he must pierce through what the others see—to the reality of it.'.[3] What Picasso needed to pierce through was the fundamental essence, if not the nature, of suffering, which was represented for him in 1937 not simply by the grieving women of Guernica but more personally by his companion, Dora Maar. 'Dora, for me, was

always a weeping woman. Always. Then one day I was able to paint her as a weeping woman.'[4] Simultaneously, he extended the traditional Christian images of *mater dolorosa* and *magna peccatrix* towards the universality of human experience, 'taking up the most universal image of suffering ... Mary Magdalene pouring forth tears for eternity'.[5]

On 17 October 1937, Picasso painted two versions of the *Weeping woman*, both of which he retained for his private collection—a gesture signifying the personal importance of a work to its creator. In the one selected for inclusion in this exhibition, Picasso has created one of his most haptic female vehicles for grief and anguish in the dramatic tension of its entangled geometric forms and the dark tonality of greys, greens and purples. The dichotomy of the desire to believe and the despair of being 'beyond belief' in the modern age is denoted in the control of the firm hands clasping the handkerchief and the emotion of the elongated tears that wound her right cheek. She is a visual metaphor for public as well as personal agony—a succinct yet poignant image of grief and guilt.

The *Weeping woman* is a descendant of the Christian motif of the Magdalene as weeper, and signifies the modern 'cry' of suffering, grief, inhumanity, terror, loneliness and fear in a world gone awry. She is a vehicle for the range of universal emotions from grief to anxiety, especially those of the modern woman alone in a world 'beyond belief'—in search of compassion and grace. '... there are not many people who have the gift of tears ...'[6]

Diane Apostolos-Cappadona

Notes

1 Medieval Christianity delineated three categories of the 'gift of holy tears'; penitential tears; tears of love (or grace), and tears of compassion wept for Christ. See E. M. Cioran, *Tears and Saints*, Chicago, University of Chicago press, 1995, p. ix.

2 For an explanation of these aesthetic and visual correspondences, see Diane Apostolos-Cappadona, 'Essence of Agony: Grünewald's Influence on Picasso', *Artibus et Historiae* 26, 1992, pp. 31–48.

3 Cited in André Malraux, *Picasso's Mask*, Holt, Rhinehart & Winston, 1976, p. 137.

4 Ibid., p. 138.

5 Brigitte Léal, '"For Charming Dora": Portraits of Dora Maar', in *Picasso and Portraiture: Representations and Transformations*, William Rubin (ed.), New York, The Museum of Modern Art and Harry N. Abrams, 1996, p. 396.

6 Athanasius, *De Virginitate*, 17, as cited in Moshe Barasch, 'The Crying Face', *Artibus et Historiae* 15, 1987, p. 29.

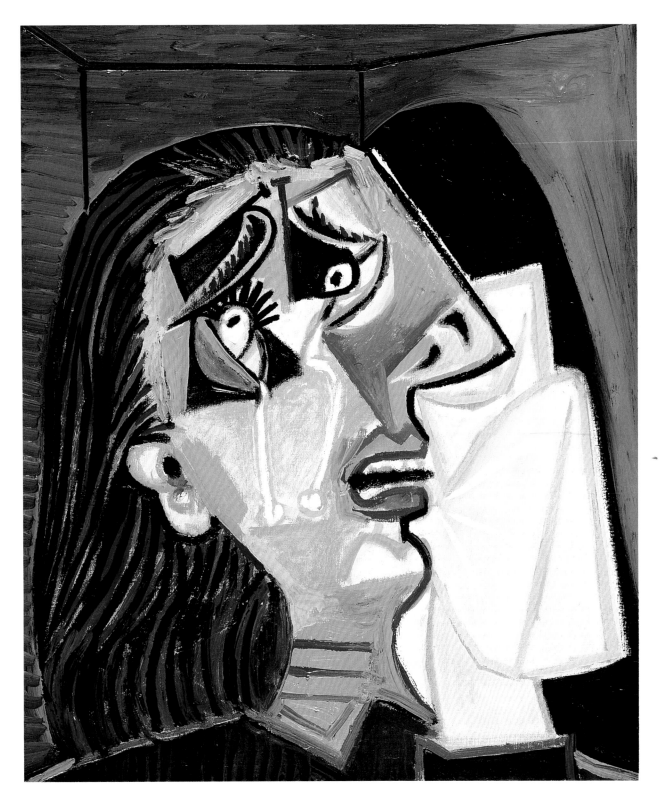

Christ's desert experience reflects that of the artist and of the spectator within the mystery of ordinary human struggle.

Gustave van de Woestyne belongs to the first generation of painters who established themselves in Saint-Martens-Latem, a small rural village in Belgium. Reacting against Impressionism, they identified themselves as the School of Latem. Most of van de Woestyne's work is situated at the boundaries of Symbolism and Expressionism. Although his style suggests links with contemporaries such as Renoir, Monet, Khnopff, Dix and Magritte, or older traditions like the Flemish primitives (Breughel), the Burgundy miniaturists, or Byzantine paintings, he recreates with his own depth what was explored already by other artists.

Latem means a place where the humble, the poor, the lonely and the blind establish themselves. Van de Woestyne's work demonstrates his preference for portrayal of ordinary people whose innermost feelings he seemed to understand. His work relates to his personal experience of unrest and anxiety, of the ineluctable loneliness, separation and isolation of human existence. He often pictures himself at the centre of the emotional struggle of his paintings.

In *Christ in the desert* (1939), van de Woestyne probably began, characteristically, by painting the eyes with an amazingly clear and detailed figurative shape; and then building around this central focus.

The Christ figure, slightly to the left of the middle of the canvas, expresses an immobile inner stillness, similar to the eternal sameness of the surrounding desert. There is no symmetry in the composition of the body. The two eyes seem to be lost in different worlds, with a different content, a different degree of involvement. One eye gazes as though what is seen evokes clarity, purity, strength, hope and security; the other suggests vagueness, lacks sharpness, is lost in confusion and sadness, looks in a different direction. The eyes communicate different messages. One eye sees things at the horizon—inaccessible in this world but absolutely essential for the meaning of

life. The other eye represents the inner experience of van de Woestyne himself, the probing and inescapable loneliness.

The face is marked by the ascetic discipline of withdrawal into the inner world and confrontation with the inherent split of human nature, recognizable in the strange composition of the hands. The mouth is shut and mute, receptive but controlling carefully what is to be exchanged with the outside world.

The hands express a decisive struggle: the immersion in a painstaking dialogue about a fatal paradox, life and death. One hand is slightly closed, pointing upwards and to the body, as if protecting an inner treasure, a subtle thought. The colour is similar to the vibrant and lively expression of the face. Details are carefully articulated, bespeaking the probing time of their being painted—reminiscent of the time of the transforming process of being lost in a desert. The other hand is half open, painted in a lively colour, ready to let go, to die, but still part of the body, still echoing a threatening inner voice.

Christ's dress evokes the image of a seamless garment, without decoration or relief.[1] One piece of undisturbed sameness, this, clearly separated from the burning desert, unchangeably the same beyond time.

There are three main coloured spaces: Christ's head with the unspoiled black hair, and one hand; the pale dress; and the desert. These three spaces suggest a clear separation, dimensions of life which cannot be mixed. Fusion and confusion are to be transcended.

The figure of Christ expresses the bare and emptying experience of entering one's own loneliness as the only access to the contemplation of an unexpected reality. In this Christ figure, the painter reveals his personal story. Christ's desert experience reflects that of the artist and of the spectator, within the mystery of ordinary human struggle.

Herman Lombaerts

Notes

1 The infant Jesus is often depicted as wrapped in bands of continuous cloth ('swaddling bands'); and the great Passion altars of the late Middle Ages contrast the plain, unsewn tunic, the *chiton*, worn by Jesus with the garb of his taunters and of the soldiers who cast lots for this garment. Raymond E. Brown, *The Death of the Messiah: From Gethsemane to the Grave*, vol. 2, London, Geoffrey Chapman, 1994, pp. 955–8, notes the reference in John (19:23–24) to this tunic, 'without seam from the top [to the bottom] woven throughout', pointing out that the evangelist attaches considerable importance to this garment. Rich in symbolic associations, the *chiton*, worn next to the skin, says Brown, recalls the special coat of Joseph (Genesis 37:3), the garment of the high priest (Lev. 21:10), and the clothing worn by the Galilean poor. It is also a symbol of unity.

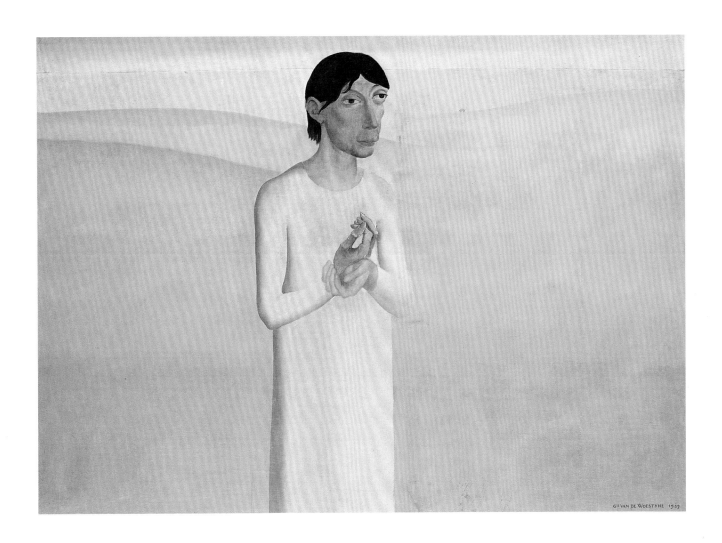

Gustave VAN DE WOESTYNE
1881–1947
Christ in the desert 1939
tempera on hardboard
122.3 × 168.9 cm
Belgium, Ghent, Museum of Fine Arts
© Gustav van de Woestyne 1939 / ADAGP
Reproduced by permission of VI$COPY Ltd, Sydney 1997

How often would I have gathered thy children together, even as a hen gathereth her chickens under her wings, and ye would not! *Matthew 23:37*

Consider the lilies of the field, how they grow; they toil not, neither do they spin. *Matthew 6:28–29*

For wherever the carcass is, there will the eagles be gathered together. *Matthew 24:28*

Although undated, the drawings for these works were completed around 1939[1] and the paintings in the series were completed between 1939 and 1954—*Christ in the wilderness: 'Consider the lilies …'* in 1939, *The eagles* at the height of the war (1943), and *The hen* in 1954 after the death of his beloved Hilda Carline, his first wife, to whom he continued to address letters until his own death in 1959.

The dates of the completion of these three works seem to invite allegorical interpretation closely linked with societal change, but the paintings belong together and are part of a loosely-conceived scheme Stanley Spencer had for a 'church-house' for his loved village of Cookham-on-Thames. Originally there were to be forty paintings in the series (he completed eight), one for each day in Lent, one for each day Christ spent in the wilderness: 'I did them in an exercise book, forty little squares, and then filled in as many as I could with how Christ may have spent each day'.[2] At the time he was closeted in Adelaide Road, London, in some sort of personal but 'peaceful wilderness' after the break-up of his second marriage: 'As each one was done, I put it on the mantelpiece. With the fire below and the subdued light above, it was a little shrine'.[3]

The rest of the 'church-house' would hold his other works— the day-to-day scenes of the village in the nave, the intimate sexual portraits with Patricia Preece in one chapel, paintings of Hilda in another. For Spencer, the splendour of God was present in all creation, as much in a moment of sexual intimacy as in a resurrection or in Christ's retreat in the desert.

The setting for all these encounters was the small world that Spencer had chosen to inhabit. Throughout his life he lived intensely, self-absorbed, displaying remarkable attention to visual detail, often with humour.

As well as being Christological reflections on particular scriptural passages, these 'wilderness' paintings, like all of Spencer's works, are autobiographical. His Christ is revealed as innocent and filled with wonder at the flowers in the field in *Consider the lilies* as he is dispassionate and self-absorbed in the face of the horrendous destruction of *The eagles* and tired and reflective in *The hen*: 'I loved it all because it was all God and me, all the time'.[4]

Rosemary Crumlin

Notes

1 Ordinarily, Spencer drew first, then squared off the drawing and transferred it to the canvas. The drawings held in the Art Gallery of Western Australia indicate that he followed this process here.

2 Quoted in Maurice Collis, *Stanley Spencer*, London, Harvill Press, 1962, p. 156.

3 Ibid.

4 Quoted in Duncan Robinson, *Stanley Spencer*, Oxford, Phaidon Press Ltd, 1979, p. 64.

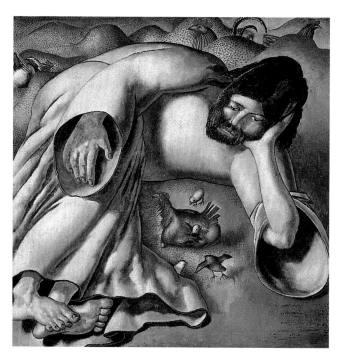

Stanley SPENCER
1891–1959
Christ in the wilderness: The hen 1954
oil on canvas
56.0 × 56.0 cm
Art Gallery of Western Australia
© Stanley Spencer 1954 / DACS
Reproduced by permission of VI$COPY Ltd, Sydney 1997

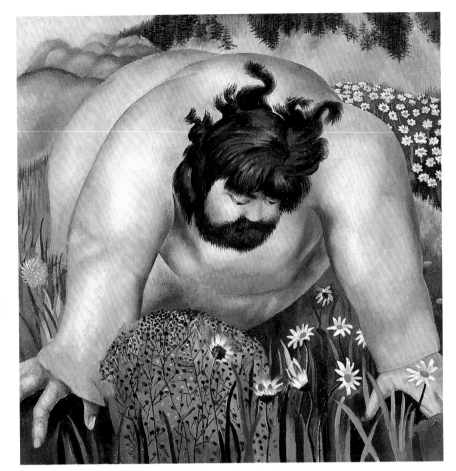

Stanley SPENCER
1891–1959
Christ in the wilderness: 'Consider
the lilies ...' 1939
oil on canvas
56.0 × 56.0 cm
Art Gallery of Western Australia
© Stanley Spencer 1939 / DACS
Reproduced by permission of
VI$COPY Ltd, Sydney 1997

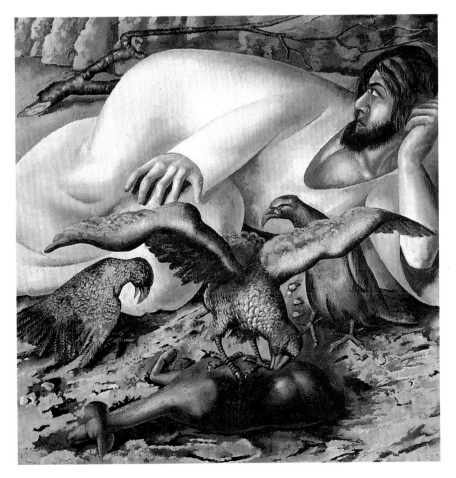

Christ in the wilderness: The eagles 1943
oil on canvas
56.0 × 56.0 cm
Art Gallery of Western Australia
© Stanley Spencer 1943 / DACS
Reproduced by permission of
VI$COPY Ltd, Sydney 1997

OTTO DIX

Otto Dix belongs to a generation of artists who, after World War I, radically rejected bourgeois conventions in art and life.

His training began in Gera, his home town in Germany, and at the School of Art and Crafts in Dresden (1909–14). His shocking pictures of disabled veterans and of the underworld of poverty and vice brought the young Dresden art student to early fame. During his attendance at the Düsseldorf Academy (1922–25), which brought him into contact with the young Rhineland group, Dix increasingly adopted the cool, objective Neue Sachlichkeit approach. Dix's precise, mercilessly sharp observation and description of the world around him largely shaped the veristic stream within Neue Sachlichkeit in the 1920s. After a period in Berlin, Dix returned to Dresden in 1927, where he held a professorship until it was rescinded by the Nazis in 1933.

In 1936 Dix moved to Hemmenhofen, a small village on the Bodensee (Lake Constance). During the last month of the war, when Hitler gave the order to children and old people to enlist in order that Germany could keep fighting, Dix became a soldier at the age of 54. He was captured by the French in April 1945 and put in a prisoner-of-war camp near Colmar. In February 1946 he was released. He could now start painting again, but the situation was difficult.

Very few works of art created just after the war in Europe, and especially in Germany, reflect the terrible situation of the countries that were completely destroyed by bombs other weapons, where emaciated people stumbled through the ruins in search of surviving relatives or looked for something to eat. That the reality was too atrocious to be depicted by the artist is the main reason why there are almost no artistic documents in the field of painting reflecting the situation of World War II in Germany. Most of the artists embraced abstraction to escape that reality, and the latter became a symbol of freedom directed against all totalitarian regimes, which always rejected this form of art.

Dix is among the few artists who faced the situation and tried to translate the horror into form and composition. After coming back to Hemmenhofen some time between 1946 and 1948, Dix painted a series of canvases dedicated to suffering human beings (*Hiob*), to prisoners of war (*Self portrait*), to the life in the cities (*Masks in ruins*), as well involving himself in as religious painting, the field to which *Ecce Homo II* (c. 1946–48) belongs. The Christian iconography is here brought together with the universal and personal experience of suffering. The naked, skinny man sitting between the barbed-wire fences is Christ and a prisoner of war at the same time. His head is wrapped with barbed wire instead of a crown of thorns. In the left corner the artist himself is pointing to him, as if to say: 'Look at the man! Ecce Homo. That is Christ.'. The colours are dark and mournful. The dark-red and brown tones are contrasted with ice-cold areas of blue and green.

Evelyn Weiss

In 1943, Dix was held and questioned in a Gestapo prison in Dresden. He painted *Christ and Veronica* in the same year. Veronica here is about to wipe the face of Jesus, who has fallen on his way to Calvary. The Roman soldiers of Bible history have become sturdy, local thugs—personifications of evil. Ordinary people, good (light) and bad (dark) stand passively. Dix is allegorizing the situation while, at the same time, inviting the onlookers to place themselves in the scene.

Rosemary Crumlin

<div style="text-align: center;">

Otto DIX
(1891–1969)
Christ and Veronica 1943
oil on panel
78.0 × 98.0 cm
Vatican Museums, Vatican City
© Otto Dix 1943 / Bild-Kunst
Reproduced by permission of VI$COPY Ltd, Sydney 1997

</div>

Otto DIX
(1891–1969)
Ecce Homo II c. 1946–48
oil on canvas
100.0 × 81.0 cm
Museum Ludwig, Köln
© Otto Dix 1946 / Bild-Kunst
Reproduced by permission of VI$COPY Ltd, Sydney 1997

Grosz expresses his anguished and tormented spiritual state in response to the horrific events of the recent past in this nightmarish vision of Hitler as a fascist monster surrounded by an apocalyptic landscape.

GEORGE GROSZ

George Grosz had been a prominent artist in Germany throughout the years of the Weimar Republic but was forced into exile during Hitler's rise to power in the early 1930s. One of the first artists to be officially blacklisted by the National Socialists, Grosz settled permanently in America on 12 January 1933, just eighteen days before Hitler came to power. In the years leading up to and during World War II, Grosz produced a series of works that were deeply critical of contemporary Germany under Hitler's regime. He thematized fascism as one of the greatest menaces to humanity and portrayed Hitler as the perpetrator of the apocalypse.

Cain or *Hitler in Hell* (1944) is the culmination of a series of visions of hell in which Grosz depicted the modern world in decline through ruins, death and apocalyptic figures.[1] The painting, begun in 1942 is based on an earlier drawing of the same subject entitled *Beware of him whose eye is cold* dated 1935.[2] In both works, Hitler is personified as Cain, who symbolically represents the destructive forces of humanity. Cain is portrayed as an apocalyptic figure who, in his trail of destruction, has killed his brother. Abel's decomposing body can be seen lying face down in the muddied landscape. In his remarks on this allegory of Hitler as Cain, Grosz described Hitler as a fascist monster, and the mound of tiny skeletal figures in the fore-ground as Hitler's children who frantically consume their creator.[3] Endless fires destroy cities in the distance beneath a blackened sky and a doomed, bloodstained landscape.

The extreme pessimism of this work reflects not only the disintegration of life in Germany but the disintegration of Grosz's own life.[4] He admitted to being tormented by the stories of the mass killings in the concentration camps that he heard through other exiles and emigrants.[5] The anguished state of Grosz's inner world is here expressed through his nightmarish vision of hell on earth created by humanity itself. Grosz drew on the techniques of the Old Masters—Bosch, Grünewald and Breughel—to heighten his modern apocalyptic landscape. In this painting, however, in contrast to the strongly linear and sharply realist qualities of Grosz's work in the 1920s, there is a strong sense of the dissolution of form and a dissolving of the landscape. Grosz alludes not only to his own inner state of agony and despair but more generally to the collective pessimism felt by the German people at the end of one of the darkest chapters of twentieth-century history. It is the complete loss of faith that Grosz conveys here as the spiritual condition of the modern age.

Jacqueline Strecker

Notes
1 Beth Irwin Lewis, *George Grosz; Art and Politics in the Weimar Republic*, Madison, 1971, p. 237.
2 Peter-Klaus Schuster, *George Grosz; Berlin–New York*, catalogue for travelling exhibition, Staatsgalerie, Stuttgart, 7 September–3 December 1995, p. 290.
3 Peter-Klaus Schuster, ibid., pp. 378–9.
4 Lewis, op. cit., p. 235.
5 Schuster, op. cit., p. 35.

BEYOND BELIEF: MODERN ART AND THE RELIGIOUS IMAGINATION
74

George GROSZ
1893–1959
Cain or *Hitler in Hell* 1944
oil on canvas
100.0 × 125.0 cm
George Grosz Estate
© George Grosz 944 / Bild-Kunst
Reproduced by permission of VI$COPY Ltd, Sydney 1997

There is an area of the nervous system to which the texture of paint communicates more violently than anything else.

Francis Bacon made the exploration of that area his lifetime's task. His subject the human condition, he painted the animal nature of human beings: woman as avenging fury or rapacious sphinx; man as brute, dissolving into shadows the colour of his own dried blood. Often he caged his subjects, not so much to entrap them as to display them better. At other times they are exhibited on tabletops—as in *Second version of triptych 1944* (1988). And yet the paradox of a Bacon painting is that finally it is subtly affirmative.

In this painting Bacon revisits his best-known work, *Three studies for figures at the base of a crucifixion* (1944), first exhibited in the final days of World War II. *Three studies* marked Bacon's arrival at his mature style and rapidly led to his recognition as Britain's major twentieth-century painter. Forty-four years later, at the age of 79, Bacon returned to his first masterpiece with a painting four times as large and with a red background substituting for the original bright orange ('the neon of the first becomes the damask of the second'[1]), resulting in a surprising lyricism: the anger of youth tempered by the wisdom of experience.

Bacon generally painted his friends: 'If they were not my friends, I couldn't do such violence to them.'.[2] The identity of these figures is open to a variety of interpretation. The title of the 1944 original refers to the figures who traditionally stand at the foot of a Crucifixion—the two Marys and St John. Bacon, never afraid to mix Christian and pagan imagery, referred to them as furies; perhaps they are the howling furies of World War II or of Aeschylus's *Oresteia*. Perhaps, too, they personify the young

Bacon's guilt over his sexual attraction for his father (the great love of his youth), his homosexuality. Certainly present are a figure from Poussin's *Massacre of the innocents*, the nurse from Eisenstein's film *The Battleship Potemkin* and images from Buñuel's surrealistic *Un Chien Andalou*.

Possibly there is a hint of Ingres's sphinx. Perhaps present, also, are civilian casualties of war, helpless, like those at the foot of the cross. Most viewers find that Bacon's work, properly engaged with, is ultimately uplifting. This is sometimes ascribed to the sensual texture of his paint, which outweighs the horrifying imagery it encapsulates. Bacon observes the traditions of tonal painting and modelling and, as with all good oil painting, when things work, the quality achieved can be that of joy. Others see that quality to be due to the purgation and emotional release that accompany confronting the abject fragmentation of human culture.

Theologically, however, Bacon has rediscovered, perhaps for the first time since the Middle Ages, that the truly terrible is potentially as much the locus of God's presence as the truly beautiful—if not more so, there being less scope for deceit. In a century grown suspicious of truth and beauty (which could provide no defence against Auschwitz)—and inured to traditional religious iconography—it is more effective to seek transcendence in horror or pain. Or, differently stated, in an age of numbing materialism, Bacon shows the spiritual necessity of hell.

Charles Pickstone

Notes

1 John Russell, *Francis Bacon*, London, Hudson & Hudson, rev. edn, 1979, p. 21.
2 Ibid., p. 86.

 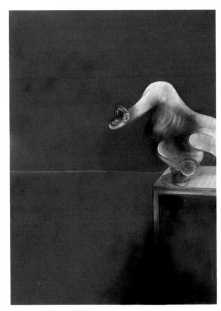

Francis BACON
1909–1992
Second version of triptych 1944 1988
oil and pastel on panel
three panels, each 198.0 × 147.5 cm
Tate Gallery, London. Presented by the artist 1991
© Francis Bacon 1988
Reproduced by permission of Marlborough Fine Art (London) Ltd, 1997

The viewer is drawn into what is happening.
Does the fallen Stephen or the upright watcher dominate the painting?

JOSÉ CLEMENTE OROZCO

Stephen, the victim of brutal oppressors, is at the centre of Orozco's meaning. While the account of Stephen's death in The Acts of the Apostles emphasizes his visionary speech that so enrages his hearers, Orozco shows us, in his *Martyrdom of Saint Stephen* (El martirio de San Esteban) (1943) the defenceless victim being done to death, stone by stone.

Both victim and executioners are naked. They are alike in being so exposed to what is happening. Only the watcher is clothed, protected by his powerful toga, looming from top to bottom of the painting. Yet his profiled face is like Stephen's. This watcher is implicated.

He is Saul of Tarsus, and soon, on the road to Damascus, he will be unhorsed from his murderous certainties and hear a voice saying 'I am Jesus, whom you persecute.' (Acts 9:5). So Jesus identifies himself with the victim. Stephen, servant of the people, had identified himself with the work and the sufferings of Jesus. He too died at the hands of the unjust, while the well-educated Saul 'approved of his murder' (Acts 8:1).

Does Stephen bow to Saul?

Saul as the martyr's witness shakes Saul the man of power to his depths. Soon, Stephen's vision of life will overturn Saul's heart and make him Paul. Oppressors too, whoever and wherever they are—in Mexico, to take Orozco's not-so-hidden reference—are vulnerable to the power of those who align themselves with the oppressed of the earth. Oppressors can only murder, no more; martyrs do more.

There is no red blood in this picture, just black and white to etch the brutal shape of the action into our imagination, and the brown of flesh and earth. Orozco pitches the scene up close to the viewer. The implacable wall of buildings—of the biblical Jerusalem, but anywhere else also—blocks out the possibility of escape, as does that edge of impenetrable darkness to the left.

There are no traditional signs of spiritual transcendence here—no angel, vision, halo, rays of light; instead, there is the twentieth century's preferred way of transforming darkness through suffering witness.

Orozco, with Rivera and Siqueiros one of the 'big three' Mexican muralists in the first half of the century, painted works that expressed his commitment to the downtrodden and his hope for the transformation of their conditions; but unlike the other two, he never aligned himself with any specific political movement. His paintings are works of visionary humanism.

Maybe the loss of his left hand in an accident at the age of seventeen deepened Orozco's commitment for the victims of an exploitative society and his admiration of those figures, like Stephen, who served them and sought to reverse their plight. Orozco certainly painted hands eloquently: look at Stephen's left hand.

Stephen is ringed by his killers—the men naked in their brutality—and Saul. And viewers of this painting, forced by Orozco's graphic power to watch, can ask 'Where do I stand?'. Orozco leads us to ponder the implications of standing before this scene. At worst, hands can itch to cast a stone, with the graphic violence of Stephen's assailants. Or, there is the alternative represented by Saul, who is implicated by his hands-off and upright approval.

This painting suggests that when art engages with the religious imagination the viewer is pulled towards being a participant. Orozco draws the viewer towards Stephen, as if being on one's knees is the inevitable and final position from which the visionary and transforming truth can be seen.

Andrew Bullen

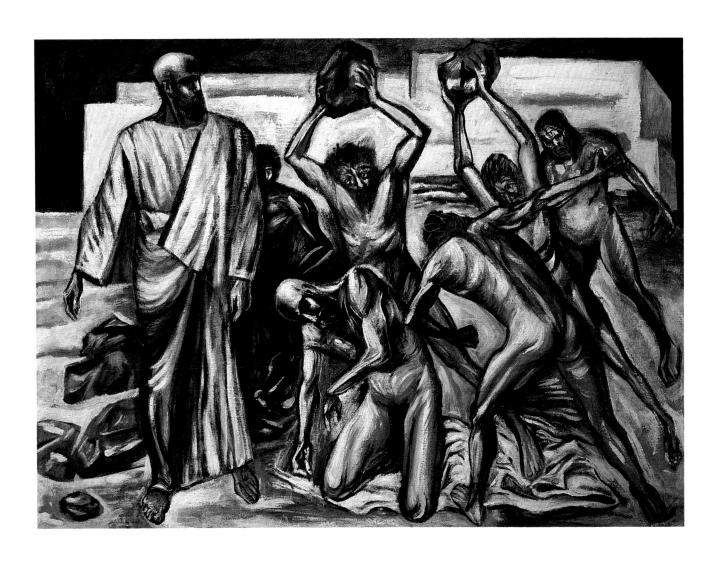

José Clemente OROZCO
1883–1949
El martirio de San Esteban (Martyrdom of Saint Stephen) 1943
oil on canvas
99.1 × 132.0 cm
Private collection, courtesy Galeria Arvil, Mexico
© Jose Clemente Orozco 1943 / SOMAAP
Reproduced by permission of VI$COPY Ltd, Sydney 1997

> Meanings emerge from the artist's will as well as from the spectator's will: both of them criss cross the art work.
>
> *Octavio Paz*[1]

For the Western spectator, Julio Castellanos's *The angel kidnappers* (Los Robachicos) (1943) is a hard-hitting piece of social realism that is as modern and apposite as the stolen children controversy of the 1990s. Australians may see in it the removal of indigenous children by religious and state authorities so that they could be given a 'better life' in a white Westernized society. Aboriginal men and women will remember the event with ineffable sadness. Both will be angry at the injustices perpetrated in the name of the common good. Others, especially women, will remember the removal from young mothers of infants conceived outside of marriage who were given up in adoption to strangers. And there will be some who see and weep for a past act that, in the name of God, left them with little hope.

But for Julio Castellanos the death of poor children was a daily event. Since pre-Hispanic times, death was celebrated as part of life; and with Catholicism came angels, so that even the Angel of Death, seen here, is regarded more as a guardian angel who carries the soul back into Paradise.[2]

The painting is like a scene from a play; the surroundings like stage scenery. The near wall has been removed and the stage divided into two by a wall. Through the window an angel steps out, so linking the outside life with the main arena of action inside. Here two poor Indians are asleep, scrunched together in bed. Around them are the bare necessities—a curtain for privacy, a cupboard with a glass water container, the baby's crib. The angel carries the child while he or she looks back in sweetness to the parents. Outside, a companion angel peers into the distance. The drama is frozen at this moment in time, like a frame in a movie picture.

Castellanos painted this when he was 39 years old, four years before his premature death. With Tamayo and Izquierdo (p. 89) he was regarded by the young poet and critic Octavio Paz as the most exciting of the younger generation of Mexican artists.[3] Those before him, led by Rivera, Siqueiros and Orozco, had strutted the city like giants and left their mark in intensely nationalistic murals. By 1943 the mood had changed; Mexico had entered the war; food was short. Despite this, the city continued to be a haven for a close-knit international community of poets, painters, musicians and film-makers. Castellanos knew them all, but his art, like Izquierdo's, shows that before all else he is compassionate, deeply spiritual, and proudly Mexican.

Rosemary Crumlin

Notes

1 Octavio Paz, in Alicia Azuela, *Images of Mexico*, Dallas Museum of Art, Dallas, Texas, 1987, p. 52.

2 On the Day of the Dead and its vigil (November 1 and 2), children are given sweets shaped like skulls ('calaveras'), skeletons and coffins. Adults join the festivities.

3 Octavio Paz, 'Maria Izquierdo, seen in her surroundings', *Essays on Mexican Art*, New York, Harcourt, Brace & Co., 1993, p. 259.

Julio CASTELLANOS
1905–1947
Los Robachicos (The angel kidnappers) 1943
oil on canvas
57.5 × 94.9 cm
The Museum of Modern Art, New York. Inter-American Fund 1944

Who in the world ...
Where in the world ...

The power of David Alfaro Siqueiros's *The hanging one* (El Colgado) (1947) comes from submitting oneself to this image, allowing it to disturb.[1] What draws us into this picture is its essential ambiguity. This claim may seem strange to those who find the picture anything but ambiguous. The man strung up here is clearly a victim of human cruelty. Still, if one enters and ponders the scene, its ambiguities become vivid.

Is this man dead or alive? It is not clear. Are his closed eyes a sign of unconsciousness, of exhaustion, or of death? Has he been tortured? Could it be that he hangs here awaiting in terror the next round of torture? If he is dead, did he die from the slow, excruciating strangulation that comes from being suspended by the wrists with one's feet off the ground, the sort of death caused by crucifixion, the very sort Hitler chose for those who planned his botched assassination. The mass of this man's chest might suggest this possibility. And so, the figure's basic condition as victim is clear. His more specific condition as alive or dead is ambiguous.

Surely Siqueiros expected viewers of his picture to ask about its missing figures: those who did this deed and what their purpose could have been. The artist pokes us with the ambiguous, shadowy figure on the left, faceless, the way so many killers and torturers are. Or is the figure a shadow of all the others who endured similar deaths?

There is an irony to *The hanging one's* power. The claim, made by some, that the image is of a religious figure, the Roman martyr Sebastian tied up and shot with arrows, diminishes the religious power of the painting. Seen this way, it depicts an event of imperial Rome, the death of a saint. However, if the man victimized here depicts the many thousands in Mexico murdered for seeking just living conditions, then the picture has a very different kind of religious power. Why?

Some would hold that the key religious issue at the end of the twentieth century can be summed up in two questions: Who in the world is He? and, Where in the world is He? For religious people aware of the twentieth century's legacy, these questions are the seminal ones. Where do we find the face of Christ today? Who is the proxy of Jesus? Siqueiros finds him hanging from a tree, naked, either dead or waiting to be dead. The religious power of his painting lies in its protest against inhumanity. The Marxist Siqueiros drags us into this scene and demands that we stare at the man hanging from a tree.

Michael Warren

Notes

1 David Freedberg cautions against aestheticising a picture as a way of avoiding its deeper power as image. He points out the danger of becoming disengaged voyeurs before various representational art forms. See David Freedberg, *The Power of Images*, Chicago, University of Chicago Press, 1989.

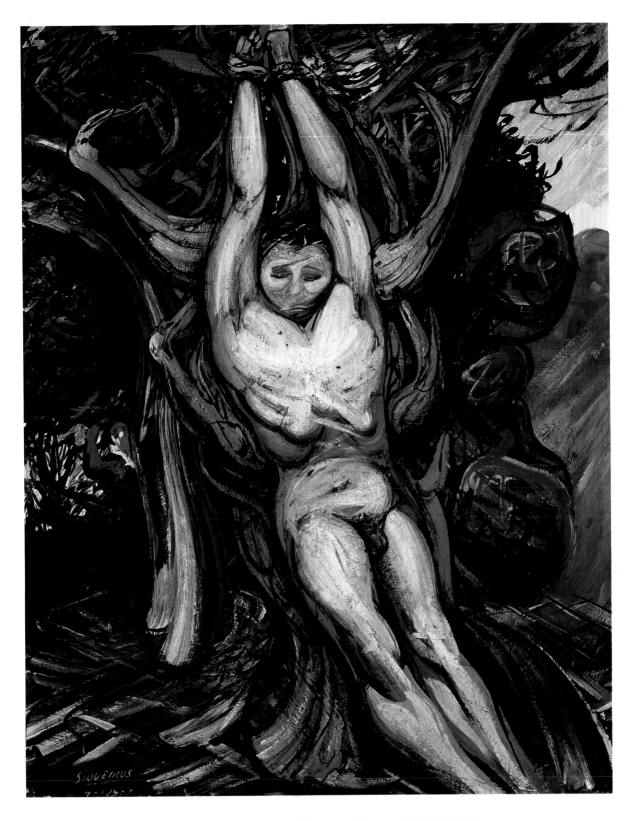

David Alfaro SIQUEIROS
1896–1974
El Colgado (The hanging one) 1947
oil on wood
70.0 × 60.0 cm
Private collection, courtesy Galeria Arvil, Mexico
© David Alfaro Siqueiros 1947 / SOMAAP
Reproduced by permission of VI$COPY Ltd, Sydney 1997

Like all the whole songs seen

Frida Kahlo[1]

FRIDA KAHLO

Frida Kahlo's *Sun and life* (Sol y vida) (1947) confronts the viewer with intertwined messages. These prompt a quest to interpret and to understand what emerges from the sinuosity of line, the roundness of composition, the lushness of vegetation that fills the pictorial space. The painting seems to do many things simultaneously: challenging the viewer, expressing some personal premonition, setting this visual verdancy against the frustration of Kahlo's own failure to conceive a child by Diego Rivera.

Frida Kahlo infuses this work with her own feelings, yearnings and innermost longings. A series of readings and adjectives come to mind when one tries to describe these, as they are given symbolic expression here and are disclosive of her impetuous character: sensual, introspective, obsessive, overwhelming, distressing, revealing, evocative, endearing, troubled. She has conjured up a sublimated icon of her need to reproduce through and with her Sun/Diego. This need is implied by the intense, watchful and perhaps Tantric third eye with its single tear. This eye is a central focus within the sensuous, smiling face of the sun, whose other two eyes are closed, blind, in trance, perhaps contemplating. The sun itself irradiates rhythmic concentric waves of multicoloured halos that impart energy and vitality to the surrounding foliage.

The landscape itself has no horizon, and is almost oppressive in its fertile excess—a jungle of luxuriant vegetation, tropical and fragrant. The emblematic background, with its plethora of plants, magnolia pods and veiny pistils, has evident allusion to male and female genitalia, while on top of the enigmatic sun an embryonic or foetus shape is discernible. The process of creation seems to be repeated endlessly in the intricate growth patterns of the landscape.

Through superimposed brushstrokes Kahlo has applied continuous coats of paint that give richness of texture to *Sun and life*, so that the colours themselves become strong symbols of life: red evocative of warmth, blood, heat and energy; green, speaking of hope and nature; and ivory, recalling both the exotic and flesh.

It is precisely because this work springs from the richness of the deeply personal that it yields universal symbol and metaphor. Frida Kahlo's *Sun and life* salutes the whole cosmos— plants, sun, the life-bearing and life-giving. Colours and shapes move with intertwined rhythms, so that there is no distinction between the whole and its parts. The sun and the symbolic eye suggest the mysterious consciousness of the cosmic processes. The struggle intrinsic to the life processes is simply expressed by the single tear of the third eye. The whole work is like a hymn of praise to life, a hymn that is intense, complex, energetic and tragic.

Armando Colina

Notes

1 Carlos Fuentes and Sarah M. Lowe (eds), *The Diary of Frida Kahlo*, London, Bloomsbury, 1995, p. 230.

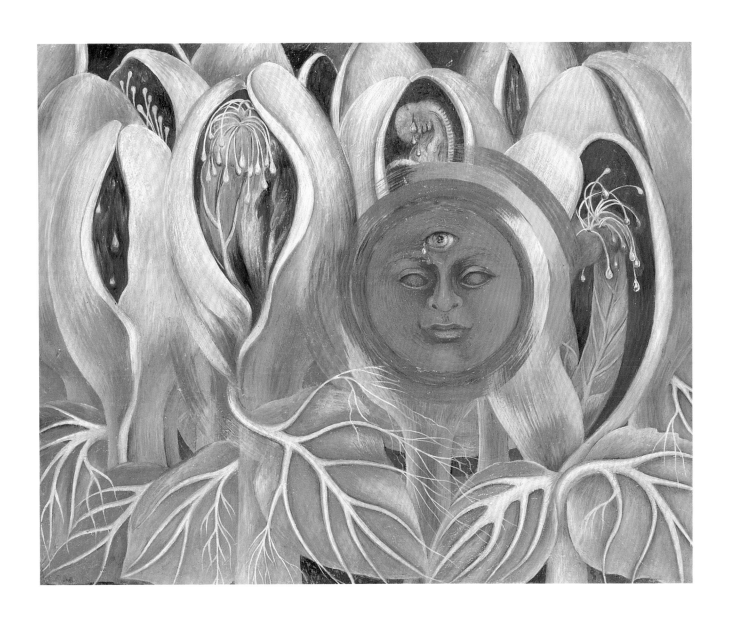

Frida KAHLO
1907–1954
Sol y vida (Sun and life) 1947
oil on hardboard
40.0 × 50.0 cm
Private collection, courtesy Galeria Arvil, Mexico
© Frida Kahlo 1947
Reproduced by permission of Galeria Arvil

Although it avoids reference to a specific religious tradition, Remedios Varo's *Creation of the birds* vividly depicts key spiritual themes such as transformation, creation, and creativity itself.

Remedios Varo's *Creation of the birds* (1957) challenges our preconceptions about what constitutes a religious or spiritual image. This is a surrealist image about alchemy that demonstrates the interconnectedness of all things. An owl-like figure, rendered exquisitely with fine brush strokes, sits at a small table. Possessing a kind, heart-shaped face and wearing a violin with three strings, this figure holds a triangular prism in one hand. The prism refracts the light from a distant star/moon. With the other hand, she or he simultaneously draws birds that come to life. Perhaps this image alludes to the story of the painter Zeuxis and the birds that pecked at his drawn grapes, thinking they were real; or to the story of Galathea and Pygmalion, about the artist's sculpture that comes to life, vividly painted by Jean Léon Gérôme in 1890.

Through the round opening on the left side of *Creation of the birds* more ethereal energy is transformed in two egg-shaped vessels and flows from the tubes as the three primary colours. One small bird pecks at seeds on the floor. The floor is composed of an imprecise checkerboard; the legs of the main figure are aligned to the central axis. It is night outside. Finally, two 'communicating vessels' inhabit the back corner while a strange old-fashioned box, perhaps another alchemical vessel, sits quietly against the other wall. Varo's use of this image of the communicating vessel might be a reference to Breton's book *Communicating Vessels*.

The image of these vessels may have been taken from an alchemical experiment, where a gas or liquid passing from one to the other would rise to the same level in each. In surrealist thought, and in Breton's book, these communicating vessels were metaphors for the interaction of sleeping and waking consciousness, of vision and external reality. They vividly demonstrate that a link between modes of consciousness is possible. Further, the second of the three parts of Breton's book

is an extended meditation on love. 'I persist', he wrote, 'in considering the workings of love as the most serious of all ... I am careful not to forget that, always from the same materialistic point of view, "it is their own essence that people seek in the other".'[1] Thus we might also take the communicating vessels as an image for love, where two persons find a degree of identity in the other, just as liquid in the literal vessels always rises to identical levels.

In alchemy, a spherical glass vessel called 'the philosopher's egg' was used as the alembic for transformation or transmutation. In this vessel three stages of the alchemical process were carried out, the goal of which was to unite the elements to produce the 'philosopher's stone'. These three stages corresponded respectively to blackening (*nigredo*), whitening (*albedo*) and reddening (*rubedo*); to black, white and red birds, as in Varo's painting; to body, soul, and spirit; to darkness, light and water; and to mercury, sulphur and salt. The science, or art, of alchemy was based on the idea of the underlying unity of the universe. Certainly this sense of interconnectedness is obvious in Varo's painting. Just as the human body contains the soul, or spirit, so the material world is permeated by a universal spirit.

Ultimately, these vague and obscure ideas are not adequate to explain Varo's references, which rely on gendered—female—imagery: metaphorical eggs, Fallopian tubes, a uterus, an umbilical cord, and the magic of hidden generativity. While the figure in *Creation of the birds* is gender-ambiguous, the surrounding imagery can be interpreted as directly related to the female body and reproduction. The owl-like figure stands for wisdom and is the agent of creation. This painting demonstrates that transformation is both a physical and a spiritual process, and that creativity itself constitutes the core of the divine.

Deborah J. Haynes

Notes

1 André Breton, *Communicating Vessels,* trans. Mary Anne Caws and Geoffrey T. Harris, Lincoln, University of Nebraska Press, 1990, p.69.

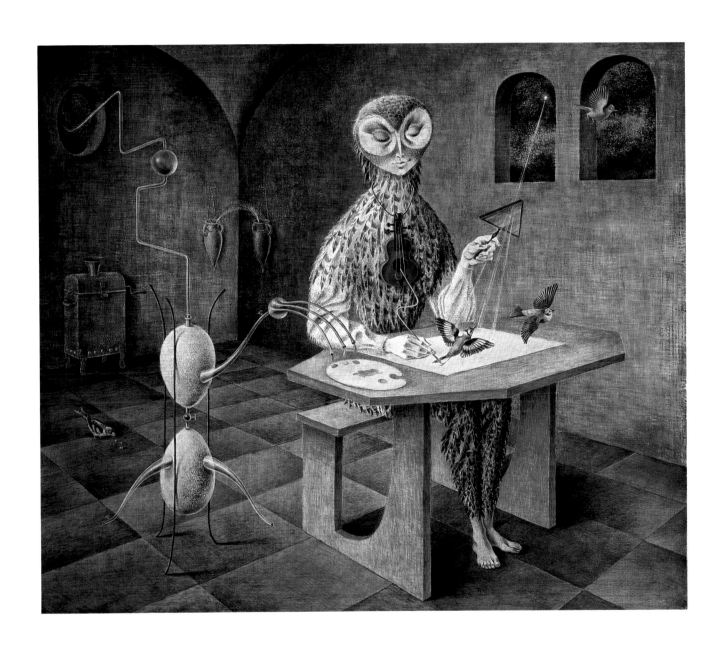

Remedios VARO
1908–1966
Creation of the birds 1957
oil on masonite
54.0 × 60.0 cm
Private collection, Mexico City
© Remedios Varo 1957 / VEGAP
Reproduced by permission of VI$COPY Ltd, Sydney 1997

In the native societies of the pre-Colombian past and in the traditional Catholic communities of contemporary pueblos, Maria Izquierdo encountered a powerful religious imagination and a potent imagery that profoundly shaped her own art.

Maria Izquierdo (1906–1955) belonged to the first generation of artists who followed upon the Mexican Revolution (1910–1920). Like many of her contemporaries, she embraced the indigenous cultures of Mexico—the native societies of pre-Colombian history and the contemporary Catholic pueblos, drawing on these rich sources as fountainheads of inspiration for her mature art works.

Altar of Dolorosa Madonna (Altar de Dolores) (1946) is one of many religious icons painted by Izquierdo. In this image of the Sorrowing Madonna, Izquierdo has incorporated traditional Christian iconography through her choice of colours and objects. The red and blue colours of Mary's mantle represent charity and fidelity; the orange and candle placed in front of Mary's image symbolize the tree of knowledge and the light of faith.

The compositional design of *Altar of Dolorosa Madonna* draws upon at least two visual traditions. On the one hand, Izquierdo's painting is reminiscent of European still-life paintings, particularly of the *alacenas*, or cupboards, depicted by Spanish artists in the eighteenth century. This painting tradition was familiar to Izquierdo through her instruction at the National Academy of Art in Mexico City. On the other hand, Izquierdo's painting also resembles the small Marian altars, festooned with paper lace borders and adorned with humble offerings, which are constructed in almost all Mexican households. Izquierdo, who equated artistic primitivism with religious sincerity, emulated the awkward stylistic techniques of Mexican folk art.

Yet, at the same time that she expressed the religious sentiments common to her nation, Izquierdo also created a revealing self-portrait in *Altar of Dolorosa Madonna*. On the foreground ledge, Izquierdo has placed her personal treasures, drawn entirely from Mexican popular culture, as intimations of her private life. In the background plane, she has placed the image of the saint for whom she was named and with whom she identified throughout her life.

In one way, Izquierdo identified with Mary through her ethnic heritage. To Mexicans of Indian origin, Mary, through her syncretic absorption of the mother goddesses of pre-Colombian religions, was an emblem of indigenous survival in a hostile society. The daughter of a Tarascan mother, Izquierdo vaunted her indigenous origins not only through her art but also through her adoption of native Mexican dress.

Izquierdo also identified with Mary, and especially with the Sorrowing Mary, through her sufferings. Painful personal losses endured by the artist included the death of her father in her early childhood, and two divorces. A painful professional loss was experienced with the withdrawal, in 1945, of an important commission for a public mural because of complaints raised by the artists Diego Rivera and David Siqueiros.

But although she identified with Mary's sorrows, Izquierdo also identified with Mary's joys. Izquierdo was born and raised in the colonial town of San Juan de los Lagos, in the state of Jalisco. One of the oldest and most prominent Marian shrines in Mexico, Our Lady of San Juan, is located in this town. The cult of Our Lady of San Juan burgeoned in the 1600s following a famous miracle involving a young circus acrobat who had fallen to her death from a high wire and who was revived by exposure to Mary's image. Throughout her artistic career, Izquierdo painted scenes filled with the circus performers who made pilgrimages to San Juan de los Lagos to honour their patron saint Mary and to ask her favours.

According to traditional accounts, the original image of Our Lady of San Juan, which dated from 1542, was modelled from a paste of ground corn pith and orchid-based binder. This sculptural medium, called *cana de mais*, was initially used in pre-Colombian societies for the images of native deities and was subsequently adopted by Spanish missionaries for Catholic saints. It could be claimed that Izquierdo herself was formed of a similar substance, and that her paintings, whatever their particular subject, are imbued with the spiritual presence and the religious devotion of the common people of Mexico.

Linnea Wren, Krysta Hochstetler and Kaylee Spencer

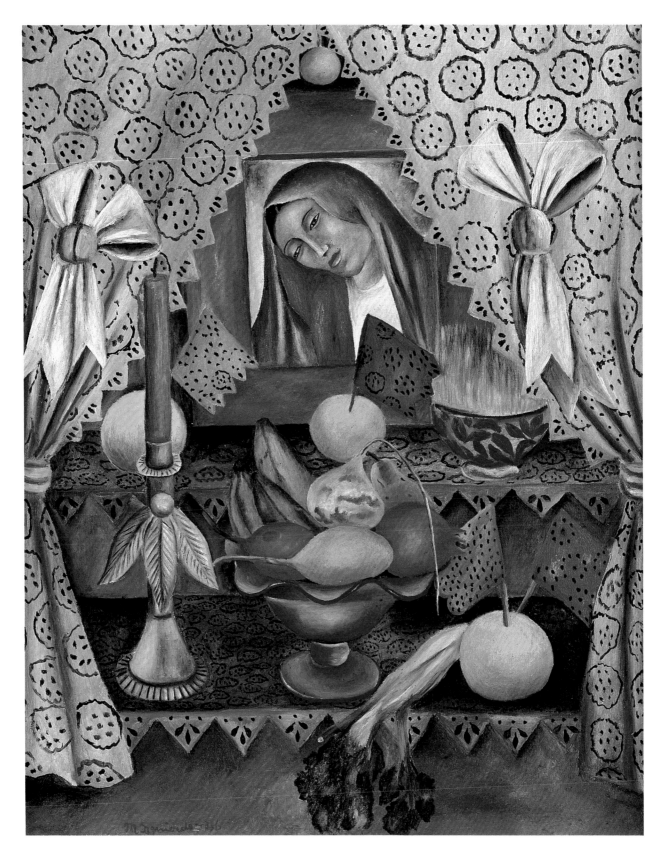

Maria IZQUIERDO
(1906–1955)
Altar de Dolores (Altar of Dolorosa Madonna) 1946
oil on canvas
75.0 × 60.5 cm
Private collection, Mexico

Alchemy: a subtle alliance of chemistry and spirituality which, although questioned by scientific chemistry, has been an important factor in material and spiritual exploration.[1]

<div style="writing-mode: vertical">LEONORA CARRINGTON</div>

Women artists in Surrealism more easily acknowledged the irrational imagination in themselves and saw more clearly into the recesses of the personal unconscious. Given the constant emphasis that the Surrealists placed upon the artistic power of women as muses and mediators of the imagination, it is not surprising that female artists such as Leonora Carrington should employ methods and address concerns that differ from their male counterparts.

Carrington's interest in the processes of alchemy, divination and life's spiritual purpose, although shared by male artists such as Max Ernst and Kurt Seligmann, propels her work and thought beyond their more patriarchal modes. Her abiding faith in the sustaining functions and forms of Jungian archetypal concepts and in the alchemical transmutation of base matter into refined amalgam, as seen in her painting *The Tree of Life* (El Arbol de la Vida) (1960), owes much to her harrowing slide into serious mental instability during World War II. This agonizing experience, candidly tabulated in her book *Down Below*, gives Carrington's work a unique emotional integrity and inner poignancy.

As a result, perhaps no other Surrealist artist has been so unremittingly honest and artistically consistent in pitting interior yearnings against exterior limitations. Much of Carrington's subsequent private emotional tumult is revealed through a selective spiritual esotericism. Consequently, her highly personalized and enchanted postwar paintings are peopled by a range of gynocentric figures drawn mainly from pre-Christian religious sources; these sources are as varied as the Tibetan *Book of the Dead*, the Apocrypha, hermetic texts, the Egyptian pantheon, the kabbala, Gnosticism, Celtic myths, South American mythology and ancient Near Eastern texts.

In *The Tree of Life* the central drama is focused upon the figurative transmutation of lead into gold; an age-old allegorical quest that is emblematic of an alchemical or demiurgic desire for transformation, purity and transcendence. This is a divinatory quest which Carrington sees as fulfilling life's highest biological and spiritual purpose. The transformative and affective elements of this universal quest must also have held a special personal significance for Carrington herself, given her painful recuperation from the mental tragedies of her brutal war-time experiences.

In this painting, the mandala-like imaginary depiction of the spectacle of transformation arises from a dark and indistinct background—a background out of which emerge the hidden forms and symbols of obscure ancient sects, as though to underline the historical lineage of this mythological process. Furthermore, the background of decalcomania-like surfaces invites our visual reading of oceanic and cosmic suggestions, while the three human forms that swirl around the central focus underscore the role of human desire and agency in the mystical process—a process guarded by two mythological winged beasts. The overall effect of this visionary depiction of human philosophic and spiritual aspiration is to elicit a sense of awe before the mystery of being; a metaphoric mystery pictured through eclectic occultism as a personal vignette of universal human purpose.

Kenneth Wach

Notes

1 Rosemary Goring (ed.), *The Wordsworth Dictionary of Beliefs and Religions*, Hartfordshire, Wordsworth Editions Ltd, 1995, p.14.

Leonora CARRINGTON
1917–
El Arbol de la Vida (The Tree of Life) 1960
oil on canvas
91.0 × 64.0 cm
Galeria Arvil, Mexico City
Private collection, courtesy Galeria Arvil, Mexico
© Leonora Carrington 1960 / ARS
Reproduced by permission of VI$COPY Ltd, Sydney 1997

Premonitions of transformation and mystery

In 1944 André Breton, the eloquent leader of the Surrealists in Paris, sought respite from the ravages of World War II in Ste Agathe at the tip of the Gaspé peninsula in Québec, Canada. There, Breton spent a secluded three months writing his highly evocative novel *Arcane 17*, published in New York in 1945—one year before Dorothea Tanning's *Guardian angels* was painted. The book and the painting form a partnership of the aesthetic imagination, common in Surrealism, which illuminates Tanning's inspirational method and artistic aim.

Breton's uplifting novel, written in the darkest year of the war, was based on the associations of the seventeenth card of the tarot: a card emblematic of peace and insight which comes after those of war and darkness. In this sense Breton's remarkable novel, which presents us with hypnotic images of regeneration and metamorphosis, may be read as an effulgent and lyrical hymn to life—a life viewed as a mystical union with Nature and her dynamic forces. Throughout the novel Breton's meditative focus is continually placed upon the famous Rocher-Percé, a large coastal rock formation that is constantly swathed in mists and surrounded by myriad flocks of strange birds. 'It is charged with all the fragility and also all the magnificence of the human gift ... the Rocher-Percé is winged only by its birds'.[1] Repeatedly meditating upon this extraordinary natural wonder, there seemed to awaken in Breton a humbling sense of awe and astonishment at the healing and regenerative powers of such a mystical solidarity with nature.

The metamorphic imagery of André Breton's *Arcane 17* underlies the strange, winged, rock-like outcrops that crowd Dorothea Tanning's *Guardian angels* of 1946—the year of her marriage to Max Ernst, the artist who introduced her to Breton's writings and Surrealism in 1942. In her enigmatic painting, probably painted at the couple's first home in the isolated desert town of Sedona in Arizona, we see a number of beds, as in a casualty ward, strewn in a desolate landscape swathed in cloth. This geological winding sheet swirls to the left of the canvas to transform itself into a number of winged forms that carry off a series of bodies in a clockwise movement toward the top right. The overall atmosphere of the painting seems informed by a sense of bizarre gloom enlivened only by the suffused glow of ethereal light which permeates sections of the canvas. Tanning's painting hints at some form of mysterious and supernatural order of the migration of the soul after death; it is a depiction which, though it eschews conventional or sentimentalized images of guardian angels, gives a highly personalized view of transformative and redemptive processes—of the kind of individual triumph over collective tragedy that pervades Breton's contemporaneous book and its poetic imagery. Tanning's more-than-coincidental extension of this sort of literary imagery into the art of painting, in this case a geological metamorphosis, is typical of the Surrealist process—a process much used by Max Ernst himself.

In total, the painting, through a visual interpretation of Breton's verbal imagery and a scrutiny of the weathered desert rocks around her Arizona home, reflects Tanning's linked and personalized meditations upon ever-present human tragedies; tragedies that must have been all the more evident during this apocalyptic period in world history. Considered in this way, Breton's earlier scrutiny of the Rocher-Percé, with its craggy surfaces enlivened by the whirling of birds, became a jumping-off point for Tanning's own spiritualized imagination. In addition, the painting's swirling vortex of interactions between the natural and the supernatural, caught in swelling imaginative associations, seems to mimic the visions reported by those who have had near-death experiences. Further, in *Arcane 17*, the very words Breton uses to describe the sustaining biological link between plants and butterflies seem to double as a description of the sustaining cosmic link between the natural and the supernatural hinted at in Tanning's visionary painting:

> And in turn it speaks in order to tell us what a consoling mystery there is in the rise of successive generations, what new blood incessantly circulates ... Man sees the trembling of the wing, which is, in all languages, the first great letter of the word Resurrection.[2]

Kenneth Wach

Notes

1 André Breton, *Arcane 17* (1945), cited in Katherine Conley, *Automatic Women: The Representation of Women in Surrealism*, Lincoln, University of Nebraska Press, 1966, p. 129.

2 André Breton, *Arcane 17* (1945), cited in Anna Balakian, *André Breton, Magus of Surrealism*, New York, Oxford University Press, 1971, p. 213.

Dorothea TANNING
1910–
Guardian angels 1946
oil on canvas
121.9 cm. × 91.5 cm
New Orleans Museum of Art, Louisiana
Museum purchase, Kate P. Jourdan Memorial Fund
© Dorothea Tanning 1946 / Bild-Kunst
Reproduced by permission of VI$COPY Ltd, Sydney 1997

We can do something else, but we cannot re-create what the collective, spontaneous effort of generations built with the faith that was theirs.

Georges Rouault[1]

The emphatic outlines and the tones, often glowing and sometimes sombre, of Rouault's paintings and prints derive from his teenage years when he was apprenticed to a glass painter and worked on restoring medieval stained glass. In his early twenties, the determinative influence upon him of his teacher Gustav Moreau[2] enabled him to follow his inner vision and liberate his own unique powers. Further friendships helped form him, among them those with writers Leon Bloy, André Suarès and Jacques Maritain. To the mainstream religious artists employed by the Church of his day, however, Rouault offered no successful rivalry. His low-life subject matter—prostitutes, the circus, the street fair—blinded most of his contemporaries to the vision with which he was graced. From the many panels, canvases and prints of the subject which he produced over many decades, *The Holy Face* (Sainte Face) (c. 1946) images seek the viewer out. Ironically, these works each show an aspect of the person of Christ—serene, shamed or agonized—emerging from the artist's prayer with the same kind of freedom as French teachers of the spiritual life were advocating, the Abbé Huvelin (1838–1910) and the Abbé Henri de Tourville (1842–1903), both followers of St Francois de Sales, being examples.

The Holy Face, with its frontal image of the head of Christ, layering of colours that give depth to the emotion borne on the face, eyes that look inward and outward with a strong but compassionate gaze upon all human suffering, illumination from within, and spiritual focus reminiscent of a Byzantine icon, speaks powerfully and compellingly. The frame within which the head is placed recalls the legend of Veronica,[3] but neither this, nor the historical circumstances of the artist—who had lived through war and the recent liberation of Paris (1944)—is made explicit in a work which is, importantly, timeless.

Where commissions for places of worship were concerned, the Catholic Church ventured and risked nothing in Rouault's lifetime, handsomely benefiting instead from the donations made after his death by his family to the Vatican Gallery of Modern Religious Art. In old age the artist received the homage of the Centre des Intellectuels Catholiques, and Pope Pius XII named him a papal knight in 1953.

An uncompromising and powerful artist of French Expressionism, Rouault is seen by many as the strongest religious painter of this century.

Tom Devonshire-Jones

Notes

1 Georges Rouault, preface to *Stella Vespertina*, Drouin, 1947.

2 Rouault was later to become the first curator of the Musée Gustav Moreau.

3 Like Otto Dix (p. 72), Rouault had depicted the woman who met Christ on the way to Calvary and wiped his pain-beaded face with her veil, which thereafter bore the imprint of his face. Rouault's *Veronica* (1945) shows her with head tilted compassionately, and her face, like the veil, bearing aspects of the Christ-face of his *The Holy Face*.

Georges ROUAULT
(1871–1958)
Sainte Face (The Holy Face) c. 1946
oil on paper
51.0 × 37.0 cm
Vatican Museums, Vatican City
© Georges Rouault 1946 / ADAGP
Reproduced by permission of VI$COPY Ltd., Sydney 1997

Matisse's chasuble designs for the Chapel of the Rosary at Vence represent a radical departure from the traditional approach to this item of the liturgical vestment, employing bold, simplified forms, brilliant colour combinations and a distinctive, modernized shape.

Toward the end of his life, when he was largely confined to a wheelchair, Henri Matisse (1869–1954) undertook the total redesign of a tiny Dominican oratory in the south of France. The project (1948–51), which was to practically consume Matisse's final years, fulfilled a lifelong artistic ambition—to synthesize all of the elements of the plastic tradition into a unified whole, to 'fuse them into one perfect unity'.[1]

Matisse had attempted this earlier with the decorative mural *The dance* (c. 1932), at Merion, but the Vence chapel enabled him to design a total environment; to become the architect as well as the painter, to design stained-glass windows, wall murals, furniture and liturgical vestments—to express himself 'through the totality of form and colour'.[2]

The revival of the French Sacred Art Movement, at its height between 1925 and 1955, saw Matisse, along with other prominent artists such as Léger, Braque, Rouault, Lipchitz and Bonnard, accepting ecclesiastical commissions to decorate churches at Assy and Audincourt. Picasso was also busy during this period decorating a Romanesque chapel at Vallauris with the secular subject *War and Peace*. But the Vence chapel was in no way a collaborative project. It was conceived, executed and financially supported to a great extent by Matisse. He was single-minded in his overall conception of the space, frequently insisting upon the symbiosis between the sun-drenched luminosity of the great stained-glass windows and the joyous yet meditative simplicity of the pure white interior, decorated with line drawings in ceramic.

Integral to this celestial cycle of light, colour and form are the chasubles, the outermost garment worn by bishops and priests when celebrating the Eucharist. Designed with the aid of paper cut-outs—indicative of Matisse's late style[3]—*Black chasuble* (1951) allowed the artist to explore the expressive possibilities of the cut-out within a truly decorative context. All such garments are vividly decorated with the symbols of the liturgy: palms, halos, fish, stars, butterflies and ears of corn resonate around the sacred cross in brilliant colour combinations of violets, greens, pinks, reds and, in this case, luminous black on white.[4]

These liturgical symbols are depicted in a highly simplified manner, characteristic of Matisse's mature style. 'There is no break', he declared, 'between my old pictures and my cut-outs; only with more formality, more abstraction, I arrive at a form decanted to the essential'.[5] Thus, we see in Matisse's chasuble designs this intentional simplicity; the perfect paring down of form to its essential elements, which are often described only by the barest gesture of a single line.

The Vence chasubles represent a critical moment in the history of this liturgical garment which, for many centuries, had been designed according to the traditional prototype of symmetricality and sedate decorative form (Hermann Nitsch, p. 169). Matisse's chasubles resonate with brilliant colours, dynamic shapes and bold forms. This unique and thoroughly modern interpretation of the chasuble provided inspiration for a new generation of artists keen to explore the decorative and artistic possibilities offered by garments invested with religious significance, such as James Lee Byars, *Four in a vestment* (p. 171).

Tracey Judd

Notes

1 Henri Matisse, 'Interview with Charbonnier', 1951, trans. in Jack Flam, *Matisse on Art*, London, Phaidon Press, 1973, p. 139.

2 Henri Matisse, 'Interview with Verdet', 1951, translated in Flam, ibid., p. 144.

3 From about 1950 Matisse abandoned all other art forms except drawing in favour of the cut-out technique. He had experimented with cut-outs since the early 1930s when planning the *Dance* mural for the Barnes Foundation, but it was not until the mid 1940s that he was employing them as an independent pictorial form.

4 Picasso was so impressed by the chasubles that he urged Matisse to make some designs for Spanish bullfighters' capes. Noted by Pierre Matisse, fn. 8, Section VII, 'The Chapel at Vence', in A. H. Barr, *Matisse: His Art and His Public*, New York, The Museum of Modern Art, 1951, p. 549.

5 Henri Matisse quoted in 'The Road to Paradise', fn. 1, p. 197 in R. Escholier, *Matisse: A Portrait of the Man and the Artist*, New York, Frederick A. Praeger Publishers, 1960.

Henri MATISSE
1869–1954
Black chasuble 1951
fabric
129.0 × 197.0 cm
Vatican Museums, Vatican City
© Henri Matisse 1951 / Les Heritiers Matisse
Reproduced by permission of VI$COPY Ltd, Sydney 1997

My pictures aim to express something my own heart has experienced and not to imitate something my eyes have seen.

Alfred Manessier[1]

Manessier's *Crown of thorns* (1951) stands in stark contrast to Barnett Newman's *Covenant* (1949) (p. 107). To move close to *Covenant* is to be enveloped by it. That was Newman's intention. Manessier had a different purpose. For him the act of painting meant to enter into contemplation and to sing a song to the Christian God. In *Crown of thorns* the deep reds and blues reverberate with the blacks like some medieval chant. Here, as in the stained-glass windows at Chartres, the work is an expression of a deeply held faith and a hymn of praise to a personal redeemer.

Manessier's relationship with the Catholic Church was more like a marriage than a romance or flirtation. The moment of his commitment he dates to a three-day retreat spent in the Trappist monastery in Soligny in 1943. The period after this retreat also marks his emerging maturity as an artist.

To his mature style he brought, distilled, the influences, experiences and enthusiasms of his earlier life. He grew up by the harbour at Le Crotoy, by the Somme, and quickly became an accomplished landscape painter. The flat river estuary—opalescent at low tide—and the play of light on the water entered his mature vocabulary as soft planes of harmonious colour suffused with light from within. Already his stance in life was contemplative and spiritual.

Manessier's sense of colour, fine draughtsmanship and the slow rhythms of the truly contemplative are present in this small work, *Crown of thorns*. Its theme, taken from the Passion of Christ, appears often in his work of this period; in paintings, such as *Pieta* (1948), *The St Matthew Passion* (1948), *Gethsemane* (1951), and in the six windows designed for the village church at Bréseaux.

Within this exhibition, Manessier stands closest to Richier (p. 101), Rouault (p. 95), and Matisse (p. 97). All were closely associated with the French Sacred Art Movement, whose goal was to rid churches of the trivial and superficial and to bring about a reconciliation of soul and spirit through contemplation. The memory and guilt of the Holocaust and the violence of war were never far from their consciousness, and each artist had been enlisted by the Dominicans Devémy and Couturier to contribute to the remarkable series of churches typified by the church at Assy.

Manessier's *oeuvre* continued to include landscapes—*Night at Mas* (1951), *The eddy* (1958), *The coast* (1959)—religious works—*Resurrection* (1961), *Buried* (1961)—and tributes to those he admired—*Homage to Miguel de Unamuno* (1965), *Homage to Martin Luther King* (1968). But in a real sense his whole life, with its unswerving commitment to an inner peace and truth, is reflected in *Crown of thorns*, and Manessier's preoccupation with narrow spatial rhythms and pulsating colour patterns remained with him until his death in 1993.

Rosemary Crumlin

Notes

1 In Pie-Raymond Régamey, *Religious Art in the Twentieth Century*, Herder and Herder, 1963, p. 196.

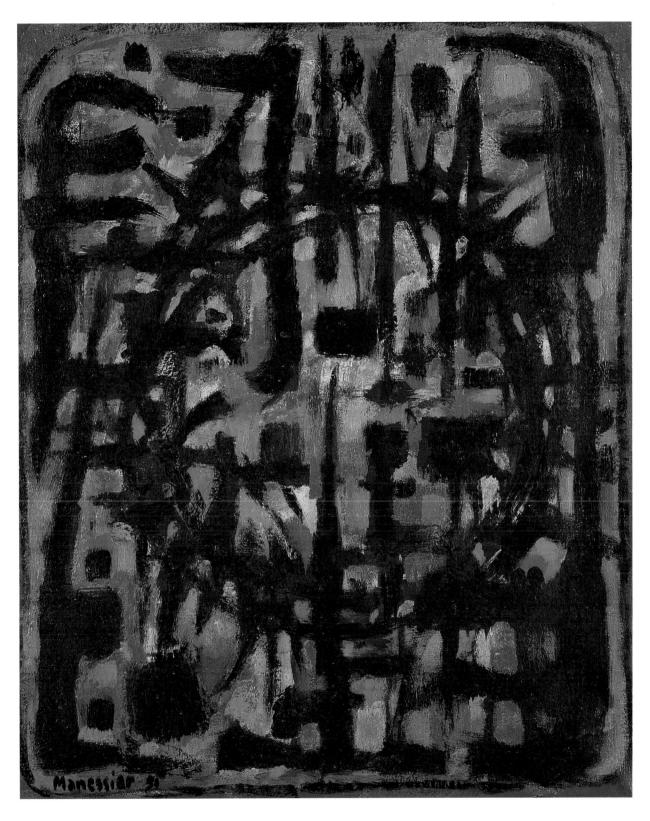

Alfred MANESSIER
(1911–1993)
Crown of thorns 1951
oil on linen-backed paper
54.0 × 45.0 cm
Folkwang Museum, Essen
© Alfred Manessier 1951 / ADAGP
Reproduced by permission of VI$COPY Ltd, Sydney 1997

A critical turning point.

GERMAINE RICHIER

This small crucifix *Christ of Assy* (1959), a maquette for the famous crucifix of the Church of Notre Dame de Toute Grâce, Assy, is in the present exhibition instead of the original, which the people of Assy refused to allow to be taken from its place in the sanctuary and sent to Australia. Only once has the original crucifix left the Assy Church, being removed in 1951 because Rome, in the person of the Bishop of Annecy, Monsignor Cesbron, ordered it. Richier's *Christ* was denounced by the extreme right-wing French church group, the Integrists, as 'blasphemous', 'scandalous', 'an infamous profanation', 'sacrilege'. However, others, like Malraux, Couturier and most of the parishioners, saw in it a distinctively human and suffering Christ, the embodiment of the Isaiah prophecy: 'For he shall grow up as a tender plant, and as a root out of a dry ground; he hath no form nor comeliness; and when we shall see him, there is no beauty that we should desire him.' (Isaiah 53:2).[1]

Under attack throughout the Catholic Church of the day was modern art in general and the Sacred Art Renewal Movement in particular. This movement, led in France by the Dominicans Devémy and Couturier,[2] sought to rid the churches of sentimental, pious imagery and weak liturgical expression, and to bring about a revolution in sacred architecture and art by involving some of the greatest living artists in their construction and decoration. Many saw this as eroding the figurative for abstraction, and a forsaking of the sacred word of God for the foibles of individualism. The reverse was the avowed aim of the Movement. As Pére Couturier reminded those gathered for the consecration of the Church at Assy in 1950:

> Nothing is born, or reborn, but of life. Tradition itself is no exception … The fact that the greatest figures among living artists were called upon is not due to snobbism. We

did not choose them because they were famous or most avant-garde, but rather because they were the most alive. They were bursting with life and life's gifts, and its greatest chances. Here is the lesson of Assy. Here too is the gamble: you have to take life wherever and however you find it.[3]

The argument reached back into Rome, for the business of sacred art (art in the service of worship) was the province of the official Church. Pope Pius XII heeded the voices of those closest to him who were against modern art and suspicious of the Dominicans.[4] In 1952 Rome issued a directive about the use of modern art as sacred art,[5] warning against 'distorted and confused execution', 'unusual images … not in conformity with approved usage of the Church'. In 1955, Pius XII again warned against having any person not of the Catholic faith involved in the art of the Church.[6]

The crucifix is important in the context of this exhibition because it focuses the concerns about sacred art and allows the distinction to be made between art that is connected with formal worship in the Church and art—such as most of the art in this exhibition—which, although deeply religious, is not sacred art in this sense. Against a background of this history and these issues, it is not surprising that the present parishioners in the mountains around Assy considered the request for the loan of the Richier crucifix and decided firmly against it—'Après délibération et vote, la résponse de notre communauté est négative et définitive'.[7] In 1951, the parishioners had no choice. In 1995, in a different atmosphere of collegiality, they exercised their choice as a discerning congregation.

Rosemary Crumlin

Notes

1 See W. S. Rubin, *Modern Sacred Art and the Church at Assy*, New York, Columbia University Press, 1961.

2 These two were responsible for the construction of and obtaining of works for the Church at Assy, to which artists such as Matisse, Leger, Chagall, Rouault and Lipchitz contributed major works.

3 M. A. Couturier, *La Leçon D'Assy*, Notre Dame de Toute Grâce, Editions Paroissales d'Assy, 1950.

4 Rubin, op. cit.

5 Pope Pius XII, *On Sacred Art*, trans. Australasian Catholic Record, 1952, pp. 283–7.

6 Pope Pius XII, *Musicae Sacre Disciplina* (encyclical), 25 December 1955, no. 27.

7 Gilbert Huissard, Curé, letter to the author, 5 July 1995.

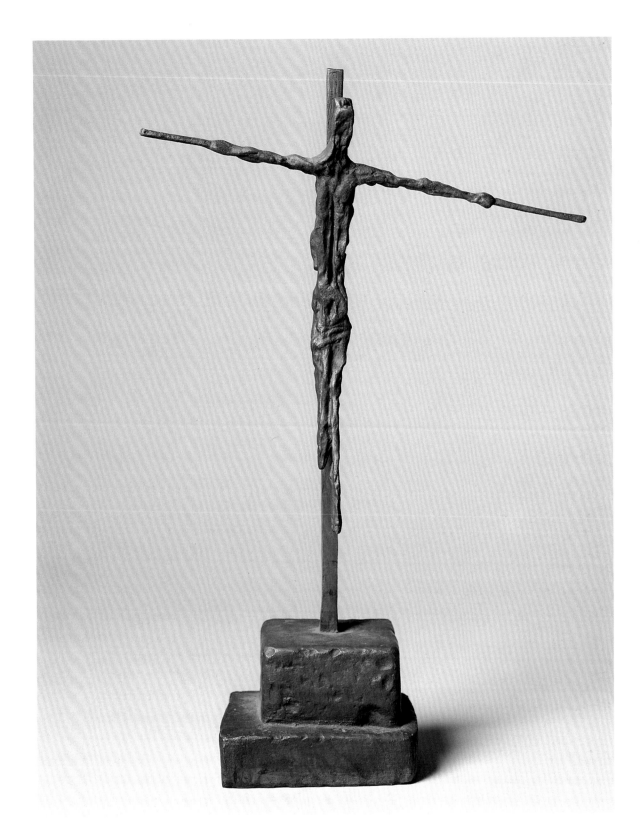

Germaine RICHIER
1904–1959
Christ of Assy 1959
bronze (maquette)
height: 48.0 cm
Museum Ludwig, Köln
© Germaine Richier 1959 / ADAGP
Reproduced by permission of VI$COPY Ltd, Sydney 1997

If I am not for myself, who is, and if I am only for myself, who am I, and if not now, when?

<div align="right">Hillel[1]</div>

BEN SHAHN

In *Third Allegory* (1955), as in his other *Allegory* paintings (begun in the late 1940s), Jewish artist Ben Shahn sought 'a mysterious unknown road'[2] which, taken, would liberate his art and social vision from what he saw as the constraining ideologies and rigidifying order of the postwar period. The title, *Allegory*, implies no simple one-to-one correspondence. Shahn drew on multiple sources: the Hebraic moral-ethical tradition, his Russian heritage,[3] immersion in bible story during early Jewish schooling, experiences as a photographer and muralist during the Depression, employment in the US Office of War Information during World War II, and all those events involving oppression and human suffering that seized his imagination[4] and clamoured for expression.

Knowing the magnitude of wartime devastation, how was the social realist to avoid general, distancing images? For Shahn, neither abstraction nor depiction of individual events would do. To describe his art as moving from social realism to 'personal realism'[5] seems inadequate to capture his quest for universal symbols in work that would unite the idea and the image, the event and inner event-full emotions, the particular and the all-embracing. The *Allegory* paintings mark a shift toward this way of speaking justice.

Third Allegory glints with a trove of interactive memories and stories. In the foreground, the beast, metamorphosed from Shahn's earlier *Allegories*, recalls Daniel in the lion's den, the vision in the Book of Daniel[6] of the four beasts, the Lion of Judah, and the lion of ancient Assyrian and Roman myth with its duality as devourer and protective conqueror of death. The leaved beard/mane is also a burning bush. Like that composite of totemic symbols, the Chinese dragon, this beast is many in one: part animal, part human, with its striped apparel, grey face and eye shape akin to that of the prophetic figure on its right. Above the beast are ornately decorated tablets of the Law. Inscribed in Hebrew on the right tablet is the first letter of each of the first five commandments; on the left is represented the word *lamed*, 'thou shalt not'. Shahn wrote of the joy of letters[7] and of how the letters grew out of the hand. Within this work, meaning grows from the calligrapher's letters and reaches out into the present. Clad in a black and white tallith, a tall figure, holding the instrument with thick working-man's hands, blows upon the ceremonial shofar, the ram's horn. Sounded on high holy days, and significant within kabbalistic mystical traditions as dispersing the forces of evil, the shofar also reminds of the fall of Jericho, and of how—in Abraham's sacrifice of a ram rather than of Isaac—the divine valuing of human life was affirmed. Above, and at a third level, stands the holy city, Jerusalem, like a promise—a sign of hope, survival and identity.

This work glows with warm, velvet colour; it is compositionally satisfying in its threefold horizontal and vertical organization, and striking in its manifold assertion of the power of the human spirit.

Margaret Woodward

Notes

1 Saying of Hillel, inscribed in Hebrew by Ben Shahn on his painting *Identity* (1968).

2 Ben Shahn, 'In Defense of Chaos', in catalogue, *The Collected Prints of Ben Shahn*, Philadelphia, Philadelphia Museum of Art, 1967, p. 13.

3 Shahn and his family emigrated from Kovno to the USA in 1906.

4 One such event was the trial of Sacco and Vanzetti. See *The Passion of Sacco and Vanzetti* (1932).

5 The artist details his use of this term in 'Biography of a Painting', in Ben Shahn, *The Shape of Content*, Cambridge, Massachusetts, Harvard University Press, 1957, pp. 25–52.

6 Daniel 7:1–9. The fire-beast in Shahn's first *Allegory* painting (cf. 'Biography of a Painting', ibid.), evolved out of many associations: the cat, the wolf, a specific fire, family memories, and emotions that surfaced from within. Similarly, the beast in *Third Allegory* is lion and more than lion.

7 Ben Shahn, *Love and Joy About Letters*, New York, Grossman, 1963.

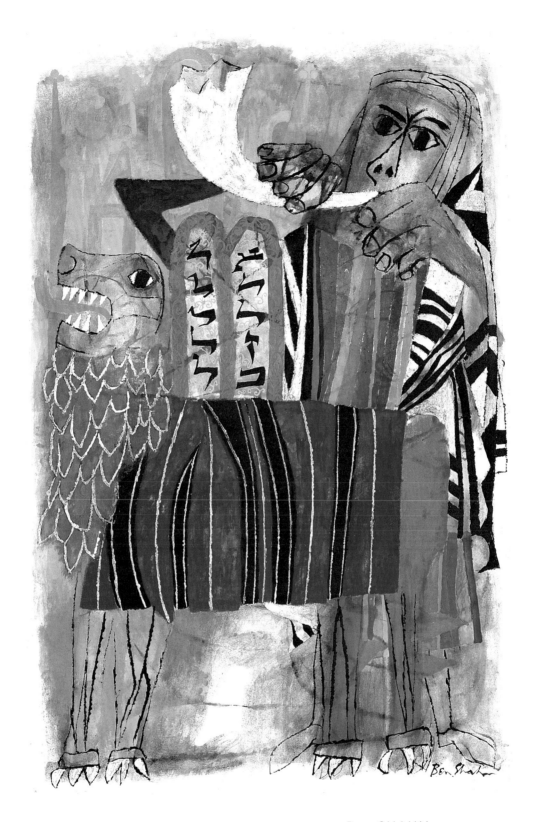

Ben SHAHN
1898–1969
Third Allegory 1955
watercolour and tempera on paper, mounted on hardboard
95.0 × 63.0 cm
Vatican Museums, Vatican City
© Estate of Ben Shahn
Licensed by VAGA, New York, NY

We have occupied ourselves too much with the outer, the objective, at the expense of the inner world.

Mark Tobey[1]

Deeply meditative, like all of Mark Tobey's work, *The Last Supper* (1945) calls for quiet attention, a slow moving inwards, rather than an immediate apprehension of the image or of its details. In this, Tobey seems to capture in aesthetic form the Baha'i idea of revelation as coming, not instantly, but progressively.

Other aspects of *The Last Supper* reveal the significance for Tobey's art of the Baha'i faith, to which he was introduced in 1918. Most crucial is the Baha'i sense of unity—unity of humankind, of religions, of religion and science, of parts within the whole—here expressed in a fluid circular structure within which the figure of Christ becomes a central core of calm. The table itself, defined in part by the figures around it, is also circular. Black and white lines appear to flow, to include angles and curves, to be differentiated yet somehow unbroken. More agitated curves and spirals move outward to the white negative space at the top of the work, but the cross slanting towards the left-hand corner remains anchored to the centre; death is not cut off from life

Hovering somewhere between Tobey's 'white writing', used in works such as *Written over the plains* (1950), and the figuration of city paintings such as *Market scene* (1944), his *The Last Supper*, in its initial shaping, owes as much to his knowledge and practice of Chinese and Japanese art,[2] and to associations with Zen Buddhism, as it does to automatic drawing. Study of calligraphy[3] would have taught him that figures and natural forms can be experienced in line, that a horizontal stroke can become a cloud-drift across the sky. He would also have learned of the fundamental requirement of *ch'i*—breath, cosmic spirit—that deep resonance which the artist receives rather than initiates. This spirit flows into the hand, which moves at once precisely and fluently in a blending of ease and care. There is intrinsic unity here, too.

Eastern expression of Buddhism, like artistic invention, allows for a kind of meditative playfulness, perhaps exemplified in the initial creation of *The Last Supper*, the playing with shape and line, the effect of a building up backwards, the movement between negatives and positives, the gradual emergence of figures and subject as the artist moves more intentionally in bringing forth light from dark. Another kind of interplay, Tobey's 'playing' the piano, his affinity for music, also finds expression in the shifts, rhythms and pattern of the work.

Tobey is often linked to Motherwell, Newman, Pollock and the other American Abstract Expressionists, but he was a generation older and his life-journey was more like a religious pilgrimage, the goal of which came to be, for him, an inner peace and joy that was deeply and committedly human rather than transcendent.

Margaret Woodward

Notes

1 From statement by Mark Tobey, catalogue, *Fourteen Americans* exhibition, New York, Museum of Modern Art, 1946.

2 Tobey developed his understanding and practice of brushwork during time spent at a Zen monastery in Japan in 1934.

3 Tobey was introduced to calligraphy by Chinese painter Deng Kui as early as 1923, extending this study in subsequent visits to Shanghai and to Hong Kong with Bernard Leach in 1934.

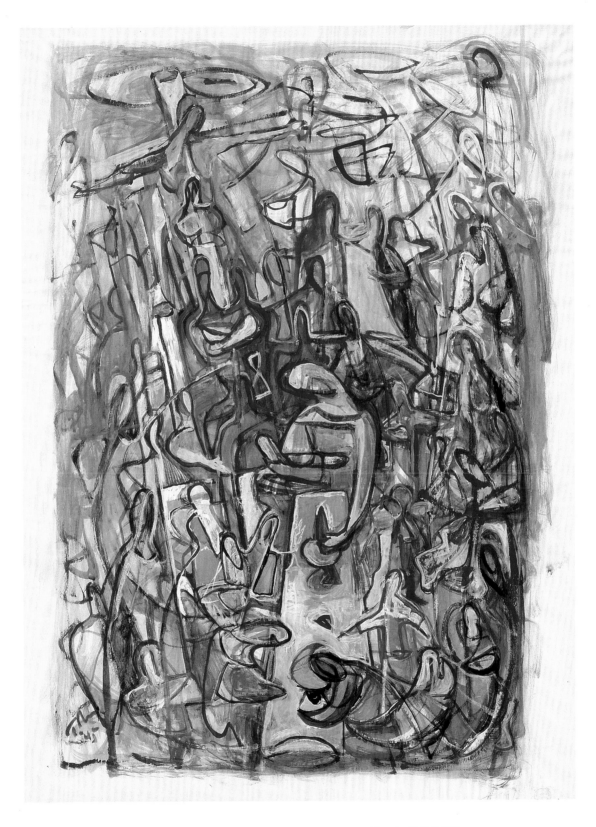

Mark TOBEY

1890–1976

The Last Supper 1945

tempera on paper

56.8 × 43.8 cm

Metropolitan Museum of Art, George A. Hearn Fund, 1946

© Mark Tobey 1945 / Pro Litteris

Reproduced by permission of VI$COPY Ltd, Sydney 1997

Touching the metaphysical pattern of life

Come close! Barnett Newman did not want the viewer to stand back from his paintings as one might with the work of the Impressionists.[1] Up close, one can *feel* the force of the zip and encounter the painting as one encounters a person. That zip which David Sylvester called *'une fermeture éclair*—a lightning fastener … a revelation of light',[2] became Newman's trademark from that intense, creative moment when he first placed a strip of masking tape down the centre of a small canvas—painted a deep reddish brown—and applied a warm orange pigment down its length, allowing the edges to ripple with excitement. In that moment, Newman reached beyond the banal to touch 'the metaphysical pattern of life'.[3] He knew—during the months he spent contemplating this small painting—that he was in touch with mystery.

Covenant (1949) was painted at the height of this awareness. It was begun at the end of his *Onement* series (1948) and is one of the first paintings where *two* zips appear. That he should move from *Onement*—Atonement (making one)—to *Covenant* is not strange. The Jewish tradition from which he came would surely suggest such thoughts. A mysterious God, who cannot be named, enters human history in the Covenant with His People.

Discussing the issue of his paintings' titles, Newman said, 'I give paintings titles actually because I think they have some meaning. I try in the title to create a metaphor that will in some way correspond to what I think is the feeling in them and the meaning of it'.[4] It is known that Newman was actually thinking about the religious issues contained in the title *Covenant* as he painted it.[5] The title, he hoped, would be 'a clue to others'.

In Hebraic tradition, Yahweh's Covenant with Abraham is seen as the beginning of Jewish history. It is not an agreement between equals. It is an act of gracious love on the part of the more powerful One. Newman expresses this by the two zips in his painting. The one on the right, bright with colour, is visually more powerful. The one on the left, while delineating the central portion of the painting, is black. This is the black of mortality, charred earth, burnt bones. Newman will use these elements in his black-on-black painting *Abraham* (1949), which he himself called 'a tragic painting'.[6]

Colour was of vital importance for Newman. The deep red of *Covenant* is carefully chosen. It glows softly behind the two zips. The cream of the right zip is like a violin string vibrating on this earthen base. The black zip recedes yet maintains its individuality in the colour field. It is the human being rejoicing in a relationship that gives meaning to existence.

All this is experienced in the encounter with *Covenant*—up close.

Patrick Negri

Notes

1 See Harold Rosenberg, *Barnett Newman*, New York, Harry N. Abrams, 1978, p. 61.

2 Interview with David Sylvester, Easter, 1965. Cited in *Abstract Expressionism, The Critical Developments*, New York, Harry N. Abrams, 1987, p. 142.

3 Barnett Newman, *Northwest Coast Indian Painting*, New York, Betty Parsons Gallery, 1946.

4 Interview with David Sylvester, Easter, 1965, in *Barnett Newman: Selected Writings and Interviews*, New York, Alfred A. Knopf Inc., 1990, p. 258.

5 Annalee Newman in conversation with the author, August 1988.

6 From the soundtrack of the film *Art New York: Barnett Newman*, 3 December 1964.

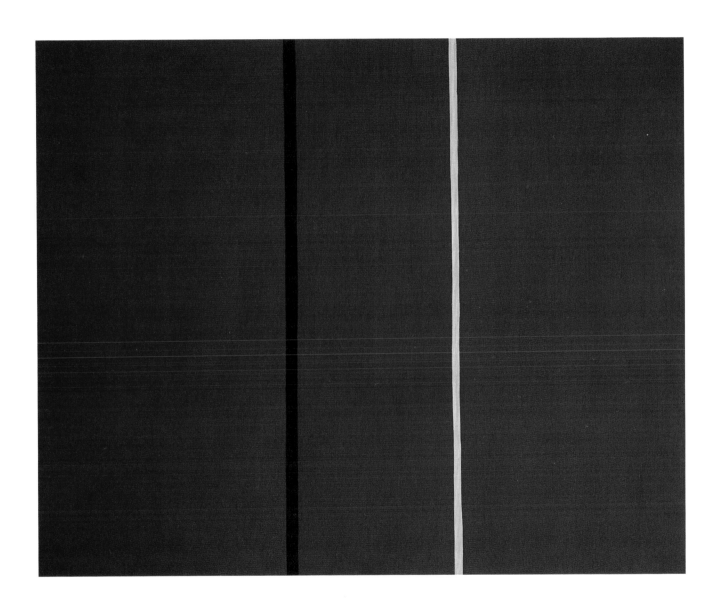

Barnett NEWMAN
1905–1970
Covenant 1949
oil on canvas
121.3 × 151.4 cm
Hirshhorn Museum and Sculpture Garden, Smithsonian Institution
Gift of Joseph H. Hirshhorn 1972
© Barnett Newman 1949 / ARS
Reproduced by permission of VI$COPY Ltd, Sydney 1997

The still, ethereal world of contemplation

MARK ROTHKO

Mark Rothko's suicide does not explain his paintings. The tragedy he dealt with was not his tendency to depression. 'The fact that people break down and cry when confronted by my pictures', he said, 'shows that I *communicate* … basic human emotions.'[1] He added that such emotions have religious significance. The people who wept had somehow tapped into the religious *experience* regarded by him as the source of his creative output. Dore Ashton, who met him late in his career, suggests that Rothko is always concerned with *la condition humaine*; that his paintings are an articulation of 'the highest points of human experience'.[2] Rothko would have agreed wholeheartedly. Early in his career—with Barnett Newman and Adolph Gottlieb—he had declared: 'We are reasserting man's natural desire for the exalted, for a concern with our relationship to the absolute emotions'.[3]

Brown, black on maroon (1957) was painted some ten years after Rothko's move from hermetic symbols to total abstraction begun when he was guest instructor at the California School of Fine Arts (June–August, 1947). By then, Rothko was master of the medium. What Irving Sandler called 'the blocks of coloured ether'[4] and Robert Rosenblum 'these infinite, glowing voids'[5] are surely placed on the picture plane. The soft glow of the maroon noticed by the viewer on first contact becomes stronger with prolonged viewing. Mesmerizing in intensity, it lifts one to a consideration of the deeper aspects of life. The painting centres one's attention; produces a sense of stillness. As Dore Ashton remarks, the light in a Rothko painting 'is as moving as the light of distant paradise in a naive early Renaissance painting'.[6] Like his friend and colleague, Barnett Newman, Rothko wanted the viewer to come close to the painting, to be warmed by the painting's presence, to be wrapped in these 'glowing, amorphous veils of light'.[7]

Having purified his art to the point of discovering this basic format, Rothko repeated it over and over again. 'The same image', writes Alwynne Mackie, 'hundreds of times over, year after year, but each image bearing a slightly different—and interesting—face.'[8]

Face to face, the viewer and *Brown, black on maroon* enter the world of contemplation.

Patrick Negri

Notes

1 Selden Rodman, *Conversations with Artists*, New York, The Devon-Adair Co., 1957, p. 93.

2 Dore Ashton, *The Unknown Shore*, Boston, Atlantic Monthly Press, 1962, p. 73.

3 'The Sublime in Now', *The Tiger's Eye*, 15 December 1948, p. 52.

4 Irving H. Sadler, 'Abstract Expressionism', in *Abstract Art Since 1945*, Jean Leymarie (organizer), London, Thames & Hudson, 1971, p. 58.

5 Robert Rosenblum, 'The Abstract Sublime', *Art News* 59:10, February 1961, p. 56.

6 Ashton, op. cit., p. 76.

7 Michael Auping, *Abstract Expressionism: The Critical Developments*, New York, Harry N. Abrams, 1987, p. 149.

8 Alwynne Mackie, *Art\Talk: Theory and Practice in Abstract Expressionism*, New York, Columbia University Press, 1989, p. 52.

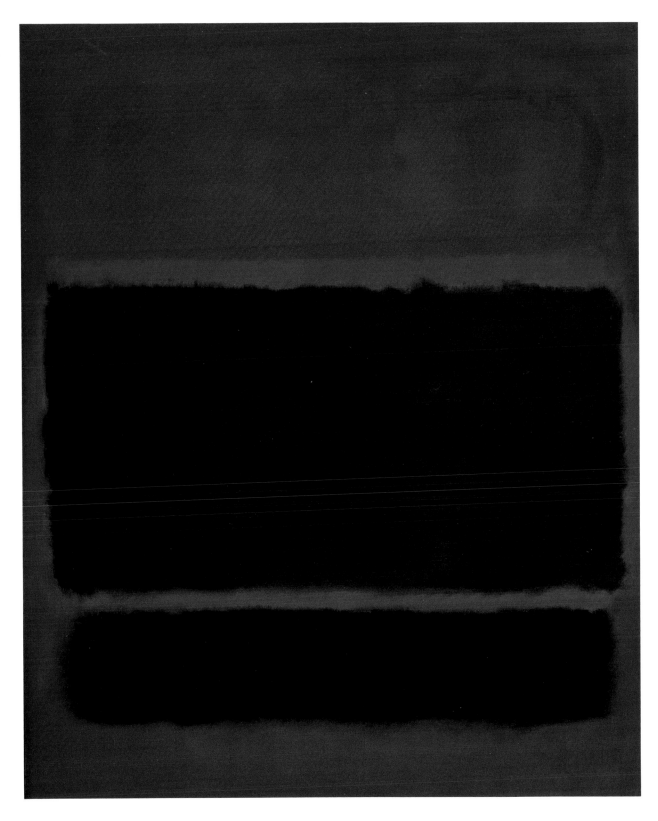

Mark ROTHKO
1903–1970
Black, brown on maroon 1957
oil on canvas
233.0 × 193.0 cm
National Gallery of Australia, Canberra
© Mark Rothko 1957 / ARS
Reproduced by permission of VI$COPY Ltd, Sydney 1997

Making an elegy is like building a temple, an altar, a ritual place.

Robert Motherwell[1]

Elegy to the Spanish Republic (1958) is one of 172 paintings of the same name that Motherwell completed before his death in 1990. His first *Elegy* was created out of his experience of Mexico, which he visited with the surrealist painter Matta, in 1941. Mexico, with its brilliant lights, its deepest shadows and its culture of romantic celebration of life and death was his first love and his greatest teacher. Related to this was his lament for the failed Republican cause in the Spanish Civil War (1936–39), a significant death mourned for the rest of his life.

However these works—all elegies or chants of mourning like the liturgical *Dies Irae* of the Catholic Church—extended in focus beyond the defeat of the Spanish Popular Front in 1939: 'The Spanish *Elegies* are not "political" but my private insistence that a terrible death happened that should not be forgot.'.[2] Death was always sitting on Motherwell's shoulder and guiding his hand. It was there in a Catholic Celtic heritage, in a childhood filled with illness, in an understanding of the 'terrible death' being wrought by industrialization in his age, and in all that caused 'dreams to weep'.[3] All the *Elegy* paintings, singly and collectively, are like the tolling of bells that call to prayer and meditative remembering, so that there is no loss of life's great truths. In this sense, each work is like a ritual celebration of life, death, and the promise of new life. Motherwell's last elegy, *Elegy to the Spanish Republic, #172 (with blood)* (1989–90), made shortly before his death, is a huge canvas[4] that required every ounce of his strength to complete. The task was finished on the floor of his studio and left to others to lift into place.

The 1958 *Elegy to the Spanish Republic* in the present exhibition was completed in New York the year that Motherwell married the painter Helen Frankenthaler. By then a highly respected writer, artist and teacher, he was regarded, along with Pollock and Rothko, as a founder-exponent of Abstract Expressionism in the United States. However, he never aligned himself for long with Pollock, for while he shared with him and with Matta a fascination with surrealist theory and the practice of psychic automatism, he was by temperament and choice closer to the European and particularly the French postwar abstractionists such as Manessier (p. 99). To enter into this 1958 work—this 'temple', this 'ritual'—demands a particular stance. It involves leaving what is familiar and distracting in the hope of finding again what is important and worth remembering.

A Motherwell work will not open itself to the passing traveller. It demands time and a willingness to stand open to darkness and mystery. It is meant to be a ritual experience which, even though it makes no physical sound, as music does, is filled with the solemn beats and throbs of its heavy and pendulous jet-black shapes, its singing, dazzling whites, and the tensions set up by the tracks and traces of colour which shrill their way across the surface or sneak out behind the major themes and tensions set up through the strong, dominant shapes. Only then will the viewer be able to answer the call that every elegy offers—to listen to the heart, to hear its call, to remember life and to be ready, too, for death.

Rosemary Crumlin

Notes

1 J. D. Flam, 'With Robert Motherwell', in *Robert Motherwell*, New York, Abbeville Press, 1983, p. 22.

2 In Robert Motherwell, *Robert Motherwell*, Northampton, Mass., Smith College Museum of Art, 1963, n.p. (13).

3 Federico Garc'a Lorca, 'The Six Strings', in Christopher Maura (ed.), *Federico Garcia Lorca: Selected Poems*, London, Penguin, 1997, p. 41. Lorca's poetry significantly influenced Motherwell.

4 213.36 × 304.80 cm.

Robert MOTHERWELL
1915–1991
Elegy to the Spanish Republic 1958
synthetic polymer paint on canvas
175.3 × 248.9 cm
National Gallery of Australia, Canberra
© Dedalus Foundation
Licensed by VAGA, New York, NY

And only for him who is like a child, will the gates of heaven open.

Gaston Chaissac[1]

Gaston Chaissac was an artist with the soul of a child. His rich imagination allowed him to create works which have firmly established themselves in the art of the twentieth century. His name is often associated with that of Jean Dubuffet. Initially, he was hailed by Dubuffet as the prototype of the Art Brut artist, as he strove for authentic naturalness. Like Dubuffet, he sought after new techniques, materials and unpretentious motifs. His vision for his art was similarly based on the expression of elementary feelings: his faces radiate emotion, joy, anxiety and fear. Even though he never considered himself an Art Brut artist, he was undoubtedly influenced by the movement. Throughout the course of his work, he dispensed neither with the figurative nor the artistic element, for example, the autonomy of colour and line. His creativity was aroused by chance encounters: the sight of a coffee pot, a discarded pail, a particular stone.

The totems form the high point of Chaissac's work as a whole. They consist of two different wooden forms: some comprise of several pieces of wood nailed together, and others, such as the totem *Person with a green face* (Totem — Personnage au visage vert) (1959), are made out of a single piece of wood, the contours of which follow its natural form.

Person with a green face is one of the most impressive of the totems, thanks to its highly expressive face. The round eyes stare spellbound at the onlooker. The mouth, twisted slightly into a smile, fails to mislead about the suffering expressed in the gaze. The green face is that of a man marked by pain. Chaissac suffered his whole life long from tuberculosis and died exhausted at the age of 54. He had, indeed, borne his cross on earth.

For all of Chaissac's intuition, intellectual control was never lacking. In contrast to the artists of the Art Brut movement, his art developed from a poetic early period into a dramatic one, then to the significantly reduced output of the later years. His art cannot be separated from the history of artistic sensibility of the 1940s and 1950s. He was very much a man of his time, attempting in his creations to come to terms with the plain and the simple. Like Jean Fautrier, Jean Dubuffet, or the artists of the Cobra group, he was searching for the fundamentals of a new art, free from academic norms, wholly devoted to naturalness.

Maria Stergiou

Notes

1 Quotation from *Chaissac* (exhib. cat.), Cologne, Kunst-Station, Sankt Peter 1994/95, p. 32.

Gaston CHAISSAC
(1910–1964)
Totem — Personnage au visage vert (Person with a green face) 1959
oil on wood
162.0 × 41.0 cm
Galerie Nathan, Zürich
© Gaston Chaissac 1959 / ADAGP
Reproduced by permission of VI$COPY Ltd, Sydney 1997

> I consider that the whole body of my work is concerned with the realization of a totality of being, with the fusion of inner and outer reality, and in that sense it is of course involved with the spiritual.
>
> *Ellen Landau*[1]

Often regarded today as a catalyst for Abstract Expressionism (The New York School), Lee Krasner (1908–1984) was one of the most well-trained artists of the twentieth century. Scholars have recognized not only the acerbic and incorrigible Brooklynite's artistic skills but her astute appraisal of European modernism and her radical thinking about politics.[2] The American critic Clement Greenberg proclaimed on more than one occasion that hers was 'the best eye in the country for the art of painting.'[3]

In *Combat* (1965) the vegetal and the human battle it out, as cadmium orange becomes background for the pyrotechnics of alizarin crimson and white. Energies are transformed in feverish gesture: eyes become eggs, fruit becomes muscle, flowers become cartilage. It is as if Krasner was transforming tropical growth into reassembled bodies to showcase new sinews and new flesh (Ezek. 37:10).

Heir to *The seasons* (1957) and paintings in her *Night journeys* series, *Combat* pays homage to a turbulent past and the metamorphosis of its potentially hostile energies. What is one to make of this cotton-candy, over-extended display, where the exuberance of form almost crushes the studied but subtle rhythms of rolled and overlapped waves. This very large painting is a set stage: a pose-down. Forms rotate and flex, as if stripped of outer skin, in order to compete for the attention of judges. Is this a war of male and female anatomies,? A friendly squirmish with the memory of her husband and kindred spirit, Jackson Pollock? Is this a temptation worthy of St Anthony? A counterpart to del Pollaiuolo, Signorelli, or Michelangelo?

Combat evokes the raw emotions exposed by death and dying and here forecast as the beginning of a path to renewed health. Recovering from Pollock's death and her own near-death from a brain aneurysm in 1962 and another serious illness in 1964, *Combat* is about transcending unhealthy distentions and accepting pulsating, tumoresque energies.[4] Following in the style of her *The eye is the first circle* (1960), Krasner floats eyes and seeds on rhythms that celebrate the present even as they hold promise for the future.[5] Was *Combat* a significant prelude to the stabilities that followed in a new apartment, her first retrospective at Whitechapel Gallery in London, and a new agent?[6] Did it offer her a catharsis—a critical step towards a more integrated, less encumbered, and deeply refreshed spiritual sense?

Within a dense net of energies Krasner launches her battle scene. Spirited flesh muscles up a simulation of a nervous system; open and flexible shapes joust intensely, as if to ensure that their synapses will eventually allow both trees and skeletal humans to form. As Barbara Rose has noted, between the mid and late 1960s Krasner 'finally found the means to express the spiritual conversion, which was one of the great bonds she shared with Pollock, that "man was part of nature, not separate from it."' Through her own words as well as in her art Krasner creatively revealed how painting could be 'as miraculous as any natural phenomenon.'[7] Through *Combat* she allows the viewer to enter the fray, to meditate on the monumentally unsettled wonder of creation.

James R. Blaettler

Notes

1 Ellen Landau, *Lee Krasner: A Catalogue Raisonné*, New York, Harry N. Abrams Inc., 1995, p. 267.

2 Robert Hobbs, *Lee Krasner, Modern Masters*, vol. 15, Abbeville Press, New York, 1993, pp. 17–18, and Ellen Landau, 'Lee Krasner's Past Continuous', in *ART News*, February 1984, p. 68.

3 Ibid., p. 71 and Landau, *Lee Krasner: A Catalogue Raisonné*, op. cit., p. 10.

4 Landau observed how the trauma Krasner underwent in the early 1960s was a 'psychologically transformative event in her life' (Landau, ibid., p. 315).

5 In discussing *The eye*, Hobbs notes how Krasner eventually came to recognize her reliance on Ralph Waldo Emerson's 'Circles', which she had read many years earlier. The Emerson poem proposes that in order to forget ourselves we humans seek 'to be surprised out of our piety, to lose our sempiternal memory, and to do something without knowing how or why; in short, to draw a new circle' (Hobbs, ibid. p. 74).

6 Landau, *Lee Krasner: A Catalogue Raisonné*, op. cit., p. 316–17.

7 Barbara Rose, *Lee Krasner: A Retrospective*, New York, Museum of Modern Art, 1983, p. 134.

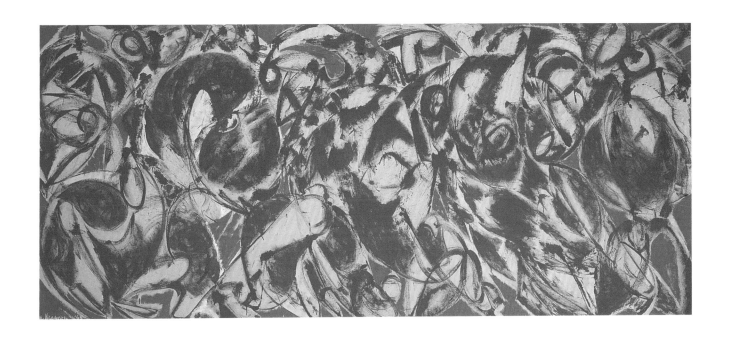

Neither the historical Jesus nor Christ

Spanish artist Antonio Saura concentrates, abstracts and extends the spectrum of traditional representations of the Crucifixion. He de-individualizes the crucified subject: his crucified figure represents neither the historical Jesus nor Christ. This figure stands for humankind in the widest sense. The picture becomes an icon for the *conditio humana*. In addition, Saura radicalizes the sufferings and the martyrs that are familiar to us from the Bible. While these biblical figures, despite distortions, retain the integrity of the human form, Saura deforms his figures to the point of total destruction—in a vivid depiction of the biblical breaking of the bones. Saura retrieves the Crucifixion from the kitsch trivialization of devotional art and takes it seriously in its original meaning: the terrifying sight of a horrendous, dehumanized abyss.

The disproportionality of the limbs and their contortions, the broken quality of the body, the human being fragmented in its visible reduction to a shadow of itself—thus it is that the figure becomes flesh without a soul. The face is no more than a mask, a horrendous grimace. In a world that is cruel, evil, raw and agonized, the artist gives the human physiognomy a repellent form. There is no trace of sanctity, the whole thing is diabolical. *Crucifixion* (1959) is pervaded by a demonic spirit, while the representation of the head dominates the canvas. This head, distorted by pain and crowned with thorns, stripped of its natural dimensions, becomes a point of crystallization that depicts the suffering figure in a modern perspective. The wide-open mouth and the eyes cry out, flinging horror at the viewer. The face seems split into two views; not just two eyes, but four, are staring out. The head hangs down to the stomach.

Another stirring element of the painting is the disproportionately large penis. This further emphasizes the animal quality of the depiction. It is also reminiscent of the shape of an arrow. The allusion to this symbolic, archetypal weapon underlines the extent of the violence portrayed here. The use of the sexual organ or an arrow as a symbol for aggression makes the picture distinctly ambiguous. Is there still some degree of violence emanating from the victim? Will the victim take on an active role? Or does Saura simply want to emphasize the violence even more strongly?

Besides the head and the genitals, the hands also draw the viewer's attention. One is reminded of the naturalistic portrayal; of the spread fingers and toes on Grünewald's Isenheim Altarpiece (c. 1512–16). Their distortions and contortions in the throes of death inspire Saura to his own exaggerated finger shapes. There is not the slightest trace of beauty or proportionality here, nor of the hand as a symbol of humanity. Saura only reestablishes contact with humanity by very obviously including his own hand-print in the painting. Thus the human being does leave traces in the midst of horror, a meta-symbol that would appear to re-open the path to an unambiguous reading of the image.

Saura makes contact with the viewer through a familiar symbol, but he alienates it so thoroughly that everything to which it has previously related is called into question. His picture demonstrates the unbearable aspect of the crucifixion. Indeed, it lays bare what most crucifixion scenes obscure: the demonic, evil side of humankind, whereby human beings are capable of crushing and destroying each other to the point of inhumanity. His representation of the crucifixion is a symbol in the true sense of the word; it allows something of what it is symbolizing to show through. Perhaps, as a meta-symbol, it even reveals the frequently trivializing and ideologizing treatment of the crucifix in Christian churches and in our daily lives. Saura's image lives on in our memories as the metamorphosis of a visual world that seems to have forgotten the *scandalum crucis*.

Johannes Röhrig

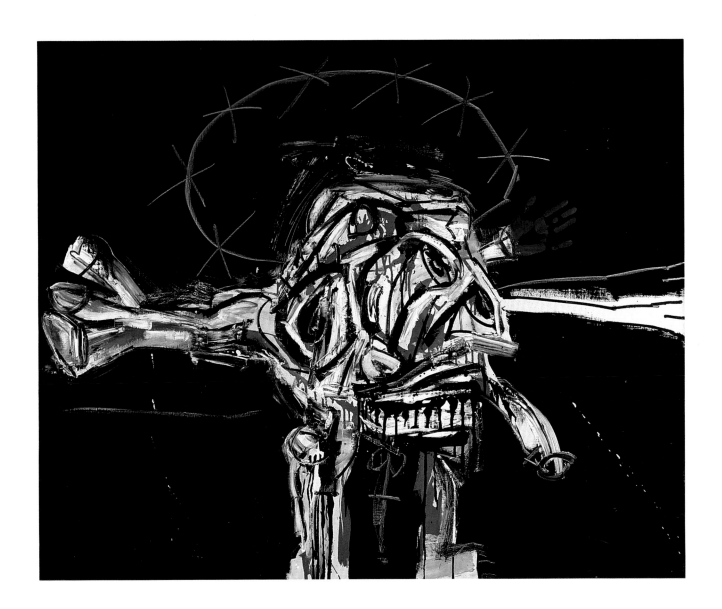

Antonio SAURA
1930–
Crucifixion 1959
oil on canvas
131.0 × 163.0 cm
Valencian Institute of Modern Art, Centro Julio Gonzalez
© Antonio Saura 1959 / ADAGP
Reproduced by permission of VI$COPY Ltd, Sydney 1997

Manresa is both ritual and performance; the photographs are the traces of the event.

On 15 December 1966, Joseph Beuys put on his FLUXUS demonstration, *Manresa*,[1] in the Galerie Schmela, Düsseldorf. It is necessary to place together photographs, props and tapes in order to reconstruct what happened. The effort involved in this is appropriate. Beuys intended not only that the viewer would respond during the course of the *Action*, but just as importantly that the viewer would be influenced in his or her subsequent behaviour by the *Action*:

> All the questions posed by human beings can only be questions of creative forming—and that is the idea of total art. It is about the potential for each individual to be a primarily creative being, and it is about society as a whole.[2]

The title of this work indicates its spiritual as well as its geographical location. Manresa, near Montserrat in Spain, was the place where St Ignatius of Loyola (1491–1555),[3] founder of the Society of Jesus, soon after a battle injury cut short his military career, had his first vision of the divine, and began to write his *Spiritual Exercises*.

In 1955, three hundred years after Ignatius's death, Beuys too suffered a deep inner crisis: his physical strength seemed to be deserting him and, plagued by doubts about his work, he sank into a depressive exhaustion. This experience explains Beuys' subsequent interest in Ignatius; in 1966 Beuys read and made notes in a volume on Ignatius's life leading up to the *Spiritual Exercises*. While both men examined a process in their own lives, this was not simply a voyage of self-discovery; on a much larger scale, it involved looking at forces in and beyond this world which are resources for humanity.[4]

Manresa may be seen as a demonstration of those forces. In the *Action* Beuys dealt largely with objects: amongst these, a half-cross swathed in felt leaning against a wall with a copper staff in front of it and with a chalk outline on the wall filling in the missing half. All this was *Element I*. *Element 2* was a wooden chest packed with objects. One of the most important roles in the *Action* was played by fat—in every form from that of being solid to that of flowing and dripping. In Beuys' view, fat best demonstrated the range and dynamism of an extended concept of art, which in itself was about reaching a creative balance between the poles of chaos and form. Using a high frequency, high voltage generator, Beuys showed we have access to the energies needed to do this.[5] Perhaps the most important aspect of the *Action* was *Element 3*, present only by virtue of its absence. Beuys asked repeatedly, 'Wo ist Element 3?' ('Where is Element 3?'). This unanswered question pointed to the role individual performers or viewers must play as 'primarily creative beings' to re-establish the contact of our world and society with the greater forces outside and above us.

Fiona Elliott
From a text by Friedhelm Mennekes[6]

Notes

1 The *Action* was performed by Beuys together with two Danish artists, composer Henning Christiansen and sculptor Björn Nörgaard.

2 Quoted in catalogue, *Documenta 6*, Kassel, 1977, p. 156.

3 Ignatius subsequently founded the Society of Jesus (the Jesuits).

4 Friedhelm Mennekes (*Christus Denken / Thinking Christ*, Stuttgart, 1996) equates Beuys' *Actions* with Ignatius's *Spiritual Exercises*.

5 Two other strands of the *Action* were the spoken tapes played by Christiansen, and Nörgaard's performance of a variety of leg movements, even encasing his feet in plaster and walking about to Christiansen's cries of 'Ich ... kann ... nicht' ('I ... can ... not').

6 Notes by Fiona Elliott draw on the definitive work in this field; Friedhelm Mennekes, *Christus Denken* (Thinking Christ), Stuttgart, 1996.

Joseph BEUYS
1921–1986
Manresa (event) 1966
photographic documentation with 30 photographs, reprinted 1989/1990
various sizes, largest 62.3 × 48.0 cm
gelatine silver prints and PE prints
Erzbischöfliches Diözesanmuseum, Köln. Sammlung der Jesuiten in Köln
© Joseph Bueys 1966 / Bild-Kunst
Reproduced by permission of VI$COPY Ltd, Sydney 1997

No Easter follows this Good Friday.

This crucifixion scene in Alfred Hrdlicka's *Good Friday* (*Karfreitag*) (1966) may be viewed as a critical response to Piet Mondrian's pictorial cosmos. While three figures hang from the ceiling, a fourth corpse lies halfway into an extermination furnace in a concentration camp. A further figure with a naked upper body stands at the right-hand edge of the scene. Their appearance recalls photographs of Jewish victims of the Nazi massacres. The conventional iconography of the crucifixion seems radically changed. As in depictions of Christ and the two thieves, there are three martyred figures, but at the foot of the martyr's stake we do not see the familiar constellation of grieving figures. Instead, beside the hanging scene, there are two further victims in different stages of torment: one awaiting the fate of the other, who is already dead. No room is left for a group of grieving figures; the viewer is left to take on the mourner's role.

In this representation Death disappears into industrially regulated anonymity, which no forms of piety withstand. The laying in the grave becomes the humiliation of outright physical destruction by incineration. Hrdlicka shows crucifixion as the most inhuman barbarity: the dignity of the human body, already dishonoured in life, is not even preserved in death. No one grieves, the corpse is not laid to rest. The foul wickedness of modernity, without precedent in history, finds its way into the picture. The *Ecce Homo* motif appears in a modern variant: a journey of human suffering degraded to the level of a spectacle relished by base executioners.

The scene is contained in a mosaic of representations of scenes of war and violence. It is part of a tableau divided into rectangles after Mondrian. Two biblical crucifixion scenes, a communion, a procession, a torture scene, sexual exploitation, Jesus walking on the water, his arrest, trench warfare waged by the Vietcong below the martial boot of an American soldier and the self-immolation of a Buddhist monk in Vietnam—together these form a multipatterned rag carpet, giving glimpses of disparate details of social and political life. Hrdlicka takes elements of violence, war and suppression from a news broadcast on Good Friday 1966 and impressionistically conflates them with the horrors of National Socialism and biblical crucifixion. The result is a representation of brutality spanning two years. Against the harmony of the De Stijl movement he sets his own despair at human malpractice and the disregard of human dignity. History seems to be caught inextricably in a cycle devoid of progress. In this context Hrdlicka takes the Cross as a symbol of redemptive hope *ad absurdum*, to the point where, in fact, it symbolizes hopelessness.

Hrdlicka sets his own belief in circularity against linear Christian historical thinking. The biblical crucifixion no longer marks the beginning of a new age, but becomes a piece in the mosaic of history, more horrifically bloodthirsty after two thousand years than ever before. No Easter follows this Good Friday; this day of deepest humiliation will not be followed by salvation for humanity. On the contrary, humanity is desperately and stubbornly at the mercy of its own sin and condemned to endless repetition of the cycle. With this, the radical nature of the detachment of the pictorial motif from its Christian framework becomes all too evident. It loses all its former meaning and becomes synonymous with the bleak cul-de-sac of human existence.

Friedhelm Mennekes
Translated by Fiona Elliott

Karfreitag (Good Friday)
(detail)

Alfred HRDLICKA
1928–
Karfreitag (Zyklus: Roll over Mondrian) /
Good Friday (from the series: Roll over Mondrian) 1966
etching, roulette with scraper, drypoint and burin
106.9 × 75.5 cm
Erzbischöflischs Diözesanmuseum, Köln. Sammlung der Jesuiten in Köln
© Alfred Hrdlicka 1966
Reproduced by permission of Alfred Hrdlicka 1997

… the silent silvered features of the father.

As a grand, sepulchral tableau in polished marble, Ipoustéguy's *Death of the Father* (La Mort du Père) (1967–68) evokes a deeply elegiac mood in its allusion to an ancient tradition of tomb sculpture. Although fundamentally Christian by definition, this tradition has pre-Christian antecedents and is based on the representation of the deceased as a recumbent effigy or *gisant*,[1] often, as here, with hands clasped in prayer and eyes closed to indicate the blissful repose of 'eternal sleep'. A feature associated largely with fourteenth-century Burgundian tomb sculpture[2] that has a bearing on Ipoustéguy's composition is the procession of subsidiary figures of mourners or weepers (*pleureurs*)[3] who surround the effigy rather like 'a funeral march in stone'.[4]

In *Death of the Father*, we have the head and clasped hands only of the sculptor's dead father. Both head and hands are a death mask cast in silvered bronze. A marble mitre identical to those worn by the encircling skulls and decomposing heads surmounts the mask. In Burgundian vernacular, these subsidiary heads and skulls can be interpreted as gruesome *pleureurs*, if indeed this is their intended role. There is a Burgundian precedent also for the representation of these heads in varying states of stylized decay.

Usually, effigies of the deceased represent the subjects *au vif*, or in a 'lifelike' manner. Certain effigies, however, do not spare us from the grisly truth, depicting subjects *en transis* or as putrefying cadavers, hideous in appearance—an allusion to the divesting of the individual in death of worldly wealth and power.

Given the formal and material austerity that characterize much twentieth-century sculpture, Ipoustéguy's richly symbolic magnum opus is a difficult work to assimilate within the modernist canon. To a degree its epic scale, unexpected conjunction of media, and deployment of 'serial' elements relate to the idiom of 'installation'. However, such a notion is plainly inconsistent with a *tour de force* of figurative marble carving.

Even in terms of his treatment of a 'conventional' subject, Ipoustéguy departs from tradition in several respects. As noted already, the effigy of the father is not a complete figure. Nor do any lamenting angels hover above it. In their place, the large nude figure of a young, sexually aroused male, presumably the artist himself, a sculptor's mallet gripped in his upraised right hand, clambers over the chill surface of the stainless-steel 'coffin' to gaze upon the silent, silvered features of his father. His expression a curious mix of mournful respect and wide-eyed rapture. His arousal a confirmation as such of procreative vigour even in the midst of death.

Death of the Father was begun as a *Death of the Pope*, conceived initially to commemorate Pope John XXIII. It has been suggested that its symbolism refers to the demise of the Catholic Church itself; but its iconography indicates a thematic continuum with certain other works by Ipoustéguy including *The agony of the mother* (1970–71), *The death of the brother* (1972) and *The death of Bishop Newmann* (1977). In this last work, the dead bishop's bronze features are rendered to reveal three different faces; 'the decayed face of death, the mask of ecclesiastical authority, and the mask of religious ecstasy'.[5]

The altered title of this work is due to the fact that in February 1968, while Ipoustéguy was working on *Death of the Pope*, his own father died. Thus, with real poignancy, it is the image and the memory of his father that supplant those of the original subject.

Writing of the artist's career in general but also in reference to this specific sculpture, Bernd Krimmel argues that 'Ipoustéguy's work is a pictorial metaphor for the transitoriness of individual existence, the cycle of human life between the poles of Birth and Death'.[6] Such is the visual force and psychological drama of *Death of the Father*, that we cannot but agree.

Geoffrey Edwards

Notes

1 For a discussion of the term *gisant* and of the significance of the recumbent effigy in sepulchral symbolism, see Henriettes' Jacob, *Idealism and Realism, A Study of Sepulchral Symbolism*, Leiden, E. J. Brill, 1954, pp. 9–44.

2 See Erwin Panofsky, *Tomb Sculpture, Four Lectures on Its Changing Aspects from Ancient Egypt to Bernini*, New York, Harry N. Abrams, 1964, p. 62.

3 See Jacob, op. cit., pp. 90–97, and *The Grove Dictionary of Art*, London, Macmillan, 1996, vol. 33, p. 28, for comment on the role of these weepers, especially in relation to their appearance on Claus Sluter's (c. 1360–1406) *Tomb of Philip the Bold*.

4 J. Huizinga, *The Waning of the Middle Ages*, London, Penguin, 1969, p. 235, as quoted in Jacob, op. cit., p. 93.

5 *The Dictionary of Sculpture*, New York, H. W. Wilson, 1984, p. 400.

6 Bernd Krimmel, *Ipoustéguy, Kunstpreis der Stadt Darmstadt 1968* (exhib. cat.), Kunsthalle Darmstadt, 1968, pp. 5–10.

Jean-Robert IPOUSTÉGUY
1920–
La Mort du Père (Death of the Father) 1967–68
marble, stainless steel
125.00 × 600.0 × 310.0 cm
National Gallery of Victoria, Purchased 1972
© Jean-Robert Ipoustéguy 1967 / ADAGP
Reproduced by permission of VI$COPY Ltd, Sydney 1997

Religious imagination clothes the figures with story and memory.

For most of us, the sea is where you go swimming or surfing or boating for pleasure. For John Bellany's family, who come from Port Seton, a small Scottish fishing village east of Edinburgh, the sea is deadly serious. Sometimes it provides an abundant livelihood, sometimes it kills. In Bellany's mother's home town of Eyemouth, a whole generation of men were drowned at sea in a single night.

A community bound up this closely with the forces of nature will inevitably have an awareness of the meaning and value of life beyond the normal. John Bellany bridges the gap between the deeply religious premodern world (there were thirteen churches in his village of four thousand people, more than the number of pubs) with the less natural and less religious world of today (as a young art student, he was at the centre of London in the swinging sixties).

This 1968 painting, *Star of Bethlehem*, is of two men standing in the boat that gives the picture its name, up to their knees in monstrous fish. One holds a fish gutter; the other has his eyes closed, his expression turned inwards. The sky behind them is vast and empty.

In a recent interview, the artist provided a brief statement about the picture:

> The *Star of Bethlehem* portrays man's elemental struggle for survival and search for peace and beauty. The name of the boat (and the title of the picture) has spiritual overtones, as well as referring to the lovely flower. The connotations are more religious in significance.

> The figure on the left is a portrait of my cousin, who has been a fisherman all his life and has the same name as myself, and the figure on the right represents age and wisdom.

> This is not Charon's boat, which was to feature so much in my later paintings, many of which were more despondent in atmosphere. Rather, this is a painting by a young man of twenty-four, full of optimism, with a vision of the world untarnished by the darker side of life he was sometimes to encounter in his future life.[1]

However, Bellany is emphatic that he does not want to dictate too literally the meaning of the picture, as he believes each viewer should bring his or her own interpretation to it. For example, the fish might represent the fecundity of nature. Bellany recounts memories of harvest festivals at a particular church, where fish were piled against the holy table. On the other hand, the fish may represent the ferocity of nature. The two figures, one historical, one symbolic, give a sense of the continuity between the living and the dead. Perhaps the boat is the barque of life, given purpose by the dignity of labour.

This painting has a dour, restrained quality that still opens up onto mystery and provokes questions about our affluent and comfortable world.

Charles Pickstone

Notes
1 Interview with the author, 26 September 1997.

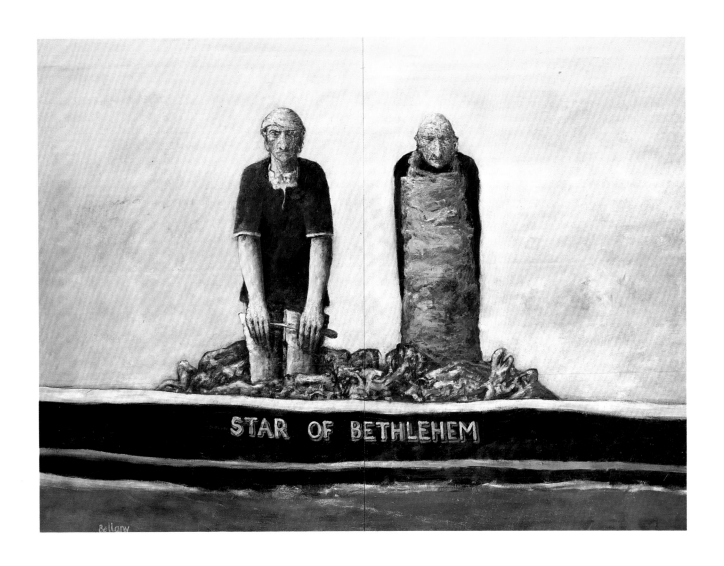

STAR OF BETHLEHEM

John BELLANY
1942–
Star of Bethlehem 1968
oil on canvas
184.1 × 245.4 cm
Tate Gallery, London. Presented by the Contemporary Art Society 1979
© John Bellany 1968
Reproduced by permission of John Bellany 1997

Speaking in questions

McCahon's artistic achievement lies in the metaphysical and religious vision that he explored to hold together landscape and belief. His early work, beginning in the 1940s, sought to place Christian biblical narratives within his native New Zealand landscape. McCahon used popular sources such as cartoon speech bubbles to transpose these stories into the present while leaving open their ambiguous contemporary references. His use of religious iconography in this manner presented critics and audiences alike with an embarrassing difficulty of interpretation.

Victory over death 2 (1970) confronts the viewer in terms of its vast size and form. An implied landscape, its elements are made up of texts drawn from the narrative of Jesus' words in the gospel of John (12:27–36). This text describes Jesus' experience of the torment of doubt and uncertainty in the midst of which he hears the words of God, the great 'I am. I am the one who is!'

The religious drama of the text is not simply illustrated but has undergone a painterly transformation. McCahon's characteristic folding and dividing of space is constructed by texts that range from architectural forms to calligraphic scratchings. Within the void of the left-hand side of the work there emerges a darkly shadowed or partly erased set of letters that turns the great I AM into an AM I? The folding of text and surface thereby creates an opportunity for questioning as both affirmations and erasures compete for final resolution.

McCahon completed a companion work during the same period entitled *Practical religion: the Resurrection of Lazarus showing Mount Martha* (1970), based on his readings of the biblical narrative of the resurrection of Lazarus (John 11). Reflecting on the story, McCahon said that it 'takes you through several levels of feeling and being. It hit me Bang! at where I was: questions and answers, faith so simple and beautiful and doubts still pushing to somewhere else. It really got me down with joy and pain'.[1]

The religious content of McCahon's work does not consist of a simple piety or an unthinking affirmation; rather, it is a dynamic form of negative theology. His painting is an act that erases what is peripheral in a radical commitment to encountering the divine essence. It is an act of folly, hopelessness or radical belief, and one that is not finally resolved within the space of the canvas. All the possibilities of faith and doubt are played out in text expressively applied and in light that emerges out of darkness. The great single letter 'I' acts as a crack of light, a beacon that emerges from the void, potentially splitting the canvas in two and yet at the same time finding itself enclosed within the space that sustains and permits all these possibilities of faith and doubt.

One is left to hold faith and doubt together as part of the conversation that defines the human, this dialogue about the experience and the definition of God.

Rod Pattenden

Notes

1 Colin McCahon, *Colin McCahon: A Survey Exhibition*, Auckland, Auckland City Art Gallery, 1975, p. 36.

Colin McCAHON

1919–1987

Victory over Death 2 1970

synthetic polymer paint on canvas

207.5 × 597.7 cm

National Gallery of Australia, Canberra

Gift of the New Zealand Government 1978

© Colin McCahon 1970

Reproduced by permission of the Colin McCahon Trust 1997

Out of an ancient culture comes the Mother.

GEORGE MUNG MUNG

After George Mung Mung died in 1991 while at initiation ceremonies in the Kimberley Ranges in Western Australia, his friend and fellow-elder, Hector Sundaloo (Jandany), the Ngapuny[1] man of the Warmun people said of him:

> He was looking forward to a blackfella way
> and a Kartiya[2] way
> He was a two-way man
> He was a very clever man for the Dreaming.[3]

The wood for this sculpture, *Mary of Warmun* (The pregnant Mary) (c. 1983), was cut by Mung Mung from a tree deep in the remote Bungle Bungle Ranges of Western Australia. The tools were an old car spring and an ordinary knife. The purpose was to make 'a Mary that will never break' (for the old plaster image of Mary had broken when the table was knocked over by the community dogs). The result is a sculpture that is at once deeply religious and immensely powerful. To create it, Mung Mung entered into his consciousness 'two-way'. He went down into his Aboriginal roots—into his belief in his ancestor spirits, in his responsibility to maintain right relationships with the land and his position as elder in the small community at Turkey Creek. But he also reflected deeply on his Catholicity, on the meaning of Mary as the Mother of Jesus and on the Incarnation. The work is a stunning reconception of the meaning and image of the Christian Mother and Child. It has no precedent in sacred art. Mung Mung's *Mary of Warmun* stands equal to any of the great images of this century.

The figure is that of a young, unmarried Warmun girl. Her body is painted with the traditional designs. She is pregnant and carries the child in her womb-shield beneath her heart. The unborn is already a man who dances within her.

Mung Mung, the traditional Warmun Aboriginal elder, said of her:
This young woman
she's a young woman, this one.
The spirit of the little baby
comes in a dream
to his mother.
Proper little one,
his mother says.
The babe grows and
he might be ready at
Christmas time.
He says,
Mother, I'm ready now.
And the old woman take her away
and the little one is born
down in the river here.[4]

Rosemary Crumlin

Notes

1 The god man, the spirit man.

2 Non-Aboriginal, 'whitefella'.

3 'Dreaming' is a summary term for Aboriginal story and myth and encodes a way of right living (law) in relation to the country. Spoken to the author.

4 Spoken in the presence of the author.

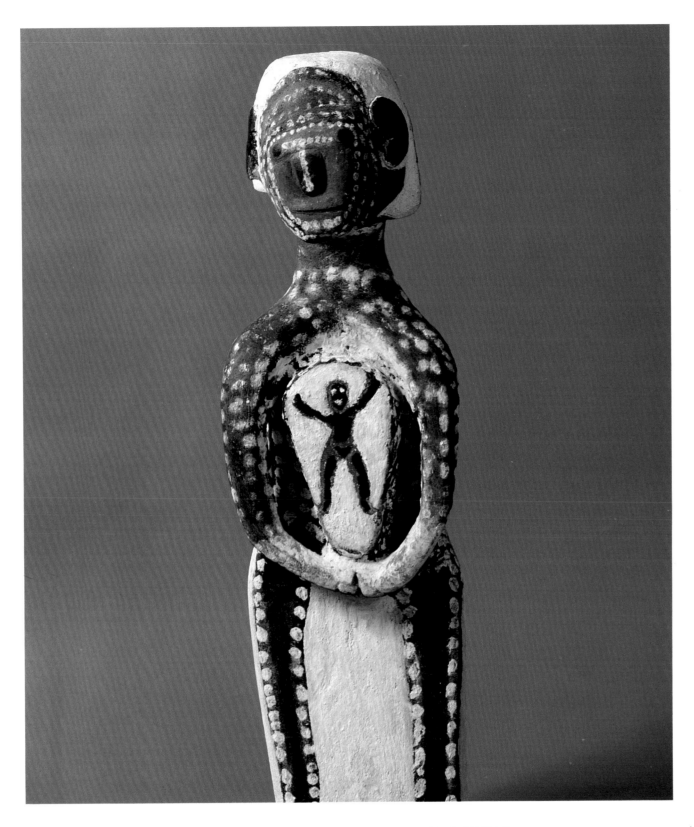

George MUNG MUNG
c. 1920–1991
Mary of Warmun (The pregnant Mary) c. 1983
carved wood, natural pigments
height: 64.0 cm
Warmun Community, Turkey Creek, Western Australia
© George Mung Mung 1983
Reproduced with permission of the Warmun Community

> Rover Thomas's *Yari country* represents important spiritual themes: creation, death and transformation, the unity of spirit and substance and the interconnectedness of all living things with the land.

Rover Thomas's *Yari country* (1989) pares down to its essence the story of an old spirit man, one of the *Wati kutjarra* (two men) of Kukatja/Wangkajunga mythology. There was a drought in the *Ngarrangkani* (Dreaming) and the old spirit man was perishing of thirst. He reached *yari* (the milky-water billabongs) and knelt down to drink the cloudy water to excess. Once he had quenched his thirst he found that the water was poisonous. He soon doubled up with pain and could no longer walk, so he decided to make camp and lit a fire to keep warm. The fire raged out of control and the old man, unable to escape from the force of the flames, was burnt to death. At this point in the landscape, the old man's spirit entered into and became the land. The vertical black bar in the work represents the old man's club and invokes his eternal presence in this country.

This complex spiritual narrative is condensed into an abstract composition of great sophistication that resembles a Mondrian in ochres. The old man's story begins in the lower right, the red-ochre section that indicates *wala* (desert), where he was dying in country ravaged by drought. This desert section is hemmed in on two sides by white expanses representing *yari* (milky-water billabongs), where the old man bent to drink and then retreated to light a fire, shown in the upper left blackened rectangle that represents *junpa* (charcoal fire). The long white shape indicates reeds on the bank of the milky billabongs.

Thomas has used a colour symbolism that is grounded in observation to conceptualize a complex story with many layers of meaning. Red ochre is the colour of red-earth desert country, like that near the artist's birthplace at Kukubanja (well 33) on the Canning stock route. White indicates cloudy expanses of whitish, poisonous water characteristic of the water of Sturt Creek, also called 'milk water', which runs into Lake Gregory. Charcoal, the colour of burnt-out land, suggests the charred remains of the old spirit man, who metamorphosed into the land. The colours of the elements—earth, fire and water—symbolize the harsh vicissitudes of desert existence and enable the viewer to picture the drama of the old man's ordeal and death.

As we have seen, Rover Thomas is concerned to distil and reveal what lies within the order of things, rather than to replicate through mimesis the concrete surface or physical appearance of the natural world. Unlike some Western artists, Thomas is not concerned with the mirroring of nature or with using his brush as a camera. Rather, he reveals a deep spiritual affinity with the land and the sacred narratives that it holds.

Whether or not the viewer is familiar with the spiritual narrative which lies behind *Yari country*, or its precise geography rendered in planar perspective, the work commands attention for its sheer geometry of design—four rectangles within a rectangle. Yet beyond the rigour of its composition is the organic life of the paint layer of pipe clay, charcoal, red ochres and plant fixatives gathered from the land. Matt and raw in texture, the painted surface forms a metaphor of the land itself: the metaphysical and the cosmic are evoked within the concrete.

Judith Ryan

The unimaginable is presented pictorially.

HARALD DUWE

It was on the occasion of a walking-tour in Germany that the painter Harald Duwe entered into a vivid discussion with his friends about whether the painting of Christian subjects was still possible in our days. The artist's answer to the question was his painting *Last Supper* (Abendmahisbild) (1978).

The picture shows a group of male persons around a dinner table, on which—besides bread and wine—the heart, the head, the hands and feet of Christ are being served. The realism in the presentation of this traditional subject is to be seen, among other details, in the fact that the faces are those of actual, living persons. We recognize the painter himself in the man holding a spoon in his hand. The other men grouped around Duwe are his friends, who took part in the initial discussion. Their faces, their haircuts, their gestures and clothes are portrayed in the utmost detail. It is not 'modern man' or any other abstract being that is shown in a relationship with God, but this special group of people who can be identified by their faces and their names.

Yet there is more in the painting than just portraits. The attention of all the participants in the meal is focused on the dishes that are served on the table. The meal consists of parts of Christ's body: His head in a bowl, His heart on a tin plate, an open hand and a cut-off foot. The words of the Eucharist have been taken literally: Christ's body is offered to be consumed.

By not clinging to a symbolic meaning and by renouncing all possible hints or allusions, Duwe challenges his viewer. Parts of Christ's body, brutally cut off, are depicted as a real meal.

He who will be eaten reaches the same evidence of reality as the really-existing persons portrayed in the painting. Christ is in fact among them.

What will the reactions of the people around the table be like, confronted with such a meal? This is the question Duwe is asking. He opens up a deep dimension of problems, worthy to be dealt with by anthropologists, psychologists of religion and sociologists, which means a wide range of questions is provided on different levels.

This kind of realism cannot be blamed for being 'flat', as for instance an expressive presentation would. The effect of Duwe's particular realism becomes evident in view of the religious implications of the theme: in a field where we are used to thinking 'symbolically' and not 'literally', Duwe confronts us with tangible concretion and a face value that may result in a shock for the viewer.

The unimaginable is presented pictorially: what would happen if, in real life, a group of friends found the crucified cut into pieces on a dinner table? It is this very moment of discovery that is caught by the painter, and he enables the viewer to follow the different reactions of the persons portrayed. They range from astonishment, hesitation, fright or consideration, to approval or even a shy grin.

The viewer is not excluded from the scene, the less so because the whole width of the laden table is spread before his eyes. Thus, all viewers themselves are involved in the action.

A single Judas is not specifically exposed. In a talk about this painting, Duwe explained that all men were Judas, and that the Christian Occident had cut Christ's body into pieces exactly like this.

Horst Schwebel
Translated by Linda Degenhard

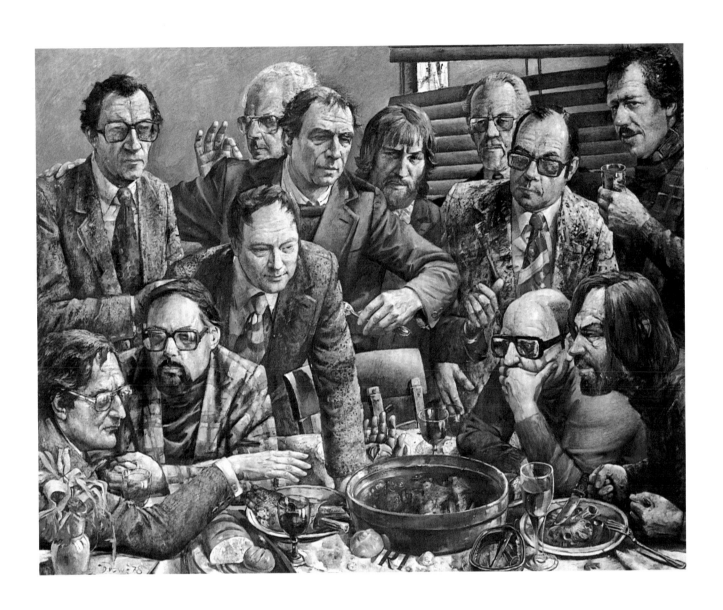

Harald DUWE
1926–1984
Abendmahlsbild (Last Supper) 1978
oil on canvas
160.0 × 280.0 cm
On permanent loan from Mrs Fincke, Berg, Germany
© Harald Duwe 1978 / Bild-Kunst
Reproduced by permission of VI$COPY Ltd, Sydney 1997

All that remains ...

The German painter Ben Willikens took Leonardo da Vinci's *Last Supper* (1495–97) (p. 22) in the refectory of Santa Maria delle Grazie in Milan as a starting point for his three-piece acrylic painting. Jesus and His disciples have been removed, whereas the room's interior perspective has been maintained.

We look into a sterile, tiled room with a long, horizontally-stretched dinner table. The smooth white tablecloth and the table with steel legs and rubber supports emphasize the general impression of emptiness and cold. Instead of the colourful wall tapestries on the side walls in Leonardo's painting, we now perceive grey, closed steel doors, similar to those in prisons or factories. Grey as the colour of asphalt and street dust returns in manifold nuances—a further contrast to Leonardo's painting, which abounds in colours, persons and gestures.

A visitor to the German Museum of Architecture in Frankfurt-on-Main, facing Willikens' painting in the central hall—which was designed for lectures and exhibition openings—will first be impressed by the sheer size of the picture. He will then almost automatically be drawn into the swirl of a perspective that reveals nothing but 'merciless' cold, and emptiness. The memory of Leonardo, as a contrasting connotation always present in the act of perceiving, works as a reinforcement of this effect.

But once having accepted guidance into the picture to this point, the viewer will become aware of a change. His eyes wander through the centrally-placed door, crowned by an arch, through the two adjacent windows into a second room, which is filled with glistening white light. The colour white, which makes the backroom undefinable, seems to have its own dynamic power, bringing the light from behind to the foreground through the door and the window openings. Thus the viewer, having first accepted the grey melancholy of emptiness, is being rewarded for his steadfastness as he gets his share of the emanation of light from behind.

If we look at other drawings and sketches for *Last Supper* (Abendmahl) (1976–79) by Willikens, we notice that we are always faced with different constellations of space and light. Light becomes the medium of a transcendent power, which gives a new dimension to the sterile, bleak rooms. Yet only those who previously accepted a visual participation in an imaginary group of people around an empty dinner table within the grey coldness of the room can achieve this experience of transcendence when looking at *Last Supper*.

In theology, iconoclasms have always been justified by the notion that God is incomprehensible, and that man has no right to dispose of Him. God is beyond the contents of human imagination, which bars the door to transcendence by concrete connotations. In the field of visual art, the fight against imagery and the flood of connotative pictures is just as well documented. Here, too, we are confronted with a negation in the shape of an addition that would not have been perceivable otherwise.

Art is approaching a borderline where it reaches contemplation via negation, as a clarifying road to mysticism.

Horst Schwebel
Translated by Linda Degenhard

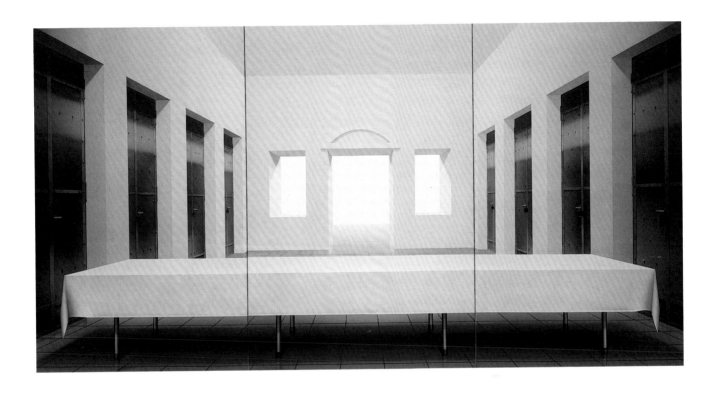

Ben WILLIKENS
1939–
Abendmahl (Last Supper) 1976–79
acrylic on canvas
triptych 300.0 × 600.0 cm
Deutsches Architektur-Museum, Frankfurt am Main
© Ben Willikens 1976 / Bild-Kunst
Reproduced by permission of VI$COPY Ltd, Sydney 1997

BEYOND BELIEF: MODERN ART AND THE RELIGIOUS IMAGINATION

135

The artwork as mystery play and political comment.

WERNER TÜBKE

Werner Tübke's art appears to stand outside all contemporary art movements. As the expression of a detached and even problematic and enigmatic world-view, his art can be described as a specific figurative and metaphorical mannerism, in which inner visions and reality influence and penetrate one another in complex layers. The subject matter is of enduring archetypes often represented in historical figures. One significant example is *The end of the Fools' Court Judgment* (Ende der Narrengerichtsbarkeit) (1978). This is a preliminary work for a large commissioned epoch painting, which, in the artist's own very personal way, depicts the turning point from the late Middle Ages to the modern era.[1]

The Court of Fools was part of the late medieval Shrove Tuesday tradition in South West Germany and parts of Switzerland. Through playful ritual enactment, it gave people the opportunity, especially in times of crisis, not only to reveal and mock—after the fashion of fools—the sins and offences of their neighbours, but also to expose, without being punished, the misdeeds of the authorities and to pillory them symbolically in the guise of a fool. Just such a Fools' Court is supposed to have been the prelude to the 'Poor Conrad' peasant revolt against the tyranny of the rulers in Würtemberg in 1514, one of the events leading up to the German Peasants' War of 1524–25, which gives the thematic background of the gigantic panoramic painting of Bad Frankenhausen.

Yet Tübke does not portray this historical incident; instead, he transforms the subject into a highly stylized mystery play that draws upon Christian iconography as well as historical facts. At the centre of the picture, a fool is bound to the cross. Beneath him stands a woman, a sinner, a magdalene. She holds a telltale money purse, while the sign of her unchaste life, a pig's mask, lies at her feet. Behind her the scales of justice rise bearing a red lily, another symbol of shameful guilt. The 'Eve' on the right hands her apple to a fool in monk's clothing, while the sacrificial animal bleeds to death watched by the Virgin mother. On the left, an angry messenger of God, pointing to the Scriptures which hang from the bridge, bestows the palm of martyrdom on the chosen and enlightened one—a frightened and reluctant peasant. The overturned horse mask may identify him as a hero in the Christian sense, bringing light and peace, as well as a heretic, whose fate will be fulfilled in that of the crucified. On the basis of Christian motifs, criticism of sinful behaviour and of intolerable taxes resulting in the demand of an armed revolt are linked to the vision of divine justice. On the bridge above, open battle is already in progress.

Tübke, whose work can be read also as a sharp political comment on the artist's present society, has set the scene against a splendid trans-alpine mountain background—the Aosta Valley in Northern Italy, which he visited in 1978. Involved with the Commedia dell'Arte at the same time, he was also interested in the figure of Arlecchino. Increasingly combined with each other, both the motif of the fool and that of the harlequin fascinated the painter; they announced the truth, uttered warnings yet remained tragic figures. Their ambivalence offered him the possibility of giving effective expression to his inner self without having to reveal himself fully. Indeed, he was able to discover a figure with whom to identify, one that defied simple, clear-cut definition.

Gerd Lindner
Translated by Pauline Smith RSM and Claudia Luenig

Notes

1 This work, called *The Early Civil Revolution in Germany* (1983–87), hangs in the Panorama Museum of Bad Frankenhausen in East Germany.

Werner TÜBKE
1929–
Ende der Narrengerichtsbarkeit (The end of the Fools' Court Judgement) 1978
mixed technique on wood
89.3 × 70.7 cm
Museum Panorama, Bad Frankenhausen
© Werner Tübke 1978 / Bild-Kunst
Reproduced by permission of VI$COPY Ltd, Sydney 1997

The cross-shape, sign and symbol—is the starting point:
'I listen for inspiration … it says 'yes' to me when I gaze at it. *Arnulf Rainer*[1]

Arnulf Rainer in conversation with Johannes Röhrig

Johannes Röhrig Herr Rainer, the cross as shape, sign and principle of form appears in all periods of your work as an artist. In itself, the sign is a geometric form. But in our culture it is connected with the death of Christ and the portrayal of salvation history. Why do you keep going back to the cross as an instrument of form?

Arnulf Rainer As a first step I grasp at this sign. A new form of the cross can develop. I listen for inspiration in that part of the picture with compelling meaning, and weighty metaphor, in respect to the structure of the picture. A shape only gradually crystallizes.

JR In your early work one does not necessarily have to see in your painting of the cross a reference to Christian icons. Only later are photographs of statues of Christ—for example, parts of the head—superimposed in your work. Later still, in the 1980s, Christ figures and Christian devotional items are integrated. Is this paradigm change more about the artistic ongoing development and dynamism of an original form once discovered, or do spiritual motives play a role?

AR You imagine that in an artist the spiritual motivation and his visual form-creating are different: an upper and a lower room. No. No art can come out of this Manichean view. At least, no pictures. The reference to tradition through the connection of historic images is always only a sort of step. Through strong, lengthy, continual painting-over that is really an absorption, these devotional objects can sink down. Often completely, sometimes partially. Whatever the state of the picture requires. It says 'yes' to me when I gaze at it. Otherwise it would be forbidden to me to keep fiddling with it.

JR One of your earlier crosses, which was with you over two decades, is the *Wine crucifix* [1957/78]. It has had a strange journey: first painted by you as an exercise for a university chapel, it was later removed by the congregation from the church. You got it back and worked over it in a rather lengthy process. Finally, after several intermediate steps, it was obtained by the Tate Gallery, London. In short, one of your crosses travelled from art studio to the Church and from there back to the secular world. Today there is an opposite situation: many communities would like to buy a Rainer cross to hang in their churches. How do you explain this change in attitude?

AR Works of art are only really treasured—looked at closely and with respect, understood better—when some external sacrifice is involved. It is the same with myself and with my own work. Through a complicated, expensive process of buying it back, through its path from altar to studio, there was enough motivation for me not to hide this cross but to improve it by adding special Christus figuring, to take it further and so to complete it. Because of a specific English taste it unfortunately came later into the Tate Gallery. An early, dark 'Spanish cross' would seem to suit the space better. Perhaps they will exchange it for a bigger one if they realize it actually belongs in a church. In any case, it is never the community but always the priest who is going to kneel before a Rainer cross. That basically does not change, even with the death of the artist.

Arnulf Rainer and Johannes Röhrig

Notes
1 Excerpted from this interview with Arnulf Rainer.

Arnulf RAINER
1929–
Wine crucifix 1957/78
oil, cotton, linen
168.5 × 103.0 cm
Tate Gallery, London. Purchased 1983
© Arnulf Rainer 1978
Reproduced by permission of Arnulf Rainer 1997

I do not wish to separate the idea of suffering by allowing just the male to be seen.

Arthur Boyd[1]

ARTHUR BOYD

An outstanding aspect of the art of Arthur Boyd is its remarkable diversity. As a painter, potter, sculptor and printmaker, Boyd has continuously explored images that have alternated between landscape and figurative subjects. Intensely personal, these works remain universal in their expression. Biblical, literary and mythical sources have provided Boyd with a wealth of imagery and inspiration, and his deep interest in biblical stories reflects the strong religious background which he absorbed as a child from his grandparents and parents.

Boyd's preoccupation with the landscape of the Shoalhaven area, near Nowra in southern New South Wales, began in the summer of 1971. Awarded a Creative Fellowship at the Australian National University in Canberra, Boyd returned to Australia after living for more than a decade in the United Kingdom. He visited the Shoalhaven River during the height of summer and began painting *plein-air* landscapes:

> I can remember the day vividly. It was so hot and searing that the oil ran from the palette onto the sand. I never paint in the shade or wear a hat because it distorts the light on whatever I'm painting. But I can remember the heat was terrifying.[2]

In 1974 Boyd purchased a property nestled in a small valley adjacent to the Shoalhaven River, and moved there the following year. From the living room he watched the Shoalhaven River meandering into the east, flanked on the left by a large hill plunging sheer to the water. He quietly observed the various times of the day and Australia's seasons, which include drought and flood.

A commanding work of great stillness and beauty, *Crucifixion, Shoalhaven* (1979–80) combines dazzling light and distinct landscape with Christianity's most powerful symbol—the crucifix. Boyd divides the composition into thirds, 'as if the water, the sky and the land are completely different identities'.[3] The image of a full-frontal nude female figure hung on a cross, suspended above the muddy waters of a river in the remote landscape of New South Wales, provides a shocking alternative to a familiar Christian theme, so thoroughly depicted by the great masters of Western art.

By breaking with a two-thousand-year tradition and placing a woman on the cross in an Australian landscape, Boyd challenges preconceived notions of gender and cultural identity.

'I do not believe it is enough to say *he* represented all of us. I do not wish to separate the idea of suffering by allowing just the male to be seen. There has been an awakening consciousness of the potential and force of women in our time.'[4]

'The idea of imposing a thought on the landscape began with the Greeks and the Christian tradition—in a way it was to get rid of it. Putting all this in an alien antipodean wilderness is an idea that attracts me.'[5]

Boyd's allegorization of the Australian wilderness imposes an historic and intellectual past onto the landscape. In *Crucifixion, Shoalhaven* the artist acknowledges the attempt of Europeans to force on the land of the Aboriginal an alien culture and civilization. At the end of the millennium Boyd produces a powerful image that grapples with the complexities of reconciliation between indigenous cultures and their colonizers.

Geoffrey Smith

Notes

1 Arthur Boyd to Rosemary Crumlin, *Images of Religion in Australian Art*, Sydney, Bay Books, 1988, p. 158.

2 Arthur Boyd, quoted in Sandra McGrath, *The Artist & the River: Arthur Boyd and the Shoalhaven*, Sydney, Bay Books, 1982, p. 20.

3 Arthur Boyd, quoted in McGrath, ibid., p. 112.

4 Rosemary Crumlin, op. cit., p. 158.

5 Arthur Boyd quoted in McGrath, op. cit., p. 256.

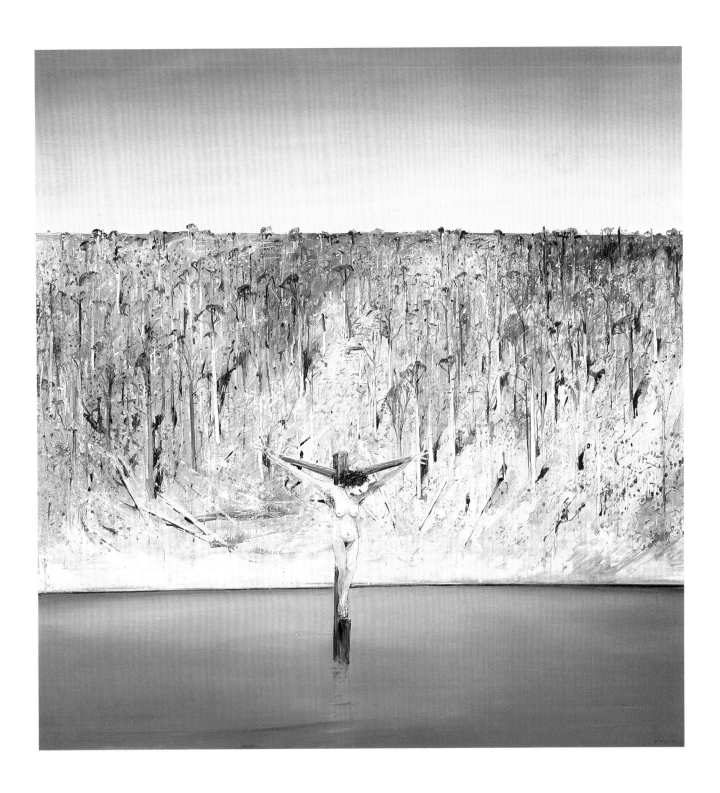

We are the material to be dissolved.

Agnes Martin[1]

<div style="writing-mode: vertical">AGNES MARTIN</div>

In 1967 Agnes Martin, then aged 55, withdrew from the personal and professional demands of New York, at a moment when her work was achieving widespread acclaim, in order, as she stated, 'to have my mind to myself'.[2]

Untitled #8 (1980) exemplifies two significant aspects of the second phase of Martin's mature career. First, while her earlier works had a tremulous linearity and grids of often minute structural division, her post-1974 painting is characterized by the employment of luminous translucent colour and broad spatial divisions. Second, after seven years' recess in the landscapes of Canada, the American West, and New Mexico, Martin returned to painting, spiritually reconnected to the philosophies that guide her life and art.[3] This shift in her work is readily perceived in the assurance and conceptual immensity of *Untitled #8*. It is this sense of immensity that has often brought her paintings within the discourse of the 'abstract sublime'. However, Martin's work is primarily an art of humility and humanity.

Martin has stated that her work is about 'perfection as we are aware of it in our minds but … the paintings are very far from being perfect—completely removed in fact—as we ourselves are'.[4] In order to perceive perfection in our lives (and here she refers to our comprehension of seemingly ordinary activities like contemplating the ocean or the wind) Martin continually emphasizes the need to distinguish between the 'untroubled mind'—the inner locus of inspiration and absolute truths—and the outer mind, clouded with worldly distractions. Martin has said of one of her meditative works that she likes the painting because 'you can get in there and rest'.[5]

Untitled #8 is, like most of her canvases, human in scale. Viewing her painting at close range gives rise to a strong communion between the body, the materiality of the work, and its allusion to limitlessness. Here is where the attachment of Minimalism's cool austerity and its disavowal of content and metaphor begin their slide from the surface of her painting. A sense of transcendent reality is central to Martin's work and to her adoption of the grid as an ideal, impersonal and detached format. The grid provides a simplified but not simple visual vocabulary with which Martin articulates 'wordless', abstract, but fundamental human emotions for which no other language exists.

Empty of references to the material world and overt personal expression, Martin's paintings are completely open to the multiple experiences and conditions of the observer who stands before them. They offer an experience of utter serenity and timelessness.

Jason Smith

Notes

1 Statement by the artist from 'The Untroubled Mind', first published in 1973. In *Agnes Martin* (exhib. cat.), New York, Whitney Museum of American Art, 1992, p. 19.

2 See Barbara Haskell, 1992, 'Agnes Martin: The awareness of perfection', in *Agnes Martin*, ibid., p. 111.

3 Agnes Martin's writings identify her primary philosophical concerns. Barbara Haskell and Anna Chave also note the importance of Buddhist and Taoist philosophies in Martin's life and work.

4 Statement by the artist from 'Notes', first published in 1973. In *Agnes Martin*, op. cit., p. 25.

5 Statement by the artist from 'The Untroubled Mind', op. cit., p. 14.

Agnes MARTIN
1912–
Untitled # 8 1980
gesso, synthetic polymer paint and pencil on canvas
183.3 × 183.6 cm
National Gallery of Australia, Canberra. Purchased 1981
© Agnes Martin 1980
Reproduced by permission of Agnes Martin 1997

Circle: Universally accepted as the symbol of eternity and never-ending existence. As the monogram of God, it represents not only the perfection of God but the everlasting God, 'Who was in the beginning, is now, and ever shall be, world without end'.

Mimmo Paladino[1]

Mimmo Paladino, one of the leading exponents of the movement known as the International Trans-Avantgarde, came to prominence in Italy at the end of the 1970s. His painting has always been concerned with story-telling and the exploration of myth. Paladino has drawn inspiration from the man-made artifacts and relics of the region of his birth. The mask-like faces in his paintings are strongly reminiscent of the Lombardic sculpture that can be found throughout Benevento—often reused in later buildings. In Paladino's painting, figures and symbols borrowed from medieval art are similarly appropriated and put to a new use.

Paladino stated that 'painting is a liturgical action and a state of mind'.[2] *Scorticato* (1983), which means 'the flayed one', can be interpreted as a depiction of the scourging of Christ as it is commemorated in the 'reproach' contained in the Good Friday liturgy: 'For thy sake I scourged Egypt with her first-born, and thou hast led me to be scourged. I led thee out of Egypt submerging Pharaoh in the Red Sea, and thou hast delivered me unto the High Priest'.[3]

The work is dominated by a great wooden cross from which hangs a flayed human figure. From this figure a ghostly form rises. Throughout the canvas many Christian symbols can be found. The cross, the eagle (representing the resurrection), and the Holy Face—the miraculous imprint of the visage of Christ on the veil of Veronica. There is an enigmatic mitred head in the lower centre of the canvas that might well represent the High Priest referred to in the liturgical 'reproach'. The choice of red as a ground is surely determined by the use of that colour in the medieval church as a symbol for martyrdom and resurrection. It also serves to remind one of the Red Sea, where the God of the Old Covenant worked his great miracle for Moses.

However, for all of its reliance on the imagery and symbolism of the Christian past, this work bears no relationship to any traditional iconographic scheme. The flayed figure is a potent metaphor of human suffering and abasement that dates well before the Christian era, exemplified by the myth of Marsyas, hung on a tree and flayed alive by Apollo after losing to the god in a musical contest. Paladino would see his work as depicting both the scourged Christian Saviour and the flayed Marsyas, seeing in both something of the condition of humanity at the end of the twentieth century.

Gordon Morrison

Notes

1 In George Ferguson, *Signs and Symbols in Christian Art*, London, Oxford University Press, 1973, p. 153.

2 Helmut Friedel, 'A conversation with Mimmo Paladino', in *Mimmo Paladino Arbeiten von 1977 bis 1985* (exhib. cat.), Städtische Galerie im Lenbachhaus, München, 1985, p. 143.

3 Good Friday Service, 'The Reproaches: II'.

Mimmo PALADINO
1948–
Scorticato (The flayed one) 1983
wood and oil on canvas
300.0 x 300.0 cm
National Gallery of Victoria, Melbourne
Presented through The Art Foundation of Victoria with the
assistance of the Gualtiero Vaccari Foundation, Governor 1984
© Mimmo Paladino 1983
Reproduced by permission of Mimmo Paladino 1997

> I can't say how it should look, and can't say 'Now I am going to draw'. I need much more patience with myself so that I can say 'Now is the time'.

HERBERT FALKEN

Herbert Falken's works *Pregnant man with two others* (Schwangerer Mann (Selbdritt)) (1981) and *Sachalin-Death* (Sachalin-Tod) (1983–84), at first sight recall traditional images of the crucifixion: images of Christ on the Cross accompanied by the two thieves. Yet the second time one looks at Falken's images, one sees that they differ substantially from what was commonly portrayed. For Falken shows Christ as a pregnant man and as a skeleton. These are images that question not only Christian iconography but also Christian theology. When the artist—as he continues to do throughout his entire *oeuvre*—concentrates on themes referring to the Bible, such as *Jacob's ladder*, *Jacob and the angel*, *Passion* or the *scandalum crucis*, his works go beyond illustration and simple narrative. And when he decides to focus on existential human challenges, on humanity captured by the boundaries of its *conditio humana*—that is, on illness, addiction and death as substantial elements of life—then fundamental questions about God and human striving for religious certainty can be discovered in Falken's drawings. Although of utmost theological significance, his work is that of an artist.

Often, the experience of social and political entanglements becomes the starting point for his artistic search. *Pregnant man with two others* was initiated by the then current discussion in Germany about abortion. The drawing shows three figures on the cross. With the history of the crucifixion-motif in mind, the figures are perceived, initially, as men, the dominating one as Christ. Yet these figures, whose heads strongly resemble skulls, are pregnant, and their bellies seem to bear skulls rather than embryos. Ambivalence pervades the drawing, raising considerations about meaningful relations between belly and earth, womb and grave, embryo and corpse, birth and death and rebirth, and, not least importantly, causing reflections about the Crucified.

The painting *Sachalin-Death* was a response to the incident in which a Japanese airliner crossed Soviet territory above the island of Sachalin[2] and was shot down as a military aggressor. More than three hundred tourists from different nations lost their lives because of this act of violence. To know of this is interesting, but not knowledge necessary for the perception of the painting. *Sachalin-Death* again mirrors the traditional Golgotha scene, although the figure of Christ is presented as a shining white skeleton, the upper part of the body bending forward, rising from the dark, in front of an inferno of flames. It prompts associations with late-medieval depictions of the Last Judgment, as well as those with disasters wrought by fire and nuclear war.

To look at these two works only is like concentrating on just one star in the Milky Way. Many of Falken's artistic subjects are not touched. Especially important are hundreds of small sheets, begun in 1975, which range from quick sketches to elaborate drawings revolving around images of clown, dancer, woman in correspondence with earth, man in the stocks, swimmer, and winged man. Comments inscribed in Falken's own hand often reveal his critical attitude towards his own artistic work or, among other things, are critical statements referring to political occurrences. All such work makes it evident that Herbert Falken's art is deeply rooted in this sensitive, individual way of experiencing the profound uncertainty of human existence. Not only questions beyond belief, but questions of vital significance arise for the viewer of Falken's images.

Katharina Winnekes

Notes

1 In Franz van der Grinten & Friedhelm Mennekes, *Menschenbild Christusbild*, Katholisches Biblework Gmbh, 1984.
2 In 1855 Japan and Russia established joint government over the island. In 1875, Sachalin went completely to Russia; in 1905, Japan regained the southern part which, in 1945, fell again to the Soviet Union.

Herbert FALKEN

1932–

Schwangerer Mann (Selbdritt) (Pregnant man with two others)

1981 *(facing page)*

indian ink, oil, graphite, crayon on paper

160.0 × 78.0 cm

Erzbischöfliches Diözesanmuseum, Köln

© Herbert Falken 1981

Reproduced by permission of Herbert Falken 1997

▲

Sachalin–Tod (Sachalin–Death) 1983–84

oil on canvas

200.0 × 140.0 cm

Erzbischöfliches Diözesanmuseum, Köln

© Herbert Falken 1983

Reproduced by permission of Herbert Falken 1997

One lives in the hope of becoming a memory.

Antonio Porchia[1]

JAMES BROWN

James Brown's painting, *Portrait of Christ* (1984), opens itself slowly, creates its own quietness, calls for a fullness of silence. Unlike many traditional and more detailed depictions of Christ, this image has a spare eloquence—a poetic precision of shape, line, colour and sign reverberative with associative power. It does not confine but releases response. Imbued also with the epic quality of deep historical narrative, the painting reflects the artist's keen interest in anthropology, religion and ethnography. Multilayered, it bears enigmatic and interpenetrating imprints of a lived and living history.

Portrait of Christ both contains and transcends many of Brown's earlier images—the more familiarly defined head in *Elegua with a big cross* (1982), and the horned, magical, flattened heads of *Horse shoes and crosses that's good luck* (1982), that, like the opaque mask-like *Large heads* (1983), take on the shape of shields. These heads emerge variously as effigy, totem and idol, as art-within-art, as present-within-past and as past-within-present. Relationships seem those of question rather than of identity. Brown's sophisticated works carry the insignia of the primordial like a shield, even as they reveal that there is a shield. What lies behind the shield, the mask? Mystery calls for entry, not explanation. Brown's works do not say; they *are*.

So it is with *Portrait of Christ*. Invested with a kind of transparency, the face of Christ wears markings of the artist's explorations in his earlier works. The painting echoes and has echoes in two thematically-linked works, *The good thief* (1984) and *The sad thief* (1984). The Christ-portrait wears the sorrow of *The sad thief* and the serenity of *The good thief*, while the face of *The good thief* is marked more pronouncedly, like Christ's, with the sign of the cross.

Indeed, *Portrait of Christ* is many images in one. To be found here are the features of the suffering and human Christ, of a regal deity, of the artist James Brown, of humankind throughout history, and of us—the viewers of the work—as we stand before it and place ourselves in it. Each visage is somehow inscribed on and in the other. There is other inscribing. Beside as well as upon the cross-marked face of Christ, is an outlined coffin shape. As outline, it might also be a passageway. Meaning, it seems, lies in the gaps, awaiting the creative interaction of the viewer.

Similarly, economy of line concentrates the image and holds fast the gaze of the beholder. Dark lines strengthen the Christ-face, investing it with a strangely stark beauty. Interacting with this darkness are softer-hued blues and greys, emblematic of crucifixion and death, yet also somehow calm and resolved. The mood is sombre, quiet and deeply contemplative.

The large size of the work and its spaciousness invite a walking into, a going within and through the image. Such openness allows no assurance of arrival point or final certitude. For though this *Portrait of Christ*, with its overlay of traces crossing boundaries of time and peoples and religions, suggests an immanent God, an *Emmanuel*, a God-with-us, there remains the evocation of a masking, of presence and absence, of what is not, and cannot be, seen. The challenge is surely as much to art as to religion. The quest of history, of belief and of the artist continues in all its hope and vulnerability.

Margaret Woodward

Notes

1 Antonio Porchia, *Voices*, trans. W. S. Merwin, Chicago, Big Table Publishing Co., 1969, p. 48.

James BROWN
1951–
Portrait of Christ 1984
enamel, oil and pencil on linen
167.0 × 167.0 cm
James Brown
© James Brown 1984 / ARS
Reproduced by permission of VI$COPY Ltd, Sydney 1997

Transcendence comes through explicit articulation of the human body in art.

George Segal[1]

GEORGE SEGAL

In the 1950s and 1960s, when artists such as Newman and Rothko advocated abstract expressionism as the way to express and experience the transcendent, Segal's sculptures featured isolated individuals or multiple noncommunicating figures reminiscent of characters in Sartre's existentialist play *No Exit*. Since the mid 1970s, Segal has created many sculptures in which biblical figures interact: Abraham and Isaac confront one another in *The sacrifice of Isaac* (1973), and *In memory of May 4, 1970: Kent State — Abraham and Isaac* (1978). Abraham embraces Ishmael in *Abraham's farewell to Ishmael* (1987). Eve emerges from the side of Adam in *The Holocaust* (1984); and we contemplate climbing a ladder to heaven with *Jacob and the angels* (1984–85).

The Expulsion (1986–87) combines the dynamics of Segal's earlier existentialist works and his more recent biblical ones. There is a sense of loss and loneliness as the wall of flame behind them bars Adam and Eve from paradise; but the two figures move together in a new direction. While they do not have eye contact and do not touch, their bodies resonate with each other as their right legs stride forward and their shoulders and arms assume similar shapes.

In a recent conversation (25 September 1997), George Segal provided his own comment on this work:

Doug Adams When I look at *The Expulsion*, I think of *Abraham's farewell to Ishmael*, completed around the same time, with its related theme of expulsion or leaving. What led you to choose this theme?

George Segal 'All my sculptures on biblical subjects were based on my restlessness: after having made a series of works on people in daily circumstances, I was hunting for a way to refer directly to their inner life of morals, ethics and learned beliefs, in addition to revelation of their feelings. Few friends of mine had much knowledge of Greek myth. More seemed at least familiar with the *Old* and *New Testament*.

I was drawn to the modernity of the characters in Genesis. Their complexity and contradictions seemed remarkably similar to my own and those of my close friends. I thought I could project all of our reactions in the interpretation of these multi-layered myths, given the paucity of adjective, the austere biblical narrative and the almost total lack of information about what the major participants were feeling.

DA You carefully select your models for each sculpture and then interact with them, so the sculpture develops differently than if you'd selected others as models. Who were the models, and what did they contribute to *The Expulsion*'s development as you worked with them?

GS The model for Adam was a young friend, a talented photographer, son of a survivor of the camps. Eve was one of his current girlfriends, intelligent, willing to do what we asked. Adam wanted me to portray him totally nude. I disagreed, pointing to his newfound shame of nakedness after his expulsion from his innocent immortality.

DA In your *Holocaust* sculpture, you included figures of Adam and Eve after the Fall. How would you compare Adam and Eve in *The Expulsion* with Adam and Eve in *The Holocaust*?

GS My same photographer friend and a different woman posed as Adam and Eve in the *Holocaust* sculpture. This was a totally different situation: they were being asked to play dead, collapsed on the floor, with some reference to identify them as Adam and Eve. Together we chose the apple to be in her hand. In *The Expulsion*, I transformed the angel's flaming sword into a painted wall of fire to prevent their return to Paradise. Now Adam and Eve inhabit our worldly space. Created immortal, they are now mortal like the dead tree. They are ashamed, naked, condemned and rewarded by this life we know and share.

Doug Adams

Notes

1 George Segal quoted in Doug Adams, *Transcendence with the Human Body in Art: George Segal, Stephen de Staebler, Jasper Johns, and Christo*, New York, Crossroad, 1991, p.14.

George SEGAL
1924–
The Expulsion 1986–87
acrylic, painted on plaster and wood, and tin (tree)
320.0 × 366.0 × 213.0 cm
Courtesy Sidney Janis Gallery, New York
© George Segal 1986
Licensed by VAGA, New York, NY

> It is not surprising that this religious man finally got round to doing religious paintings.
>
> *John Richardson*[1]

ANDY WARHOL

In 1984, Andy Warhol did a series of prints and canvases entitled *Details of Renaissance paintings*. These were based on religious paintings by Renaissance masters. These *Details of Renaissance paintings* are Warhol's selection from the data bank of art history, showing the revisionist thrust of postmodernist twentieth-century art, as Robert Rosenblum has observed.[2] Other artists were appropriating and recreating the great art of the past, often with an ironic or sardonic twist. Warhol's manipulation of these Renaissance paintings occurred through radical cropping, so that the subject matter of the original is all but unreadable. In addition, the subtle and darker palette of the Renaissance masters is replaced by the cacophony of Day-Glo colours that assault and delight the eye.

Warhol's *Details of Renaissance paintings (Leonardo da Vinci 'The Annunciation' 1472)* (1984) is based on a very early painting by Leonardo in the Uffizi, which shows the angel kneeling on a grass and flower-bestrewn lawn before the Virgin, who sits at an elaborate and obtrusive lectern which clearly fascinated Leonardo.

Warhol has eliminated all of this and focuses upon the landscape, with its pink triangular mountain joining the expressive hands of Gabriel and the Virgin. The angel's hand is erect and urgent, and the Virgin's fingers are spread responsively as her hand rests on the corner of the lectern. To those who identify the biblical source, the print may express the core of the story in a kind of sign language, the communication from the heavenly messenger to the earthly vessel at the moment of the Incarnation. To others the hands can be seen as graceful gestures signifying stimulus and response; they are set against a landscape of striking beauty. Whereas Leonardo's subtle colours are brilliant, high-keyed, and non-naturalistic, Warhol's print exists in four different colour combinations, all of them stunningly original.

At the end of his life, Warhol's personal faith found expression through the transformation of Leonardo's masterpieces, including more than one hundred works based on the *Last Supper*. This painting of Leonardo's *Annunciation* is among his earliest works associated with religious iconography.

Jane Daggett Dillenberger

Notes

1 John Richardson, ' The Secret Warhol', in *Vanity Fair*, July 1987, p. 127.
2 Robert Rosenblum, *Andy Warhol, A Retrospective*, New York, Museum of Modern Art, 1989, p. 3.

Medieval legend: Christopher, sturdy, muscular, carries the Christ child across the stream and feels upon his shoulders the weight of the whole world.

Horst Sakulowski, a painter, sculptor, draughtsman and video film-maker, remains an outsider even to the present day. Even under socialism he seeks to be answerable to his conscience alone, as *Christopher / Christbearer* (Christophorus) demonstrates.

1985 saw the approach of a celebration—the fortieth anniversary of German liberation from fascism. By commissioning certain works to mark this event, the State sought, among other things, to increase its influence over the artist community, always difficult to bring under control. Sakulowski had already completed several paintings highly critical of various shortcomings of the East German regime, so pressure was applied to ensure his participation. His chosen subject was the resistance by the Church to fascism.

Christophorus grew out of this idea, and was finished in 1987. The story of the Christbearer, described in detail in the *Golden Legends* (c. 1263–73) by the Dominican Jacobus de Voragine, is well known. Christopher intended to serve only the most powerful people, but met up with Christ in the form of a child. Using all his strength, he carried him across a swiftly flowing stream to the other side, unaware that the child was the Son of God. Halfway across, the tremendous weight forced him underwater, resulting in his receiving the sacrament of baptism. Christopher later died a martyr's death.

Sakulowski, whose way of thinking is a highly sensitive reminder of a directly visionary Christian humanism able to include early communist ideals, introduced a new and distinctive interpretation of this traditional story. A political prisoner from a concentration camp, with the marks of torture on him and the distinctive red triangle on his prison trousers, laboriously drags Christ, scourged and crowned with thorns, through the marshy morass of a desolate world. There is no river bank, no rescue in sight. The mystically-illuminated Christ alone brings a promise of hope. In an existential situation of need, the person persecuted because of politics is helping the central figure of Christianity, the 'Man of Sorrows'. This is the message: In spite of fundamentally different philosophies of life, a bond does exist. And further: In an age where moral values are under threat, this connectedness is our only prospect of continuing to live in an upright way.

To consider the period from which the painting emerged, and the escalating political situation inside the East Germany after the mid 1980s, when the churches became gathering points for the forces opposing the regime, is to understand some of the great difficulties associated with this painting. Accepted within the framework of commissioning by the State, public access to it was restricted. Yet the work's fundamental concern is a deeply human one. *Christophorus* proclaims the significance of mutual understanding, of active assistance, of coexistence with those who think differently from ourselves. It is important to remember that only the truly basic principles of life—those of shared humanity and tolerance—can make such goals possible in testing situations of an extreme and crucial nature.

Again and again, Sakulowski's art centres on the themes of human existence, the tension between integrity and the perversion of the humane. *Christophorus* highlights this focus. While Grünewald's Isenheim *Crucifixion* (c. 1512–16) was an important model, it can be said that Sakulowski achieved an independent masterpiece in *Christophorus*. With its timeless realization of Christian motifs—the legend of Christopher, the Ecce Homo, Christ in need—the image has great immediacy and power. The creation of this work signifies not only taking an ideological stand in the conflict between Church and State, but also what Sakulowski has described as his own 'search for an effective light', a light able to 'withstand dark spectres'.

Gerd Lindner

Translated by Pauline Smith RSM and Claudia Luenig

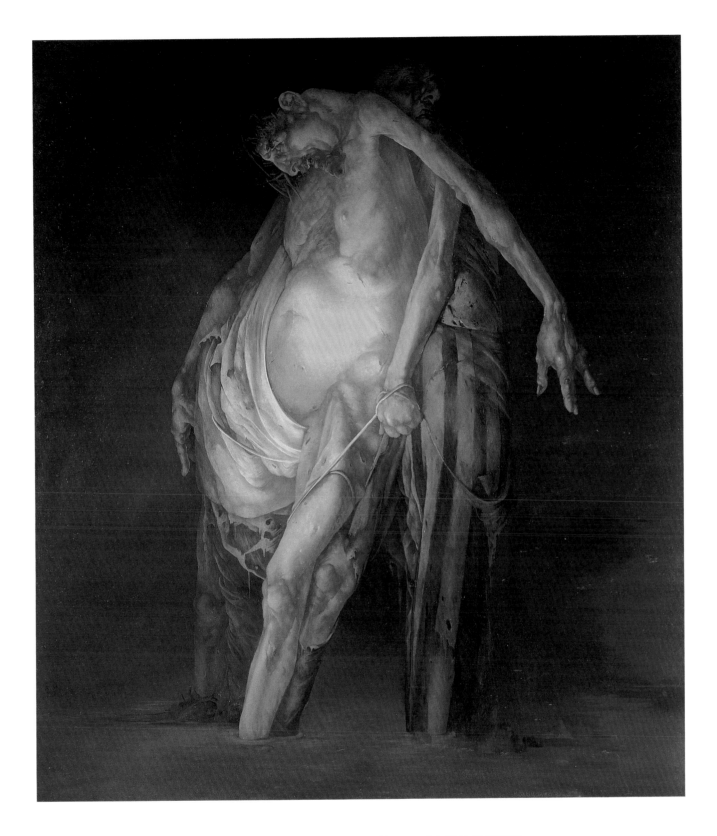

Horst SAKULOWSKI
1943–
Christophorus (Christopher / Christbearer) 1987
oil on hardboard
142.0 × 124.0 cm
Kunstgalerie, Gera
© Horst Sakulowski 1987
Reproduced by permission of Horst Sakulowski 1997

> At a time when Mapplethorpe's own sense of mortality was ever present, *Christ* is a moving reminder of the frailty of the body—and the power of the spirit.

Towards the end of his life, when the effects of AIDS had made any strenuous work in the studio difficult, Robert Mapplethorpe (1946–1989) produced a series of photographs using mainly small classical casts of male figures. These luminous images are among the most striking of his career, seeming to speak of an ideal of bodily perfection rendered eternal through the power of photography.

At the same time he was working with these classical figures, Mapplethorpe also photographed a very different type of male statue—that of the crucified Christ. It may seem a strange choice of subject at first. After all, Mapplethorpe is known as a quintessential stylist more interested in erotic nudes and sensual flower studies than Christian subject matter. However, this spare and powerful photograph bears unusually direct testament to a sense of the spiritual that operated throughout his career.

Mapplethorpe was raised as a Catholic and considered his early love of Church ritual to have influenced his work. In 1988, the year he made *Christ*, Mapplethorpe commented: 'I think … that being Catholic is manifest in a certain symmetry and approach. I like the form of a cross, I like its proportions. I arrange things in a Catholic way.'.[1] The symbol of the cross is certainly manifest in many of his photographs as a formal device and, in 1975, a youthful Mapplethorpe appears to 'play' with the idea of the crucifix in a self-portrait.[2]

It is in his depiction of the body, especially the naked male body, that the influence of Catholicism is most manifest in Mapplethorpe's photographs. Mapplethorpe revelled in the beauty of the flesh and it appears that erotic pleasure was both a form of liberation and a connection to the spiritual for him.[3] Indeed, when once asked if anything was sacred to him, he answered, apparently with great earnestness, 'Sex'.[4]

However, in *Christ* it is not the eroticism or beauty of the body that is emphasized but the aching vulnerability of flesh. While his celebrated graphic use of black and white medium is employed here to some extent, Mapplethorpe has downplayed technical virtuosity in favour of a strikingly simple image. The artist has placed a small sculptured figure of the crucified Christ—missing its original cross—on the black stones of a pavement. The warm glow of natural sunlight illuminates the tortured body of Christ, highlighting his painfully gaunt form.

The Crucifixion is the most powerful symbol in the Christian religion, representing the ultimate triumph of the spirit over the body, and it is hard to avoid a sense of personal significance that this subject must have held for the artist. At a time when Mapplethorpe's own sense of mortality was ever-present, *Christ* is a moving reminder of the frailty of the body—and the power of the spirit.

Isobel Crombie

Notes

1 Robert Mapplethorpe interviewed in Janet Kardon, *Robert Mapplethorpe: The Perfect Moment*, Philadelphia, University of Pennsylvania, 1988, p. 25. Mapplethorpe also referred to his way of constructing a photograph as being similar to 'little altars'. See Ingrid Sischy, 'A Society Artist', in Robert Marshall, *Robert Mapplethorpe*, New York, Whitney Museum of American Art, 1988, p. 82.

2 *Self portrait* (1975) shows the artist, arm extended across the picture frame, in a parody of the Crucifixion; a puckish grin on his face giving him the appearance of a modern-day Pan delighting in his youth, health, and freely expressed sexuality.

3 It can be argued that the ecstatic core that lies at the heart of even his most transgressive photographs, involving sexual submission and pain, have a connection to the transcendence achieved through the mortification of the flesh portrayed in Christian martyrdoms. For an exploration of this idea see Eleanor Heartney, 'Postmodern Heretics', in *Art in America*, February 1997, p. 34; and Dave Hickey, *The Invisible Dragon: Four essays on beauty*, Los Angeles, Art Issues Press, 1993, p. 55.

4 Arthur Danto, *Playing with the Edge: The photographic achievements of Robert Mapplethorpe*, Berkeley, University of California Press, 1996, pp. 53–5.

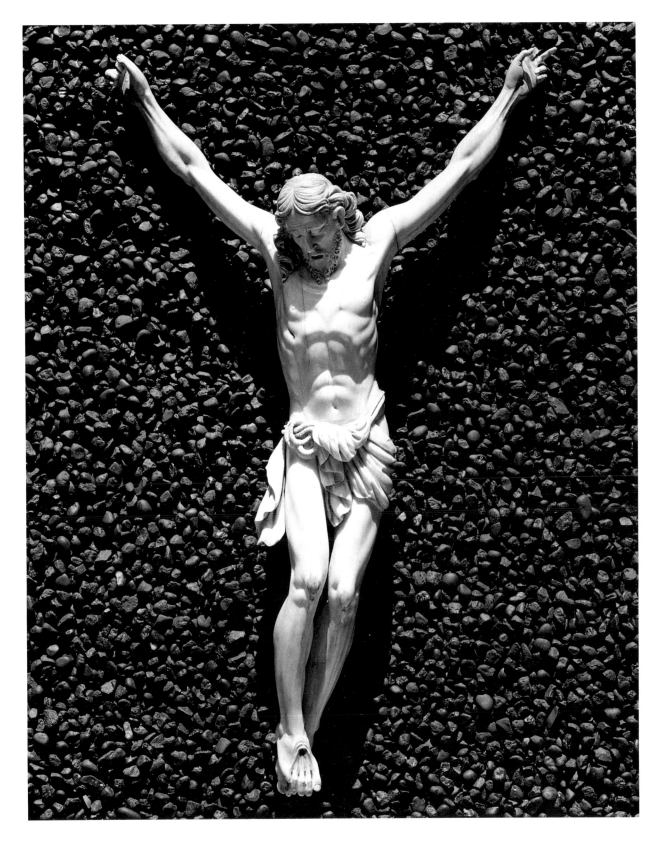

Robert MAPPLETHORPE
1946–1989
Christ 1988
black and white photograph
51.0 × 61.0 cm
Collection A. Grassi, Milano – Courtesy Le Case D'Arte, Milano
© Estate of Robert Mapplethorpe. Used by permission

Night without limits

German conceptual artist, Rosemarie Trockel, first wrote the words, *Ich habe Angst* (I have Angst), on masonry in the old and war-ravaged sanctuary of St Peter's Church, Cologne in 1993. Her work of art is, in many senses, a triptych. Together, place, space and text shape it. Initially the place was a church; the space was sacred, set apart for worship; and the work was formed out of the interaction of these contexts and the text. The three words, *Ich habe Angst* also form a triptych; each word draws upon the other, as well as upon its location, in a further creative interplay.[1] Appropriately, there is a third triptych, involving the text, the context and the beholder.

For the religious beholder in St Peter's Church, *Ich habe Angst* perhaps reverberates with the cry of those whose fidelity lives in and through experiences born of human finitude. Possibly the believer recalls those reluctant prophets who begged God to relieve them of the burden of forth-telling, or Christ on the Mount of Olives facing impending crucifixion and death, or any other person whose way of being in the world has been marked by integrity and struggle. Here, as in other confrontations with what seems impossible or to be inescapably the human condition, expressions of angst derive from the capacity and courage to imagine.

Within the gallery setting—itself a public place, and within a particular kind of space shaped by the theme and surrounding art works of *Beyond Belief: Modern Art and the Religious Imagination*, the text again functions as part of a creative triptych. The interplay that shapes the work of art renders it powerful and enigmatic.

The sentence, *Ich habe Angst* (I have Angst), is short, declarative, unavoidable. Present tense gives visceral energy to what meets the listening eye as a plain utterance, but offers access to conceptual and contemplative depths. *Ich* (I), in being personal, taps into what is human and shared. The I who speaks is both external, someone speaking to the beholder, and internal, calling forth an echoing *Ich habe Angst* from within the viewer. The verb *habe* (have) uncompromisingly owns the fear, disturbance, concern, anxiety and uncertainty that are manifestations of *angst*. The text itself is visually simple. Nothing intervenes, nothing decorates or diminishes the power of the black letters. There are neither stridencies nor qualifiers. The unadorned voice cannot go unheard.

As with all of Trockel's works—paper, sculpture, knitted panels, xeroxed images, mundane objects rendered surprisingly significant—*Ich habe Angst* does not confine interpretation and response. Instead, it is rich in ambiguity. The three words may be a plea, a cry, a cool assertion, a confession, an analytic comment, an accusation, a challenge, a reaching out. The voice could belong to an individual or a group or a society. It could express all the anguish of a troubled century, or contain resonances that cross time and human history, or tap into one person's pain.

While Trockel's work awakens much pondering, a first and perhaps most appropriate response is simply to stand before it. Each beholder, as listening participant in the triptych, will then release the words to speak.

Margaret Woodward

Notes

1 For further detail of these two aspects of Trockel's triptych and of its place in St Peter's Church, Cologne, see Friedhelm Mennekes, *Triptychon: Moderne Altarbilder*, Frankfurt, Insel, 1995, p. 102.

Rosemarie **TROCKEL**
1952–
Ich habe Angst (I have Angst) 1993
word installation
Monika Sprüth Galerie, Köln
© Rosemary Trockel 1988 / Bild-Kunst
Reproduced by permission of VI$COPY Ltd, Sydney 1997

ICH HABE ANGST

In choosing to parody paintings of the Madonna and Child in her *Art History* series, Cindy Sherman highlights the manner in which such art images circulate and are consumed in contemporary society, quite outside of their religious content; functioning instead as icons of worship in the history of Western art.

CINDY SHERMAN

Created in 1989 after a stay of almost two months in Rome, Cindy Sherman's *Untitled #216* is one of only a few photographs from her Art History series that is based upon an identifiable source.[1] For most of this series, Sherman worked from a combination of reproductions and memory, achieving photographs that hover uneasily as replicas of almost-recognizable paintings.

In the *Art History* series Sherman turns her attention away from the investigation of the myths of femininity that has characterized her work, to the history of Western painting. But Western painting has always played a significant role in the construction of the feminine ideal, and never more so than in depictions of the Virgin and Child. In true Sherman style, the artist is both the director and subject of the lens in *Untitled #216*. But Sherman's Madonna (or Sherman as the Madonna) no longer functions, as such an image did in the Renaissance, as an ideal of womanhood.[2] Gone is the serenity and beauty traditionally associated with representations of the Madonna del Latte. The smooth countenance of the Madonna is replaced by a broad, crater-like brow, and a huge prosthetic breast protrudes from her chest, mocking the gift of sustenance that it would ordinarily supply. The Madonna doesn't gaze adoringly at the Saviour, but averts her eyes; drawing attention to the fact that the Christ-child too is only make-believe.

Under Sherman's control, the all-seeing eye of the camera playfully mocks the idealization of sitters throughout the history of classical painting, and the associated notions of feminine beauty that were both constructed by, and emerged from, this practice. The sumptuous surface of the photograph renders every detail painfully clear. The Madonna's crumpled garments and thrift-shop crown, for example, only serve to highlight the sense of artifice. The manipulations of photography, and image-making generally, receive maximum exposure in this large scale work.

Cindy Sherman's art is not concerned with religion; Cindy Sherman's art is concerned with representation. Yet by adopting the iconography employed in Renaissance paintings of the Virgin, Sherman also refers the 'worshipper' back to these 'originals'.[3] Ridiculous in print but plausible in paint, the Virgin's monstrous attributes cause the viewer to question not only the nature of representation, but the foundation of belief.

While foregrounding the 'art-historical fetishization'[4] of such images, and of course, their economic value, Sherman's game goes one step further, however, for the success of her own photographs depends very much upon contemporary manifestations of this system. Sherman's status as one of the major women artists of the 1980s and 1990s is a product of both her critical appraisal and art market success. As she displays in *Untitled #216*, though, she may be implicated, but she is never unaware, and is always willing to have fun.

Kelly Gellatly

Notes

1 *Untitled #216* is based upon Jean Fouquet's *Madonna of Melun* (c. 1450), reproduced in Arthur C. Danto, *Cindy Sherman History Portraits*, New York, Rizzoli, 1991. Sherman herself, however, is reluctant to pinpoint specific images: 'The only pictures I planned were the Bacchus, the big Madonna with plastic tits holding a baby, which is based on a work by a French painter whose name I forget, and one based on a Raphael painting.' (quoted in Noriko Fuku, 'A Woman of Parts', in *Art and America*, vol. 85, no. 6, June 1997, p. 80).

2 For discussions of the representation of the Virgin in the Renaissance see Margaret Miles, 'The Virgin's One Bare Breast: Female Nudity and Religious Meaning in Tuscan Early Renaissance Culture', in Susan Rubin Suleiman (ed.), *The Female Body in Western Culture: Contemporary Perspectives*, Massachusetts, Harvard University Press, 1986, pp. 193–208, and Marina Warner, *Alone of All Her Sex: The Myth and Cult of the Virgin Mary*, London, Pan Books, 1985.

3 Untitled #223 from the *Art History* series is also a version of the Madonna and Child.

4 Laura Mulvey, 'A Phantasmagoria of the Female Body: The Work of Cindy Sherman', in *New Left Review*, no. 188, July–August 1991, p. 147.

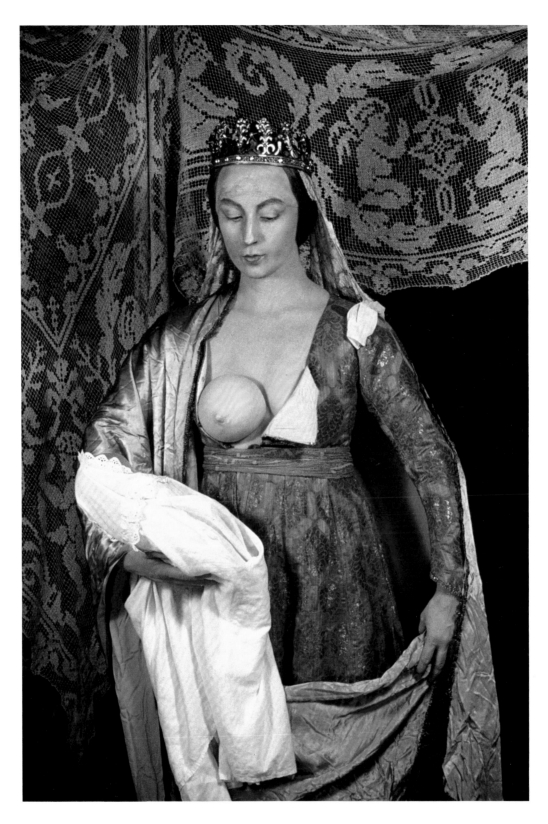

Cindy SHERMAN
1954–
Untitled #216 1989
colour photograph
228.0 × 154.0 cm
The Saatchi Collection, London
© Cindy Sherman 1989
Reproduced by permission of Cindy Sherman 1997

Jenny Holzer's *Mother and child* (1990) challenges banal and often glossily sentimental motherhood images designed for easy consumption in a mass media age. Disturbing in its kaleidoscopic tumbling together of conflicting emotions, the work draws upon intensities of language—fearful, passionate, incendiary, tender, ferocious, self-accusatory—to represent more truthfully the complexities of life and maternal feeling. The incisive psychological portrait of what it is to be mother at this time in history and society is strengthened by personal experience: Holzer gave birth to a daughter, Lili, in 1988. Voices and emotions compete, subvert each other, exist within one person, and conjure up the circumstances and voices of many different persons. Language in this art work becomes physical; 'pain', as Holzer says, 'is not thought'. Though the text ends on a note of doubtful hope, the whole confirms the strength of the bond of motherhood even as it concedes human frailty. The artist's use of LED (light emitting diode) signs, the language of advertising, renders this composite, this voice of a twentieth-century Madonna, even more direct, her anxieties even more unavoidable.

Margaret Woodward

I AM INDIFFERENT TO MYSELF BUT NOT TO MY CHILD. I ALWAYS JUSTIFIED MY INACTIVITY AND CARELESSNESS IN THE FACE OF DANGER BECAUSE I WAS SURE TO BE SOMEONE'S VICTIM. I GRINNED AND LOITERED IN GUILTY ANTICIPATION. NOW I MUST BE HERE TO WATCH HER. I EXPERIMENT TO SEE IF I CAN STAND HER PAIN. I CANNOT. I AM SLY AND DISHONEST TALKING ABOUT WHY I SHOULD BE LEFT ALIVE. BUT IT IS NOT MY WAY WITH HER. SHE MUST STAY WELL BECAUSE HER MIND WILL OFFER NO HIDING PLACE IF ILLNESS OR VIOLENCE FINDS HER. I WANT TO BE MORE THAN HER CUSTODIAN AND A FRIEND OF THE EXECUTIONER. FUCK ME AND FUCK ALL OF YOU WHO WOULD HURT HER.

I DID NOT WANT MY CHILD BECAUSE I KNEW I COULD NOT LIKE THE FEELING WHEN SHE WAS THREATENED, BUT ONE MORNING IN A MOVEMENT OF INFINITE TENDERNESS I CALLED HER. I CANNOT PRECLUDE HER DEATH AND OUR DEPENDENCE LETS EVERY DANGER WORK UNCHALLENGED. THE IDEA THAT I AM CRIMINAL RECURS EACH TIME THERE IS REAL TROUBLE. I WOULD KILL HER RATHER THAN WATCH A DIRTY ENDING BUT THE KILLING WOULD SPOIL MY PITY. IF MY INSTINCT IS RUINED I WILL BE THE PERSON WHO CAN DO ANYTHING TO YOU.

I AM SULLEN AND THEN FRANTIC WHEN I CANNOT BE WHOLLY WITHIN THE ZONE OF MY INFANT. I AM CONSUMED BY HER. I AM AN ANIMAL WHO DOES ALL SHE SHOULD. I AM SURPRISED THAT I CARE WHAT HAPPENS TO HER. I WAS PAST FEELING MUCH BECAUSE I WAS TIRED OF MYSELF BUT I WANT HER TO LIVE. I HATE EACH OF YOU WHO MURDERS. NOW MY BEST SENSES ARE BACK AND WHAT I FEEL AFTER LOVE IS FEAR.

I FEAR FIVE THINGS AND MYSELF.

I FEAR THE NEW ILLNESS. I AM NOT SURE IF THE CHILD AND I ARE SICK. NOW THAT SHE IS BORN I AM AFRAID TO KNOW. I TOUCH HER NECK. I AM NOT CERTAIN I COULD CARE FOR HER.

I FEAR PEOPLE CRAZY MAD FROM NEED AND THE CONTEMPT OF EVERYONE WHO COULD HELP THEM. I GO WALKING AND I HOPE SOMEONE DOES NOT SEE MY FAT BABY AS AN INSULT.

I AM AFRAID OF THE ONES IN POWER WHO KILL PEOPLE AND DO NOT ADMIT GRIEF. THEY WILL NOT STAY IN A ROOM WITH A DYING BABY. THEY WILL NOT SPEND THE DAYS IT CAN TAKE.

I FEAR SUBSTANCES THAT CANNOT BE SENSED AND MUST NOT BE TOUCHED, THE RESIDUE OF GOOD AND BAD IDEAS. I TURN THE CHILD OVER AND OVER TO LOOK FOR SIGNS. CONTAMINATION MAKES THE NEW WEATHER AND THE STINKING HEAT. THE BABY IS RED AND TRIES TO PULL AWAY FROM ME. AFTER THIS IDIOT PERIOD OF SQUANDERING AND WAITING I FEAR EVERYONE WHO DOES NOT WELCOME CHANGE.

THE SHOCK OF A CUTTING BIRTH REMINDS ME THAT PAIN IS NOT THOUGHT. MY NEED TO PROTECT COMES WITH THE CHILD. IT MAY GIVE ME TIME.

Jenny Holzer

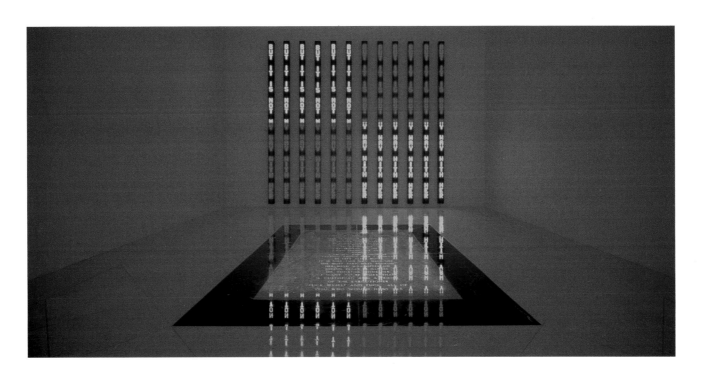

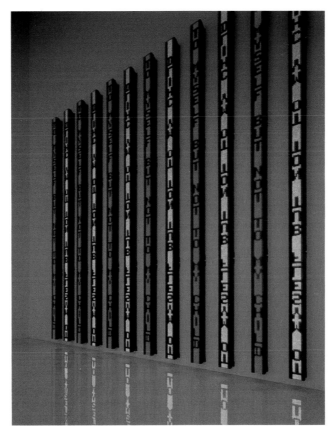

Jenny HOLZER
1950–
Mother and child 1990
two vertical LED (light emitting diode) panels
365.8 × 54.0 × 11.5 cm
Courtesy of Jenny Holzer Studio, New York
© Jenny Holzer 1990
Reproduced by permission of Cindy Sherman 1997

I tell stories in my pictures to show what's behind the story, I make a hole and go through.[1]

In these two works, *Untitled* from the series *Angel of History* (1989) and *Lilith* (Lilit) (1988–90), Anselm Kiefer can be seen standing at a junction of history. His life work had been a call to the German people to memory and repentance for the devastation of war and, particularly, for the Holocaust. He was a lone figure in art also—reclaiming landscape and the complexity of historical and religious myth at a time when others were deserting image and myth for Minimalism and were denying the possibility of 'making art' in any traditional sense. By 1989 the political movement for the reunification of Germany had gathered strength and in 1991 Kiefer left Germany to settle eventually in France, and so to embark on the second half of his life's journey.

One way to enter into Kiefer's work is through his iconography, but the works are infinitely more than their individual elements and themes, which can be understood more like markers on the earth than the earth itself. Kiefer works deliberately with layers of meaning through which, like a medieval alchemist, he seeks transformation and transcendence.

The 1989 exhibition, *Der Engel der Geschichte, Mohn und Gedächtnis* (The Angel of History, Poppy and Memory) centred upon the images of the plane, wings, lead, ashes and the female mythical heroine Berenice (who had shaved her beautiful hair as a sacrifice so that Ptolemy III, her husband, would return from war as the victor of Asia) and Lilith of Sumerian and kabbalistic tradition. .

The aeroplane is a symbol of power and aggression but it is also Icarus who flew too close to the sun and perished; smoke, in Mercia Eliade (whom Kiefer read) is a manifestation of fire with its transformative, magical properties capable of turning lead, the most basic and vulnerable of materials, into gold; ash is the trace of what remains of what does not remain[2] after fire has swept through. Across all this is the divide—what is and what could have been and what might yet be. This work yearns for it all.

Lilith uses lead—not simply the colour of lead as in the photograph *Untitled* but as the very material of the work. Thus the painting is subject to constant and evident chemical change and because of its softness, is vulnerable and malleable. On this Kiefer has thrown and spattered other materials which sometimes interact with the surface and sometimes sit on top of it. Kiefer here resembles Pollock, but is unlike him in that his intention is to recall story, create ambiguity and allow the beholder to enter into history and feel its weight.

In other works also entitled *Lilit*, Kiefer has the strings of a dress pulling a plane. Here the ties flow over the work like two snakes escaped out of Eden to bring the knowledge of what happened. The dress is a potent symbol used by Kiefer of women of history such as Brunhilde, Shulamite and Lilit who survive great catastrophe. It is not clear whether Kiefer's *Lilit* is the evil spirit of the kabbalist myth, the first wife of Adam, or the dark face of Shulamite or the Babylonian 'lil', meaning 'wind' or 'spirit'. It is probable that Kiefer had in mind the ambiguity of all three.

Anselm Kiefer—shaman, alchemist, artist—is bent on reminding all who look that they are of the earth and of human history, and that is where redemption is to be found.

Rosemary Crumlin

Notes

1 Anselm Kiefer, quoted in Steven Madoff, 'Anselm Kiefer: a call to memory', *Art News* 86, no 8, 1987, p. 128.

2 Jacques Derrida, '"Shibboleth" in Midrash and Literature', quoted in Mark C. Taylor, *Disfiguring*, Chicago, University of Chicago press, 1992, p. 302.

Anselm KIEFER

1945–

Lilit (Lilith) 1988–90 *(facing page)*
lead, electroplating deposit (galvanic mud), dress
243.0 × 172.0 cm
Private collection, Mühling, Germany
© Anselm Kiefer 1988
Reproduced by permission of Anselm Kiefer 1997

▲

Untitled (from the series *Angel of History*) 1989
overpainted photo, ashes
128.0 × 116.0 cm
Private collection, Mühling, Germany
© Anselm Kiefer 1989
Reproduced by permission of Anselm Kiefer 1997

Beyond its playful dimension, *Le Croix* addresses a serious question: are we only a carcass that can be dissected and hung like meat or do we possess a spiritual dimension that transcends the corporeal?

'Conceptual art interests me in the same way that ... religious art might ... I pinch their beautiful forms from them; selfishly hoard and steal them, and transform all these different worlds into my own thing, my own world.'[1]

Annette Messager (born 1943) is a maker of idiosyncratic and often unsettling 'worlds'. Her ripe imagination draws on artistic and religious traditions, memories of childhood, and feminine stereotypes to evoke a highly distinctive physical and spiritual sense of the body. Viewing her work can be deceptive: while we may initially be attracted to the playful, childlike forms, there is invariably a point at which we recognize all is not as benign as it seems. The artist frequently renders the familiar surreal to create complex installations that fluctuate between the innocent and the disturbing.

In *The Cross* (Le Croix) (1994), Messager has brought her original vision to bear on the most pivotal of Christian symbols—the Crucifixion. She has often referred to religious iconography in her career and has written, 'An artist has to show his culture ... my work is the work of a French Catholic woman.'.[2] In 1988, for instance, she created *Mes Voeux* (My vows), a myriad of small framed photographs of body parts that refer to the votive tablets placed in chapels by supplicants. While her use of photography in this work maintained a link—albeit disjointed—to the 'real' body, Messager moves into different imaginative territory in *The Cross*.[3]

In this work, Messager has hung a number of brightly coloured, immensely tactile 'body organs' constructed from felt from a simple wooden cross. An oversized stuffed heart—with stitched vessels and different coloured aorta and ventricles—gently swings by a loosely-tied string alongside a brown spine and a blue and red diaphragm. Other, more amorphous shapes make up this surreal rendering of the internal human form. The soft shapes carry dual connotations: they are reminiscent of the simplified drawings of a child's biology textbook, but also have the more nightmarish connotations of hung meat.[4]

The sewing involved in producing these body parts may intentionally refer to traditional feminine skills, but there is little about this work to suggest the gender of the internal organs on display.[5] The body of Christ, as shown here, is no longer male or female but a universal form that speaks to the physical experience of either gender. In portraying the body in this way, Messager has created a humanistic work that raises a deep human vulnerability. Beyond its playful dimension, *The Cross* addresses a serious question: Are we only a carcass that can be dissected and hung like meat, or do we possess a spiritual dimension that transcends the corporeal?

Isobel Crombie

Notes

1 Annette Messager, quoted in Joann Cerrito (ed.), *Contemporary Artists*, Detroit, St James Press, 1990, p. 630.

2 Annette Messager, quoted in Penelope Rowlands, 'Art that Annoys', *ART News*, October 1995, p. 135.

3 *Le Croix* is related to the series *Pénétration* (Penetration) (1993–94), in which Messager has created a much larger installation of hanging body organs suspended from the ceiling along with lights.

4 Messager has written of her use of body organs: 'They are clichés (or recollections) from our childhood class books'. Kate Davidson and Michael Desmond, *Islands: Contemporary Installations*, Canberra, National Gallery of Australia, 1996, p. 54.

5 Messager has often used crafts such as sewing or embroidery in her work as a means of connecting with traditional feminine practices. She has also employed such practices as a means of commenting on stereotypical views of women; see for instance *Ma Collection de Proverbes* (My collection of proverbs), series of art works, 1974.

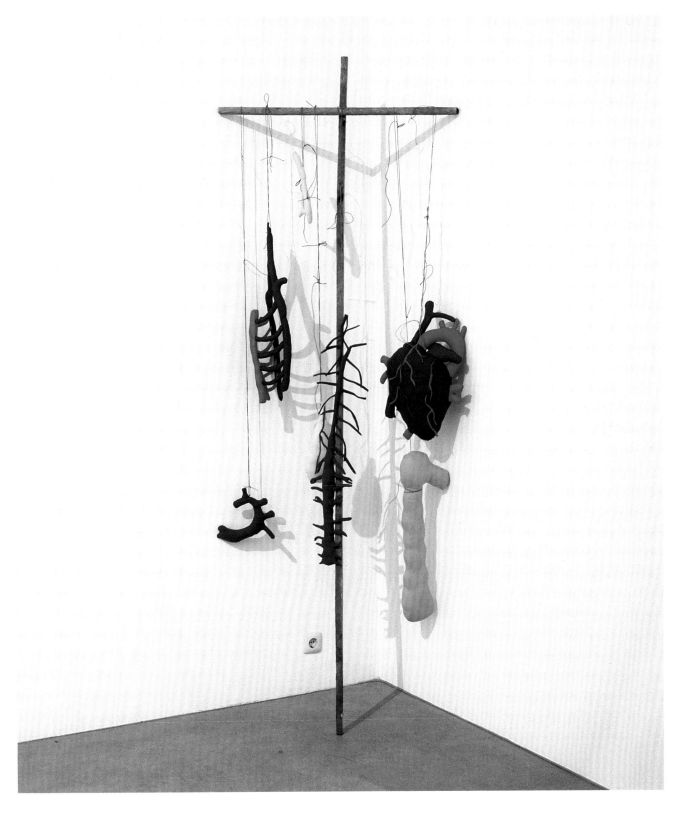

Annette MESSAGER
1943–
Le Croix (The Cross) 1994
wood, fabric, cord
190.0 × 140.0 × 20.0 cm
Monika Sprüth Galerie, Cologne
© Annette Messager 1994 / ADAGP
Reproduced by permission of VI$COPY Ltd, Sydney 1997

Nitsch's chasuble is part of a performance, a new ritual action, that evokes pagan pre-Christian and Christian sacrifice.

This chasuble, a traditional vestment worn by the priest who celebrates the Mass, was given by performance artist Hermann Nitsch to Friedhelm Mennekes of St Peter's Church, Cologne. Nitsch has spattered the vestment with red paint, resembling blood, as a poignant reminder of the historic origins of the Mass not only as a memorial meal but also as a sacrifice, one in which, as the words of consecration, the most solemn moment in the Mass, say: 'This is my body which will be given up for you ... this is the cup of my blood, the blood of the new and everlasting covenant. It will be shed for you ... so that sins may be forgiven.'.[1]

The notion of sacrifice is an integral part of many religions. Rituals of sacrifice symbolize the passing over from the human to the divine; at root they are actions of submission and expiation. The Scriptures are rich with accounts of sacrificial actions—Noah's gift of the lamb, Abraham's willingness to kill his son out of love for God, the stories of Solomon, David, Elijah. Pagan religions also abound with examples—Mucius Scaevola, Iphigenia, Achilles. These myths have always been part of an extensive iconographical bank for Western artists.

Within this group of works, all of which reflect the religious imagination of the artists of this century, Nitsch's 1972 chasuble relates most clearly to the other liturgical garments—Matisse's *Black chasuble* (p. 97), made for the services in the Chapel at Vence, and James Lee Byars' *Four in a vestment* (p. 171), made for a wedding ceremony of friends. In each case the work was part of a ritual action, but now is regarded as a 'work of art', separate from the original intention of the artist but functioning always as a reminder or a memorial of the original action. In this sense, each of these works is an example of 'performance art'.

There is also a strong relationship with Arnulf Rainer's *Wine crucifix* (p. 139), now owned by the Tate Gallery in London, but originally intended as an altar painting for a Catholic seminary. As such, it would have watched over the ritual memorial services, and its strong wine colours spilt like blood across the canvas would have been a constant symbolic reminder of the meaning of the life and death of Christ. Likewise, in Duwe's *Last Supper* (p. 133), the friends gather round the sacrificial table which holds head, hands, heart and feet of the redeemer, who offers himself up for others.

Less clear, but profoundly moving, is the visual and symbolic connection with Daniel Goldstein's *Icarian II / Incline* (1993) (p. 175), in which the skin of an animal (leather) carries the imprint of human bodies wasted with AIDS which, in the most enigmatic way, have come to symbolize the sacrificial ritual of death in our time.

Hermann Nitsch's theatrical performances are often highly controversial as he pursues imagery of the most violent and destructive aspects of Western society. They are often actions designed to be cathartic for both the artists performing and the watchers. Nitsch's chasuble, with its overtones of the destruction of the traditional chasuble, and of sacrifice to expiate the sins (the wrongs and injustices) of present-day society, is also a warning against the dangerous human impulse to 'do again what [our] ancestors did [to] repeat some foundational violence with substitute victims'.[2]

Rosemary Crumlin

Notes

1 Eucharistic Prayer, The Order of the Mass, in *The Roman Missal*, Sydney, E. J. Dwyer, 1975, pp. 282–3.
2 René Girard, *A Theater of Envy*, New York, Oxford University Press, 1991, p. 210.

Hermann NITSCH
1938–
Chasuble 1972
blood, chalk on nineteenth-century vestment
115.0 × 65.0 cm
Kunst-Station Sankt Peter Köln
© Hermann Nitsch / VBK
Reproduced by permission of VI$COPY Ltd, Sydney 1997

This and thus in the turning robe

'Be (as ego) already long dead and do what gives pleasure.' This is a saying from the Pi-Yen-Lu or Chinese 'Blue Cliff Records', a collection of question-and-answer games from great twelfth century Ch'an (or in Japanese, Zen) masters. Pleasure means to find it in losing ego-centredness. In the dwindling of its gravitational pull, captivity to the ego's self-importance (which Nietzsche, in his *Zarathustra*, called the spirit of gravity) is to be shaken off in order to dwell with things in their 'alas-ness'. *Mono no avare*, the 'alas-ness of things', is what the Japanese call that 'aesthetic' sensibility which, in becoming aware of the natural selfhood of things, makes them receptive to taking in things in the way they are, in their 'thus-ness'.

Plato's metaphysics laid the foundation for that specific Occidental constitution of the subject which, in the course of history, established the separation of subject and object in a model of organized appropriation of the world by the ego. The driving motivation is a self-entrapped striving which is active in the fathomless desire for the perfect and unchangeable, the timeless and placeless. James Lee Byars became infected with the models of the Occident and the Orient. He enthusiastically follows the various paths towards perfection in both cultures and brings them together in his art in a unique way.

Byars seeks out ingeniously and collects together in his works what he finds at the opposite poles of East and West. Works such as *The figure of question is in the room* (1986–89), a gilded marble column with a square cross-section bearing the monogram Q.R. at eye level in order to open the room of questioning in all directions, and *Four in a vestment* (1996), are situated at the aesthetic midpoint that Byars creates, there, where he allows the cultures to commingle in a loop of attentiveness. The turning from this to thus is performed in his works. The demonstrative pronoun 'this' stands for the European way: a subject points to something, identifies it on the basis of the subject's given requirements and establishes a 'this'. 'Thus', by contrast—especially when used without a direct reference—indicates a serene becoming-aware-of in which a thus-ness appears as it presents itself in the alas-ness of things. The transition from this to thus, a narrow path between the cultures, is called transformation or turning.

In the turning robe *Four in a vestment* the transformation is performed in both directions. The circular white linen cloth measures eight metres across in diameter. In its middle, four round openings for the heads of its wearers form a square around the centre. The fourfold empty repetition of the circle becomes the optic midpoint and causes the midpoint proper of the circular cloth to be overlooked. In the simple geometric form of the circle, Byars disrobes the robe of its social significance, removes it from its history, divests it of its status, strips it of its duties to protect, warm and cover. Turned into a circle, it reveals itself as open to bear the metaphors and signs of two cultures.

The entire circle *is* already at its centre, which can only be viewed in its ideality; it becomes real in the perimeter that circumscribes it. Thus, what is incompatible runs together. The One as ideal non-difference absorbs the manifoldness of reality. Dante represented God neo-Platonically as a centre which expands in circular waves and returns to itself. This is preserved in Byars' circles alongside thus from the Pi-Yen-Lu, the Zen book of wisdom: A learned monk asked Chuang-tzu: 'All the tens of thousands of things go back to one thing. What is the place to which this One itself goes back?'. Chuang-tzu answered: 'As a young man, I wove and tailored a linen habit to last a lifetime which had a weight of not less than seven pounds'. The one answering demonstrates his own earlier false conduct to the questioner. With the self-made robe he is too heavily equipped for life. Tightly enrobed, all openness has been lost. The self-entrappedness of the spirit of gravity helped weave the overweight cloak and made it impossible to encounter things in their serenity.

Beyond belief lies the unbelievable. The everyday expression 'incredible', with which we describe anything held to be impossible, says it all.

On the seventh of April 1996, an Asian woman and a European man wear the robe during their marriage ceremony. It enrobes them in its woven differences.

Heinrich Heil
Translated by Michael Eldred

James Lee Byars persued question, social change and perfection throughout his life. Through performance, word, object and evocative and provocative sculpture such as *The concience* (1985), *The book of 100 perfects* (1985), *The halo* (1985) and *This This* (1985) Byars cajoles the onlooker into becoming participant, and states over and over that, as in the title of a 1986 work, THE FIGURE OF QUESTION IS IN THE ROOM.

Rosemay Crumlin

James Lee BYARS
1932–1997
The conscience 1985
gold sphere, antique column
pedestal, and glass dome
185.0 × 58.0 × 58.0 cm
Courtesy Michael Werner
Gallery, New York and
Cologne
© Courtesy of the Estate of
James Lee Byars 1997 ▼

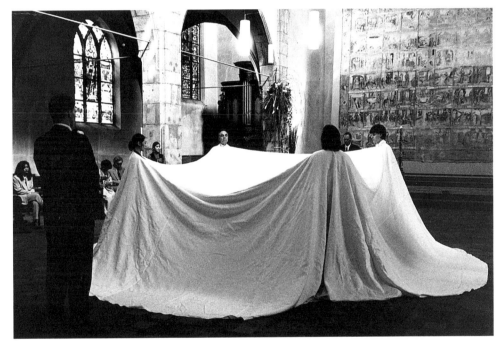

Four in a vestment 1996
linen
diameter: 8 m
Erzbischöfiesches Diözesanmuseum Köln
Sammlung der Jesuiten in Köln
© Courtesy of the Estate of James Lee Byars 1997

That desire towards wholeness

MAX GIMBLETT

Mithra (1996) leans against the wall, an object in space, two bronze feet on the ground. Juxtaposed against this sculptural presence is the two-dimensional surface of water-gilded copper over red clay, a slice of material resonant with associations of fire, of transformation and history.

Gimblett's work is both obstacle and opportunity. The work's physical presence poses a difficulty for the viewer. It is a square, and resistant to further simplification or abstraction. It plays on its own ambiguity of material substance, given that it could be heavy and metallic or light and reflective. Its leaning stance creates anxiety about stability and its shadow allows speculation about what lies behind or around.

The shape and positioning of the canvas is part of a search for a symbolic form. Many of Gimblett's canvases take on archetypal shapes such as the cross, the mandala, and the quatrefoil. These forms are bodily referential and have ancient histories in many religious traditions. They structure a form of viewing and thought that seeks to overcome more dualistic modes of being. They allow more speculative ways of thinking that inhabit the edge of memory where familiar and alien territories stake a claim on our consciousness.

The surface of the work suggests the breaking of boundaries. It reflects the viewer; there are glimpses of movement that play into its illusionary space. The implied formalism of the copper foil grid is mutated by the human acts of construction. There are separations looking for resolution in surface and depth, order and change, time and timelessness.

During the Roman period Mithra was a popular Persian god, understood to be the bringer of light into the world. He was the guide for those seeking immortality beyond the limitations of material existence. Mithra was born out of a divine rock and was often figured still partly emerging from this static state.

Mithra is traditionally depicted holding in his hands a torch and a dagger. These two objects provided an analogy for the spiritual journey towards clarity and insight, as well as a reminder of the need for readiness and a warning against danger. The knowledge of self, whether at the mundane level of honesty and integrity or at the personal boundary of social and meta-physical consciousness, brings with it the dangers of conflict, of being overpowered, even of death, as well as the promise of greater wholeness.

In apprehending this work there is a sense of anticipation, as if we have only grasped a portion of it. This awareness leads to the speculative action of wondering over the conditions of completion and wholeness. The alluring surface, the coy shift of plane, the shadowed edges offer points of invitation to the viewer's imagination. This seductive slice—like pungent ripe fruit—a surface laid bare—provides a visceral memory of this rumoured wholeness, for as the artist affirms, 'images have the potential to heal'.[1] This work anticipates the joining of what is often considered separate, of skin and feeling, of surface and depth, of spirit and flesh.

Rod Pattenden

Notes

1 Interview with the artist, New York, 15 August 1997.

Max GIMBLETT
1935–
Mithra 1996
gesso, red bole clay, water-gilded hand-burnished copper/wood panel
177.8 × 177.8 × 7.3 cm
Collection of the artist and Barbara Kirshenblatt-Gimblett
© Max Gimblett 1996
Reproduced by permission of Max Gimblett 1997

The Icarian series ... The son of Daedalus, maker of wings, Icarus soars upward in joyous flight. But the sun melts the wax which holds fast his wings, and the golden youth falls into the sea.

Daniel Goldstein's *Icarian* series (1993), though culturally and artistically a work of great modernity, has as its frame of reference a traditional artistic and religious concept, that of the reliquary. As art objects, the pieces of which it is formed are compositions of skin, wood, sweat, copper and plexiglass, made from the leather bench-covers of a San Francisco gymnasium, enclosed within display cases. Thus the artworks have a direct relationship to human bodies, and to a kind of asceticism which promotes health through strenuous exercise. They are therefore reliquaries in both the physical and the conceptual sense, in that they contain examples of 'somatic virtue',[1] as Howard calls it, acquired in the cause of health, just as the traditional reliquaries contained examples of spiritual virtue acquired in the cause of holiness.

The covers in their cases offer a further comment on this idea, in that they contain traces of the human person in the form of a faint image, rather than in the form of preserved bone or clothing. Having functioned originally as supports for the visual, live body, they now offer ghostly tracings or prints of it, which make comparison with the Shroud of Turin immediate and obvious. This in turn gives them an unmistakable religious reference, which is clear, not merely through the title, but through the work of art itself.

The idea and the art form have dominated Goldstein's work since 1991, when the series began, and what distinguishes these modern reliquaries from their classical counterparts is, as has been noted by Atkins,[2] the abstraction and lack of specificity. The reliquaries avoid particular subjects and so extend the conceptual category and the artistic genre by universalizing and generalizing it. The forms suggest a theology of bodily presence and absence, in a presentation in which life and image are interwoven. The titles of the different pieces are taken from the machines from which the covers come; and since the gym which supplied them was caught up in the AIDS epidemic, there is a second context to the work, which adds to the multilayered possibilities of its interpretation.

These studies, which take their place among the number of artworks generated by the AIDS crisis, form a critique of it, and by extension, of mortality and the idea of life in general. Though related artistically to the genre of found objects, and to developments in photography, they evoke and discuss death without any of the cynicism or irony which characterizes much modern artistic comment on the subject. By their humanity and their humanism they negate contempt, and by their relationship to other ghostly images of the religious tradition, particularly that of the suffering Christ, they go further, even suggesting an element of hope.

Mary Charles-Murray

Notes

1 Richard Howard, essay in catalogue *Daniel Goldstein: Reliquaries The Icarian Series*, New York, Foster Goldtrom, 1993. (Unpaginated catalogue; also contains essays by Robert Atkins and David Maxim.)
2 Robert Atkins' essay in catalogue, ibid.

Daniel GOLDSTEIN
1950–
Icarian II / Incline 1993
leather, sweat, wood, copper, felt, plexiglass
185.4 × 94.0 × 15.2 cm
Private collection, USA
© Daniel Goldstein 1993
Reproduced by permission of Daniel Goldstein 1997

In the Catholic temples of Mexico, onto the clothing of sacred images people pin metallic shapes of hearts, eyes and other parts of the human body such as hands, arms and legs. These shapes are called miracles. And on the altars people place personal objects and small paintings that are mostly done on lamina. These are called ex votos because they are a thanksgiving for favours received. They are also demonstrations of faith. The title of my work is *Faith*, and is inspired by these altars.

Nahum B. Zenil[1]

Both in image and word, Nahum Zenil has placed himself in the mainstream of modern Mexican art that acknowledges its roots in the eighteenth-century popular culture of Mexico. This religious tradition reaches back in its expression into Mayan and Aztec art. Although Spanish-Catholic in faith and iconography, this 1996 work *Faith* (Fe) is characterized by a more ancient art, by a high quality of craftsmanship, particularly in metal, by a closely organized surface pattern, and by a preoccupation with symbolic rather than visual meaning.

Ex votos were small paintings, often on thin rolled-out metal (lamina) or wood, signifying miraculous cures, and commissioned by the recipients of such divine intervention. These *ex votos*, together with a metal replica of the part of the body so healed, were taken to the altar of the patron saint. The pictures were left there and the other offerings were pinned to the vestment that clothed the patron saint's statue.

Zenil's patron saint is imaged in *Faith*, in a framed portrait of the Christ, crowned with thorns and suffering. The eyes confront the viewer. The metal shapes are all hearts, each engraved differently and reminiscent of the personal story once told in the *ex votos*. The repetition of the heart shapes and the small red ribbon with which each is tied point to the overt symbolism which, while multivariant, must include the meaning given to it by those who wear it to honour and remember the men and women who are HIV positive. There is an unexpectedness, a potent ambivalence, in these *ex votos*. Perhaps the red ribbons are a decorative touch, indicative and affirming of a characteristically Mexican cultural expression of faith. Could they also link all that seems unanswered, incurable, unhealed or unliberated with *ex votos*, forms of thanksgiving, rather than with supplicatory *miracles*? For some viewers the juxtaposition of the strong but anguished head of Christ with the metallic hearts and ribbons may signify that all that is possible is shared pain, com-passion, and that it is this which invests human suffering with profound meaning and purpose.

Rosemary Crumlin

Notes

1 (Unpublished) comments by the artist, 1977. Trans. Frank Rodriguez.

Nahum B. ZENIL
1947–
Fe (Faith) 1996
oil and metal on wood
119.2 × 100.5 cm
Collection of the artist, Mexico
© Nahum B. Zenil 1996 / SOMAAP
Reproduced by permission of VI$COPY Ltd, Sydney 1997

As in twilight, neither awake nor asleep
as on the rock eroded by memory
when by heart you remember only the wrong thing
and for a thousand years
tears fall on the same rock
from the same weeping eye
afflicted by that grief distinctly yours
the same for all in not having a name.

Threading in vain the path of satisfaction
Fear the left foot
hostility the right
stepping on the one stone
left unturned by hatred and greed
let it be as in forgotten songs
of mercy and sympathy
the pristine sound of the broom
sweeping the yard.

Francesco Clemente[1]

Italian artist Francesco Clemente accompanies the 51 paintings created out of his 51-day visit to Mount Abu, North West India in 1995 with poetry which, like these paintings, has the quality of myth, of that which is most deeply true. Travelling regularly between Italy, India and New York, Clemente has been fascinated by India (which he first visited in 1973), by its beauty, and by the urban life of the people, their inventiveness, their religions, the most fundamental aspects of their world. Mount Abu is an important site of pilgrimage for adherents to Jainism. In his own artistic encounter, Clemente embarks upon an inner journey, a pilgrimage within. Over the 51 days he witnesses seasonal change, the shift from glowing colour to colour that is muted and greyed by monsoon rains. All his experiences of this time seem to wash through this allusive work, and indeed, like the monsoon rains, to be in it. Shapes are suggestive, nondescriptive, yet organic. Dream fragments, shifting moods, intuitive images and story mysteriously coalesce, drawing the viewer into what cannot be spoken and lies in, as well as beneath what can be shown.

Margaret Woodward

Notes

1 This is a segment of the poetry written by Francesco Clemente and included in *Fifty One Days on Mount Abu* (exhib. cat.), London, Anthony d'Offay, 1997, p. 115.

Francesco CLEMENTE
1952–
Fifty one days on Mount Abu: XLI Fish 1995
watercolour on handmade paper
53.7 × 70.8 cm
Francesco Clemente, courtesy Anthony d'Offay Gallery,
London
© Francesco Clemente 1995
Reproduced by permission of Francesco Clemente 1997

Fifty one days on Mount Abu: XLVI Food 1995
watercolour on handmade paper
53.7 × 70.8 cm
Francesco Clemente, courtesy Anthony d'Offay Gallery,
London
© Francesco Clemente 1995
Reproduced by permission of Francesco Clemente 1997

Fifty one days on Mount Abu: XLIX Bridge 1995
watercolour on handmade paper
53.7 × 70.8 cm
Francesco Clemente, courtesy Anthony d'Offay Gallery,
London
© Francesco Clemente 1995
Reproduced by permission of Francesco Clemente 1997

When the Lord God made earth and heaven there was neither shrub nor plant growing wild upon the earth because the Lord God had sent no rain on the earth; nor was there any man to till the ground ... Then the Lord God formed a man from the dust of the ground and breathed into his nostrils the breath of life.

Genesis 2:5–7

Kiki Smith's *Lilith* attempts to embody the feminist understanding of the ancient myth of Lilith. In Hebrew mythology Lilith ('she of the night') was Adam's first wife who married Samael, the king of demons; in Sumerian-Babylonian myth, she is the goddess Belili; a tablet from Ur (c. 2000 BC) addresses her as 'Lillake'. In many traditions she is the Great Mother whose flower was the lily (lotus). The Lilith of all mythologies was overtly sexual, sensual and powerful, and equal in relationship.

Smith completed her *Lilith* in 1994, well after the feminists had reclaimed the legend and transformed the she-devil into heroine. Within her own artistic career this work may signal a shift away from a preoccupation with the body and patriarchy as themes. Her own background was Catholic—her mother was a convert to Catholicism but was later fascinated by Buddhism. Religions, and more specifically Christianity, influence her iconography. For instance, in her 1994 *Mary Magdalene*, the sinner-saint drags a ball and chain, symbolic of woman's role in a patriarchal Church; her 1995 *Untitled* crucified figure bends from the wall so that long hair (a horse's tail) covers identifying genitalia; even *Ice man* (1995) could be an ascension.

Smith has that rare quality that allows her to take already-worn themes and surprise the viewer with new insight and deeper questions that are ultimately life-enhancing. The glittering glass eye of *Lilith* refutes domestication and will not be tamed.

Smith's *Lilith* defies gravity and logic. She hangs spider-like from the surface. Has she already climbed the Garden wall and so is beginning the hazardous descent into a new life? Or has Smith deliberately hung the work so as to unsettle the viewer?

Rosemary Crumlin

*Lilith, the first
woman, created equal to Adam
refused to lie under him.
God, said Adam,
Make me a woman
who will do as I say
this woman you have
given to me refuses
to obey me
she has her own will
she is strong and evil.
God listened to Adam
and then
there was Eve
Lilith climbed the garden
wall hardly looking back
cursed by Adam
she fell into the night
whispering and calling
the Eves across the centuries,
Yes—
you are equal—listen
you are not of Adam's rib
you are*

Kiki SMITH
1954–
Lilith 1994
bronze, glass
81.0 × 80.0 × 43.0 cm
Collection of the artist, courtesy Anthony d'Offay Gallery, London
© Kiki Smith 1994
Reproduced by permission of Kiki Smith 1997

Everything we learn, every place we've been, every relationship, affects everything we do.

Audrey Flack

To do what Audrey Flack does is to create work with spiritual content.

Tom Wolfe

Audrey Flack

One of my intentions, and what I would really like to see happen, and what will happen eventually, is to have real vines and ivy and mosses grow over the roots of Daphne's hair, so that she really becomes part of nature. She is an ecological icon. She is a metaphor for the rape of the earth. And she survives. This is a work of hope. Daphne is Nature. Rather than be raped, Daphne asks her mother, the Earth, and her father, the River-God, for help, and they turn her into a tree, a laurel tree (which is where the term 'poet laureate' comes from). But, she survives! Nature has been around—how many wars has this planet been through?—and Nature survives. And so I do want *Daphne* (1996) to be a living sculpture, really out there. I think she'll be fabulous out there. People have asked me about the bolts and shells that crown her diadem. What happens is that they are the only man-made objects, objects of war, and she transforms them. She has survived all these wars; and she takes these objects and wears them as ornaments, as decorations.

Tom Wolfe

Audrey Flack's figures are radical in three ways. First of all, they are representational. Not only are they representational, they are not vaguely representational, not representational gestures. They are anatomically correct women, they are real figures with real sinews and real muscles and joints, highly articulated. Secondly—and here again what she has done is a gross violation of the current tenets of the New York art world—these are figures that idealize beauty. These are intentionally beautiful women in a contemporary sense. You'll notice that the figures are highly sensual and yet they're lean and somewhat muscular. In fact they are goddesses. They represent spiritual values, and in many cases mythical values, brought forward into the last days of the twentieth century. This is something that is anathema to the contemporary art world because it's not ironical. When Daphne speaks, she speaks truth, and when she speaks, she speaks with her heart. But the greatest violation that Audrey commits when she does these figures is that she does them with skill. And skill, the artist's handiwork, is considered artifice. Here is work of intentional beauty, work of the idealization of the role and the place of woman not only in the contemporary world but in the universe, woman as the creature who speaks—as Daphne does—for all of mankind. This is anathema, this is rebellion that the art world has not seen for some time.

Audrey Flack and Tom Wolfe
Guild Hall Museum, East Hampton, New York, 1996

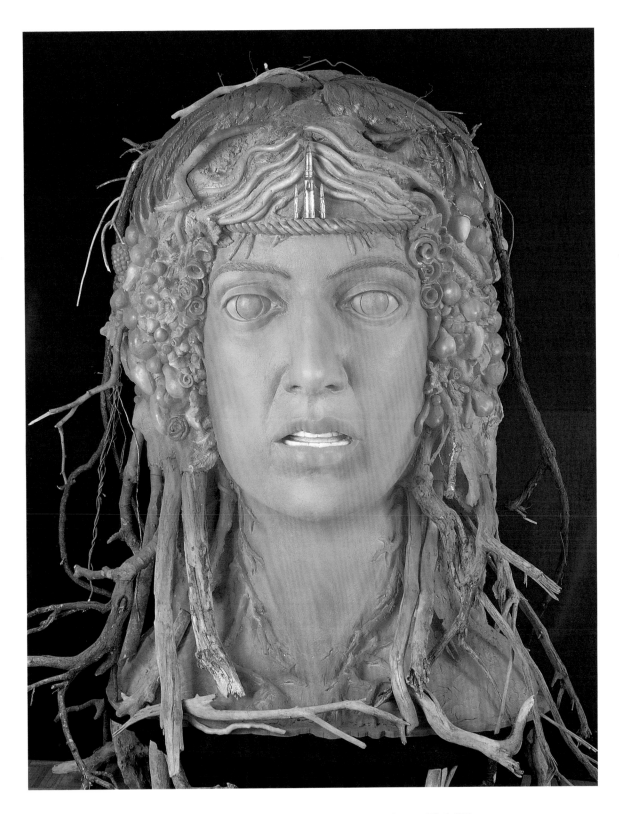

Audrey FLACK
1931–
Daphne 1996
eurethane, wood
177.8 × 157.5 × 81.3 cm without base
213.4 × 157.5 × 81.3 cm with base
Possession of the artist
© Audrey Flack 1996
Reproduced by permission of Audrey Flack 1997

WORKS IN EXHIBITION BY ARTIST'S NAME

THE ARTISTS IN CONTEXT: Biographical Information

What follows is intended to provide a context for the works in this exhibition rather than a more comprehensive account of the artists' biographies.

BACON, FRANCIS
b. Dublin, 28 October 1909; d. Madrid, 28 April 1992.
Education: Predominantly self-educated artist. **Influences**: Picasso, Leger, van Gogh, de Maistre, Sutherland, Freud, Surrealism. **Travel**: London (1925); Berlin (1926); Paris (1927); Monte Carlo (1946–50); Italy (1954); Tangier (1956). **Work**: Part-time furniture and rug designer, visited galleries, Paris (1927); early drawings and water-colours (1926–27); returned London (1928), first oil paintings (1929); exhibition with Roy de Maistre (1930); three *Crucifixion*(s) (1933); after failed 1934 solo exhibition, London's Transition Gallery, painted little until 1943, in the war years destroying much of his earlier work: painted full-time from 1943; significant 1940s works include *Three studies for figures at the base of a Crucifixion* (1944), *Figure in a landscape* (1945), *Painting* (1946); began his ten *Screaming Popes* (1948); later works included paintings of animals (1950s), large-scale sequential series (1950–61), triptychs (from 1962), and expressionistic portraits; often drew on Greek and Christian myths. **Exhibitions**: Exhibited Europe, England, USA; Metropolitan Museum of Art, New York, retrospective 1975.

BARLACH, ERNST
b. Wedel, Holstein, 2 January 1870; d. Rostock, 24 October 1938.
Education: Dresden Academy (1891–95), l'Académie Julian, Paris (briefly, in 1895). **Influences**: Trip to Russia, 1906. **Work**: Sight of Russian peasants, vast Russian landscape and interest in medieval woodcarving influenced subject matter (*The Russian shepherd* 1906); Villa Romana Prize (Florence, 1909); woodcuts (1912); military service (1915–16); major exhibition of graphics and sculptures (1917); 1920s sculptures (*Horror, Old woman with a flask, Pregnant girl, Old woman dancing*) demonstrate emotional range, use of diverse media (terra cotta, wood, bronze, clay), reaction to wartime experience; 1920s–1930s commissions: religious sculptures (*God the Father hovering* 1922, *Christ and Thomas* 1926) and war memorials (Güstrow Cathedral, 1927; Magdeburg Cathedral, 1929); included in *Degenerate art* exhibition (1937). All Barlach's works are expressionist, direct, without artifice; finished works, even when cast in bronze, look as if carved from single block of stone. **Exhibitions**: Two exhibitions at Cassirer Gallery (1917, 1926).

BECKMANN, MAX
b. Leipzig, 12 February 1884; d. New York, 27 December 1950.
Education: Weimar Academy of Art (1900–1902). **Influences**: Mythology, Symbolists, French Primitives, Cézanne, van Gogh, Michelangelo, Munch, Lovis Corinth, Schopenhauer, Nietzsche, German Expressionist painters. **Travel**: Paris (frequently); Geneva (1904); Florence (1907); Paris and Holland (1936–47); USA (1947). **Work**: Mainly in Berlin (1904–14); Villa Romana Prize (1906); formed Berlin Secession (1910), resigned (1914); active military service (1914), nervous breakdown and discharge (1915); began most important work with the explicitly religious (*Christ and the woman taken in adultery* 1917, *Deposition* 1917) and the allegorical (*The night* 1918–19); leading force in movement, exhibition, 'Neue Sachlichkeit' (New Objectivity) with Dix and Grosz (1925); Professor, Städel Art College (1929); earliest of 9 triptychs (*Departure* 1932); included in *Degenerate art* exhibition (1937); in Amsterdam where he completed triptychs *Acrobats* and *Temptation* (1937–47); USA (1947), taught, Brooklyn Museum Art School and Washington University; last self-portrait (*Self-portrait in blue jacket* 1950). **Exhibitions** include *Venice Biennale* (1922); retrospectives: Basel, Zurich (1930).

BELLANY, JOHN
b. Port Seton, Scotland, 1942.
Education: Edinburgh College of Art (1960–65); Royal College of Art, London (1865–68). **Influences**: Max Beckmann retrospective (1965); visit to Buchenwald (1967). **Work**: Travelling scholarship, Holland, Belgium; first solo exhibition, Holland (1965); experience of Buchenwald (1967) exerted ongoing influence on work; exhibited with London Group (1970, 1975, 1976); appointed lecturer in painting, Goldsmith's College (1978); artist-in-residence, Phillip Institute of Technology and Victorian College of the Arts, Melbourne (1982), also New York and Cambridge; Hon. Fellow, Trinity Hall, Cambridge. **Major exhibitions** include *Scottish Realism*, Arts Council travelling exhibition (1971); *A Choice Selection*, Scottish Arts Council Gallery, Edinburgh (1974); *Four Scottish Realists*, Arts Council Gallery, Edinburgh; *British Painting 1952–1977*, Royal Academy, London (1977); major retrospective: *John Bellany — 'A Renaissance'*, Scottish National Gallery of Modern Art (1989).

BEUYS, JOSEPH
b. Krefeld, 12 May 1921; d. Dusseldorf, 23 January 1986.
Education: Preparatory Medical Studies, Rindern (1940); State Art Academy, Dusseldorf (1947–51). **Influences**: Period as circus performer, literature, Galileo, da Vinci, social/political events. **Work**: Radical, independent artist living mainly Dusseldorf (1951–86); radio operator, fighter pilot (1940–45); professor, Dusseldorf (1961–72); Hamburg (1974–75); political and social activism (Fluxus International Movement, 1962; German Students Party, 1967; Joint Action Party for Independent Germans, 1976); created series of 'performances'/'events'/'happenings', taking common ingredients of life—felt, fat, wire or a meeting between people on street corner, in room—and forced awareness of their symbolic capacity. Sculptor, poet, performer, shaman, Beuys altered the direction of art since 1960s by drawing attention to the inner life of those who make and those who participate; 1960s works include *Brown/cross/felt* (1964), *Piano in fat* (1966), *Manresa* (1966). **Exhibitions** in Germany, Holland extensively (from 1952), then Austria, England, Italy, France, Switzerland; *Documenta 3, 4, 5*, Kässel; Guggenheim Museum, New York (1979).

BOYD, ARTHUR MERRIC BLOOMFIELD
b. Murrumbeena, Australia, 1920.
Education: Paternal grandparents (artists); home (introduction to Bible, art milieu); left school (1934); 6 months, night classes, National Gallery School, Victoria. **Influences**: Often mutually influ-

ential—Nolan, Bergner, Tucker, Perceval, Vassilieff. **Travel**: Central Australia (1951); Europe, England, (1959–71). **Work**: Draughtsman, ceramicist, printmaker, painter; landscapes, portraits (1936); solo exhibition (1937); army (1941–44); Biblical paintings (1945); ceramic sculpture, *The sisters* (1952–53); aboriginal themes (*Half-caste/Bride* series 1956); stage designs (including *Electra*, Covent Garden 1963); *Diana and Actaeon* series (1962); pastels, lithographs (1964–65); *Nebuchadnezzar* series (*Nebuchadnezzar running in the rain* 1968–71); *Potter* series (1967–69); *Four portraits of Joseph Brown* (1969); Creative Art Fellowship, Australian National University (1971); copper landscapes (1974–75); *Narcissus* series (1976); *Shoalhaven* series (*Crucifixion, Shoalhaven* 1979–80); tapestry, Parliament House, Canberra (1984); *Scapegoat* etchings, *Prodigal Son* series (1996). **Exhibitions** include *Venice Biennale* (1958), Tate Gallery, London (1963); retrospectives—Whitechapel, London (1962); Arts Centre, Kent (1980–81); travelling retrospective, Art Gallery of NSW (1993–94).

BROWN, JAMES

b. California, 1951.

Education: Immaculate Heart College, Hollywood (1972); Ecole Supérieure des Beaux-Arts, Paris (1973–75); Instituto Michelangelo, Florence (1979). **Influences**: African art, Christian symbolism, New York Museum of Natural History. **Travel**: Extensive; lives in Mexico and New York. **Work**: Highly individual, deep symbolic value, simplicity of form (cross, mask, nail), reverence, detachment and humour; Christian and primitive sources evident in *Crucifixion* (1984–86) and *The Virgin of the seven sorrows, Eleven portraits of Buddha* sculptures (1983–86); range includes ceramics (*Untitled* 1985), lithographs, bronzes (*Portrait of Buddha* 1987), collage (*Shadow XIII* 1990, *Tangiers* 1994). **Exhibitions** include Cité Internationale des Arts, Paris (1976); *San Paolo Biennale*, Brazil (1983); *Mosaic, 83*, Spain; *American neo-Expressionists*, Aldrich Museum, Conn. USA; *States of War*, Seattle Art Museum (1987); *Myth and Mystery*, Santa Monica (1987); *Art Kites*, Japan, touring (1988–89); Russia, Germany, Paris (1990).

BYARS, JAMES LEE

b. Detroit, 10 April 1932; d. Egypt, 1997.

Education: Merrill Palmer School for Human Development, Wayne State University (1948–56). **Influences**: Zen and Noh theatre; philosophy: Stein, Einstein, Wittgenstein; Beuys. **Travel**: Residence established Japan, mainly Kyoto (1958–67); extensive travel: Europe, especially Germany, Holland, Egypt; divided year between USA and Europe. **Work**: From earliest childhood, an accomplished stage performer; critical years in Japan encouraged thirst for perfect communication that raised rather than answered key religious and philosophical questions; first group action in Japan (1960) reading from Gertrude Stein's *Ten Philosophical Questions* (Jisha University, Kyoto, 1961); *The Holy Ghost* action (Piazza San Marco, Venice 1974); *Manresa* action (1966); actions often included sculptures (*The conscience* 1985, *The book of the 100 perfects* 1985); installations (*The angel* 1983) and books (*The death of Thomas McEvilley* 1985). **Exhibitions** include *Documenta 6, 7, 8*, Kässel (1977, 1982, 1987), *Gegenwart Ewigkeit*, Berlin (1990).

CARRINGTON, LEONORA

b. Lancashire, 6 April 1917.

Education: Early education, boarding school (Florence); Amedée Ozenfant Academy, London (1936). **Influences**: Surrealists, Robert Graves' *The White Goddess*, Remedios Varo. **Work**: Traceable in works is woman's and the artist's spiritual quest, traversing childhood fantasy, alchemy, magic and myth (Celtic, Egyptian, Assyrian), with painting as means of entering into inner enlightenment; met Max Ernst, London (1937); self-portrait, *The inn of the dawn horse* (1936); Celtic mythology and animals of continuing significance—swans in *Carved decorated woman* (1951); first short stories illustrated with collages by Ernst (1938–39); Ernst interned (1940); settled, Mexico (1942); Varo's influence evident in works such as *The temptations of Dagobert* (1945); Egyptian myth of Isis and Osiris drawn on in *Palatine predella* (1946), *Pilgrimage to Syrius* (1947); solo exhibition, New York (1948); associations with alchemy evident in works such as *El arbol de la vida* (1960); mural, *The magic world of the Mayans*, Mexico City (1963). **Exhibitions** include solo exhibition, New York (1948); major retrospectives: Mexico (1960), New York (1976).

CASTELLANOS, JULIO

b. Mexico City, 3 October 1905; d. Mexico City, 16 July 1947.

Education: Academy of St Carlos, Mexico City. **Influences**: Mexican painter Manuel Lozano, whose work takes religious, apocryphal scriptural stories—such as death of St Anne—using these to portray Mexican social life and political concerns. **Travel**: USA (1918); Buenos Aires with Lozano (1925); France (1925). **Work**: Castellanos a contemporary of Diego Rivera, Siqueiros, Varo, Kahlo, Orozco and Izquierdo at time when Mexican art community was especially vital; mural and easel painter; used everyday themes as means of drawing attention to major social and political deprivations of poor in Mexico; theatre scenery, Mexico City (1925); exhibited with Tamayo, Mérida and Lozano (1928); murals for library, Acapotzaco (1932); joint award with Frida Kahlo for *La Lluvia* (1946).

CHAGALL, MARC

b. Vitebsk, Russia, 7 July 1887; d. St-Paul-de-Vence, 28 March 1985.

Education: Jehuda Penn, Vitebsk (1906); Imperial School for the Protection of the Arts, St Petersburg (1907); Zvantseva School, Bakst, Saidenberg (1908–09). **Travel**: Russia, Middle East, Poland, USA, France, Holland, Spain. **Work**: Lived Paris (1910–13), developed individual style, incorporating cubism, fantasy (*I and the village* 1911); exhibition, Der Sturm gallery (1914); remained Russia—war (1914–22); founded art school, Vitebsk (1917); Commissar of Art (1918); set, Kamerny Theatre (1920–21); illustrated *Dead Souls, Mein Leben* (1923); trip Middle East, first Bible etchings (1931); Poland visit confirmed sense of Jewish identity, awareness of suffering (1935); Bible etchings (1931–39, 1952–56); French citizenship (1937); *White Crucifixion* (1938), suffering of Jews and Christ; back-

drops, New York Ballet (1942); France (1944), illustrations, La Fontaine's *Fables* (1952); ceramics, marble sculptures (1950s); Biblical paintings (1952–66); stained-glass windows (Metz and Reims Cathedrals, Jerusalem synagogue, UN building). **Exhibitions** include Der Sturm Gallery (1914); retrospectives: Royal Academy, London (1985); Museum of Modern Art, Paris (1990).

CHAISSAC, GASTON

b. Avallon, Burgundy, 13 August 1910; d. La-Roche-sur-Yon, 7 November 1964.

Education: Compulsory years of schooling only; various jobs, including shoemaking. **Influences**: Particular attachment to Celtic past. **Work**: Encouraged by Otto Freundlich, Chaissac began artistic career (1937); produced both abstract and figurative works; characteristics include archaic use of forms, powerful symbolism of colour in oil paintings and totems, face as main motif—a reflection of the divine, expressive of entreaty; substantial body of literary work; letters to Jean Dubuffet, Jean Paulhan, Bernard Coutant, dealing with such subjects as the Church and art (published as *Hoppobosque au bocage* and *Le laisser-aller des éliminés*); several works depicting victims of crucifixion, one of the most remarkable of these, once belonging to Dubuffet, now in Musée de l'Art Brut, Lausanne. **Exhibitions** include Galerie L'Arc-en-Ciel (1947); Galerie Nathan, Zurich (from 1971 on); Musée National d'Art Moderne, Paris (1973); Kunst-Station Sankt Peter, Cologne (1996–97); Museums of Linz-Tübingen-Wuppertal-Frankfurt (1996–97); retrospective, Museums of Nantes-Montpellier-Charleroi (1998).

CLEMENTE, FRANCESCO

b. Naples, March 1952.

Education: No formal art training; enrolled briefly, architecture student Rome (1970). **Influences**: Highly independent, articulate artist; interests include Giotto, Fra Angelico, Italian Renaissance painters, ancient Greek, Egyptian and Roman cultures, contemporary poetry, Hindu and Buddhist traditions, mysticism, tantric philosophy. **Work**: Highly accomplished draftsman (both word and image); work shows consistent fascination with human body as channel linking inner and outer reality, spirit and world; originally body distinctively male, then amorphous, more recently the female body, often portrayed as goddess; labelled 'Trans-avantgarde' by art critic Oliva (1980); works include Christian subject matter (*Fourteen Stations* 1981–82), religious and secular mythology (*Water and wine* 1981), and poetic response to Hindu experience (*Fifty one days on Mount Abu* 1995). **Exhibitions**: *São Paulo Bienal* (1975); *Europa*, Stuttgart (1979); *Venice Biennale* (1980); *Documenta 7, 9, 10*, Kässel.

DENIS, MAURICE

b. Granville, Normandy, 25 November 1870; d. Paris, 13 November 1943.

Education: Lycée Condorcet, Paris (1882); drawing lessons (Professor Zani, 1884); Ecole des Beaux-Arts and l'Académie Julian, Paris (1888–90). **Influences**: Fra Angelico, Symbolists, Gauguin, van Gogh, Neo-Impressionism, English Aestheticism, Egyptian and Japanese art. **Travel**: Italy, Spain, Germany, Switzerland, Belgium, USA, Russia, Egypt, Jerusalem, Greece. **Work**: Key theoretician, cofounder (with Sérusier) of Nabis (1888), secret group espousing pictorial Symbolism; explicitly religious paintings (*Catholic Mystery* 1889–91); domestic and pastoral scenes (*The two sisters* 1891); portraits; murals (ceiling painting Champs Elysées Theatre, 1912); stained-glass windows (St Paul, Geneva 1918; Notre-Dame Du Raincy, 1924); decorative projects; set design (Théatre de l'Oeuvre, 1893); woodcuts (*Imitation of Jesus Christ* 1906); lithographs; writing (*Théories 1890–1910*); embraced classical revival (trips to Italy, 1895,

1897); founded *Ateliers d'Art Sacré* (1919); moved to neo-traditionalism (1920s); from this period on, devoted to religious art work. **Exhibitions**: Retrospectives: International Exposition, Venice (1922), Union Centrale des Arts Décoratifs (1924).

DIX, OTTO

b. Untermhausen, near Gera, 2 December 1891; d. Singen, 25 July 1969.

Education: Apprentice painter/decorator, Gera (1905–09); Dresden School of Arts and Crafts (1910–14); Dresden Academy of Art (1919–22); Düsseldorf Academy of Art (1922–25). **Influences**: Impressionism, Cubism, Italian Futurism, Mannerists, Dada, Expressionism. **Work**: Impressionistic landscapes (c. 1910); portraits (1912–13); cofounder Dresden Secession 'Gruppe 1919' (Expressionist group); woodcuts (1919–20); shift to *Neue Sachlichkeit* realism (1920s); paintings a dark commentary on postwar capitalism (paintings of prostitutes 1921, 1922); harshly revealing portraits (*Self-portrait with model* 1923); *War* lithographs (1923–24); watercolours, figurative paintings, Dusseldorf (1922–25); avant-garde 'Das Junge Rheinland' (1925); professor, Dresden Academy (1927–33); dismissed, paintings confiscated, included in *Degenerate art* exhibitions (1933, 1937); arrested by Gestapo (1939), conscripted, imprisoned in France; Lake Constance (1945); allegorical paintings (1940s); scenes from Christ's life (1959–60); member Academy of Arts (West Berlin, 1955; East Berlin 1956); last lithographs (1968). **Exhibitions**: Dada Fair, Berlin (1920); Museum of Modern Art, New York (1931); *International Exhibition of Paintings*, Carnegie Institute, Pittsburgh (1959); retrospective, Berlin, London (1991).

DUWE, HARALD

b. Hamburg, Germany, 28 January 1926; d. Kiel, 15 June 1984.

Education: Apprentice lithographer (1943); Staatliche Hochschule für Bildende Künste, Stockholm, Kungliga Akademi für de Fria Konsterna Hamburg Kunsthalle, Stockholm (1946–49). **Influences**: Realism, work of Wilhelm Leibl; (briefly) Impressionism. **Work**: Moralist and critical realist; began engagement with art after military service (World War II); art studies, subsequent effort to establish himself as an independent artist (1951); early impressionist landscapes; shift to realistic depiction of miseries of contemporary capitalist society; themes included Germany's postwar poverty and cosy unreflective middle-class existence, consumerism, violence, tensions between industrial advance and despoliation of the environment; figures in paintings often in shallow picture plane that emphasizes brutality or satirical intent of subject matter; religious images often ironically locate Christ in present-day, post-Christian context (*Christusbild der Gegenwart* and *Last Supper* 1978); Duwe taught Fachlochschule, Hamburg (1964–67), Kiel (1970s), to supplement meagre income from art.

ENSOR, JAMES

b. Ostend, 13 April 1860; d. Ostend, 19 November 1949.

Education: Académie Royale des Beaux-Arts, Brussels (1877–79). **Influences**: Turner, Callott, Rembrandt, Daumier. **Work**: Early works: landscapes, portraits, domestic scenes (1876–79); joined Groupe des XX (1883) which repeatedly rejected his work; first mask painting *Scandalized masks* (1883); began spectral, fantasy images (*Skeleton looking at Chinese curios* 1885) showing preoccupation with death; engravings (*The cathedral* 1886); focus on religious subjects (*Adam and Eve expelled from Paradise* 1887, *Entry of Christ into Brussels* 1888, *Christ calming the storm* and *Man of Sorrows* 1891); often identified with Christ (*Christ and the critics* 1891); paintings explore effects of light; further masks paintings; etchings, drypoints (1895–99); *Seven deadly sins* prints exhibited (1902); output slows from 1900; major

retrospective, Galerie Giroux, Brussels (1920); mask theme continues (*Death and the masks* 1927) as do religious themes (*The finding of Moses* 1924). **The major museum** of Ensor's works is Museum voor Schone Kunsten, Oostend, Belgium.

ERNST, MAX
b. Brühl, Germany, 2 April 1891; d. Paris, 1 April 1976.
Education: Philosophy, University of Bonn (1908–14); no formal art training. **Influences**: Strict Catholic upbringing, Nietzsche, Freud, early German painters, van Gogh, Picasso, de Chirico, Orphism; friendships with Macke, Arp, Breton. **Work**: August Macke introduced him to German Expressionists (1911); exhibited Der Sturm Gallery, Berlin (1913); *Kreuzigung* (1913); with Arp, Baargeld, founded Dada, Cologne (1919); to Paris, *Oedipus Rex* (1922); friendship with surrealist theorists; introduced 'frottage' (*Natural history* series, 1926); cofounded Surrealist Movement (1925); *The great history* series (1926); direct reference to Nazi oppression (*The angel of hearth and home* 1935); broke with Surrealists (1938); interned, France (1939–40), escaped, USA (1941); *Vox angelica* (1943), *Eye of silence* (1943); linked up with Dorothea Tanning (*Temptation of St Anthony* 1945); *Father Rhine* (1953); Grand Prize for Painting, *Venice Biennale* (1954); theatrical designs (1966–68). **Exhibitions**: Retrospectives—Berne (1956), Paris (1959), New York (1961), Cologne (1963), Grand Palais, Paris (1974), Guggenheim (1975).

FALKEN, HERBERT
b. Aachen, Germany, 1932.
Education: Studied drawing, Aachen; Academy of Art (briefly): philosophy, theology, Bonn and Aachen (1958–64); ordained Catholic priest (1964). **Influences**: Theological and Biblical studies, Bacon, German artists, Guernica. **Travel**: Mainly Germany, visited Florence, Paris, Salzburg. **Work**: Focused on questions arising from commitment to Christianity, priestly ministry; constantly pursued underlying truth and spirituality of life-events, saw everything as sign or symbol of greater reality—Christ, for Falken, incarnated in the pregnant person, the sick and poor, while Crucifixion happens in fires of war and starvation of the world; first great cycle, *Apocalypse* (1961); second cycle of crucifixes (*Scandal of the Cross 14* 1969); later works (*Death and the girl* 1987, *Jacob and the angel* 1984, *Requiem* 1987) have great energy and verve, executed with great freedom of line and technique. **Exhibitions**: Suermondt-Ludwig-Museum, Aachen (1953, 1964, 1974); Kunst-Station Sankt Peter, Cologne (1990); retrospective, Diözesanmuseum, Cologne (1995–96).

FLACK, AUDREY
b. New York, 1931.
Education: Cooper Union, New York (graduated 1951); Yale (1952).
Influences: Pop Art, Abstract Expressionism, Mannerism, Baroque Art, Albers. **Work**: Teacher, Pratt Institute, New York University (1968–74); School of Visual Arts, University of Bridgeport, Connecticut (1975); moved from Abstract Expressionism in 1950s to photorealism—*Kennedy's motorcade* (1964); *Vanitas* paintings inspired by Counter Reformation; *Marilyn* 1977; symbolic nature of objects; Flack sees herself embedded in society with power to make a difference: her *Queen Catherine of Braganza* to stand on Queens Bank of East River (1996)—simultaneously the Queen of History and a contemporary goddess mediating beauty, health, power; other 'new' goddesses are *American Athena* (1989), *Medicine woman* (1989), bejewelled skeleton *Sophia* (1995), and *Daphne* (1966). **Exhibitions** include *Twenty Two Realists*, Whitney Museum (1970); *New Photo Realism*, Wadsworth Atheneum, Conn. (1974); *American Paintings of the Seventies*, Albright-Knox Art Gallery, New York (1979).

GIMBLETT, MAX
b. Auckland, New Zealand, 1935.
Education: Apprenticed to potter, Ontario (1962); Ontario College of Art (1962); San Francisco Art Institute (1964). **Work**: Travelled England, Europe (1958); began painting (1964); paintings as icons, imbued with and evocative of the spiritual; works draw upon myth (Biblical, Celtic), Eastern philosophies, archetypal symbol (ovoid, circle, etc.), alchemy, transmutations (7 works, *Objects of alchemy* 1982); solo exhibitions (1970–72); visiting Associate Professor of Art, Pratt Institute, School of Arts and Design, Brooklyn; prints (*New Zealand suite* 1979); significant shift in work from 1982—greater range of image, materials, artistic methods—metallic pigments, shapes of canvas, quatrefoil; range evident in Crucifixion images (*Harvest cross* 1989, *Aquarius* 1992, *Buddha* 1991–92, *Monkey me* 1992, *Torah/Breath* 1994–95).

GOLDSTEIN, DANIEL
b. Mt Vernon, New York, 1950.
Education: Brandeis University (1968–70); University of California, Santa Cruz (1973–74); St Martin's School of Art, London, with Anthony Caro. **Influences**: Early Renaissance art, Romanesque church architecture, Grünewald, prehistoric and Japanese culture, contemporary dance. **Work**: All works concerned with elements of transformation, movement and the cyclical nature of the passage of time; recently, the image of the body in a state of entropy dominates; range of works: leather assemblages, glass sculptures, large-scale permanent installations; works include the artist's response to AIDS, the *Icarian* series (1994); a large public installation, *Leonardo's dream* (1996); *Lazarus* (1997). **Exhibitions** include Brooklyn Museum (1983); Achenbach Foundation (1979); MOCRA, St Louis (1995).

GROSZ, GEORGE
b. Berlin, 26 July 1893; d. Berlin, 6 July 1959.
Education: Dresden Academy (1909–11); Academy of Arts and Crafts, Berlin (1912–13); Colarossi Academy, Paris (1913). **Influences**: Caricatures; Italian Futurists. **Work**: Caricaturist for satirical magazines; military service (1914, 1917), discharged unfit, pen drawings (1915–18); work for *Neue Jugend*; joined German Communist Party, Dadaists (1918); realistic painting (1920s), sketched brush drawings (1923–27); *Ecce Homo suite* (1923); link with *Neue Sachlichkeit* (1925); *Pillars of society* (1926); *Background collection* (1928)—controversy, blasphemy charge over gas-masked Christ on cross; shift to less grim works, synthetic realism (late 1920s); Visiting Professor, Art Students League, New York (1932, 1950–55); targets Nazism in work (1930s); residence USA (1933); sets up Sterne-Grosz School, New York (1933–37); condemned as 'degenerate' artist (1937); painted dune landscapes, nudes (Cape Cod, 1936–46); monochrome watercolours, persistent images—'stickmen' and void (1949 on); illustrations (1954); final watercolour (1954); Pop collages (1958). **Exhibitions**: Kunsthaus, Zürich (1930); Art Institute of Chicago (1936); Whitney Museum, New York (1954); Travelling exhibition, Stuttgart (1995).

HOLZER, JENNY
b. Gallipolis, Ohio, 29 July 1950.
Education: Ohio University (1971–72); Rhode Island School of Design (1975–77); Whitney Museum, independent study programme fellowship (1977). **Influences**: Conceptualism, Kosuth. **Work**: Abandoning early abstract painting, explored relationship of captions, words, writing, in visual representation; created texts, often discordant with consumerist expectation, distributed and displayed these in public sites; *Truisms* (1977–79); *Inflammatory essays* (1979–82); *Living* series incorporating portraits by Peter Nadin

(1980–82); Holzer organized *Manifesto Show* (manifestos of 150 artists); continued to locate texts on/in different materials: painted on walls (Kranefuss House), printed (e.g., on styrofoam cups), inscribed on stone, painted on metal, presented as electronic signs (e.g., in sports centres and shops and above Times Square); completed *Survival* series (1983–85); *Under a rock* (exhibited 1986); 13 sarcophagi, *Laments* installation, displayed 1989–90; *Mother and child*, in *Venice Biennale* (1990); completed *Lustmord* (1993–94). **Exhibitions**: Dallas Museum of Art, Texas (1984); (with Barbara Kruger) Israel Museum, Jerusalem (1985); Guggenheim Museum, New York (1989); *Venice Biennale* (1990); St Peter's Church, Cologne (1993).

HRDLICKA, ALFRED
b. Vienna, 27 February 1928.
Education: Art and painting, Vienna, with Gütersloh, Dubrowsky (1946–52), and painting under Wotruba (1952–57). **Influences**: Michelangelo, Rembrandt, Goya, Brücke. **Work**: Sculptor and graphic artist; relentlessly committed to figuration in work and equally against total abstraction of artists like Mondrian (*Roll over Mondrian* 1967); although Marxist, in substantial amount of work looks to scriptures, particularly life of Christ as way of revealing power of basic religious images and myths (*Christ on the Cross* 1959, *Homage to Pasolini* 1983, *Marsyas II* 1962) to raise awareness, compassion and anger about horrendous actions of Nazi Germany; Hrdlicka's other work often takes up the sexually explicit; he is an artist who reaches into the darkness of the human spirit. **Exhibitions**: Kunstlerhaus, Vienna (1963); Marlborough Fine Art, London (1968); Nationalgalerie, West Berlin (1975); Museum of Modern Art, Mexico City (1984); retrospective, Akademie der Künste, East Germany (1985).

IPOUSTÉGUY, JEAN-ROBERT
b. Dun-Sur-Meuse, France, 20 January 1920.
Education: Part-time in studio Robert Lesbounit (1938); self-taught sculptor, painter, architect, printmaker. **Influences**: Brancusi, Moore, Freud, Surrealism, Henri-George Adam, visit to Greece. **Work**: Carver and modeller; most important work post-1949; earlier work: painting, stained-glass windows, tapestries; emphasis since 1959 on male body as holder of meaning and mystery of life (*Val de grâce* 1976) or suggested by its absence and destruction (*David and Goliath* 1959); first major female figure (*Woman in the bath* 1966); in quarries at Carrara (1967–68); *The death of the Father* (1967), and *Mother's agony* (1970–71) probe the meaning of death and ambiguity of father-son/mother-son relationships; return to modelling techniques (1976); *The house* (1977); returned to painting briefly (1976), then more seriously to printmaking and commissioned sculpture (*Val de grâce* 1977, Paris). **Exhibitions** include National Gallery, Berlin (1974); Museum of Modern Art, Paris (1982); Guggenheim Museum, New York (1983).

IZQUIERDO, MARIA
b. Jalisco, Mexico, 1906; d. Mexico, 3 December 1955.
Education: Art lessons (1912); Academy of St Carlos, Mexico City (1927–28). **Work**: Grew up during Mexican Revolution (1910–20), belonged to generation of artists (Kahlo, Tamayo, Rivera, Siqueiros) who self-consciously reclaimed indigenous pre-Spanish roots, folk traditions; more than the others, Izquierdo incorporated into dress and work, elements of Indian folk practice—brightly painted designs, flowers, small toys, home altars with votive images and candles; work is poetic; befriended by two poets, Artaud, Neruda; established studio, partnership with Rufino Tamayo (1929); *Landscape* (1930); *Good Friday* altar (1943); prevented from executing mural designed for Palacio de Gobierno by Diego Rivera and David Siqueiros on the grounds of her inexperience; *The Dolorosa Madonna* (1947); works now much sought and valued. **Exhibited**: New York Art Centre (1931), Gallery René Highe, Paris (1933); exhibited often, European galleries (1933–35); represented, Surrealist exhibition, Gallery of Art, Mexico City (1940).

KAHLO, FRIDA
b. Coyoacán, Mexico City, 6 July 1907; d. Mexico City, 13 July 1954.
Education: Preparation for medical studies (1922); apprenticeship to commercial painter (1925). **Travel**: San Francisco with Rivera (1929); Detroit (1932); New York City (1933, 1938); in France (1939) met Kandinsky, Picasso, Ernst, Miró, Tanguy, Duchamp. **Work**: Began painting after accident (1925); art, passionate response to everything in life; work, like her life, dominated by ill-health; diary charts experiences in writing, drawings, watercolours, as do her paintings; married Diego Rivera (1929); self-portraits based on Madonna (*Self portrait with small monkey* 1945), on her life with Rivera (*Frida and Diego Rivera* 1931), on her ill-health (*Henry Ford Hospital* 1932) and on her psychological state (*The two Fridas* 1939); others drew on religious symbolism and sources (*The broken column* 1944, *Sun and life* 1947, *Moses or the nucleus of creation* 1945). **Exhibitions**: Julien Levy Gallery, New York—Breton, catalogue preface (1938); Museum of Modern Art, New York (1940); first one-person exhibition, Gallery of Contemporary Art, Mexico City (1953).

KANDINSKY, WASSILY
b. Moscow, 4 December 1866; d. Neuilly-sur-Seine, 13 December 1944.
Education: Painting, drawing lessons as child; law, economics, Moscow University (1886–1902); Anton Azbé Art School, Munich (1897–99); Royal Academy, Munich (1900). **Work**: Key figure in development of twentieth-century art towards total abstraction, works express a deeply-pursued spirituality; began painting, Munich (1896), leadership, avant-garde painters; cofounded Phalanx (1901), disbanded as too restrictive (1904); founded Munich New Artists Association (1909), membership included Gabriel Münter, Alexei Jawlensky, Franz Marc, August Macke; revolutionary tract, *Towards the Spiritual in Art* (1911), advocating new freedom for art and theoretical basis for abstraction; reflecting this movement—*Composition II* (1910), *All Saints I* (1911), *Composition VII* (1913); returned Moscow (1914), a founder of Academy of Arts and Science; taught: Swomas, Weimar Bauhaus (1922); Bauhaus closed (1932); Paris (1933); work declared 'degenerate', Germany (1937). **Exhibited** in newly formed *Der Blaue Reiter* exhibition (1911); second *Der Blaue Reiter* (1912) which also included Klee, Kirchner; widely, Europe, USA, England.

KIEFER, ANSELM
b. Donaueschingen, Germany, 8 March 1945.
Education: Painting, under Dreher, Freiburg (1966–68); Akademie der Bildenden Künste (1969); Staatliche Kunstakademie, Dusseldorf (1970–72). **Influences**: Beuys, Conceptualism, American Abstract Expressionists. **Work**: Nonnarrative, Kiefer's art draws upon myth, legend, symbol and history in work with distinctively German yet multilayered themes; Kiefer has used words and images, word-as-image; visited monastery, La Tourette (1966); photo-series *Occupations* (1969); watercolours (1970); set up studio, Buchen (1971); works based on Wagner's operas (*Germany's spiritual heroes* 1973, *Brunhilde* series 1975–78); apocalyptic landscapes (1974); 'scorched earth' works—burnt surfaces, use of lead, shellac, oil, sand, wood, paper, emulsions (1974); *Ways of worldly wisdom* (1976–80); *Margarete* and *Shulamite* series (1981); *Icarus* series (1981–82); Hans Thoma Prize (1983); visited Israel (1984); *Osiris and Isis* (1986);

concern with nuclear energy, transformation continued in alchemistic, material pictures (1990s). **Exhibitions** include retrospective, Bonn (1977); *Venice Biennale* (1980).

AF KLINT, HILMA

b. Karlberg, Sweden, 26 October 1862; d. Djusholm, 21 October 1944.

Education: Stockholm polytechnic, portrait painting (1880); Academy of Fine Arts, Stockholm (1882–87). **Influences**: Spiritism, theosophy, anthroposophy (philosophy of Rudolph Steiner). **Work**: Landscapes, portraits (1887); draughtsmanship, Stockholm (1900–01); experiments with automatic writing; mediumship; first 26 oil paintings (*WU* series), mediumistically produced, surface-oriented, with letters, dark symbols (1906); second series, rose-coloured backgrounds, sketches and paintings (1907); 10 figural paintings, 10 other works—4 ages of humankind (1907); *Seven stars /Sic transit gloria mundi* series, and 17 watercolours (1908); met Rudolph Steiner, influence of his philosophy evident in *Swan* series and abstract *Altar paintings* (1912–15); *Tree of knowledge* series (1913–15); further works employing motifs derived from spiritism and theosophical beliefs (*Convolution of astral forces* 1916); anthroposophical respect for important religious belief (as in *The Christian religion, Buddha's point of view on earthly life, The Muslim standpoint* 1920), *Flowers, mosses and lichens* (1920); watercolours on paper (1922–31).

KOKOSCHKA, OSKAR

b. Pöchlarn, Austria, 1 March 1886; d. Montreux, 19 February 1980.

Education: School of Arts and Crafts, Vienna (1905–09) where Klimt taught, Schiele also a pupil. **Influences**: Klimt, Cizek, writers of the Enlightenment, South Sea masks, Japanese woodcuts, Austrian Baroque art. **Travel**: France, Italy, Spain, Ireland, Tunisia, Hungary, Greece. **Work**: Paintings (1907); postcards (1908); significant portraits (1908–14); work in Kunstchau exhibition and plays brought heavy criticism; expelled, School of Arts and Crafts (1909); Switzerland briefly, then travelled Vienna–Berlin (1910–14); critics denigrated work, Hagenbund exhibition, Vienna (1911); subject of some paintings: love for, separation from, Alma Mahler (*The tempest* 1914); served Russian Front (1914–17); lithographic portraits (1918); professor, Dresden Academy (1919), resigned (1924) when Jewish artists dismissed; travelled (1920s, 1930s), cityscapes, London (1926) and Prague (1934–38); art declared 'degenerate' (Munich 1937); to London (1947); major retrospective, Switzerland (1947); teaching, Salzburg (1954–62). **Exhibitions** include Gallery Der Sturm, Berlin (1912); New Gallery, Vienna (1924); Kunsthalle, Basel (1947); *São Paulo Bienal* (1953); Tate Gallery, London (1962/69/74), *Venice Biennale* (1922, 1932, 1948, 1952).

KOLLWITZ, KÄTHE

b. Konigsberg, Germany 8 July 1867; d. Moritzberg, 22 April 1945.

Education: Private art study (1880, 1888–89); School for Women Artists, Berlin (1885–86); l'Académie Julian, Paris (1904).

Influences: Max Klinger's prints, Rodin's sculptures. **Work**: Printmaker, sculptor; expressiveness, realism characterize work; ceased painting (1891); etchings, lithographs exhibited Berlin (1891); graphics, *Weavers' uprising* cycle (1895–98); met Rodin, began sculptures (1904); Villa Romana Prize (1907); met Barlach, began woodcuts (1917); among themes of work—women, death (*Death and the woman* 1910, *Death* lithographs 1934–35), mothers and their children (*Mother and son* 1903); war (*Battlefield* 1907, woodcuts *War* series 1922–33), violence (*Rape* 1907); significant sculptures of 1930s include *Self-portrait* (1926–36), *The mother* and *The father* (1931–32), *Parents' monument* (1924–32); teaching,

Graphics Art Academy, Berlin (1928); professor, Prussian Academy of Arts, Berlin (1919–33); lost position (1933), art withdrawn, exhibiting prohibited (1936); left Berlin 1943. **Museums** in honour of Käthe Kollwitz are located in Cologne and Berlin.

KRASNER, LEE

b. Brooklyn, 27 October 1908; d. New York, 19 June 1984.

Education: Women's Art Schools of Cooper Union, Manhattan (1926–29); the Art Students League (1928); National Academy of Design (1929–32); City College of New York, Greenwich House (1933); Hans Hofman School of Fine Arts (1937–40). **Influences**: De Chirico, Miró, Arshile Gorky, Pollock, Matisse, Tobey, Russian fairy tales, ancient writing forms. **Work**: Abstract expressionist; early experiments with portraiture (*Self-portrait* 1930), Surrealism, Social Realism, later Cubism and Fauvism; joined Artists Union and American Abstract Artists (1940); married Jackson Pollock (1945), promoted him strongly at some cost to her own reputation; *Little image* series (1945–50) classic examples of Abstract Expressionism; major works of the 1970s, including *Mysteries* (1972), combine flat earlier rhythms and shapes with calligraphic energy of early work; in last works such as *Imperative* (1976), attempted to acknowledge many movements of her artistic development. **Exhibitions**: USA; England; France; touring retrospective, Museum of Fine Art, Houston (1983).

McCAHON, COLIN

b. Timaru, New Zealand, 1 August 1919; d. Auckland, New Zealand, 27 May 1987.

Education: King Edward Technical College Art School, Dunedin (1937–39). **Work**: Outstanding New Zealand painter of this century; two themes run through McCahon's work—the physical land that is New Zealand and personal search to resolve questions of faith and doubt; landscapes include *Otaga peninsula* (1946), *Six days in Nelson and Canterbury* (1959), *Light falling through a dark landscape* (1972). Like the landscapes, McCahon's religious works are imbued with deep sense of spirituality while at same time calling for some kind of redressive action; words often integral part of composition—*The King of the Jews* (1947), *Easter landscape: Triptych* (1966); *Victory over Death 2* (1970). **Exhibitions** include Helen Hitchens Gallery, Wellington (1949); *Fifteen New Zealand Painters*, Irving Galleries, London (1952); *Contemporary Painting in New Zealand*, Smithsonian Institute Travelling Exhibition; *I will need words*, University of Sydney, Australia (1984).

MANESSIER, ALFRED

b. Saint-Ouen (Somme), 5 December 1911; d. Orleans, 1 August 1993.

Education: Architecture, Amiens; School of Fine Arts, Paris (1929–33); various ateliers of Montparnasse, Paris, Academy Ranson. **Influences**: Childhood landscape at Le Crotoy, Old Masters, Klee, Bissière, Delaunay, Cubism, Surrealism, Picasso; conversion experience, Trappist monastery, Soligny (1943) which directed life and painting towards mystical and contemplative experience; French Sacred Art Revival movement (1939). **Travel**: Holland, Provence, Spain; Canada (1967). **Work**: Predominantly painter, mainly landscapes and religious themes, but also tributes to admired people (Martin Luther King, Allende, Romero); military service (1939–41) as technical draughtsman; with Bazaine and Singier organized exhibition, *Young Painters of the French Tradition*, Paris; commissioned stained-glass windows (Bréseux 1948–50, Arles 1953, Cologne 1964, Bremen 1966); tapestries, mosaics and liturgical vestments. **Exhibited** widely, France, Belgium, Germany, USA, Italy, England, Switzerland; *Mannessier: Retrospective*, Palais des Beaux-Arts, Charleroi, Belgium, 1979.

MAPPLETHORPE, ROBERT

b. Queens, New York, 4 November 1946; d. Boston, 9 March 1989.
Education: Pratt Institute of Graphic Arts and Design, Brooklyn (1963–70). **Influences**: Nineteenth-century photographers, Nadar, Julia Cameron, F. Holland Day, Sam Wagstaff, Andy Warhol. **Work**: A perfectionist; photographs consistently redescribe boundaries of what photograph is/can do; progress of artistic life a pilgrimage in search of ideal image, fame; self-portraits (1971), portraits of friends (*Patti Smith* 1976, 1986), celebrities and artists (*Paloma Picasso* 1980, *Phillip Glass* 1986, *Cindy Sherman* 1988), publicity shots for magazines (*Bathing suit* 1985), still lifes and flowers (*Roses* 1983, *Canna lily* 1984), and consistently for a long period, the male, black nude in homoerotic pose (*Ken Moody* 1983, 1985); experimented with number of photographic processes, including gelatin silver prints, platinum prints, photogravures. **Exhibitions** include *Polaroids*, Light Gallery, New York (1976); Retrospective, Institute of Content Art, London (1983); platinum-on-canvas prints, Robert Miller Gallery (1987); *The Perfect Moment*, Institute of Contemporary Art, Philadelphia (1988).

MARTIN, AGNES

b. Saskatchewan, Canada, 22 March 1912.
Education: Western Washington College of Education, Bellingham (1935–38); Columbia University (1941–42, 1951–52); University of New Mexico, Albuquerque (1946–47). **Influences**: Minimal (reclusive life-style); interest in Adolph Gottlieb, Arshile Gorky, Miró; New York painters—Ellsworth Kelly, Jack Youngerman, Robert Indiana, James Rosenquist. **Travel**: Within North America—New York, New Mexico. **Work**: Linked with abstract expressionism; seen as forerunner, minimalist art; American citizenship (1940); early paintings—landscapes, still lifes, figures (1940s); shifts, from recourse to biomorphic abstraction (mid 1950s), to hard-edged austere works (first solo exhibition 1958), to grid system, floating colour, horizontal and vertical pencil lines (begun early 1960s); New Mexico (1967); writing (1967–74); returned to art (1974), continued grid paintings with significant refinements of tone, colour and composition. **Exhibited** widely, travelling exhibitions Kunstraum, Munich (1973–74), Arts Council of Great Britain (1977); Pace Gallery, New York (1980); retrospectives: Philadelphia (1973), Stedelijk Museum, Amsterdam (1991), Whitney Museum, New York (1992).

MATISSE, HENRI

b. Le Cateau-Cambresis, 31 December 1869; d. Nice, 4 November 1954.
Education: Law, Sorbonne (1887); drawing, Ecole Quentin de la Tour (1890); l'Académie Julian, Ecole des Arts Décoratifs (1891–92); Ecole des Beaux-Arts, Paris (1895); studio Gustav Moreau (1895–99). **Influences**: Cézanne, Neo-Impressionism, Pissarro. **Travel**: Corsica, Algeria, Germany, Spain, Russia, Morocco, Tahiti, USA. **Work**: Began painting (1890); early work—still lifes, interiors; impressionist style—colour, brushwork, palette (1896–97); shift in landscapes (1898); founded Salon d'Automne (1903); experimented, pointillism (1904); Fauvism (1904–06); paradisial *Joy of life* (1905–06), travel, painted figures, portraits, still lifes (1908–12); began *Odalisques* (1918); sets, costumes for Diaghilev ballet (1920–25); lithographs, etchings (1929); USA, Tahiti (1930–31); commissions—*Mallarmé* illustrations (etchings, 1932), mural, Barnes Museum, Pennsylvania (1930); first tapestries (1934); used paper, scissors (*The dancer* 1938); drawings, book illustrations, cut-out paper technique (1940s); oil paintings (1946–48); Vence Chapel: crucifix, candlesticks, vestments, mural (1948–51). Exhibited widely, Europe, India, USA, Canada; Musée Matisse, Nice.

MESSAGER, ANNETTE

b. Berck-sur-France, 30 November 1943.
Education: Ecole Normale Supérieure des Arts Décoratifs, Paris (1962–66). **Work**: Sardonically compartmentalises objects and artistic work (art/life dichotomy); violent, ambivalent images (*Children with their eyes scratched out, Boarders at rest* 1971–72), *Album collections* (1971–74); body of the artist, photographic series (1975 onwards) and prints (*The horrifying adventures of Annette Messager* 1974–75); feminist irony, *My collection of proverbs* (1972–73); phantasmagoric *Chimera* series (1982–84); disturbing death-focused *Effigies* series (1984–86); *My trophies* series (1986–88); *My little effigies* series and *Embroidery works* (1988), juxtaposing innocence and menace; religious imagery, *My vows* (1988), and amalgam of the physical and religious in *Sin* (1990); *Map of tenderness* (1988) and *Garden of tenderness* series (1989); *Pikes* (Piques) 1994. **Exhibited** widely, Europe, New York; *Sydney Biennale*, Australia (1984); *Biennale de Lyons* (1993).

MOTHERWELL, ROBERT

b. Washington, USA, 24 January 1915; d. 16 July 1991.
Education: Otis Art Institute (1926–29); California School of Fine Arts (1932), Stanford Institute (1932–37), Harvard (1937–38), Columbia University (1940). **Influences**: Cubist collage, Surrealism, theory of automatism, films dealing with Spanish Republic, French literature and aesthetics, Spanish poetry, psychoanalytic theory, Delacroix, Matisse, Brancusi, Mondrian. **Travel**: Mexico with Matta; extensively, Europe. **Work**: *Mexican sketchbook* (1941) explored rapid drawing, interactive shapes that with 'plastic automatism' became the vocabulary of his Abstract Expressionist works; friendship with Baziotes, Pollock, de Kooning; cofounded 'Subject of the Artist' School, New York (1948); works include lithographs (*Bastos* 1975), oils and collage (*The French line* 1960), acrylic and charcoal (*The hollow men* 1983); large mural-like works, *Spanish elegy* series (1949–90) move in slow sombre rhythms of black and white, express powerful sense of tragic mortality; late 1960s paintings saturated in sensuous colour, large colour-field. **Exhibitions**: Art of the Century (Peggy Guggenheim) Gallery (1944); large retrospective, Museum of Modern Art, New York (1966); retrospective (travelling), Albright-Knox Gallery, Buffalo (1983).

MUNG MUNG, GEORGE

(language group: Gija) b. Inwunji Gorge near Turkey Creek, Western Australia, c. 1920; d. Kimberley, Western Australia, 1991.
Education and work: Like other traditional Australian Aborigines, gained education within the community where he was gradually initiated into full membership with clearly defined responsibilities; for many years, head stockman and drover; began painting in early 1980s when already an elder committed to seeing that right relationships were maintained with the people and the country; fulfilled this role through story, dance, song, paint and carving; used local clays, ochres and natural gum binders; narrative and ritual work; in 1970s, with Hector Jandany, set up Ngalangangangpum bicultural Christian school; in 1982 established out-station with Jack Britten at Frog Hollow, Western Australia; received National Aboriginal Art Award, Darwin (1990) for *Tarrajayan country*. **Exhibitions** include *Aboriginal art and spirituality*, High Court of Australia, Canberra (1991); *Images of power: Aboriginal art of the Kimberley*, National Gallery of Victoria, Melbourne (1993).

NEWMAN, BARNETT

b. New York, 29 January 1905; d. New York, 4 July 1990.
Education: Art Students League (1922); City College (1923–27).
Influences: Kropotkin; Russell; Surrealism, especially automatism.

Work: With Pollock, Rothko, Kline, Newman a protagonist of total abstraction as it developed in postwar America, with resultant shift of 'centre' from Paris to New York (1950s); theoretician, convincing rationale for abandonment of figuration; active political role (1931); manifesto *On the need for political action by men of culture* (1933), to help remedy 1930s social depression; wrote catalogue, opening exhibition at Betty Parsons' Gallery *Northwest Coast Indian Painting* (1946); he and Pollock exhibited with Parsons (1946); cofounded 'Subjects of the Artist' School; painted *Onement I* (1948), wrote 'The Sublime is Now' (1948); *XVIII Cantos* exhibited (1965); *The Stations of the Cross, Lema sabachthani* (1966); *Who's afraid of red yellow and blue* series (1966–70); sculpture, *Broken obelisk* (1963–67). **Exhibited** extensively: *New American painting* (1959); retrospectives, Pasadena (1970), Museum of Modern Art, New York (1971), Tate Gallery ,London (1972); important group exhibitions—*Documenta 2*, Kässel (1959), Tate Gallery (1964).

NITSCH, HERMANN

b. Vienna, 29 August 1938.

Education: Teaching and Research Institute for Graphic Design, Vienna (1953–58). **Influences**: Tachism, Action Painting, Abstract Expressionism. **Work**: Works on paper including *Crucifixion (After Rembrandt)* 1956; early drawings, printmaking; Nitsch developed Orgien Mysterien Theater (1957), public and theatrical painting action, involving theatre, painting, music, choreography; his intention, to stir conscience, confront mysteries of life and death, invest work with a ritual/liturgical function; incorporated Christian symbol, mysticism, religious objects, processions, sacrificial elements (blood); paintings include *Station of the Cross, bread and wine* (1960); cofounded Weiner Aktionismus (1960s), began public painting actions—*Malaktionen* (1960), *Action* (1975), *Three day play* (1984), *Malaktion* (1988); set up performance studio, Schloss Prinzendorf (1971); later paintings include *Schüttbild* series (1991), *Kreuzwegstation* series (1990–92), *Chancel installation*, St Peter's Church, Cologne (1992). **Exhibited** widely, Germany, Austria; also Italy, Switzerland; retrospectives: Van Abbemuseum, Holland (1983), Villa Pignatelli, Naples (1987).

NOLDE, EMILE

b. Nolde-Schleswig, 7 August 1867; d. Seebüll, 13 April 1956.

Education: School of Arts and Crafts, Flensburg (1884–88); art classes, Karlsruhe (1889); Sauermann School of Carving, Flensburg (1898); Hoelzel's school, Dachau (1899); l'Académie Julian, Paris (1899). **Influences**: Da Vinci's *Last Supper*, Manet, Ensor, Gauguin, Munch. **Travel**: Europe, Asia, Melanesia. **Work**: Apprentice woodcarver; watercolours, St Gallen (1892–98); *The mountain giants* (1897); studio, Copenhagen (1900); to Alsen (1903); *Fantasies* series (1905); Die Brücke exhibitions (1906, 1907); religious works (1910–12), religious etchings (1911); *Pentecost* rejected, expelled from Berlin Secession, founded New Secession (1910); nightscapes, Berlin (1910); *Autumn sea* series (1911); exhibited, *Blaue Reiter* (1912); lithographs (1913); drawings, masks, paintings—influenced by German New Guinea Expedition, South Seas (1913–14); landscapes, Utenwarf (1918–19); Prussian Academy of Arts (1931–37); declared 'degenerate artist', Germany (1937); watercolours, Seebüll (1938–45); Professor of Art, Schleswig-Holstein (1946); Graphic Art Prize, *Venice Biennale* (1952). **Collections**: Most extensive collection of Nolde's work held by the Seebüll Foundation, Aida and Emil Nolde.

O'KEEFFE, GEORGIA

b. Sun Prairie, Wisconsin, 15 November 1887; d. Santa Fe, New Mexico, 6 March 1986.

Education: Art Institute of Chicago (1905–06); Art Students League (1907); summer classes, University of Virginia (1912); Columbia University, New York (1914–15). **Influences**: European Modernism, Arthur Dow, Arthur Steiglitz. **Travel**: To and from New Mexico; France, Germany, Spain (1953, 1958); India (1958). **Work**: Commercial artist (1908–12); charcoal abstractions (1915) with organic, gender-based motifs; first solo exhibition (1917), watercolours, drawings, at Steiglitz's gallery, *291*; married Stieglitz (1924); began using cropped, close-up techniques of photography as in flower series (*Pink sweet peas* 1927) and more representational forms (*Rib and jawbone* 1935); city paintings (*Radiator building — night New York* 1927); settled New Mexico (1949); New Mexico landscape-linked colour and themes (e.g., *Black cross, New Mexico* 1929, *Cow's skull — red, white, and blue* 1931); air travel (1953), further themes (*Sky above clouds* series 1963); autobiography (1976). **Exhibitions** include retrospectives: Brooklyn Museum, New York (1927), Fort Worth Museum, Texas (1965), Whitney Museum, New York (1970).

OROZCO, JOSÉ CLEMENTE

b. Ciudad Guzman, New Mexico, 1883; d. Mexico City, 1949.

Education: Academy of Fine Arts, San Carlos (1890, 1906–14) **Influences**: Julio Ruelas, Dr Atl, José Guadalupe Posada, Eva Sikelianos, Rivera and Siqueiros. **Travel**: USA, 3-month European tour. **Work**: Caricaturist (in periodicals: *El Hijo del Ahuizote* 1912, *La Vanguardia* 1915); studio, Mexico City; *House of tears* series (1912); first solo exhibition (1916); to USA (1917); founder, Union of Revolutionary Painters, Sculptors, Engravers (1923); muralist, Escuela Nacional Preparatoria (1923); *Omniscience, Social revolution* (1925–26); New York (1927–34); lithographs (1928); murals: USA (*Prometheus* 1930; Baker Library cycle, 1931; Museum of Modern Art, 1940); Mexico—vibrantly coloured *Guadalajara* series (1936–39); lithographs, *Suite Mexicana* (1935); *Man of fire* mural (1938); founder, El Colegio Nacional (1943); anticlerical antimilitary paintings (1945); further murals (*Church and the Imperialists*), easel paintings (1948–49). **Exhibitions** include Art Center, New York (1928); *Mexico in Revolution*, New York; Albertina, Vienna (1930); Los Angeles Museum (1930); retrospective, Mexico Palace of Fine Arts (1947).

PALADINO, MIMMO

b. Camponia, Italy, 18 December 1948

Education: Art School of Benevento (1964–68). **Influences**: Principally, cultural heritage of geographical area: Roman, Etruscan, Graeco-Roman, Early Christian, Romanesque. **Work**: After moving to Milan (1977), concentrated on painting; later, sculpture and printmaking work explores the spiritual themes of life, sacrifice, death and mystery; iconography often includes animals, plants and masked figures involved in some kind of ritual; work came to international attention after being named by art critic Achille Bonito Oliva (1980) as a leading member of the 'Transavantgarde'. **Exhibitions**: *Nuovi Strumenti*, Brescia, Italy (1976); Centre of Contemporary Art, Geneva (1979); Marion Goodman, New York (1980); *Documenta 7*, Kässel (1982); *L'Incanto e la transcendenza*, Trent (1994).

PICASSO, PABLO

b. Málaga, 25 October 1881; d. Antibes, France, 8 April 1973.

Education: La Llonja Art School, Barcelona (1896–97); Royal Academy of San Fernando, Madrid (1897); Cordona's studio, Barcelona (1899–1900). **Work: (1930–40)**: Dark mood (encroaching Fascism, 1930s Europe); cubist inspiration, Catholic background, sources for *Crucifixion* (1930), preceded by drawings focused on emotional response of spectators; this (with its relationship to death of Pichot) and subsequent *Crucifixions* (Sept.–Oct. 1932), their

primitivising and ritualistic staging, Mithraic reference, challenge equation of religious title with religious work; *Head of a woman* sculpture (1930–31); portraits, sleeping women, nudes (1932); Minotaur image (1935); met Dora Maar (1936), *Weeping woman* (1937); Spanish Civil War, Directorship, Prado (1936); *The dream and lie of Franco* etchings (1937); *Guernica* (May–June, 1937), elements from Dora Maar images and *Crucifixions*, perhaps more religious than *Crucifixions*. **Important exhibitions of religious work** (1930–40): Museum of Fine Arts, San Francisco (1939); Museum of Modern Art, New York (1939); *The body on the cross*, Picasso Museum (1993).

RAINER, ARNULF

b. Baden, 8 December 1929.

Education: (Briefly) Hochschule für Angewandte Kunst, Vienna (1949); Akademie der Bildenden Künste, Vienna (1950). **Influences**: French Surrealism, Art Brut, Gestural Abstractionists, Grünewald's Isenheim altar. **Work**: Surrealist work (1948–51); prints (1950); cofounded Hundsgruppe (1950); overpaintings, finger paintings, colour as actual and symbolic expression; surrealist automatism (early 1950s); *Blind drawings* series (1951–54); articulates oft-quoted 'la peinture pour quitter la peinture' (1952); *Proportion studies* (1953–54); overpainted monochromes (*Overpaintings* 1953–75); focus—religious practice, symbol, cruciform shapes (*Black cross* 1956, *Wine crucifix* for church, Graz 1957); large (6 ft) early painted crosses; surrealistic drawings, attenuated human figure (1962–71); physical expression of feeling—*Face-farces* and *Grimace-photos* (*Canary* 1970–71, *With eye amplifier* 1971); finger-painting (*Finger smear* 1974); reworked photographs (1974–77); death masks (*Totem mask* 1978); *Hiroshima* series (1980s); teaching (1981 onwards), Akademie der Bildenen Künste, Vienna, Staatliche Akademie der Bildenen Künste, Stuttgart; creates further Crosses (1988, 1990). **Exhibited** widely, Europe, USA; retrospective, Nationalgalerie, West Berlin (1980).

RICHIER, GERMAINE

b. near Arles, France, 16 September 1904; d. Montpellier, 31 July 1959.

Education: Art College, Montpellier (1922–25); Paris studio, Antoine Bourdelle—who worked with Rodin, (1926–29); traditional emphasis on accurate rendering of human figure in classical techniques of carving and modelling. **Work**: Worked faithfully in traditional techniques of carving and casting for bronzes (1929–39); created sculptures which evoke war horrors; creatures (*Praying mantis* 1946, *The Bat-Man* 1946), no longer Rodin-like, opened way for succeeding generations of sculptors, England and France, (e.g., Butler, Chadwick) to break domination Rodin had exerted; controversy about her crucifix for the church at Assy (1950); with its removal on directive from Rome, media attention of world focused for short time on her work; represented in *The New Decade: 22 European Painters and Sculptors*, Museum of Modern Art, New York (1954); prestigious travelling exhibition, *New Images of Man*, Museum of Modern Art, New York (1958); *Vienna Biennale* (1948, 1952, 1954, 1958, 1960, 1964).

ROTHKO, MARK

b. Gvinsk, Russia, 25 September 1903; d. New York, 25 February 1970.

Education: Yale University (1921–23); Art Students League, New York (1924–26, 1931). **Influences**: Matisse, Surrealists. **Work**: American Abstract Expressionist; arrived USA (1913); painting (1926); teaching, Jewish Center Academy (1929); cofounded 'Gallery Secession' (1932); solo exhibition (1933); formed abstract-expressionist group, 'The Ten' (1935), exhibited Paris (1936); employed, WPA (1936–37); visit, exhibition of abstract, cubist and surrealist art (1937), subsequent abstract surrealism, biomorphic forms, use of mythical symbol; founded Federation of Modern Painters and Sculptors, New York (1940); Rothko/Gottleib art manifesto (published, *New York Times*, 1943); move from surrealism (*Entombment I* 1946); cofounder 'Subjects of the Artist' group (1948); part of New York School (late 1940s); taught (1947–67) Colorado, Tulane, California Universities, Brooklyn, Hunter Colleges; commissions (1958–64): murals—Harvard, deMenil family (Rothko Chapel). **Exhibitions** include Contemporary Arts Gallery, New York (1933); Art of This Century, New York (1945); *Venice Biennale* (1958); retrospectives; Los Angeles County Museum (1970), Guggenheim Museum, New York (1978).

ROUAULT, GEORGES

b. Belleville, Paris, 27 May 1871; d. Paris, 13 February 1958.

Education: Apprentice stained-glass maker (1985); Ecole des Arts Décoratifs, Paris (1885); Ecole des Beaux-Arts, Paris (1891–92), continued association (1892–95). **Influences**: Italian Renaissance artists, Rembrandt, Leon Bloy, Redon, Matisse. **Work**: Catholic artist—aligns human suffering, exclusion, with Christ's sufferings; Prix de Chenavard for *The child Jesus among the doctors* (1894); Curator, Gustav Moreau Museum after Moreau's death (1898); cofounded Salon d'Automne (1903); courtesan paintings (1903–04); Fauve exhibition (1905); *Baptism of Christ* (1911); clown paintings (1914–18); *Crucifixion* (1918); spiritual horrors of war (*Guerre et misère* and *Miserere* series 1922–27); sets, Diaghilev Ballet, *The prodigal son* (1929); landscapes (1930s); *Biblical autumn, Nazareth* (1948); *The Holy Countenance* series (1931–58); *Head of Christ* (1937–38), compassion-linked *Head of a clown* and *Wise Pierrot* (1940–44); etchings, woodcuts (1939); stained-glass windows, Assy (1945); *Man is wolf of man* (1940–48); *Ecce Homo* (1952). **Exhibited** widely, Europe, USA, Japan; touring exhibitions: Museum of Fine Arts, Boston (1940), Tate Gallery, London (1966).

SAKULOWSKI, HORST

b. Saalfeld, Germany, 28 August 1943.

Education: Academy for Graphics and Book Arts (1962–67). **Influences**: Magic Realism and Surrealism, especially Dali and Magritte; Old German Painting; Grünewald; Italian High Renaissance—Leonardo da Vinci, Michelangelo, Andrea del Sarto—influential especially in drawing. **Work**: On basis of very sensitive drawing learned from study of Old Masters, Sakulowski's work from the beginning bore the dualism of strong connection with reality and allegorical fantasy; he developed principles of design for films (Andrej Tarkowskij), sculpture, photography, installation; characteristically worked across different genres on basic questions of human existence; central theme—upholding of ethical, human values in everyday life as well as under conditions of global threat to life from manipulation, annihilation of body and spirit; achieved this mostly through isolated figures of commanding size with strong symbolic and often antithetical character; from beginning of 1980s gave more attention to themes of death, transitoriness; since 1990 has also worked with video camera.

SAURA, ANTONIO

b. Huesca, Spain, 22 September 1930.

Education: Self-taught art. **Influences**: Spanish art—Velasquez, Goya, Picasso's *Guernica*; German art; Grünewald; Expressionism; Matta, Surrealists; Hartung; Wols. **Travel/residence**: Madrid, Paris. **Work**: With Tàpies, credited with revitalizing European art after World War II; from 1950, work moved to violent yet figurative form of Abstract Expressionism; crucifix holding tortured body of Christ a

constant theme figuratively (*Grand Crucifixion* 1959, *Crucifixion* 1960, 1962, 1967, 1985); symbols and fragments (*Crucifixion* 1959); both series in homage to Goya (*Infanta* 1960, *Gran retrato imaginario de Goya* 1963, *Portrait imaginaire de Goya* 1962) and portraits (*Sandra* 1956, *Dora Maar* 1983) comment on social, political chaos, need for reform and transformation (*Metamorphosis* 1985); triptych *Crucifixion* (1990) for Church of St Peter, Cologne—reflection on Rubens' *Crucifixion of St Peter* which was created for the church. **Exhibited** widely, represented in most important public collections throughout the West. Numerous awards include Guggenheim Award for Painting (1960), Carnegie Prize (1964).

SCHMIDT-ROTTLUFF, KARL

b. Rottluff, 1 December 1884; d. W. Berlin, 10 August 1976.
Education: Architecture, Dresden Technical School (1905). **Influences**: Other members of Die Brücke group (Heckel, Kirchner, Bleyl, 1905; Nolde, 1906); Art Nouveau; Neo-Impressionism, van Gogh, Matisse, Cubism, African sculpture. **Travel**: Paris (1924); Italy (1930). **Work**: Cofounded Die Brücke (1905), Dresden-based (1905–11) anti-traditions artist group; stayed with Nolde, Alsen (1906); use of characteristic forms, woodcuts (1909 onwards); strong landscapes (*Manor house in Dangast* 1910); to Berlin (1911); *The Pharisees* (1912); Die Brücke dissolved (1913); individual style emergent; strong, angular forms in paintings and wood sculptures (1913–17); military service (1915–18); woodcuts, life of Christ (*The road to Emmaus* 1918); joined anti-academic art group, Arbeitsrat Für Kunst; member Prussian Academy (1931), expelled 1933, declared 'degenerate', Germany (1937); professor, Berlin Hochschule für Bildende Künst (1947). **Exhibitions** include the major exhibitions of the Brücke—*Brücke I* and *II*, Dresden (1906, 1907); *New Sec I*, Berlin, Sonderbund, Cologne (1912).

SEGAL, GEORGE

b. New York, 26 November 1924.
Education: Cooper Union, New York (1941–42); Rutgers University, New Jersey (1942–46, 1961–63); Pratt Institute, Brooklyn (1947–48); New York University (1948–49); State University of New York (1949–50). **Influences**: Edward Hopper, assemblage artists. **Work**: Figurative paintings (1950); sculpture: often unpainted, anonymous plaster-cast figures made up of exterior of cast, posed in specific social settings (late 1950s); late 1960s–1970s more lifelike works; tableaux include *The diner* (1964–66); shifts to colours (*The restaurant window* 1967), greater detail (*Memory of May 4 1970, Kent State: The sacrifice of Isaac* 1973); monuments, public sites (*The Holocaust* 1987, *Abraham and Isaac* 1978); draws subject matter, inspiration from scriptural sources to make political and social comment (*The Expulsion* 1986–87, *Abraham's farewell to Ishmael* 1987). **Exhibitions**: Museum of Contemporary Art, Chicago (1968); Centre of Contemporary Art, Paris (1972); Basel Art Fair (1974); Israel Museum (1985); retrospectives: Minneapolis, San Francisco, Whitney, New York (1978); touring exhibition, USA, Canada (1997).

SHAHN, BEN

b. Kovno, Lithuania, 12 September 1898; d. New York, 14 March 1969.
Education: Apprentice lithographer, Manhattan (1913–17); Art Students League (1916, 1941); New York University (1919–21); City College, New York (1921–22); National Academy of Design (1922); Académie de la Grande Chaumière, Paris (1925). **Influences**: Traditional and contemporary European art. **Travel**: North Africa, Italy, France, Spain. **Work**: USA (1906); communicative and design potential of letters (*Alphabet of creation* 1957); aware of emerging fascism through travels (Europe 1924–25, 1927–29), rejected European abstractionism, espoused social realism; 13 watercolours on Dreyfus (1930); major social realist work, *Passion of Sacco and Vanzetti* (23 gouaches, 1931–32); art, documentary photography, murals, WPA and FSA, (1930s–1940s) reflect justice concerns; collaboration with Diego Rivera, murals (1933); serigraphs (1940–42); shift to personal realism; teaching USA universities (1947, 1950, 1951); Charles Eliot Norton Professor of Poetry, Harvard (1956–57); lithographic, illustration, mural work; author/illustrator (1947–68). **Exhibitions**: Retrospectives—Museum of Modern Art, New York (1947); Stedelijk Museum, Amsterdam (touring 1971); Staatliche Kunstalle, Baden-Baden (touring 1962).

SHERMAN, CINDY

b. Glenn Ridge, New Jersey, 19 January 1954.
Education: State University of New York, Buffalo (1972–76). **Influences**: Conceptual Art. **Work**: Shifted from study of painting to photography, artist-run Hallwells Exhibition Space (1975); NEA fellowship, moved to Manhattan (1977), launched professional career, frequently self as 'subject', made up to look like film star on 1950s set (*#54* 1979—Marilyn Monroe), a teenager relaxing (*#96* 1981), a murder victim (*#153* 1985), corrupting body part erupting from within (*#177* 1987), or like a reincarnated character from history (*#198* 1989), from myth (*#224* 1990), or religious image (*#216* 1989); setting and characters in 'history' pictures from Renaissance paintings, reconstructed faithfully yet turned into stereotypes; photographs not individual self-portraits, but designed to enable viewers to see aspects of themselves. **Exhibited** widely, USA, Europe (1978–98), including the Kitchen Centre and Metro Pictures, New York (1978); large retrospective, Whitney Museum, New York (1987). Awarded Guggenheim Fellowship (1983).

SIQUEIROS, DAVID ALFARO

b. Chihuahua, Mexico, 29 December 1896; d. Mexico City, 1974.
Education: Escuela Nacional de Bellas Artes (1911–13); Escuela al Aire Libre (1913). **Influences**: Mexican history, Marxism, European painters; shares many characteristics with German Expressionists. **Work/travel**: Murals, easel paintings, social realist style; Revolutionary Army (1914–18); to Europe (1919); murals at San Idelfonso (1922), Guadalajara (1924); trade-union work (1925–30); prison, painting (1930); painted, exhibited extensively (1932); founded Siqueiros Experimental Workshop, New York (1935); fought in Spanish Civil War (1937); taught, Paris (1938); in Mexico (1939–43); founded Centro Realista de Arte Moderno (1944); mural, *Cuauhtemoc* (1944); important 1947 works include *The devil in the Church* and *Funeral of Cain*; included in *Venice Biennale* (1950); travel to Poland, Soviet Union, Cuba, Venezuela (1951–60); imprisoned, Mexico (1960–64); new painting, commissions; National Art Prize (1966); Lenin Peace Prize (1967); Chairman, Mexican Art Academy (1968).

SMITH, KIKI

b. Nuremberg, West Germany, 1954.
Influences: Three major interlocking factors are abiding influences in work—German background of theatrical family, Catholicism of formative years, gender preoccupation with physicality as expression of total spirituality. **Work**: Travelling puppet theatre (1971); studied industrial baking (1972); study of *Gray's Anatomy* text (*Womb* 1985, *Severed limbs, ribs* 1987, *Big head* 1992–93); solo exhibition, *Life Wants to Live*, The Kitchen, New York (1982); to Germany for *Documenta 7*, Kässel (1993); explored Virgin Mary theme as icon, myth and model (*Virgin Mary* 1992) and other biblical and mythical prototypes (*Mary Magdalen* 1994, *Milky Way* 1993, *Lilith* 1994); materials traditionally associated with women's home activities: cloth,

glass (*Skirt* 1990), wax (*Tale* 1992), paper and papier mâché (*Hard and soft bodies* 1992), as well as more 'masculine' processes of bronze and steel (*Scaffold body* 1995). **Exhibited** extensively, including *Projects 24*, Museum of Modern Art, New York (1990), Whitney Biennale, Whitney Museum, New York (1991).

SPENCER, STANLEY

b. Cookham, England, 30 May 1891; d. Cliveden, 14 December 1959. **Education**: Painting classes with Dorothy Bailey (c. 1906); Maidenhead Technical Institute (1907); Slade School (1908–12; spring, 1923). **Influences**: Bible stories, William Blake, village life, Roger Fry, Italian 'primitives', Cubism, symbolic narrative and religious allegory. **Travel**: War service, Salonika (1916–17); Yugoslavia (1922), Switzerland (1938), China (1955). **Work**: Official war artist (1918); religious murals for Burghclere Chapel (1923, 1932); *The Resurrection, Cookham* (1926); *Christ in the wilderness* series (1938); *St Francis and the birds* and *The dustman* rejected by Royal Academy (1935); landscapes, domestic scenes, *Resurrection, Port Glasgow* series (1942–50). **Exhibitions**: England, Scotland, Wales, France. Belgium, Austria, Australia; *Venice Biennale* (1932); retrospectives: Temple Newsam, Liverpool (1947); Tate Gallery, London (1955); Royal Academy, London (1980).

TANNING, DOROTHEA

b. Galesburg, Illinois, 25 August 1910. **Education**: Mainly self-taught; Chicago Academy of Art (briefly, 1930); visits to Art Institute of Chicago (1930). **Influences**: Literature, exhibition, *Fantastic Art, Dada, Surrealism* (1936), Breton, Ernst, Georges Visat. **Travel**: Travel/residence, USA, France; Italy (1954). **Work**: Work consciously feminist; drawings (*The coast* 1937); family portraits, Stockholm (1939); self-portrait *Birthday* and surrealist *Children's games* (c. 1942); first solo exhibition, Levy Gallery (1944); set, costume designs, ballet and theatre (1945); lithographs (*The seven spectral perils* 1949); taught, University of Hawaii (1952); painting (*Death and the maiden* 1953, *Two words, fanatical angels* 1959, *Dogs of Cythera* 1964); surreal *Cloth sculptures* (1969, 1972–74); for Centre Pompidou—*Chambre 202, Hôtel du Pavot* (1970s); lithographs (1972–73); installation, Pompidou (1977); collages, paintings, etchings (1980s–1990s); *Messages* exhibition (1990). **Exhibitions** include: retrospectives: Knokke-Le Zoute, Belgium (1967), National Centre for Contemporary Art, Paris (1974); prints, New York Public Library (1992); Malmö Art Gallery, Sweden (1993).

THOMAS, ROVER

(language group: Kukatja/Wangkajunga) b. Kukubanja, Gibson Desert, Western Australia, c. 1926.
Education and work: Desert community then Billiluna Station; jackaroo, stockman in Western Australia and Northern Territory; moved to Turkey Creek (1975); received in dream the songs and dances for the Gurrir Gurrir (Kuril Kuril, Krilkril), an important public ceremony concerned with the long journey of the deceased woman (his classificatory mother) from the site of her dying back to her conception site; performed from the late 1970s using ochre-painted plywood story-boards carried on shoulders during the dance; paintings usually of the land and its Dreamtime stories (*Yari Country* 1989, *Dreamtime story of the willy willy* 1989). **Awards and exhibitions** include John McCaughey Prize (*Blancher country* 1990); *Venice Biennale* (1991); *Images of power: Aboriginal art of the Kimberley*, National Gallery of Victoria (1994); *Power of the land: masterpieces of Aboriginal art*, National Gallery of Victoria (1994); *Roads cross: The paintings of Rover Thomas*, National Gallery of Australia, Canberra (1994).

TOBEY, MARK

b. Centerville, Wisconsin, 11 December 1890; d. Basel, 24 April 1976. **Education**: Formal art education—Saturday classes, Art Institute of Chicago (1906). calligraphy, Shanghai (1934); brushwork, Zen monastery, Japan (1934); ongoing study, Asian art. **Influences**: Painter Juliet Thompson introduced him to Baha'i movement (1918); William Blake (1918); Cubism (1922); Juan Gris; Feininger; Deng Kui, Chinese artist (met 1923); Persian, Arabic calligraphy (1926). Travels: France (1925); Spain, Greece, Constantinople, Beirut, Haifa, Acca and Sinai (1926), Paris (1954); Belgium, Germany (1958). **Work**: Fashion illustrator (1911, 1913, 1917); portraits, caricatures (1920s); images of working-class males (Great Depression years); teaching, Devon (1930); 'white writing' compositions (1936–1940s); return to Seattle (1938) and to the city energy captured in many of his works; guest art critic, Yale University (1951); *Meditation* series, Seattle and *Abstract Japanese Calligraphy* exhibition, New York (1954); 'black writing' in sumi ink (1956); Olympia Library mural (completed 1959); resided Basel (1960–76). **Exhibited** widely—Europe, England, USA; retrospective, Knoedler Gallery, New York (1976).

TROCKEL, ROSEMARIE

b. Schwerte, Westphalia, 13 November 1952. **Education**: University studies, including theology, Cologne (1970–78); painting, School of Applied Arts, Cologne (1974–78). **Work**: Trockel's work has no one style or material—she draws, knits, writes, makes sculptures, paints, photographs; all work comments on social position of women or other minority groups throughout history; knitted objects (*Untitled* 1985—hammer and sickle flag), designed on computer and made on knitting machine, smashed stereotype of work of art as made from 'art materials' (*Balaclava* 1986–90); found/built/cast/designed memorial (1994) to homosexuals destroyed by Hitler; *Angel*, bronze from plaster cast found by Cologne Cathedral—nothing changed except head broken, set back at impossible angle; wrote over altar, St Peter's Cologne, the words *Ich habe Angst* (I have Angst) (1993); work assimilates all that has gone before it. **Exhibited** widely, including Monika Sprüth, Cologne (1983), Museum of Modern Art, New York (1988), Institute of Contemporary Art, London (1988), Museum of Modern Art, Frankfurt (1997).

TÜBKE, WERNER

b. Schönedeck on the Elbe, Germany, 30 July 1929. **Education**: Academy for Graphics and Book Arts, Leipzig (1948–49); Greifswald University (1950–52). **Influences**: European art, especially fifteenth and sixteenth centuries; Mannerism in particular, also Baroque. **Work**: Initial orientation towards nineteenth-century Realism; since 1950s, persistent turning to earlier art—Renaissance, Mannerism, Baroque; figurative compositions designed in associative, metaphorical way, often in connection with hierarchical forms of pictures, such as multiple panels and predellas, with mythological references and elements of Christian iconography; most of cyclical work up to 1980s used topical and historical themes which combined with visionary humanism to reflect individual and social conflict in concentrated, archetypal way. Main work: huge panoramic painting in Bad Frankenhausen (completed 1987); after this, work expanded into metaphysical scenes, hallucinative, like marionettes, of the Mediterranean landscape; stage design for Carl Maria von Weber's opera, *der Freischutz* (1990–93); most recent work, altar triptych for St Salvatoris in Clausthal-Zellerfeld in the Harz (dedicated 1997).

VARO, REMEDIOS

b. Girona, Spain, 16 December 1908; d. Mexico City, 8 October 1966.
Education: Real Academy, Madrid (1934). **Influences**: Surrealism, writings of Breton; reading of witchcraft, sorcery, alchemy, Tarot, magic; Bosch, Goya, El Greco; friendship with Leonora Carrington. **Travel**: Spain, France, Mexico (1941), Venezuela (1947–49), Mexico (1949–66). **Work**: Moved to Paris (1937) with poet husband, Benjamin Péret, then, after fall of France, to Mexico City (1942); contact with other surrealists, such as Carrington and Wolfgang Paalen; worked, commercial art; painting full time (1953); rejected surrealist doctrines; technically outstanding, fine polished surfaces, masterly draughtsmanship and an iconography that is sometimes whimsical (*Towards the tower* 1961), often mystical (*The escape* 1961) and occasionally humorous (*Bankers in action* 1962); major works chart some kind of journey (*The call* 1961) or moment of creative transformation (*Creation of the world* 1958, *Creation of the birds* 1957). **Exhibitions**: *Second Inter-American Biennale Exhibition*, Mexico City (1960); *Tribute Exhibition*, National Museum of Modern Art, Mexico City (1964), The New York Academy of Sciences (1986), Museo Carrillo Gil, Mexico City (1987).

WARHOL, ANDY

b. McKeesport, Pennsylvania, USA, 6 August 1928; d. New York, 22 February 1987.
Education: Commercial art, Carnegie Institute of Technology and Art (1945–49). **Work**: Warhol consistently sought to break from whatever was acceptable and to set up new norms for others to follow; wrote extensively, made films, works on series of prints and paintings, and proclaimed his personal deviance in the media; much of work is shot through with ambiguity of intention; this especially so in his later religious series which used imagery from Renaissance paintings; Warhol came to be a practising Catholic; series include many works incomplete at time of death, *Suicide* (1962), *Do it yourself* (1962), *Campbell's* (1962–), *Car crash* (1963), *White car crash 19 times* (1963–), *Electric chair* (1963–), *Brillo* (1964), *Heinz* (1964), *Portraits* (1964–), *Flowers* (1970–), *Catastrophe* (1982–), *Religious* (1982–86). Exhibited extensively, Europe, England, USA.

WILLIKENS, BEN

b. Leipzig, 1939.
Education: Painting, State Academy of Fine Arts, Stuttgart; study awards/grants—Study Foundation of German People (1964), Study Foundation for London (1955–56), Academy of Arts, Berlin (1968), Villa Romana Prize (1970), Villa Massimo Prize (1972). **Influences**: Renaissance painting, shift to Mannerism, architecture. **Work**: Early works reflect dilemmas of modern world through objects (*Locker no. 43 with rubber sheet* 1971, *Asylum bed no. 1* 1973, *Wheeled stretcher*

no. 3 1973) and rooms admitting no view beyond themselves; first prize *FDR, Graphic Biennale*, Florence (1972); monumental *Last Supper* (1976–79); Professor of Painting, Pforzheim (1977), College of Fine Arts, Brunswick (1982); important works include *Room — homage to Andrea del Sarto* (1982–83), *Transformation of a room — painting as installation* (1981), the triptych *Wesel altar* (1981–83), and *Chapel* project (begun 1984). **Exhibited** widely, including *Forms of Realism today*, Musée d' Art Contemporain, Montréal (1980); *Nouveau plaisirs d'architecture*, Pompidou, Paris (1985).

VAN DE WOESTYNE, GUSTAVE

b. Gand, 1881; d. Uccle/Brussels, 1947.
Education: Ghent Academy (1895–99). **Influences**: Ghent Symbolist writers, including poet brother Karel van de Woestyne and Maurice Maeterlinck; Primitives; pre-Raphaelites; Expressionism. **Work/travel**: Laethem-Saint-Martin (1899); with Minnie, van den Abeele, Servaes, formed Laethem-Saint-Martin group; painted *Saint Dominique* for Laethem church (1902); Benedictine novitiate, Louvain (1905); moved to Louvain (1909–12), then to Brussels and Tiegem; war years (1914–18) in Wales, where works characterized by Baroque symbolism; shift to Expressionism after war evident in *Violiniste aveugle* (1920); returned Belgium (1921); religious works include *Christ montrant ses plaies* (1921), *Notre-Dame des sept douleurs* (1925), and the graphic *Christ nous offrant son sang* (1925); became Director of Academy, Malines (1925); member of 'The Group of Ten' (1926); his *Dernière Cène* (1927) critically acclaimed; taught l'Institute Supérieur de la Cambre and at Antwerp (1928). **Exhibitions** include Societé des Beaux-Arts, Paris (1903); Palais du Cinquantenaire, Brussels (1910); Stedelijk Museum, Amsterdam (1912).

ZENIL, NAHUM B.

b. Chicontepec, Mexico, 1947.
Education: Escuela Nacional de Maestros, Mexico City (1959–64); Escuela Nacional de Pintura y Escultura, part-time (1968–72). **Work**: Teaching (1964–84), then full-time painting; early works abstract, then moved to figurative works often addressing justice-based concerns. **Exhibitions**: One-person exhibitions include Instituto Nacional de Bellas Artes, Mexico City (1972); Museo Carrillo Gil (1982); Museo de Arte Moderno, Mexico City (1987); parallel project—New York, Los Angeles, San Antonio—for Mary-Anne Martin Fine Art, New York (1990); *Nahum B. Zenil, Witness to the self*, The Mexican Museum, San Francisco, California and the Study Centre, New York University, New York (1996); represented in *Pasión por la vida. La revolución del arte Mexicano en el siglo XX*, Castel dell'Ovo, Naples, Italy (1997).

BIBLIOGRAPHIES

Individual Artists
Selected Bibliographies

BACON, FRANCIS

Domino, Christophe. *Francis Bacon: Taking Reality by Surprise* (English trans.), London, Thames & Hudson, 1997.

Russell, John. *Francis Bacon* (rev. ed.), London, Thames & Hudson, 1979.

Schmied, Wieland. *Francis Bacon: Commitment and Conflict*, Munich, Prestel, 1996.

Sylvester, David. *Interviews with Francis Bacon*, London, Thames & Hudson, 1975.

BARLACH, ERNST

Dopplstein, Jürgen (ed.). *Ernst Barlach: beeldhouwer, tekenaar, graficus, schrijver; Sculpteur, dessinateur, graveur, écrivain; Bilhauer, Zeichner, Graphiker, Schrifsteller, 1870–1938*, Leipzig, E. A. Seeman, 1994.

Schult, Friedrich. *Ernst Barlach Werkverzeichnis*, 3 vols., Hamburg, 1960–71 (catalogue raisonné).

Werner, Alfred. *Ernst Barlach*, New York, McGraw-Hill, 1966.

BECKMANN, MAX

Beckmann, Max. *Self-portrait in words: Collected writings and statements*, Barbara Copeland Buenger (ed.), Chicago, Chicago University Press, 1997.

Belting, Hans. *Max Beckmann: Tradition as a problem in modern art*, trans. P. Wortsman, New York, Timken Publishers, 1989.

Schulz-Hoffmann, Carla, and Weiss, Judith (eds). *Max Beckmann: Retrospective* (exhib. cat.), Saint Louis, Saint Louis Art Museum, 1984.

Selz, Peter. *Max Beckmann*, New York, Abbeville Press, 1996.

BELLANY, JOHN

John Bellany: a Toast to Mexico (exhib. cat.), London, Beaux Arts Gallery, 1997.

John Bellany: Paintings, Watercolours and Drawings (exhib. cat.), London, Fischer Fine Art, 1986.

John Bellany: paintings 1972–82 (exhib. cat.), Birmingham, Ikon Gallery, 1983.

McEwen, John. *John Bellany*, Edinburgh, Mainstream Publishing, 1994.

BEUYS, JOSEPH

Joseph Beuys: Manresa Hbf (exhib. cat.), Barcelona, Centre d'Art Santa Mònica, 1995.

Mennekes, Friedhelm. *Joseph Beuys: Christus Denken* (Thinking Christ), Stuttgart, Verlag Katholisches Bibelwerk, 1996.

Thistlewood, David (ed.). *Joseph Beuys: Diverging Critiques*, Liverpool, Liverpool University Press, 1995.

BOYD, ARTHUR

Crumlin, Rosemary. *Images of Religion in Australian Art*, Kensington, Bay Books, 1988.

Hoff, Ursula. *The Art of Arthur Boyd*, London, André Deutsch Ltd, 1986.

Philipp, Franz. *Arthur Boyd*, London, Thames & Hudson, 1967.

BROWN, JAMES

James Brown (exhib. cat.), Danilo Eccher, Milan, Galleria Civica di Arte Contemporanea, Trento, 1995.

Mennekes, Friedhelm. *Faith: Das Religiöse im Werk von James Brown*, Stuttgart, Verlag Katholisches Bibelwerk, 1989.

Mennekes, Friedhelm. 'Regard extérieur — regard intérieur: Visages de James Brown', *Galeries Magazine*, 19, 1987, pp. 88–95.

BYARS, JAMES LEE

Elliott, James. *The Perfect Thought: Works by James Lee Byars*, Berkeley, University of California, 1990.

James Lee Byars, Cologne, Michael Werner, 1985.

CARRINGTON, LEONORA

Barnet-Sanchez, Holly (ed.). *Leonora Carrington: The Mexican Years, 1943–1985*, San Francisco, The Mexican Museum, 1991.

Carrington, Leonora. *The House of Fear: Notes from Down Below*, London, Virago Press, 1989.

Hubert, Renée Riese. *Magnifying Mirrors: Women, Surrealism and Partnership*, Lincoln, University of Nebraska Press, 1994.

Knapp, Sarah. 'Leonora Carrington's Whimsical Dream World: Animals Talk, Children are Gods, a Black Swan lays an Orphic Egg', *World Literature*, vol. 51, no. 4, 1977, pp. 525–30.

CASTELLANOS, JULIO

Billeter, Erika (ed.). *Images of Mexico: the contribution of Mexico to 20th century art* (exhib. cat.), Texas, Dallas Museum of Art, 1988.

Twenty Centuries of Mexican Art / Viente Siglos de Arte Mexicano (exhib. cat.), Museum of Modern Art, New York and the Instituto de Antropolog'a e Historia de México, Mexico, 1940.

CHAGALL, MARC

Compton, Susan (ed.). *Chagall* (exhib. cat.), Royal Academy of Arts, London and Philadelphia Museum of Art, Philadelphia, 1985.

Le Targat, François. *Chagall*, New York, Rizzoli, 1985.

Meyer, Franz. *Chagall*, New York, Harry N. Abrams Inc., 1957.

Sorlier, C. (ed.). *Chagall by Chagall*, trans. J. Shepley, New York, Abrams, 1979.

CHAISSAC, GASTON

Brütsch, Françoise. *Gaston Chaissac*, Bern/Berlin, Gachnang & Springer, 1993.

Dubuffet, Jean. *Chaissac*, intro. for exhibition *Chaissac*, Galerie Arc-en-Ciel, Paris, 1947, in Jean Dubuffet. *Prospectus et tous les écrits suivants*, Paris, Gallimard, 1967.

Gaston Chaissac, cat. of travelling exhibition, Linz-Tübingen-Wuppertal-Frankfurt, 1996/97.

Nathan-Neher, Barbara. *Chaissac*, English trans., London, Thames & Hudson, 1987.

CLEMENTE, FRANCESCO

Clemente: An Interview with Francesco Clemente by Rainer Crone and Georgia Marsh, Elizabeth Avedon Editions / Vintage Contemporary Artists, New York, Vintage Books, 1987.

Clemente: Two Horizons (exhib. cat.), Tokyo, Sezon Museum of Art, 1994.

Francesco Clemente: Fifty One Days on Mount Abu (exhib. cat.), London, Anthony d'Offay Gallery, 1997.

DENIS, MAURICE

Bouillon, Jean-Paul. Maurice Denis, Geneva, Skira, 1993.

Chasse, Charles. The Nabis and Their Period (Les nabis et leur temps), trans. Michael Bullock, London, Lund Humphries, 1969.

Clement, Russell T. Four French Symbolists: a sourcebook on Pierre Puvis de Chavannes, Gustav Moreau, Odilon Redon, and Maurice Denis, Connecticut, Greenwood Press, 1996.

Raynal, Maurice. De Baudelaire à Bonnard: Naissance d'une vision nouvelle, Geneva, Skira, 1949.

DIX, OTTO

Baudin, Katia. 'La modernité du passe: Otto Dix, les maitres anciens et la Republique de Weimar', Cahiers du Musée National d'Art Moderne, no. 53, Autumn 1995, pp. 78–101.

Karcher, Eva. Otto Dix 1891-1969, Cologne, Taschen, 1992.

Otto Dix, 1891–1969 (exhib. cat.), Galerie der Stadt, Stuttgart; Nationalgalerie Berlin; Tate Gallery, London, 1991.

Otto Dix: zem 100 Geburstag (Otto Dix: on the centenary of his birth) (exhib. cat.), Albstadt, Germany, Städlische Galerie, 1991.

DUWE, HARALD

Harald Duwe: Bilder, 1948–1982 (exhib. cat.), West Berlin, Gallerie Poll, 1983.

In memoriam Harald Duwe (exhib. cat.), Gifkendorf, Hamburger Kunsthalle, 1984.

ENSOR, JAMES

Farmer, John David (ed.). Ensor (exhib. cat.), The Art Institute of Chicago and The Solomon R. Guggenheim Museum, New York, George Braziller Inc., 1976.

Fierens, Paul. James Ensor, Paris, Édition Hypérion, 1943.

Haesaerts, Paul. James Ensor, New York, Harry N. Abrams Inc., 1959.

ERNST, MAX

Canfield, William A. Max Ernst: Dada and the Dawn of Surrealism, Munich, Prestel, 1993.

Ernst, Max. Beyond Painting and other writings by the artist and his friends, New York, Wittenborn, Schultz, 1948.

Max Ernst (exhib. cat.), Národní Galery v. Praze, 1993.

Max Ernst: prints, Collages and Drawings 1919–73 (exhib. cat.), Tate Gallery, London, Arts Council of Great Britain, 1975.

FALKEN, HERBERT

Herbert Falken — Arbeiten der 70er und 80er Jahre, catalogue raisonné, Cologne, 1996.

Herbert Falken. Aus der Dunkel heit für das Licht (exhib. cat.), Käthe Kollwitz Museum, Cologne / Leopold-Hoesch-Museum, Düren, Cologne, 1993.

Herbert Falken. Jakobskampf. Malerei, Zeichnungen (exhib. cat.), Wieland Schmeid (ed.), Haus am Lützowplatz, Berlin, 11 June – 14 July 1985.

Juan de la Cruz — In dunkler Nacht / Herbert Falken — Gitterköpfe (exhib. cat.), Deutsche Gesellschaft für Christliche Kunst, Galerie an der Finkenstrasse, München, 15 October 1994 – 8 January 1995.

FLACK, AUDREY

Audrey Flack: Daphne Speaks (exhib. cat.), New York, Guild Hall Museum, 1996.

Breaking the Rules … Audrey Flack: A Retrospective 1950–1990 (exhib. cat.), Thaelia Gouma-Peterson (ed.), New York, Harry N. Abrams, 1992.

Flack, Audrey. Art & Soul: Notes on Creating, New York, E. P. Dutton, 1986.

Jones, Arthur F. Audrey Flack: Love Conquers All (exhib. cat.), Virginia, Art Museum of Western Virginia, 1996.

GIMBLETT, MAX

Dunn, Michael. Contemporary Painting in New Zealand, Roseville East, Craftsman House, 1996.

Max Gimblett: Painting as Paradox (exhib. cat.), Sydney, Sherman Galleries, 1995.

Renker, Diana. 'Reflections: Recent Paintings by Max Gimblett', Art New Zealand, no. 67, Winter 1993, pp. 74–8, 106.

GOLDSTEIN, DANIEL

Bayliss, Sarah. 'Foster Goldstrom Gallery, New York; exhibition', Art News, vol. 93, March 1994, p. 141.

Daniel Goldstein: Reliquaries The Icarian Series (exhib. cat.), New York, Foster Goldstrom, 1993.

GROSZ, GEORGE

George Grosz: Berlin — New York, cat. for travelling exhibition, Staatsgalerie Stuttgart, 7 September – 3 December 1995.

Grosz, George. A Little Yes and a Big No: the Autobiography of George Grosz, 1946, New York, 1946.

Kranzfelder, Ivo. George Grosz 1893–1959, trans. M. Hulse, Cologne, Benedikt Taschen, 1994

Lewis, Beth Irwin. George Grosz; Art and Politics in the Weimar Republic, Madison, 1971.

HOLZER, JENNY

Auping, Michael. Jenny Holzer, New York, Universe, 1992.

Jenny Holzer: Writing (exhib. cat.), Germany, Cantz Verlag, 1996.

Jenny Holzer: The Venice Installation (exhib. cat.), New York, Albright-Knox Art Gallery, 1990.

Waldeman, Diane (ed.). Jenny Holzer (exhib. cat.), New York, The Solomon R. Guggenheim Foundation, 1997.

HRDLICKA, ALFRED

Hrdlicka: Kreuzigung (exhib. cat.), Cologne, Kunst-Station Sankt Peter Köln, 1994.

Lewin, Michael (ed.). *Alfred Hrdlicka. Das Gesamtwerk*, 4 vols, Vienna, Europa Verlag, 1987–92.

Mennekes, Friedhelm. *Kein schlechtes Opium: Das Religiöse im Werk von Alfred Hrdlicka*, Stuttgart, Bibelwerg Verlag, 1987.

IPOUSTÉGUY, JEAN-ROBERT

Artaud, Évelyne. *Ipoustéguy, Parlons ...*, Paris, Éditions Cercle d'Art, 1993.

Gaudibert, Pierre. *Ipoustéguy*, Paris, Éditions Cercle d'Art, 1989.

Ipoustéguy: sculptures et dessins de 1957 à 1978 (exhib. cat.), Paris, Fondation Nationale des Arts Graphiques et Plastiques, 1978.

IZQUIERDO, MARIA

Ferrer, Elizabeth. *The True Poetry: the Art of Maria Izquierdo*, New York, Americas Society Art Gallery, 1997.

Maria Izquierdo, Mexico City, Centro Cultural Arte Contemporaneo, 1988.

Maria Izquierdo, Chicago, Mexican Fine Arts Center Museum, 1996.

Paz, Octavio. 'Maria Izquierdo, seen in her Surroundings and Set in Her Proper Place', in Octavio Paz, *Essays on Mexican Art*, trans. Helen Lane, New York, Harcourt, Brace & Co., 1993, pp. 246–65.

KAHLO, FRIDA

Kahlo, Frida. *The Diary of Frida Kahlo: an intimate self-portrait*, London, Bloomsbury Publishing, 1995.

Kettenmann, Andrea. *Frida Kahlo 1907–1954: Pain and Passion*, Cologne, Benedikt Taschen, 1993.

Milner, Frank. *Frida Kahlo*, New York, Smithmark Publishers Inc., 1995.

KANDINSKY, WASSILY

Becks-Malorny, Ulrike. *Kandinsky*, Cologne, Benedikt Taschen, 1993.

Kandinsky, Oeuvres de Vassily Kandinsky (1866–1944) (exhib. cat.), Musée National d'Art Moderne, Paris, 1985.

Grohman, W. *Wassily Kandinsky. Life and Work*, London, Thames & Hudson, 1959.

Roethel, Hans K. and Benjamin, Jean K. *Kandinsky, Catalogue Raisonné of the Oil-Paintings*, vol. 1 (1900-15), London, Sotheby Publications, 1982.

KIEFER, ANSELM

Gilmour, John. *Fire on the Earth: Anselm Kiefer and the Postmodern World*, Philadelphia, Temple University Press, 1990.

Maenz, Paul and de Vries, Gerd (eds). *Anselm Kiefer*, Cologne, Galerie Paul Maenz, 1986.

Rosenthal, Mark. *Anselm Kiefer*, Chicago and Philadelphia, The Art Institute of Chicago and the Philadelphia Museum of Art, 1987.

AF KLINT, HILMA

Fant, Ake. *Secret Pictures by Hilma af Klint* (exhib. cat.), The Nordic Arts Centre, Helsinki, 1988.

Fant, Ake. *Hilma af Klint: Ockult Malarinna och Abstrakt Pionjar*, Stockholm, Hilma af Klint Foundation, 1989.

Okkultismus und Avantgarde: von Munch bis Mondrian 1900–1915 (exhib. cat.), Frankfurt, Schirn Kunsthalle, 1995.

KOKOSCHKA, OSKAR

Goldscheider, Ludwig (collaboration with Oskar Kokoschka). *Kokoschka*, Phaidon Press, 1963.

Kokoschka, Olda and Marnau, Alfred. *Oskar Kokoschka Letters 1905–1976*, trans. Mary Whitall, London, Thames & Hudson, 1992.

Oskar Kokoschka 1886–1980 (exhib. cat.), New York, Solomon R. Guggenheim Museum, 1986.

Oskar Kokoschka 1886–1980 (exhib. cat.), London, Tate Gallery, 1986.

Schröder, Klaus Albrecht and Winkler, Johann (eds). *Oskar Kokoschka*, Munich, Prestel-Verlag, 1991.

KOLLWITZ, KÄTHE

Hinz, Renate, (ed.). *Käthe Kollwitz: Graphics, Posters, Drawings*, London, Pantheon Books, 1981.

Klipstein, August. *Käthe Kollwitz: Verzeichnis des graphischen Werkes*, Bern, Klipstein & Co., 1955.

Kollwitz, Hans (ed.). *The Diaries and Letters of Käthe Kollwitz*, trans. Richard and Clara Winton, Chicago, Henry Regenery Co., 1955.

KRASNER, LEE

Hobbs, Robert. *Lee Krasner*, New York, Abbeville Press, Modern Masters, vol. 15, 1993.

Landau, Ellen G. (with Jeffrey D. Grove). *Lee Krasner: A Catalogue Raisonné*, New York, Harry N. Abrams Inc., 1995.

Lee Krasner: A Retrospective (exhib. cat.), Houston, Museum of Fine Arts; New York, Museum of Modern Art, 1983.

Lee Krasner: Large Paintings (exhib. cat.), New York, Whitney Museum of American Art, 1974.

McCAHON, COLIN

Barr, Mary (ed.). *Headlands: Thinking Through New Zealand Art*, Sydney, Museum of Contemporary Art, 1992.

Brown, Gordon. H. *Colin McCahon: Artist*, Wellington, Reed, 1984.

Colin McCahon: A Survey Exhibition (exhib. cat.), Auckland, Auckland City Art Gallery, 1972.

Gifkins, Michael (ed.). *Colin McCahon, Gates and Journeys* (exhib. cat.), Auckland, Auckland City Art Gallery, 1988.

MANESSIER, ALFRED

Bourniquel, Camille. *Trois Peintres*, Paris, Galerie René Drouin, 1946.

Cayrol, J. *Manessier*, Paris, La Musée de Pouche, 1955.

Houdin, J. P. *Manessier*, Bath, Adams & Dart, 1972.

MAPPLETHORPE, ROBERT

Danto, Arthur. *Mapplethorpe*, New York, Random House, 1995.

Kardon, Janet. *Robert Mapplethorpe: The Perfect Moment*, Philadelphia, University of Pennsylvania, 1988.

Marshall, Richard. *Robert Mapplethorpe*, New York, Whitney Museum of American Art, 1988.

Morrison, Patricia. *Mapplethorpe: A Biography*, New York, Random House, 1995.

MARTIN, AGNES

Agnes Martin (exhib. cat.), Institute of Contemporary Art, Pennsylvania, University of Pennsylvania, 1973.

Haskell, Barbara (ed.). *Agnes Martin* (exhib. cat.), Whitney Museum of American Art, New York, 1992.

Martin, Agnes. 'We are in the midst of reality responding with joy', in *Agnes Martin: Paintings and drawings 1957–75*, Arts Council of Great Britain, 1977, pp. 17–39.

MATISSE, HENRI

Barr, Alfred. H. *Matisse: His Art and his Public*, New York, The Museum of Modern Art, 1951.

Flam, Jack. D. *Matisse on Art*, London, Phaidon Press, 1973.

Henri Matisse: A Retrospective, New York, The Museum of Modern Art, 1992.

Turner, Caroline and Benjamin, Roger (eds). *Matisse* (exhib. cat.),

Brisbane, Queensland Art Gallery and Art Exhibitions Australia Limited, 1995.

MESSAGER, ANNETTE

Annette Messager (exhib. cat.), New York, Museum of Modern Art; Los Angeles, Los Angeles County Museum of Art, 1995.

Davidson, Kate. 'Annette Messager: Penetration', in Kate Davidson and Michael Desmond, *Islands: Contemporary Installations*, Canberra, National Gallery of Australia, 1996.

Gourmelon, Mo. 'Arbitrated Dissections', *Arts Magazine*, November 1990, pp. 66–71.

Rochette, Anne, and Wade, Saunders. 'Savage Mercies', *Art in America*, March 1994, pp. 78–82.

MOTHERWELL, ROBERT

Caws, Mary Ann. *Robert Motherwell. What Art Holds*, New York, Columbia University Press, 1996.

Collins, Bradford R. 'The Fundamental Tragedy of the *Elegies to the Spanish Republic* or Robert Motherwell's Dilemma', *Arts Magazine*, vol. 59, September 1984, pp. 94–7.

Mattison, Robert S. 'A Voyage: Robert Motherwell's Earliest Works', *Arts Magazine*, vol. 59, February 1985, pp. 90–3.

Terenzio, Stephanie (ed.). *The Collected Writing of Robert Motherwell*, New York and Oxford, Oxford University Press, 1992.

MUNG MUNG, GEORGE

Caruana, Wally. *Aboriginal Art*, London, Thames & Hudson, 1993.

Crumlin, Rosemary (ed.). *Aboriginal Art and Spirituality*, Melbourne, Collins Dove, 1991.

Ryan, Judith, and Akerman, Kim. *Images of Power: Aboriginal Art of the Kimberley*, Melbourne, National Gallery of Victoria, 1993.

NEWMAN, BARNETT

Barnett Newman: The Complete Drawings 1944-1969 (exhib. cat.), Baltimore, The Baltimore Museum of Art, 1979.

Hess, Thomas B. *Barnett Newman*, New York, The Museum of Modern Art, 1971.

O'Neil, John P. (ed.). *Barnett Newman: Selected Writings and Interviews*, New York, Alfred A. Knopf Inc., 1990.

Rosenberg, Harold. *Barnett Newman*, New York, Harry N. Abrams, 1978.

NITSCH, HERMANN

Bell, Jane, 'Gunther Brus, Hermann Nitsch, Arnulf Rainer', *Art News*, no. 84, April 1985, p. 137.

Body, catalogue and essays, Art Gallery of New South Wales, Bookman Press, 1997.

Eccher, Danilo (ed.). 'Hermann Nitsch', in *L'incanto e la trascendenza* (exhib. cat.), Galleria Civica d'Arte Contemporanea di Trento, Milan, Electra, 1994, pp. 178–85.

McEvilley, Thomas, 'Hermann Nitsch', *Artforum*, Summer 1988, pp. 131–2.

NOLDE, EMIL

Brücke: German Expressionist prints from the Granvil and Marcia Specks Collection (exhib. cat.), Mary and Leigh Block Gallery, Northwestern University, Illinois, 1988.

Dietrich, Dorothea, and Ackley, Clifford S. 'Perspectives on Emil Nolde: a conversation between Cliff Ackley and Dorothea Dietrich', *The Print Collector's Newsletter*, vol. 25, January/February 1995, pp. 205–11.

Painters of the Brücke: Heckel, Kirchner, Nolde, Pechstein, Schmidt-Rottluff (exhib. cat.), Tate Gallery, London, Arts Council of Britain, 1964.

Perl, Jed. 'Emil Nolde', *Modern Painters*, vol. 9, Spring 1996, pp. 52–5.

O'KEEFFE, GEORGIA

Castro, Jan Garden. *The Art and Life of Georgia O'Keeffe*, New York, Crown Trade Paperbacks, 1995.

Cowart, Jack, and Hamilton, Juan. *Georgia O'Keeffe: Art and Letters*, Boston, Little, Brown & Co., 1987.

Eldredge, Charles C. *Georgia O'Keeffe*, New York, Harry N. Abrams Inc., 1991.

O'Keeffe, Georgia. *Georgia O'Keeffe*, New York, Penguin, 1977.

OROZCO, JOSÉ CLEMENTE

Helm, MacKinley. *Man of Fire: José Clemente Orozco, an interpretive memoir*, New York, Harcourt & Brace; Boston, The Institute of Contemporary Art, 1953; reprinted Connecticut, Greenwood Press, 1971.

Hurlburt, Laurance P. *The Mexican Muralists in the United States*, Albuquerque, University of New Mexico Press, 1989.

Orozco, José Clemente. *Autobiografia*, Mexico DF, Edicciones Occidente, 1945 (rev. ed., Mexico DF, Edicciones Era, 1970).

Orozco, José Clemente. *The Artist in New York: Letters to Jean Charlot and Unpublished Writings 1925–1929*, trans. Ruth L. C. Simms, Austin, University of Texas Press, 1974.

PALADINO, MIMMO

Mimmo Paladino (exhib. cat.), Munich, Städtische Galerie im Lenbachhaus, 1985.

Mimmo Paladino: Recent Painting and Sculpture, 1982–86 (exhib. cat.), Richmond, Virginia, Museum of Fine Art, 1986.

Politi, Giancarlo (ed.). *Mimmo Paladino*, Giancarlo Politi, Milan, 1990.

PICASSO, PABLO

Apostolos-Cappadona, Diane. 'Essence of Agony: Grünewald's Influence on Picasso', *Artibus et Historiae*, vol. 26, 1992, pp. 31–48.

Barasch, Moshe. 'The Crying Face', *Artibus et Historiae*, vol. 15, 1987.

Malraux, André. *Picasso's Mask*, New York, Holt, Rinehart & Winston, 1976.

Rubin, William (ed.). *Picasso and Portraiture: Representations and Transformations*, New York, The Museum of Modern Art and Harry N. Abrams, 1996.

RAINER, ARNULF

Arnulf Rainer (exhib. cat.), Stedelijk Van Abbemuseum, Eindhoven; Whitechapel Art Gallery, London, 1980.

Arnulf Rainer Kreuze 1980-1984 (exhib. cat.), Galerie Heike Curtze, Dusseldorf, 1984.

Fuchs, R. H. *Arnulf Rainer*, Munich, Prestel-Verlag, 1990.

RICHIER, GERMAINE

Couturier, M. A. *La Leçon d'Assy*, Notre Dame de Toute Grâce, Assy Editions Paroissales d'Assy, 1950.

Devémy, Jean. *Le chanoine Devémy et ses amis parlent de l'Eglise d'Assy*, Assy, Notre Dame de Toute Grâce, 1985.

Rubin, S. *Modern Sacred Art and the Church of Assy*, New York, Columbia University Press, 1961.

ROTHKO, MARK

Bowness, Alan (ed.). *Mark Rothko 1903–1970*, London, The Tate Gallery, 1987.

Breslin, James E. B. *Mark Rothko: A Biography*, Chicago, University of Chicago Press, 1993.

Chave, Anna C. *Mark Rothko: Subjects in Abstraction*, New Haven, Yale University Press, 1989.

Waldman, Diane. *Mark Rothko, 1903–1970: A Retrospective*, New York, The Solomon R. Guggenheim Museum, 1978.

ROUAULT, GEORGES

Courthion, Pierre. *Georges Rouault*, New York, Harry N. Abrams, 1977.

Faerna, José Mariá (General Editor, Great Modern Masters series). *Rouault*, trans. Alberto Curotto, New York, Harry N. Abrams, 1997.

Maritain, Jacques. *Georges Rouault*, New York, Harry N. Abrams, 1952.

Rouault: Retrospective Exhibition (exhib. cat.), New York, Museum of Modern Art, 1953.

SAKULOWSKI, HORST

Horst Sakulowski (exhib. cat.), Museum Publications of Böblingen 13, Böblingen, Wilhelm Schlecht Publishers, 1995.

Horst Sakulowski (exhib. cat.), 'Wende' — Reflections 11, Städtische Galerie ADA Meiningen, Kunststation Kleinsassen, Meiningen, Börner PR Publishers, 1996.

Lindner, Elke. *Continuity and Change: On the artistic work of Horst Sakulowski*, University Leipzig, 1992.

SAURA, ANTONIO

Antonio Saura (exhib. cat.), New York, Jason McCoy Inc., 1991.

Antonio Saura: Pinturas 1956-85 (exhib. cat.), Madrid, Ministerio de Cultura, Centro de Arte Reina Sof'a, 1989.

De Cortanze, Gérard (ed.). *Antonio Saura*, Paris, La Différence, 1994.

SCHMIDT-ROTTLUFF, KARL

Brücke. German Expressionist Prints from the Granvil and Marcia Specks Collection (exhib. cat.), Mary and Leigh Block Gallery, Northwestern University, Illinois, 1988.

Chipp, Herschel B. 'German Expressionism in Los Angeles', *Art Journal*, vol. 44, Spring 1984, pp. 82–5.

Grohmann, W. *Karl Schmidt-Rottluff*, catalogue of paintings, 1905–54, Stuttgart, 1956.

SEGAL, GEORGE

George Segal (exhib. cat.), Paris, Galerie Maeght Lelong, 1985.

George Segal: Sculptures (exhib. cat.), Minneapolis, Walker Art Center, 1978.

Van der Marck, Jan. *George Segal*, New York, Harry N. Abrams (rev. ed.) 1979.

SHAHN, BEN

Morse, John D. (ed.). *Ben Shahn*, New York, Praeger, 1972.

Shahn, Ben. *Love and Joy About Letters*, New York, Grossman, 1963.

Shahn, Ben. *The Shape of Content*, Charles Eliot Norton Lectures, 1956–57, Cambridge, Harvard University Press, 1957.

The Collected Prints of Ben Shahn (exhib. cat.), Philadelphia, Philadelphia Museum of Art, 1967.

SHERMAN, CINDY

Cindy Sherman Retrospective (exhib. cat.), Chicago, Museum of Contemporary Art; Los Angeles, The Museum of Contemporary Art; London, Thames & Hudson, 1997.

Fuku, Noriko. 'A Woman of Parts', *Art and America*, 85, no. 6, June 1997, pp. 73–81, 125.

Mulvey, Laura. 'A Phantasmagoria of the Female Body: The Work of Cindy Sherman', *Parkett*, no. 29, 1991, pp. 136–50.

Solomon-Godeau, Abigail. 'Suitable for Framing: The Critical Recasting of Cindy Sherman', *Parkett*, no. 29, pp. 112–15.

SIQUEIROS, DAVID ALFARO

Hutton, John. 'So far from Heaven, David Alfaro Siqueiros' The march of humanity and Mexican revolutionary politics', *The Art Bulletin*, vol. 71, June 1989, pp. 319–23.

Rochfort, Desmond. *Mexican Muralists*, Laurence King Publishing, ?London, 1993.

Siqueiros en la colecci — n del Museo Carrillo Gil (exhib. cat.), Mexico, Instituto Nacional de Bellas Artes/Museo de Arte Contemporáneo Alvar y Carmen T. Carrillo Gil, 1996.

SMITH, KIKI

Kiki Smith (exhib. cat.), Louisiana 4, Denmark, 1994.

Kiki Smith, Institute of Contemporary Art, Amsterdam; The Hague, SDU Publishers, 1990.

Kiki Smith. Unfolding the Body (exhib. cat.), Brandeis University, The Rose Art Museum; Massachusetts, Rose Art Museum pub., 1992.

Kimball, Roger. 'Oozing out all over', *Modern Painters*, vol. 8, no. 1, Spring 1995, pp. 52–3.

SPENCER, STANLEY

Collis, Maurice. *Stanley Spencer: a biography*, London, Harvill Press, 1962.

Robinson, Duncan. *Stanley Spencer*, Oxford, Phaidon Press Ltd, 1979.

Stanley Spencer RA. (exhib, cat.), London, Royal Academy of Arts/Weidenfeld and Nicolson, 1980.

TANNING, DOROTHEA

Caws, Mary Ann. *The Surrealist Look: An Erotics of Encounter*, Cambridge, MIT Press, 1997.

Chadwick, Whitney. *Women Artists and the Surrealist Movement*, London, Thames & Hudson, 1985.

Tanning, Dorothea, and Jouffroy, Alain. *Dorothea Tanning*, Paris, Centre National d' Art Contemporain, 1974.

Tanning, Dorothea. *Birthday*, San Francisco, Lapis Press, 1986.

THOMAS, ROVER

Nowra, Louis. 'Blackness in the Art of Rover Thomas', in *Art and Australia*, vol. 35, no. 1, Sydney, Fine Arts Press Pty Ltd, 1997, pp. 94–9.

O'Farrell, Michael. 'Rover Thomas', in *Venice Biennale, Australia. Artists: Rover Thomas — Trevor Nickolls*, Perth, Art Gallery of Western Australia, 1990.

Ryan, Judith, and Akerman, Kim. *Images of Power: Aboriginal Art of the Kimberley*, Melbourne, National Gallery of Victoria, 1993.

Thomas, Rover, and Akerman, Kim et al. *Roads Cross: The Paintings of Rover Thomas*, Canberra, National Gallery of Australia, 1994.

TOBEY, MARK

Coignard, Laurent. 'Seattle USA: Interview Daniel Abadie', *Cimaise*, vol. 34, June/July/August 1987, pp. 5–23.

Rathbone, Eliza E. *Mark Tobey: City Paintings*, Washington, National Gallery of Art, 1984.

Tobey, Mark. *The World of a Market*, Seattle, University of Washington Press, 1964.

TROCKEL, ROSEMARIE

Beuys and After: contemporary German drawings from the collection (exhib. cat.), New York, Museum of Modern Art, 1996.

German and American Art from Beuys and Warhol (exhib. cat.), Stuttgart, Froelich Foundation in association with Tate Gallery Publishing, 1996.

Rosemarie Trockel (exhib. cat.), Cologne, Kunst-Station Sankt Peter Köln, 1993.

Tegninger af Rosemarie Trockel (Drawings by Rosemarie Trockel) (exhib. cat.), Statens Museum for Kunst, Copenhagen, 1992.

TÜBKE, WERNER

Meißner, Günter. *Werner Tübke, Leben und werk*, Leipzig, E. A. Seemann Verlag, 1989.

Tübke, Werner. *Bauernkrieg und weltgericht, das Frankenhauser Monumentalbild einer Wendezeit*, Leipzig, F. A. Seeman Verlag, 1995.

Tübke, Werner. *Das graphische werk 1950–1990*, Bearbeitet von Brigitte Tübke, mit einer Einführung von Günter Meißner, Düsseldorf, Edition GS, 1991.

Tübke, Werner. *Gemälde, aquarelle, zeichnungen, lithographien / Katalog*, Berlin, Henschelverag, 1989.

VARO, REMEDIOS

Gruen, Walter, and Ovalle, Ricardo (eds.). *Remedios Varo: Catálogo Razonado* (Catalogue Raisonné), Mexico, Editiones Era, 1994.

Haynes, Deborah J. 'The Art of Remedios Varo: Issues of Gender Ambiguity and Religious Meaning', *Woman's Art Journal*, no. 16, Spring/Summer 1995, pp. 26–32.

Kaplan, Janet. *Unexpected Journeys: The Art and Life of Remedios Varo*, New York, Abbeville, 1988.

Remedios Varo, 1908-1963 (exhib. cat.), Mexico City, Museo de Arte Moderno, 1994.

WARHOL, ANDY

Bourdon, David. *Warhol*, New York, Abrams, 1989.

Colacello, Bob. *Holy Terror: Andy Warhol Close Up*, New York, Harper Collins, 1990.

Honnef, Klaus. *Andy Warhol 1928-1987. Commerce into Art*, Cologne, Benedikt Taschen, 1993.

Warhol, Andy. *The Andy Warhol Diaries*, Pat Hackett (ed.), New York, Warner Books, 1989.

WILLIKENS, BEN

Ben Willikens: Metaphysik des Raumes (Metaphysics of Space) (exhib. cat.), Frankfurt, Deutsches Architekturmuseum Frankfurt am Main, 1985.

Der ausgesparte Mensch, Aspekte der Kunst derr gegenwart (exhib. cat.), Kunsthalle Mannheim, 1975.

Honisch, D., and Grisebach, L. *Kunst in der Bundesrepublik Deutschland von 1945 bis 1985*, Nationalgalerie Berlin, 1985.

Transformation eines Raumes — Malerei als Installation (exhib. cat.), Sprengelmuseum, Hannover, 1981.

VAN DE WOESTYNE, GUSTAVE

La premier groupe de Laethem-Saint-Martin 1899–1914 (exhib. cat.), Brussels, Musées Royaux des Beaux-Arts de Belgique, 1988.

La thematique Religieuse dans l'Art Belge 1875–1985 (exhib. cat.), Belgium, Galerie CGER, 1986.

Langui, Emil. *Expressionism in Belgium*, trans. Alistair Kennedy, Brussels, Laconti, 1971.

ZENIL, NAHUM B.

Nahum B. Zenil, Mexico City, Galer'a de Arte Mexicano, 1985.

Peden, Margaret Sayers. *Out of the Volcano: Portraits of Contemporary Mexican Artists*, Washington DC, Smithsonian Institution Press, 1991.

Sullivan, Edward J. *Aspects of Contemporary Mexican Painting*, New York, Americas Society, 1990.

General Works
A Select Bibliography

Ashton, Dore. *American Art Since 1945*, London, Thames & Hudson, 1982.

Ashton, Dore. *The New York School: A Cultural Reckoning*, New York, Penguin Books, 1972.

Baigell, Matthew. *Dictionary of American Art*, New York, Harper & Row, 1969.

Berger, John. *Ways of Seeing*, London, Penguin Books, 1977.

Billeter, Erika (ed.). *Images of Mexico: The contribution of Mexico to 20th century art* (exhib. cat.), Dallas, Dallas Museum of Art, 1987.

Bowker, R.R. *Who's Who in American Art 1993–94*, New Providence, New Jersey, 1993.

Broude, Norma, and Garrard, Mary D. (eds). *The Power of Feminist Art*, London, Thames & Hudson, 1994.

Caws, Mary Ann. *The Surrealist Look: An erotics of encounter*, Cambridge, MIT Press, 1997.

Cerrito, Joann (ed.). *Contemporary Artists*, Detroit, St James Press, 1996.

Chipp, Herschel B. *Theories of Modern Art*, Berkeley, University of California Press, 1968.

Ferrer, Elizabeth. *Latin American Artists of the Twentieth Century*, Waldo Rasmussen, et al. (eds), New York, Museum of Modern Art, 1993.

Goldwater, Robert, and Treves, Marco. *Artists on Art: from the XIV to the XX century*, New York, Pantheon Books, 1972.

Haftmann, Werner. *Banned and Persecuted: Dictatorship of Art under Hitler*, trans. Eileen Martin, Cologne, DuMont Buchverlag, 1986.

Haftmann, Werner. *Painting in the Twentieth Century*, vols 1, 2, London, Lund Humphries, 1965.

Harrison, Charles, and Wood, Paul (eds). *Art in Theory 1900-1990*, Oxford, Blackwell, 1992.

Heller, Jules, and Heller, Nancy G. *North American Women Artists of the Twentieth Century: A Biographical Dictionary*, New York, Garland Publishing Inc., 1995.

Hughes, Robert. *Nothing If Not Critical*, London, Collins Harvill, 1990.

Hughes, Robert. *The Shock of the New: Art and the century of change*, London, British Broadcasting Corporation, 1980.

Joachimides, Christos M., and Rosenthal, Norman (eds). *The Age of Modernism: Art in the 20th Century*, Stuttgart, Verlag Gred Hatje, 1997.

Kandinsky, Wassily, and Marc, Franz (eds). *The Blaue Reiter Almanac*, New York, Viking Press, 1974.

Krens, Thomas et al. (eds). *Refigured Painting: The German Image 1960–88*, New York, Prestel, 1989.

Marks, Claude. *World Artists 1950-1980*, New York, H. W. Wilson Company, 1984 (reprinted 1991).

Marks, Claude. *World Artists 1980–1990*, New York, H. W. Wilson Company, 1991.

Naylor, Colin (ed.). *Contemporary Artists*, Chicago, St James Press, 1989.

Naylor, Colin,J and P-Orridge, Genesis (eds). *Contemporary Artists*, London, St James Press, 1977.

Osborne, Harold (ed.). *The Oxford Companion to Twentieth-Century Art*, Oxford, Oxford University Press, 1981.

Parry-Crooke, Charlotte. *Contemporary British Artists*, London, Bergstrom+Boyle Books Ltd, 1979.

Paz, Octavio. *Essays on Mexican Art*, trans. Helen Lane, New York, Harcourt Brace & Company, 1993.

Polcari, Stephen. *Abstract Expressionism and the Modern Experience*, Cambridge, Cambridge University Press, 1991.

Rasmussen, Waldo, et al. *Latin American Artists of the Twentieth Century*, New York, Museum of Modern Art, Harry N. Abrams, 1993.

Rosenblum, Robert. *Modern Painting and the Northern Romantic Tradition: Friedrich to Rothko*, Harper & Row, 1975.

Sandler, Irving. *The Triumph of American Painting: A History of Abstract Expressionism*, New York, Harper & Row, 1970.

Seitz, William. *Abstract Expressionist Painting in America*, Cambridge, Harvard University Press, 1983.

Selz, Peter. *German Expressionist Painting*, Berkeley, University of California Press, 1957.

Shlain, Leonard. *Art & Physics: parallel visions in space, time & light*, New York, William Morrow, 1991.

Stiles, Kristine, and Selz, Peter (eds). *Theories and Documents of Contemporary Art*, California, University of California Press, 1996.

Sylvester, David. *About Modern Art*, London, Chatto & Windus, 1996.

The Twentieth Century Art Book, London, Phaidon Press, 1996.

Turner, Jane. *The Dictionary of Art* (34 volumes), New York, Grove's Dictionaries Inc., 1996.

Twentieth Century Art: Painting and Sculpture in the Ludwig Museum, a selective catalogue, Museum Ludwig, Stuttgart, Ernst Klett Verlage, 1986.

Twenty Centuries of Mexican Art (exhib. cat.), Museum of Modern Art, New York and Instituto de Antropolog'a e Historia de México, Mexico, 1940.

Wheeler, Daniel. *Art Since Mid-Century to the Present*, London, Thames & Hudson, 1991.

Religion, Spirituality and Modern Art
A Select Bibliography

Adams, Doug, and Apostolos-Cappadona, Diane (eds). *Art as Religious Studies: Insights into the Judaeo-Christian Traditions*, New York, Crossroad, 1993.

Ann, Martha, and Imel, Dorothy Myers. *Goddesses in World Mythology*, California, ABC-CLIO Inc., 1993.

Apostolos-Cappadona, Diane. *Dictionary of Christian Art*, New York, Continuum Publishing Co., 1994.

Apostolos-Cappadona, Diane. *Encyclopaedia of Women in Religious Art*, New York, Continuum Publishing Co., 1996.

Astel, Ann W. (ed.). *Divine Representations: Postmodernism and Spirituality*, New York, Paulist Press, 1994.

Belting, Hans. *Likeness and Presence: A History of the Image before the Era of Art*, Chicago, University of Chicago Press, 1994.

Berry, Philippa, and Wernick, Andrew (eds). *Shadow of Spirit: Postmodernism and Religion*, London, Routledge, 1992.

Blaettler, James Raynor. '"Lovely in Limbs": Sketching the Exhibition', essay in exhib. cat. *The One Chosen: Christ in Recent New York Art*, Thomas J. Walsh Art Gallery, Fairfield University, 1997, pp. 17–22.

Charles Murray, Mary. 'The Art of the early Church', *The Month*, vol. 30, no. 10, October 1997, pp. 388–91.

Charlesworth, Max, and Morphy, Howard et al. *Religion in Aboriginal Australia*, St Lucia, University of Queensland Press, 1986.

Couturier, M. A. *Sacred Art*, trans. Granger Ryan, Austin, University of Texas Press, in association with the Menil Foundation, 1983.

Crowther, Paul et al. 'The Contemporary Sublime: Sensibilities of Transcendence and Shock', *Art & Design*, 40, 1997, pp. 6–96.

Crumlin, Rosemary. *Aboriginal Art and Spirituality*, Melbourne, Collins Dove, 1991.

Crumlin, Rosemary. *Images of Religion in Australian Art*, Kensington, Bay Books, 1988.

Dempsey, T. (ed.). *Consecrations: the spiritual in art in the time of AIDS* (exhib. cat.), Museum of Contemporary Religious Art, St Louis University, 1994.

Dempsey, Terrence. 'Reclaiming the Holy in Contemporary Art: The Reemergence of Judaeo-Christian Themes in Twentieth Century American Art', paper delivered at symposium accompanying *The One Chosen* exhibition, Thomas J. Walsh Art Gallery, Connecticut, 18 April 1997.

Devonshire-Jones, Tom. 'Art: Theology: Church — A Survey, 1940–1990 in the United Kingdom', in exhib. cat. *Images of Christ*, Northampton Museum & Art Gallery, 1993, pp. 28–32.

Dillenberger, Jane. *Image & Spirit in Sacred & Secular Art*, New York, Crossroad, 1990.

Dillenberger, Jane. *Secular Art with Sacred Themes*, Nashville, Abingdon Press, 1969.

Dillenberger, John. *A Theology of Artistic Sensibilities*, London, SCM Press, 1986.

Eccer, Danilo (ed.). Catalogue, *L'incanto e la trascendenza*, Trent, Electa, 1994.

Eliade, Mircea (editor-in-chief). *The Encyclopaedia of Religion*, New York, Macmillan, 1987.

Eliade, Mircea. *Symbolism, The Sacred, and the Arts*, New York, Crossroad, 1988.

Encyclopaedia Judaica, Encyclopaedia Judaica Jerusalem, Israel, Keter Publishing House, 1971.

Francis, Richard (ed.). *Negotiating Rapture* (exhib. cat.), Chicago, Museum of Contemporary Art, 1996.

Freedberg, David. *The Power of Images: Studies in the History and Theory of Response*, University of Chicago Press, 1991.

Fuller, Peter. *Images of God: The Consolations of Lost Illusions*, London, Chatto & Windus, 1985.

Gutfeld, L. *Jewish Art from the Bible to Chagall*, New York, T. Yosseloff, 1968.

Harris, Maria. *Dance of the Spirit*, New York, Bantam, 1989.

Harris, Maria, and Moran, Gabriel. *Reshaping Religious Education*, Louisville, Westminster John Know, 1998.

Haynes, Deborah. *The Vocation of the Artist*, Cambridge, Cambridge University Press, 1997.

Kampf, Avram. *Jewish Experience in the Art of the Twentieth Century*, Massachusetts, Bergin & Garvey Publishers Inc., 1984.

Kölbl, Alois; Larcher, Gerhard and Johannes Rauchenberger (eds). *Entgegen. Religion Gedächtnis Körper in Gegenwartskunst* (exhib. cat.), Graz, Cantz, 1997.

Lipsey, Roger. *An Art of Our Own: The Spiritual in Twentieth Century Art*, Boston, Shambhala Publications Inc., 1988.

Mann, A. T. and Lyle, Jane. *Sacred Sexuality*, Brisbane, Jacaranda Wiley, 1995.

Mennekes, Friedhelm, and Röhrig, Johannes. *Crucifixus*, Freiburg, Herder, 1994.

Mennekes, Friedhelm. *Triptychon: Moderne Altarbilder* (Triptych: modern Altarpieces), St Peter's, Cologne, Frankfurt, Insel, 1995.

Ousterhout, Robert, and Brubaker, Leslie (eds). *The Sacred Image East and West*, Chicago, University of Illinois Press, 1995.

Pattison, George. *Art, Modernity and Faith*, London, Macmillan, 1990.

Pickstone, Charles. '"Visualising Masculinities": Theology, Art and Identity', in *ARTS: The Arts in Religious and Theological Studies*, 5, 2, Winter 1993, pp. 24–6.

Régamy, Pie-Raymond. *Religious Art in the Twentieth Century*, New York, Herder and Herder, 1963.

Regier, Kathleen J. (ed.). *The Spiritual Image in Modern Art*, Illinois, Theosophical Publishing House, 1963.

Ricoeur, Paul. *Figuring the Sacred: Religion, Narrative and Imagination*, Minneapolis, Fortress Press, 1995.

Robinson, Edward. *The Language of Mystery*, London, SCM Press, 1987.

Schildkraut, Joseph J. and Otero, Aurora (eds). *Depression and the Spiritual in Modern Art*, Sussex, John Wiley & Sons, 1996.

Schiller, Gertrud. *Iconography of Christian Art*, vols. I & II, trans. Janet Seligman, London, Lund Humphries, 1971.

Schmied, Wieland (ed.). *Gegenwart Ewigkeit: spuren des transzendenten in der Kunst unserer zeit* (exhib. cat.), Berlin, Martin-Gropius-Bau, Edition Cantz, 1990.

Schwebel, Horst. 'Three Modes of Transcendence in Modern Spiritual Images', *Arts: The Arts in Religious and Theological Studies*, 9, 2, 1997, pp. 18–21.

Schwebel, Horst. *Die Bibel in der Kunst das 20. Jahrhundert*, Stuttgart, Deutsche Bibelgesellschaft, 1994.

Schwebel, Horst. *Glaubwürdig: Fünf Gespräche über heutige Kunst und Religion mit Joseph Beuys, Heinrich Böll, Herbert Falken, Kurt Marti, Dieter Wellershoff*, Munich, Kaiser Traktate, 1979.

Spirit and Place: Art in Australia 1861-1996 (exhib. cat.), Sydney, Museum of Contemporary Art, 1996.

Taylor, Mark C. *Disfiguring: Art, Architecture, Religion*, Chicago, University of Chicago Press, 1992.

Taylor, Mark C. *Hiding*, Chicago, University of Chicago Press, 1997.

The Body on the Cross (exhib. cat.), Musée Picasso, Paris and The Montreal Museum of Fine Arts, Montreal 1992.

Tuchman, Maurice (ed.). *The Spiritual in Art: Abstract Painting 1890–1985* (exhib. cat.), New York, Abbeville Press, 1986.

Walker Bynum, Caroline. *Fragmentation and Redemption: Essays on Gender and the Human Body in Medieval Religion*, New York, Zone Books, 1991.

Wigoder, Geoffrey (editor-in-chief). *The Encyclopaedia of Judaism*, New York, Macmillan Publishing Company, 1989.

Winnekes, Katharina (ed.). *Christus in der bildenden Kunst*, Munich, Kösel-Verlag, 1989.

Woodward, Margaret. *The Arts and Education for Justice: Theory and Practice* (unpublished doctoral thesis), Monash University, Clayton, 1986.

INDEX